Romanticism

Critical Essays in American Literature

Romanticism

Critical Essays in
American Literature

EDITORS

JAMES BARBOUR
University of New Mexico

THOMAS QUIRK
University of Missouri

GARLAND PUBLISHING, INC.
NEW YORK & LONDON
1986

LIBRARY OF CONGRESS CATALOGING-IN-PUBLICATION DATA
Main entry under title:
Romanticism.

(Critical essays in American literature)
1. American literature—19th century—History and criticism—
Addresses, essays, lectures. 2. Romanticism—United States—
Addresses, essays, lectures. I. Barbour, James. II. Quirk, Tom,
1946– . III. Series.
PS217.R6R597 1986 810'.9'003 85-20649
ISBN 0-8240-9348-8
ISBN 0-8240-9349-6 (pbk.)

Cover and book design by Jonathan Billing

Manufactured in the United States of America

Contents

v

Contents

Foreword

T he conception of this series is a simple one. We wished to collect in each volume a rich and stimulating selection of criticism that would be instructive to students of American literature. Specifically, we wanted to provide affordable volumes that might actually be used in the classroom. We were, therefore, especially mindful of the way a college-level survey course in American literature is usually taught. For that reason, this volume differs from other collections of criticism in purpose and scope. It is not, nor was it meant to be, a text that represents a single author's literary achievement. Rather we wanted to offer a book of criticism that was distinguished both by its appropriateness to the study of a definable literary period and by the relative completeness of critical perspective it offers for the study of important individual literary works of that era.

This volume contains an essay in definition and groups of essays about those imaginative literary writings most likely to be read and discussed in the course itself. No doubt a student would profit by an intensive reading of *The Biglow Papers* or *What Maisie Knew*, but the chances are that he or she will actually be studying "Song of Myself" or *Portrait of a Lady*. Moreover, we have not forgotten that there will be a teacher in the classroom; this book is meant to be supportive, not preemptive. We wanted to produce a text that included distinct and intelligent voices that addressed substantive matters concerning some of America's most memorable literature, voices that students might profit by, learn from, and, perhaps, quarrel with. To that end, we consulted an advisory board of distinguished scholar/critics and asked them to recommend those critical selections they have found especially rewarding in the teaching of key texts in American literature. We wish to thank them for their assistance. Undoubtedly, the present volume has benefited by their better wisdom. Needless to say, however, the final responsibility for the selections included here is ours alone.

James Barbour
Thomas Quirk

Introduction

A National Literature and Romantic Individualism 1826–1861

Robert Penn Warren,
Cleanth Brooks, and
R.W.B. Lewis

In 1776 the hand of Thomas Jefferson wrote: "We hold these truths to be self-evident: that all men are created equal. . . ." In 1820, in the first great crisis over slavery, the same hand wrote: "This momentous question, like a fire bell in the night, awakened and filled me with terror. I considered it at once the knell of the Union."

These two utterances bracket the first period of the life of the young Republic, and in the next period, that between Jefferson's death, on July 4, 1826, and the firing on Fort Sumter, on April 12, 1861, the paradox of chattel slavery in a nation founded on the conception of the natural rights of man continued to be the central fact of national life. But the problem of how to give meaning to the dream of freedom and justice was not tidily confined to the fate of the black slave. It also appeared in many other forms during the period. It appeared in connection with the rise of Jacksonian democracy, which dramatized the problem of the pos-

Reprinted from *American Literature: The Makers and the Making* (New York: St. Martin's Press, 1973), pp. 325–51. Copyright 1973 by St. Martin's Press. Reprinted by permission of St. Martin's Press. Abridgments are indicated by three ellipsis points within brackets. Some of the endnotes have been omitted and the remainder renumbered.

sible tyranny of the majority and that of maintaining standards in a society based on a theory of egalitarianism. It appeared, too, with the rise of the industrial order, which raised, in an especially acute form, the problem of economic justice as related to freedom, and that of the human personality vis-à-vis the machine. And undergirding and overarching all such issues was the great philosophical and psychological reorientation demanded by the rise of science.

This was the age of the literary giants: Emerson, Hawthorne, Poe, Whitman, and Melville, who, along with lesser artists, consolidated and developed the new national literature of which Cooper had been the founding father. (Of course Cooper lived on into this age and did much of his best work in it.) These men, even Hawthorne and Poe, who at first glance seem more detached, were intensely of their time. Their work is both a record of, and a reaction to, all of its shocks and strains, and if through their work we best sense the *inwardness* of the age, it is, by the same token, necessary to gain some understanding of the age in order to sense the inwardness of the struggles that eventuated in their work.

One measure of the tremendous shifts in the structure of American life in the first half of the nineteenth century, and its most important political development, was the rise of Jacksonian democracy. In Revolutionary times, and even after, the word "democracy" was, to many ears, roughly synonymous with "anarchy." Democracy, declared Fisher Ames, a New England Federalist speaking in the accents of the old-time Puritan pulpit, "is an illuminated Hell that in the midst of remorse, horror and torture, rings with festivity; for experience shows, that one joy remains to the most malignant description of the damned, the power to make others wretched." Even Jefferson, who was regarded (by conservative citizens) as Antichrist and the fountainhead of anarchy, never applied the word "democrat" to himself—and he certainly did not use the word in the Declaration of Independence.[1] Even though, in one facet of his complex and sometimes paradoxical thinking about politics, he suggested that a revolution might be needed every twenty years, Jefferson agreed wholeheartedly with Washington that the "tumultuous populace of large cities are ever to be dreaded." Among the founding fathers there was certainly no consensus on the notion that the majority will is right, and they would have been appalled by the notion of universal suffrage. The voter in the new Republic was a man of property—or at least a taxpayer.

But powerful forces were afoot. The American Revolution proved to be an incitement to democracy. So, too, did the revolution in France. Both stirred up the nonpropertied American and provided him with an argument for full enfranchisement which was louder than words. American religion, too, after the Great Awakening of the middle of the eight-

4

eenth century, and the revivalism that became part of the back country and frontier culture, made for a democratization of life: if a man got "converted," he was filled with the "spirit" and knew as much about politics, or anything else, as his rich and educated neighbor and therefore, in common justice, should have the vote.

Even so, the movement toward universal manhood suffrage was slow, state by state, and as late as 1820, Daniel Webster, along with the ex-President John Adams, was fighting a losing battle against it in a Massachusetts constitutional convention. The movement toward a political system in which the nomination of candidates would have some reference to the popular will was even slower.

The democratization of American politics was, in fact, a gradual and complex pragmatic growth, not a projection of theory, and one of the stimuli to that growth was fear. When James Fenimore Cooper, in *Notions of the Americans* (1828), observed that his countrymen were "getting clearly more democratic," he explained the event by saying that men in power were aware "that while the votes of a few thousand scattered individuals (the unpropertied) can make no great or lasting impression on the prosperity or policy of the country, their disaffection at being excluded might give a great deal of trouble." Democratization was, as the clear-headed, hardheaded, old ex-Federalist-turned-democrat indicates, as much a matter of prudence as of idealism.

The crisis came when, in 1824, Jackson first ran for the presidency. He won a plurality of the votes in a four-way contest, but lost to John Quincy Adams, the election having been thrown into the House of Representatives. The new states across the mountains felt cheated, for they had found their ideal in Jackson—a man of common origins but master of an elegant estate and of a high manner when occasion demanded, a man of hardihood, a duelist, a connoisseur of horseflesh, a breeder of fighting cocks, a soldier with a natural air of command, unimpeachable courage, and iron endurance, the hero of the Battle of New Orleans, a politician of pungent vocabulary, ruthless logic, and ferocious partisanship, and a husband of fanatical devotion to his Rachel.

In 1828, Jackson routed Adams and his supporters among the rich and well-born, the bankers, great merchants, and spokesmen of polite opinion in pulpit, editorial chair, college classroom, and drawing room. He took every electoral vote except those of New England. Jackson had forged a coalition between the trans-Appalachian woodsmen and farmers and the "tumultuous populace" of the eastern cities (though Jackson also drew some support from men of wealth in the East, especially in New York, and some from well-born New Englanders like Hawthorne and the Brahmin George Bancroft, the historian). In 1800, when Jefferson had won out over the elder Adams, the people had had a triumph,

5

but now it was a different and more outlandish breed of people who thronged into the White House, on Inauguration Day, to celebrate.

This process of democratization, with all its crudities, injustices, and brutalities, was irreversible and was intimately associated with the development of the industrial system. By 1800 John Fitch's steamboat had given a successful demonstration, a spinning mill had been set up, Eli Whitney had patented his cotton gin, and David Wilkerson had invented a machine for making machines. Sixty years later the annual value of manufactures was at two billion dollars—the sum having doubled in the previous decade—and one third of the population, according to the census of 1860, were "supported, directly or indirectly, by manufacturing." By this time, too, the steam packet was driving the clipper ship from the seas, and railroads linked the western cities of Chicago, St. Louis, and Cincinnati with the eastern seaports. Telegraph lines crisscrossed the country, and newspapers, with advanced techniques for gathering news and for manufacturing and distributing their product, dramatically emphasized the growing democratic fluidity.

On the one hand, the industrial and technological developments worked to bind the country together, but on the other, they exacerbated and shifted into a new dimension the conflict between the North and South. When the period began, the spirit of Union, in spite of Jefferson's forebodings, was strong. Even John C. Calhoun, who was to become the architect of the philosophical and political program of the slaveholding South, began public life as a good Unionist and a firm believer in the "internal improvements" that would bind the country into a true nation. But the industrial developments that made such improvements more necessary and more readily available also increased, ironically enough, sectional tensions. The success of northern industry made slavery appear anomalous, and to the free labor of the North slavery became, in general, though with some peculiar shifts and crosscurrents, more and more repugnant—though, as we shall see, not necessarily on idealistic grounds. At the same time, the obvious success of the industrial order in the North drove the South more and more into desperation. Before the Civil War efforts toward industrialization in the agrarian South came to nothing. And the hard fact was that, by 1861, the worth of city property, including industrial plants, was considerably greater than that of all agricultural holdings in the entire nation—and most of that industrial urban property, along with a good deal of the nation's agricultural worth, was located above the Mason-Dixon line. The slaveholder's growing awareness that he was falling behind economically made him resort more and more to purely political solutions which left the root of his problems untouched.

One of the many ironical aspects of the North-South conflict was that the proslavery apologists, because they did stand outside the industrial

system, could clearly see the brutalities and miseries that it entailed, the fact that the factory worker was becoming merely part of the machine, to be thrown on the junk heap when his usefulness was, even temporarily, gone. The analyses of capitalism and industrialism by southerners, such as George Fitzhugh, in *Cannibals All!* (1857), resemble those of Karl Marx. We are not to conclude, however, that in the period before the Civil War the only critical reaction to the industrial system came from the South. There was response, too, from many segments of northern society. Melville won special praise from Friedrich Engels, the friend and collaborator of Karl Marx, for his depiction of the slums of Liverpool, in *Redburn* (1849). Hawthorne wrote of the "crowds of pale-cheeked, slender girls who disturb the ear with the multiplicity of their short dry coughs . . . seamstresses who have plied the daily and nightly needle in the service of master tailors and closefisted contractors until now it is almost time for each to hem the borders of her own shroud"; and went on to an almost Whitmanesque catalogue of "the prison, the insane asylum, the squalid chamber of the almshouse, the manufactory where the demon machinery annihilates the human soul." (But, playing no favorites, he added to his list of horrors "the cotton field where God's image becomes a beast of burden.")

Those at the bottom of the industrial heap naturally protested against the system. The new industrial city was being born, fed by domestic migration and by European immigration that, from a mere trickle in 1800, had grown to an annual half million by the time of the Civil War. The city, along with the new industrial town, was now packed with a toolless proletariat living on a daily wage and subject to the mysterious fluctuations of prosperity and money-panic characteristic of the industrial order. Westward migration was still something of a safety valve, but thinking men were beginning to fear the future, and meanwhile the "tumultuous populace" that Washington had dreaded were learning the meaning of politics and the rudiments of labor organizations.

Labor unions existed at the beginning of the century, and by the time of Jackson's presidency there was an attempt at national organization. An active labor press was developing and with it a lively intellectual debate that absorbed and adapted early European ideas of socialism; and after 1848, when the Communist Manifesto appeared, the doctrines of Marx began to circulate, and Marx himself did some writing for Horace Greeley's New York *Tribune*. It was, as a matter of fact, another foreigner, Fanny Wright, whom Walt Whitman remembered from his boyhood as announcing that the "war of classes" was upon the world: "It is the ridden people who are struggling to throw from their backs the 'booted and spurred' riders." Long after he had ceased to be a journalist for the Democrats and had become the poet of democracy, Whitman declared

that Fanny Wright had "possessed herself" of him "body and soul." She was, however, only one of many educators of labor, native and foreign, and well before 1861 labor was on the way to becoming a potent factor in American life. But the question of slavery was more and more absorbing the energy of idealists and reformers, and the Civil War evidently fell right across what might have been a natural development of the labor movement.

Even so, by 1840 many men were aware of the incoherence and injustice of the new industrialism in America and had before their eyes the image of what was happening in England. Schemes for redeeming society, or establishing new societies, were epidemic. "Not a reading man but has a draft of a new community in his waistcoat pocket," Emerson wrote Carlyle in 1840. One scheme, land reform, would have set up an order of simple communities on public lands as a refuge for the dispossessed. But a more apocalyptic notion appeared in 1840 with Albert Brisbane, who published *The Social Destiny of Men*, adapted from the work of the French philosopher François Marie Charles Fourier, which was to prove highly influential.

Brisbane, brilliant, persuasive, neurotic, and epileptic, always looked, according to Whitman, "as if he were attempting to think out some problem a little too hard for him"; and the problem he was trying to think out was the same one that faces us today—that of how to restore to man, in the face of a technological society, his unity of being and a right relation to nature and to other men. Even in the relatively simple society of that time, Brisbane could say that "monotony, uniformity, intellectual inaction, and torpor reign: distrust, isolation, separation, conflict and antagonisms are almost universal. . . . Society is spiritually a desert." Brisbane set out to remedy the situation by establishing small communal organizations in which capital, labor, and talent would cooperate (according to an elaborate psychological analysis by Fourier, in which, by the way, the smallest return was assigned to labor) in producing necessary goods, with no nonproducers, such as middlemen, lawyers, and bankers, admitted. Society, then, would become an overall organization of these frictionless and happily balanced small units. More than forty "phalansteries" were founded by the "associationists"—and all came to grief.

There had been, of course, other communities in the same period that aimed to create an ideal society outside the industrial order—for example, New Harmony, Indiana, founded by the indefatigable Welsh philanthropist and reformer Robert Owen. New Harmony survived the ravages of human nature for only three years, but Brook Farm, founded in 1840, lasted longer, until 1847, and eventually shifted from its transcendentalist origins into the more widely advertised Fourierist orbit. Hawthorne, though no more transcendentalist than Fourierist, went to Brook Farm, hoping

for a retired and inexpensive life to which he might bring a bride, but he grew quickly weary of both the conversation and the shoveling of literal manure. He did, however, get a novel, *The Blithedale Romance,* out of his experience. [. . .]

The period was, then, a time of frenetic passion for reform. Established faiths—both political and religious—were breaking up, and men, the ignorant and the learned, were reaching out in all directions for meaning in life and for solutions for the problems of society. There was a babel of tongues and a confusion of prophecies. But all reforms, frivolous and profound, somehow flowed into one another, for they had all been generated in the same psychological matrix. In 1840, for instance, we find a great Convention of Friends of Universal Reform, which was attended by Dr. Channing, Bronson Alcott, Garrison, Theodore Parker, the poet Jones Very, and various other notables of New England, who for nine days bore witness, and whose proceedings Emerson reported, with equal-handed sympathy and irony, in the transcendentalist magazine the *Dial.*

It was perhaps because of the enormous tensions developing in this period that the expectation was for reform that would be total, universal, immediate, and apocalyptic. The ignorance of historical process and of human nature that permitted such expectations was considerable, as was the lack of a sense of proportion that would permit such faiths and panaceas as Amelia Bloomer's bloomers (worn by females in some of the Fourierist colonies), mesmerism, phrenology, hydropathy, the abjuring of tobacco or alcohol, or the eating of Dr. Graham's bread (a special table for "grahamites" was provided at Brook Farm) to be elevated to the same level of discourse as the abolition of slavery, the rights of women, and the problem of war.

But if, as William Lloyd Garrison said, there is a "unity of evil," then it could be argued that any social evil was connected at root with all others, and all had to be eradicated together. Meanwhile the evangelical fervor of the Great Awakening, along with Jonathan Edwards' doctrine of the "spiritual light," was now transferred into the secular arena and thus provided for the "enlightened" some of the secular satisfactions of personal vanity and the love of power. James Russell Lowell, whose first wife, Maria White, had led him from his natural bent of irony into the throbbing life of reformism, looked back in his late years and wrote, in his essay on Thoreau, that every form of "intellectual dyspepsia brought forth its gospel," and the reformers "stood ready at a moment's notice to reform anything but themselves." And even before the Civil War, Theodore Weld, one of the most committed and effective of abolitionists, withdrew from active propagandizing because, as he said to an admirer, he found that "he himself needed reforming" and that he "had been laboring to destroy evil in the same spirit as his antagonists."

In the great heyday of reform, however, men like Lowell, with his

irony, Weld, with his self-scrutiny, and Emerson, with his Olympian detachment from human fumbling, were few. The intoxication of personal revelation and the certainty of being right made a heady brew. Promise was in the American air, and the millennial dream drew on old pieties, on the faith of the founding fathers, and on the same psychic energies, expansive optimism, and arrogant sense of being chosen by God (however "God" might be interpreted) that made the idea of manifest destiny seem perfectly natural, that set the American flag on the ramparts of Chapultepec in 1847 and seized an empire from Mexico,[2] and that led the Conestoga wagons across the plains. Energy is energy.

We should note, too, that the millennial dream was related not only to the expansive mind of the age, but to the impulse to "tinker," to invent, to short-cut nature and tradition. When Whittier said that Longfellow's "Psalm of Life" was greater than "all the dreams of Shelley, Keats, and Wordsworth," he gave as his reason that it was redolent "of the moral steam-enginery of an age of action." Whittier's phrase was beautifully apt—reformism was "moral steam-enginery." And behind this indigenous American impulse of "moral steam-enginery" were two other impulses. First, the scientific idea of general evolution that was being developed long before Darwin and second, the more specifically social idea implied by the founding fathers but succinctly put by the French philosopher the Comte de Saint-Simon, whose proud boast was that he had been a soldier under Washington and who predicted the inevitable "perfection of the social order."

If, looking back on that period, we find much of the reformism absurd, we must remind ourselves that history is never tidy, that in spite of all the frothy idiocies, hare-brained schemes, tin-horn fanaticism, and lust for power involved in the reformism of the age, real issues of the greatest practical and moral significance were sometimes at stake—women's rights, injustice to labor, the rights of the minority against a majority, the relation of man to nature in the age of the machine, and, most dramatically, chattel slavery. [. . .]

If abolitionism—or at least one brand of it—set up, squarely and by principle, an absolute individualism and the "higher law" against the assumption of the majority will in a democratic society, it did so merely as one example of the philosophical tendency of the age. And this brings us to the question of transcendentalism.

Transcendentalism was a movement—philosophical, literary, and social—that emerged among New England intellectuals, mainly in the environs of Boston, in the 1830's. Underlying the philosophical, literary, and social manifestation, the root impulse of transcendentalism was, however, theological. By this time Puritan Calvinism had relaxed into

Unitarianism, a belief not unlike the Deism of Franklin and Jefferson in its need to accommodate eighteenth-century thought to a theological framework; unitarianism was, in fact, the institutionalizing of a rationalistic humanism, with general cultural pretensions, perfumed by religious sentiment. That is, Unitarianism represented the triumph of the liberalism of the age against the old orthodoxy, a triumph which in New England had been prepared for by a "liberal Christianity" carrying the day against the spirit of Edwards and which, in the apt phrase of one scholar, marked a movement from "piety" in religious matters to a mere "moralism." But soon that "liberal Christianity," in its Unitarian guise, began to seem to some of the young little more than a new orthodoxy of smug social conformity that denied the spiritual and emotional depths of experience—"corpse-cold Unitarianism," as Emerson was to call it. The appetite for mystery and intensity left unsatisfied by Unitarianism was satisfied, to some degree at least, by the philosophical and literary works of the Romantic movement of Germany and England, some of which almost achieved the status of scripture to the transcendentalists; but, as Perry Miller, an authoritative student of the movement, says, the basic impulse behind transcendentalism was "a religious radicalism in revolt against a rational conservatism."

Here the word "radicalism" must not be taken, as is commonly done in our time, to mean merely an impulse toward sweeping and violent change, presumably of a left-wing variety. It is to be understood, more literally, as meaning a will to return to the "root"—here the "root" of Christianity, to "preach the Holy Ghost," as Margaret Fuller, a famous transcendentalist, put it, instead of "preaching Man"; to emphasize faith instead of understanding, revelation instead of reason, mysticism instead of rationalism. But, oddly enough in one perspective, this revolt, with what might well seem its obscurantist and illiberal aspects, was the work, as we have suggested, of the young. What the young were trying to do was to return to, or rediscover, what they regarded as a deeper "truth" of life than the "truth" of their "liberal" fathers. In this sense, the transcendentalists, whom Emerson called "the party of the Future" against "the party of the Past," were both revolutionary and reactionary, radical and conservative, and to understand them is to see this apparent paradox in historical terms.

To see transcendentalism in such terms demands that we regard it as more than the concern of a handful of men and women of special culture and talent—most notably Emerson and Thoreau[3]—removed from the hurly-burly of life. We must regard it, instead, as a response to the fundamental—if sometimes concealed—issues of the age which that handful of men and women had the gift of perceiving and analyzing. That is, transcendentalism represented a complex response to the democratiza-

tion of American life, to the rise of science and the new technology, and to the new industrialism—to the whole question, in short, of the redefinition of the relation of man to nature and to other men that was being demanded by the course of history.

We must see, too, how the definition of those fundamental issues by the transcendentalists, and even how some of their particular attitudes toward the issues, could affect men who may seem to have opposed transcendentalism—men such as Hawthorne, Whitman, and Melville. Furthermore, and perhaps most importantly, we must try to see how the issues defined by the transcendentalists are related to our own time.

Even if transcendentalism did represent the revolt of the young, "the party of the Future," various older strains of thought flowed into it. Plato was for most transcendentalists the archetypal philosopher, and Emerson went so far as to say that "Plato is philosophy and philosophy is Plato." Too, the very name "transcendentalism" indicates the Platonic idealism according to which reality subsists beyond the appearances of the world. Like Plato, the transcendentalists held that the world is an expression of spirit, or mind, which, by definition, is sheer intelligibility and therefore good. But to Plato's influence must be added that of Immanuel Kant, who emphasized the "native spontaneity of the human mind" against the passive conception of the eighteenth-century psychology; and the influence of Coleridge, in a sense a disciple of Kant, and of other German and English Romantics who insisted on the importance of the sense of wonder, the antirationalism, and the primacy of the individual consciousness characteristic of the transcendentalists. In addition to all these nonindigenous influences, the transcendentalists carried on certain elements of New England Calvinism, especially its ethical seriousness and, more specifically, inherited one aspect of Jonathan Edwards' thought, the doctrine of a "spiritual and divine light immediately imparted to the soul," by which the individual can know absolute truth.

So much for definable influences; but perhaps the best way to approach transcendentalism is to understand that when, on September 18, 1836, George Ripley, a scholar of Boston, later to be a founder of Brook Farm, convened in his study a congenial group of seekers, including Emerson, "to see how far it would be possible for earnest minds to meet," the meeting was not so much of minds as of temperaments, of yearnings, of aspirations, and of rejections, and that what emerged was not so much a philosophy as an atmosphere and a state of sensibility.

The rejections made by the earnest little group at their first meeting are significant. Emerson, looking back late in life on the movement, called it a reaction "against the too formal science, religion and social life of the earlier period." He had already confided to his journal that

"Pure intellect is the pure devil when you have got off all the masks of Mephistopheles," and the rebels were concerned with a faculty that would give truth beyond that possible to the "pure devil" of intellect.

The too formal science against which the transcendentalists were rebelling was what the most learned American of his time, Theodore Parker, calls "sensationalism"—by which he meant the philosophy of empiricism of John Locke and David Hume, which had dominated the eighteenth century; Locke, and Hume after him, held that the mind begins as a blank page—a *tabula rasa*—and that all knowledge develops from sensation. As Parker, in attacking the doctrine, described it: "There is nothing in the intellect which was not first in the senses"—by intellect meaning the whole "consciousness of man." An idea, then, would be but a "transformed sensation."

The transcendentalists believed, on the contrary, that starting from sensation a man could know only the "facts of consciousness" and not ever anything of the existence of the material world. Worse, starting from sensation, man could never arrive at any truths about values. For the transcendentalists the only knowledge of any final worth would be absolutely "certain" knowledge—especially certain knowledge on moral questions; and this appetite for certainty in a world of flux and crumbling beliefs may be said to underlie the whole of their intellectual effort. And the key to such certain knowledge was man's faculty to intuit truth directly. It did not, they would maintain, have to come through the senses.

Our chief concern here is with the transcendentalists vis-à-vis the society of their time, but perhaps the best way to understand this is to begin with their conception of objective nature. By and large, they were, as we have said, Platonists, and Emerson, though he did, as he put it, "acquiesce entirely in the permanence of natural laws," held that "the question of the absolute existence of nature still remains open" and the "culture"[4] leads "man to attribute necessary existence to spirit" and "to esteem nature as an accident and an effect." Sometimes he was even inclined to believe that "all outward circumstance is but a dream and a shade"; and the tale goes that one day, discovered in the act of carrying in wood for his domestic arrangements, he remarked, "I suppose we must do this as if it were real."

Nature might be, then, merely a "divine dream from which we may presently awake to the glories and certainties of day." In this "divine dream" of nature (with the dreamer never quite specified), every "natural fact is a symbol of some spiritual fact," and the "whole of nature is a metaphor of the human mind"; and the end of man is, therefore, not to study nature as such, but to seek to engage the "spiritual fact" that nature symbolizes or to interpret the metaphorical burden. Man should

not, that is, undertake to find truths about nature but to move through nature to the certainties thus afforded by his own intuition, his own "revelation."[5] For example, when Emerson became engrossed with the study of geology, he discerned that the excess of sandstone over coal and that of coal (a fossil of vegetables) over the fossils of animals represented a spiritual truth.

Even Thoreau, celebrated for his scrupulous attention to natural fact, was not, he confessed in a passage which in itself is a beautiful and brilliant little poem, finally concerned with things of Time (such as nature), but of Eternity:

> Time is but the stream I go a-fishing in. I drink at it; but when I drink I see the sandy bottom and detect how shallow it is. Its thin current slides away, but eternity remains. I would drink deep; fish in the sky, whose bottom is pebbly with stars.

Transcendentalism, in this dimension, represented a reaction not only against the Enlightenment of the eighteenth century, with Locke and Hume, but against the continuing development of science in the nineteenth century. It is interesting to compare this attitude toward science with that of the German Romantics of a couple of generations earlier. When the revolutionary scientific work *The System of Nature*, by Paul Henri d'Holbach (1770), reached Germany, Goethe wrote: "How hollow and empty did we feel in this melancholy, atheistical half night, in which the earth vanished with all its images, the heaven with all its stars." What the transcendentalist, like Goethe, wanted was his own version of nature with its "images"—neither the nature of common sense nor that of science, but a "romantic" nature, nature poeticized to please his spirit and taste. Upon receiving a letter from the Association for the Advancement of Science asking him what branch of service he was especially interested in, Thoreau wrote in his journal, under the date of March 5, 1853, that he couldn't properly answer, for the Association did not "believe in a science which deals with the higher laws." He was, he affirmed, "a mystic, a transcendentalist, and a natural philosopher" to boot. He was ultimately concerned with scientific fact only insofar as it was a doorway to the universal, and even at the time of the letter to the Association for the Advancement of Science he had not departed from his early application (in 1842, at Emerson's solicitation) of transcendental methodology to scientific fact in his "Natural History of Massachusetts," in which he concluded that "It is with science as with ethics, we cannot know truth by contrivance and method; the Baconian is as false as any other. . . ." We learn, he asserted, only "by direct intercourse and sympathy."

If for Thoreau nature held this secondary rank, it was only to be expected

that by transcendentalists in general the observation of the facts of nature, especially the disciplined observation by the scientists and the disciplined process of generalizing abstractly from the facts, was likely to be taken as, on the one hand, a blasphemy against God (or the Over-Soul, to use Emerson's term) or, on the other, a demeaning of man. "Empirical science," says Emerson in *Nature,* his first book, "is apt to cloud the sight, and by the very knowledge of functions and processes to bereave the student of the manly contemplation of the whole." Both Emerson and Parker held a contempt for observation and for inductive reasoning based on it, Emerson proclaiming that the "astronomer, the geometer, rely on their irrefragable [because deductive] analyses, and disdain the results of observation." In other words, deductive reasoning, coming from the mind, asserts the creative primacy of the mind—like intuition. And associated with deduction against the vulgarity of observation and the fallibility of induction is set the personal vision of "wholeness"; for a "dream," Emerson says, "may let us deeper into the secret of nature than a hundred concerted experiments."

We must ask, even at the risk of a distraction, exactly what Emerson may mean in this particular assertion of the primacy of mind. Does he merely mean that, as with the case of the literal dream of the chemist Kekulé, who thus discovered the benzene ring, many scientific discoveries have come with visionary speed? Such discoveries, with their fascinating hints of how the creative mind works, are indeed a matter of record, but it is also a matter of record that no dream, vision, or intuition of any scientific importance has come to anyone who did not have training in science (just as no poems have come in dreams except to poets); and so we are back to observation and induction after all. The "dream" can come only, as the great scientist Pasteur puts it, to the "prepared spirit." Furthermore, if the "dream" does come to the "prepared spirit," it cannot be validated by the fact of its being a dream, but only by the vulgar tests of observation, experiment, and induction.

The transcendentalist's theory of nature and the attitude toward science had crucial consequences and parallels when he came to face society and its problems. First, the mere fact that nature was regarded as "an accident and an effect" of the reality of spirit, as "but a dream and a shade," would tend to drain events in the objective world, including human events, of their urgencies. Emerson, as a philosopher, sought a perch above the issues of the untidy—and unreal—world. "The relation of men of thought to society is," he declared, "always the same; they refuse that necessity of mediocre men, to take sides." There is, clearly, sound sense here; in a world of violent passion and irrational partisanship, the wise man does seek to give a detached judgment. But more than that is involved here, as will become clear as we look at a second consequence of the attitude toward nature.

15

If nature, insofar as it can be said to exist, is a manifestation of spirit, then, as Emerson says, "All things are moral," for, in "their boundless changes" they have an "unceasing reference to spiritual nature," and all "animal" functions "echo the Ten Commandments." In such a world evil could not, of course, exist. If Emerson might, in fits of weakness or realism, admit that "Famine, typhus, frost, war, suicide, and effete races must be reckoned calculable parts of the system of the world," he had at least a verbal formula for exorcism in his dictum, in the divinity school address, that good is "positive," while evil is "merely privitive." So he could say, in "Spiritual Laws," that "only the finite" has "wrought and suffered," while the "infinite lies stretched in smiling repose." His "whole philosophy," he summed up, "teaches acquiescence and optimism." He was, apparently, undisturbed when the Scots writer Thomas Carlyle, whom he greatly admired, warned him that he seemed to be "in danger of dividing" himself "from the facts of this present universe, in which alone, ugly as it is, can I find any anchorage, and soaring away after these Ideas, Beliefs, Revelations, and such like." And Carlyle added: "It is the whole Past and the whole Future, this same cotton-spinning, dollar-hunting, canting and shrieking, very wretched generation of ours. Come back into it, I tell you."

Emerson could not often be summoned back to the "finite" with its dollar-hunting and shrieking, for even if man was, after all, a part of nature, his important business was not with man or nature at the finite level, but with the "Over-Soul." It should be noted, however, that Emerson did, finally, accept the obligation of action; in spite of his earlier distaste for abolitionists, the question of slavery finally drew him into the world that "wrought and suffered." As Arthur Schlesinger, Jr., says in *The Age of Jackson,* when he came to an issue that he cared enough about, Emerson scuttled theory. Meanwhile, too, he had offered analyses and judgments on the life around him.

But on what terms might the transcendentalist *as transcendentalist* face the problems of the world of action? In matters of morals and politics, he could no more be satisfied with the empirical approach than in matters of science; this smacked of the "too formal" doctrine of Locke and Hume, which could give no "certain knowledge." In his famous essay "Transcendentalism," Parker deals at length with the whole question. The empirical approach depends on the "lamp of experience" for light and holds that there is no "final truth," only the appeal to history, tradition, and experience. And so Parker posits in the human psychology a specific "moral faculty" that tells a man what is right and just, so that he can, as Parker affirms, be "certain of it."

Furthermore, the empirical approach not only fails to give certainty, but involves the utilitarian notion that the moral thing is what "works

well in the long run." In other words, you can no more look to the future for guidance than to the past.

In any case, since man can have the revelation of absolute truth, he should dismiss the whole matter of consequences. He should not look "to the consequences of virtue" as a test for it, for virtue is an "absolute good to be loved not for what it brings, but is." The only question a man must, therefore, ask himself is what "says conscience—what God?" This, with the obvious implication that the voice of conscience and the voice of God always issue identical instructions.

If we state the matter less theologically, the transcendentalist found in the mind itself intuitions that need no proofs, intimations that were guaranteed to be right by the very fact of their appearance in the mind. The moment when an intuition appeared might indeed be very thrilling, and the thrill itself might be taken as a proof of the "truth" received. One day James Russell Lowell, in the middle of a conversation, saw a whole system of thought rise up "like a vague Destiny looming from chaos." At the moment, he was so overwhelmed that the "very air seemed to waver to and fro with the presence of something I knew not what." Lowell promised himself that he would study his "revelation" through until he understood its "grandeur," but somehow, with his streak of worldliness and toughmindedness, he never got around to it.

A number of men—less imperfect transcendentalists than Lowell—did stand more staunchly by their "revelations." Such an intuition—whether the voice of moral faculty, conscience, or God—was, in Parker's words, to be placed "before all institutions, all laws, all traditions." The transcendentalist, with his Platonic bias and his conviction of possessing "absolute truths" about morals, politics, religion, and any other matter, might find himself withdrawn, apart in his "smiling repose," superior to the "finite" world which "wrought and suffered" and in which affairs were meanwhile being conducted by men not privy to "absolute truths." So Thoreau could say of the world around him that he would have none of its "dirty institutions." Margaret Fuller, the most famous female transcendentalist, who confessed to having an intellect the equal of any she had ever encountered and who was the queen of Brook Farm and the model of Zenobia in *The Blithedale Romance,* was, according to the Englishwoman Harriet Martineau, a perfect example of such superior withdrawal from actualities; "While Margaret Fuller and her adult pupils sat 'gorgeously dressed,' talking about Mars and Venus, Plato and Goethe, and fancying themselves the elect of the earth in intellect and refinement, the liberties of the republic were running out."

Sometimes, in fact, there was in the transcendentalists a streak of the excessive refinement and fastidious shrinking that prompts the hero of

17

the play *Axel* (by Villiers de L'Isle-Adam, 1890) to say to his beloved, "As for living, our servants can do that for us."

As long as the transcendentalist stood outside society, the basic problems entailed by his notion of the intuition of absolute truth did not, in any practical sense, arise. But once he had left off letting his servants do his living for him and was in contact with other men—some of whom, perhaps, had their own convictions of absolute rightness—and had to face conflict with their views, how could he really know that his own intuition was unimpeachable? How, in the rough and tumble of things, could he distinguish the authenticity of one intuition from that of another? Parker faced this question in regard to the "transcendental moralist." The moralist, he admitted, might "take a transient impulse, personal and fugitive, for a universal law; follow a passion for a principle, and come to naught; surrender his manhood, his free will to his unreflecting instinct. . . ." Therefore, he concluded, men should be not "transcendental-mad," but "transcendental-wise."

But we are forced to go beyond such a merely verbal solution and ask on what ground does one distinguish the "transcendental-wise" from the "transcendental-mad"—in morality, science, or anything else. Are we forced to resort to the dreary, complex, unexciting, and uncertain tests disdained by the transcendentalist, who relies on his intuitions and absolutes? Are we forced to make judgments by experience, by observation, by science, by history, by society, by tradition, by utility, and by that most contemptible test of all, plain, commonsensical workableness?

If such dreary criteria are rejected, must we try to settle a matter merely by the intensity of conviction and the dogmatic vigor of assertion? Or should we try emulating Mr. Noyes, the patriarch of Perfectionism at his Oneida Community, who, when some of the faithful became spiritualists as well as perfectionists and began to receive absolute truths from the "other world," truths that sometimes conflicted with his own pronouncements on policy and discipline, simply pointed out that his own "inspirational thought" was in direct communication with the will of Christ.

The "thought" of the really convinced antinomian must, of course, always claim to identify itself with the will of Christ, God, the Over-Soul, Historical Necessity, or the Universe. Emerson, in fact, talked blissfully of the moment when man "shall cease to feel his boundaries but shall be so interfused by nature and shall so interfuse nature that the sun shall rise by his will as much as his own hand or foot do now." The will of the individual, in other words, thus becomes the law of the universe.

Let us turn to the relation of transcendentalism to some of the burning questions in the actual world.

Transcendentalism, a reaction, as we have seen, against the materialism of the "too formal" science of the old order, was also a reaction against the materialism of the new. The reaction was, however, complex and even paradoxical. As always, Emerson best exemplifies the situation of his time. On the one hand, he loathed the new economic and industrial order. Things were in the saddle, ambition was for the dollar, and all the values that the Emersonian individual should strive to embody seemed to be held in contempt. But on the other hand, Emerson, insofar as he followed his idealistic philosophy and what William James was to call his "soft determinism," could lie apart in his "smiling repose," and simply assume that, even though the finite "wrought and suffered," things of that realm were really working out very well, and very morally to boot.

To take a more practical angle on the situation, though Emerson objected to the "Lords of the loom," the new textile magnates, it did not follow that he objected to wealth *qua* wealth. For him, as for a long line of Americans, wealth could be regarded as a mark of virtue. Since an "eternal beneficent necessity is always bringing things right," since there is a "league between virtue and nature," and since success "consists in close appliance of the laws of the world, and since these laws are intellectual and moral," the rewards of success are the marks of virtue. In his essay "Nominalist and Realist," Emerson is very explicit: "Money . . . is in its effects and laws as beautiful as roses. Property keeps the accounts of the world and is always moral. Property will be found where the labor, the wisdom and the virtue have been in nations, in classes, and . . . in the individual also." So we have in this dimension of Emerson's thought, in memorable phrasing, a version of the economic Darwinism that was to be so dear to the heart of the age of the Robber Barons, and which has its roots in the Puritan conviction that material success may indicate election. As Perry Miller puts it, "Vice-Presidents of banks have been known to hang framed mottos from Emerson on the walls of their offices."

If Emerson was being illogical when he attacked the "Lords of the loom," he was being quite logical when, like most transcendentalists, he declined to champion labor against those Lords or against anybody else. The struggle for a ten-hour day, for instance, was not a transcendentalist's concern, nor was the matter of a living wage. "Do not tell me," said Emerson, "of my obligation to put all men in good situations. Are they my poor? I tell thee, foolish philanthropist, that I grudge the dollar, the dime, the cent I give to such men."

In the practical world, the rise of democracy, either the trans-Appalachian Jacksonian stripe or that of the eastern slums and factory towns, was what provoked the transcendentalist to his most significant reaction.

With his unimpeachable intuition, the transcendentalist was concerned—as was, for instance, Cooper on other grounds—to protect his standards of justice, morality, intellect, and taste, as well as himself and his way of life, against the degradation of majority rule. Theodore Parker, a manly and forthright character, boasted of having protested "against the tyranny of the few over the many in Europe, and of the many over the few in America"; and here the transcendentalist would, ironically enough, find himself in bed with John C. Calhoun, with his doctrine of the concurrent majority, and with John Randolph of Roanoke, who declared, "I love liberty and hate equality." All the transcendentalists loathed the timidity, the craven spirit of conformity, which mass democracy runs the danger of breeding, and loathed the notion of quantitative, rather than qualitative, judgments.

It must be insisted, however, that Parker, along with the transcendentalists in general and James Fenimore Cooper, their contemporary critic of democracy, thought of himself as a democrat. The kind of democracy that he hoped for emerges dramatically in a passage from Emerson:

> Leave this hypocritical prating about the masses. Masses are rude, lame, unmade, pernicious in their demands and influence, and need not to be flattered, but to be schooled; I wish not to concede anything to them, but to tame, drill, divide, and break them up, and draw individuals out of them. The worst of charity is that the lives you are asked to preserve are not worth preserving. Masses! The calamity is the masses. I do not wish any mass at all, but honest men only, lovely, sweet, accomplished women only, and no shovel-handed, narrow-brained, gin-drinking million stockingers or lazzaroni at all. If government knew how, I should like to see it check, not multiply population. When it reaches its true law of action, man that is born will be hailed as essential. Away with this hurrah of masses, and let us have the considered vote of single men spoken on their honor and their conscience.

What Emerson is here concerned with is the shocking contrast between a democracy of the masses—with its mystique of the masses—and a democracy of real "individuals." On this point, taken in isolation, he is no different from Jefferson, and his "narrow-brained, gin-drinking million stockingers or lazzaroni" are simply a more eloquently defined version of the big-city mob that Jefferson, and Washington, had feared. Jefferson had naively hoped that his independent American farmer would be the "individual" in the new democracy[6] to give his "considered vote"; but by the time of Emerson that hope had grown quaint and threadbare. The American farmer hadn't quite lived up to expectations, and the cities were already bulging with their "shovel-handed," "gin-drinking" millions, and the tone of the passage conveys the sense of a desperation

quite at variance from Emerson's "whole philosophy" that was supposed to teach "acquiescence and optimism."

What Emerson wanted was not a kingdom ruled by Plato's philosopher-king, but a democracy populated by philosopher-voters, with good manners and "lovely, sweet, accomplished" wives. But he found himself in America, in the middle of the nineteenth century, with the Whigs on one hand and the Democrats on the other, with the Lords of the loom on the one hand and the unshaven rabble on the other, and he scarcely knew which way to turn.

What could be done? Emerson says he would like to see population checked, but doesn't know how. So "school" them, he says, and this means to "tame, drill, divide, and break them up" in order to "draw individuals out of them." And, as an aside, we may say that this business of schooling America in general may be taken, in a way, as Emerson's mission. So we find his cajoling, his moments of rhetorical elevation, his tactics of shock and paradox, his metaphysics all conspiring to create a new awareness of the individual's possibility. But perhaps the most potent element in this process of schooling was the example set by Emerson—as by other transcendentalists—of a man heroically striving to lead the life of the mind.

But to return to the general question of the transcendentalist confronting the world. He might, for instance, see man as "divine," but such divine creatures were in the habit of making very un-divine political arrangements and indulging Satanic impulses. What, then, could a man do? Insist that he himself was *more* divine than his fellows—more equal, to paraphrase the old joke—and could distinguish "transcendental-wise" from "transcendental-mad"? Assuming this to be his view, and that he held, with Thoreau, the notion that "one with God is always a majority," what could he do, practically speaking, to make his "intuition" stick?

If, indeed, the gross-minded numerical majority didn't accept transcendental vote-counting, should the transcendentalist then repudiate the basic practical and institutionalized principle of "one man, one vote," and abjure the faith that in the clash of the free market of ideas truth will win out? Should he deny that to make the market of ideas free, one citizen must respect the next citizen's idea, even at the price of tolerating error, and must, further, be willing to admit the possibility of his own error? Should he deny the assumption that even conscience and conviction must be assumed to be not absolute but "educable," to be subject to discussion and criticism and the test of experience—even one's own conscience? If not, then the possibility must be faced that absolute conviction of rightness of "intuition" may well lead to the only absolute test experience knows—the test of absolute force.

To "draw individuals" out of the masses—that was what Emerson

took to be his mission; and transcendentalism was, at its core, a philosophy of naked individualism, aimed at the creation of the new American, the self-reliant man, complete and independent. In America there had been from the start, set over against the will to found a society, from the theocracy of early New England on to the new Republic of 1776, a vision of the freestanding, contextless individual to whom society was sometimes little more than a congregation of shadows. The emphasis might shift from one pole to the other, but both poles were always there. In the heyday of Puritanism, there was, for instance, the will to found the godly society in this world, but there was also the will to explore in sweat, prayer, and meditation the lonely world of the individual soul in its relation to God. But shifts did occur, and as the historian Edmund S. Morgan says, if the early American thought about God, the American of the late eighteenth century was thinking almost exclusively about statecraft—about the nature of society and how to make one. But as soon as the society got made, the pendulum began to swing back, and by the 1840's, Americans—in Concord and environs, at least—were thinking of neither God nor the state, but of the Self. And, in moments, even of the Self-as-God—detached, as we have seen, from nature, history, and society. The transcendentalist was, as the not very friendly critic George Santayana puts it, a "philosophical egotist"—concerned, as a more recent writer, Quentin Anderson says, with the "Imperial Self."

It is easy to point out the limitations of such a philosophy, but it must be remembered that central to it was the seminal idea of the creative power of mind. It must be granted, of course, that the transcendentalists did not originate this idea, that, as we have earlier suggested, they derived it from the German and English Romantics; but they did reformulate it and significantly adapted it to the American scene so that, among other consequences, we find it projected into the only native American school of philosophy, the pragmatism of William James. Furthermore, it cannot be gainsaid that transcendentalism, even in its extravagances in regard to the autonomy of the self, had something to do with creating the atmosphere in which might emerge the hero of the only literary work of tragic scale in nineteenth-century America. The hero is Ahab, cruising the universe in his pursuit of the white whale. The work is *Moby-Dick,* by Melville. That work's appearance ushered in the last decade before the Civil War. We may even say that the war was the murderous flourish and thrash of the great beast's tail.

To grasp the full significance and stature of the transcendentalists we must think of them in their moment of history, early in the development of the United States, when the modern world was assuming shape. The transcendentalists were, on the one hand, the young, the idealistic, those

who were eager to break with the past and make a new world. They were, on the other hand, deeply embedded in their culture and their class, the old preindustrial elite of New England, the class of educated leadership, of teachers, scholars, clergymen and theologians, and doctors, with roots in the old system of farming and seaborne trade (not in manufacturing and banking), Congregationalism, Federalism, and the old distinctive stock that had respect for self-discipline, a full day's work, clean fields, sound learning, self-dependence, and hard money. (The grandfather of Theodore Parker was, for instance, the farmer who commanded the Minutemen at the Battle of Lexington.)

The cast of mind of these men was both an enormous asset and an enormous liability in dealing with their world. Even if they were in rebellion against what Emerson called the "formal" religion of the rationalistic Unitarianism in which they had been raised, their cast of mind was essentially religious and theological, supernatural and antinaturalistic, and their general education had been humanistic. This gave them a firm footing from which to criticize the defects of the new order; but at the same time they were completely ignorant of science, perhaps not of random facts and findings but of what is at stake in scientific thinking. Deduction and the Inner Light, a passion for absolutes, a contempt for consequences—these are not for the laboratory or for the scientific approach to a problem outside the laboratory in a modern society. The transcendentalists were also ignorant of history; they knew, of course, the historical "story," but they were not concerned with the nature of the forces operating in human affairs; their approach to history was not diagnostic but moralistic. They had lost their old-time theology, but they oddly clung to what is sometimes called the "devil theory of history." History was, to them, something like an old morality play, with Vices and Virtues aligned in debate for the human soul.

But every man must live in the limitations of his age, and the grandeur of his achievement depends on how he confronts the issues of his time in terms of its limitations. The achievement of the transcendentalists has a grandeur. They did confront, and helped define, the great issues of their time, and if they did not resolve those issues, we of the late twentieth century, who have not yet resolved them, are in no position to look down our noses at their effort. In fact, without their intellectual diagnosis we would lack much, and without their moral example, would lack much more.

Indeed, it is possible that certain issues are not to be resolved, but are to be lived into and, by the dialectic of life, merely transferred to new levels. For instance, democracy may exist only in the inevitable tension between the faith that makes institutions possible and the individual's faith in his own intuition. There is, clearly, no easy, abstract formula to

resolve this tension. Again, there is the tension between egalitarianism (and the doctrine of the majority) and the need for standards—and sometimes for simple justice. Last, and perhaps most to their credit, the transcendentalists struggled with the problem of defining a ground for the affirmation of self in the face of the great machine of the world.

American history is the record of how men, including the transcendentalists, have tried to resolve—or to live with—such tensions. American literature finds in this fact, often in a concealed and indirect but nonetheless compelling form, one of its basic and most fruitful, and often one of its most tragic, themes.

Notes

[1]Jefferson did, however, allow his party to be called "Democratic-Republican"—with the second term perhaps disinfecting the first.

[2]The Mexican War represents one of the points of crisis in the long swing toward the Civil War, subsequent ones including the Fugitive Slave Law of 1850, "Bleeding Kansas," and John Brown's raid on Harper's Ferry. The Mexican adventure struck anti-slavery people of all stripes as a high-handed attempt to expand the area open to slavery (which was indeed one of the things it was), and it provoked among abolitionists an impulse toward secession as a means of detaching themselves from the evil. It also provoked more general protest, and even such a nonideological type as U. S. Grant was opposed to it, though of course he did serve. In the aftermath of the great imperialist expansion of the Mexican War, the vast wealth from the territory seized from Mexico, particularly California and Nevada, substantially helped finance the Union war effort.

[3]Sometimes Emerson and Thoreau are regarded as peripheral to transcendentalism, but it is more by talent and character than by doctrine that they are to be distinguished from such members of the movement as Margaret Fuller, George Ripley, Orestes A. Bronson, Bronson Alcott, and William Henry Channing. Certainly, some students of the age, such as Perry Miller, regard Emerson and Thoreau as centrally important. In this connection, however, it must be remembered that there was no hard and fast body of doctrine, no orthodoxy, of transcendentalism.

[4]Emerson clearly rejects from "culture" all that bears on scientific thought.

[5]The transcendentalist, according to the philosopher George Santayana, in his essay "The Genteel Tradition in American Philosophy," might love and respect nature, as Emerson did, but he loves it because what he takes to be nature "is his own work, a mirror in which he looks at himself and says (like a poet relishing his own verses), 'What a genius I am! Who would have thought there was such stuff in me?' "

[6]Jefferson had held that the ideal political solution was not to give the vote apart from land, the hope being that ownership, making the voter economically independent, would make his vote responsible.

Emerson
Essays

I, Eye, Ay—
Emerson's Early
Essay on "Nature"
Thoughts on the Machinery
of Transcendence

Kenneth Burke

An enemy might want to rate this early essay of Emerson's as hardly other than a Happiness Pill. But I admit: I find it so charming, I'd be willing to defend it even on that level, it is so buoyant.

Also, we need not confine our speculations to the one essay. I shall try to make clear what I take to be its salient traits, as considered in itself. But I also hope that what I say about it can be considered from the standpoint of symbolic action in general. Since Emersonian "transcendentalism" was quite accurately named, I shall discuss the work from the standpoint of "transcendence."

Though dialectical transcendence and dramatic catharsis have many areas in which the jurisdictions covered by the two terms overlap, there are also terministic situations in which they widely differ. And the simplicity of the procedures embodied in Emerson's essay is exceptionally useful in this regard, as a way to bring out the contrast between transcendence and catharsis.

Catharsis involves fundamentally purgation by the imitation of victimage. If imaginative devices are found whereby members of rival factions can weep together, and if weeping is a surrogate of orgiastic release,

Kenneth Burke's "I, Eye, Ay—Emerson's Early Essay on 'Nature': Thoughts on the Machinery of Transcendence" was published in the *Sewanee Review*, 74 (Fall 1966). Copyright by the University of the South. Permission to reprint granted by the editor.

then a play that produced in the audience a unitary tragic response, regardless of personal discord otherwise, would be in effect a transformed variant of an original collective orgy (such as the Dionysian rites out of which Greek tragedy developed). Here would be our paradigm for catharsis.

But transcendence is a rival kind of medicine. Despite the area of overlap, the distinction between the two is clear enough at the extremes. And Emerson's brand of Transcendentalism is a thorough example of the difference.

There are traces of victimage even here. Similarly, in the Platonic dialogue, there are traces of victimage, insofar as some speakers are sacrificed for the good of the dialogue as a whole (sacrificed in the sense of being proved wrong—yet their errors were a necessary part of the ultimate truths in which the dialogue, ideally, culminates). A similar "cathartic" element is indicated here in reference to what has been called Hegel's "logonomical purgatory."

Though transcendence as we shall deal with it is a sheerly symbolic operation (quite as with catharsis by victimage), the process has an *institutional* base as well—and I can indicate my meaning quickly thus (or fairly quickly):

In the appendix to the revised edition of my *Attitudes toward History*, there is an article, "The Seven Offices." It aims to decide how many and how few categories are needed to designate the functions that people perform for one another. The first six are:

govern (rule)
serve (provide for materially)
defend
teach
entertain
cure

But one further function still had to be dealt with. For a while, I thought of "console." After a person has been governed, provided for materially, defended, taught, and entertained, but has gone beyond the point where he can be cured, there is nothing left to do for him but attempt to console him, as do the Churches. But the priestly function could not be confined to consolation. A priesthood also assists in the processes of rule, insofar as promises of reward in the after-life are matched by threats of punishment, though Gilbert Murray has pointed out that threats of punishment also have a consoling effect, insofar as we can tell ourselves that our unjust enemy must eventually suffer for his misdeeds—and revenge is sweet. But in any case, I suddenly realized that,

regardless of whether a priesthood is promising rewards in the after-life or threatening punishment, or even if the priesthood is discussing some other realm without reference to ultimate reward or punishment, a realm HERE is being talked about *in terms of* a realm ELSEWHERE—and there is a terminology designed to *bridge* these disparate realms. So, for my seventh office, I chose the term:

pontificate; that is, to "make a bridge."

Viewed as a sheerly terministic or symbolic function, that's what transcendence is: the building of a *terministic bridge* whereby one realm is *transcended* by being viewed *in terms of* a realm "beyond" it. Once you consider this process purely from the standpoint of *symbolic functions,* you will see that it is by no means confined to such "tender-minded" modes of expression as we find in the explicit Transcendentalism of an Emerson.

Transcendence, as we shall see, is best got by processes of dialectic (quite as catharsis is best got through drama). And in borrowing so much from Hegel's dialectic, even so "toughminded" a nomenclature as that of Karl Marx inevitably retained transcendental traces (as when conditions *here and now* are seen *in terms of* a broad historic sweep that quite *transcends* them, and thus imparts to them a kind of "ulterior" meaning).

II

The discussion of catharsis centers in speculations on the way in which an audience is purged by somewhat identifying itself with the excesses of the tragic hero. There are two main meanings of *hubris:* "pride" and "excess." (Both translations fit Coriolanus superbly. He is arrogant—and in his arrogance he embodies with great intensity a moral tension of society as we know it, the distinction between the privileged and the underprivileged.)

We must also consider a non-Aristotelian kind of catharsis, as with the Crocean stress upon the cathartic nature of sheer expression, the relief of getting things said (of turning brute impressions into articulate expression). Perhaps the most effective instance of such gratification in *Coriolanus* is the way in which the play reduces to a clear narrative line the bundle of overlapping complexities among the motives of individual, family, class, and nation.

In many ways, drama and dialectic are alike. Both exemplify competitive cooperation. Out of conflict within the work, there arises a unitary view transcending the partial views of the participants. At least, this is the dialectic of the ideal Platonic dialogue. Both drama and dialectic

29

treat of persons and their characteristic thoughts. But whereas drama stresses the *persons* who have the *thoughts,* and the dialectic of a Platonic dialogue stresses the *thoughts* held by the *persons,* in both forms the element of personality figures.

However, dialectic can dispense with the formal division into cooperatively competing voices. The thoughts or ideas can still be vibrant with personality, as they so obviously are in the essays of Emerson. Yet we think of them as various aspects of the same but somewhat inconsistent personality, rather than as distinct *characters* in various degrees of agreement and disagreement, as in a Platonic dialogue.

Though the Hegelian dialectic lays much greater stress than Emerson's upon the cooperative *competition* (as with Hegel's pattern whereby antitheses become resolved in a synthesis that is the thesis out of which will arise a new antithesis, etc.), Emerson had his variant in his doctrine of "Compensation." (The scheme amounted to this: Show how evils will have good results, but play down the reciprocal possibility whereby good might have evil results. "There is no penalty to virtue, no penalty to wisdom; they are proper additions to being." In brief, work up a dialectic that would rule out an ironic concept such as Veblen's "trained incapacity," or the French proverbial formula "the defects of its qualities.")

All told, however, at their extremes there is a notable difference between tragic catharsis and dialectical transcendence—and the Emerson essay serves as a delightful illustration of this difference. To be sure, the essay is a bit innocuous; but it is charmingly so. It has a kind of exaltation, thanks in large part to Emerson's profuse mixing of his ideas with ingratiating imagery. And we can readily understand why he was so enthusiastic about Whitman, before a more quizzical look at Whitman's poetic evangelism led him to see that it was beckoning "Come hither" to much more than a highly respectable vendor of uplift such as Emerson had bargained for. Both approached the conflicts of the century in terms that allowed for a joyous transcendental translation. To apply in a twisted way (and thereby twisting a twist) Rimbaud's demand for a poetics based on the "reasoned derangement of the senses," we might say that Emerson was as idealistically able as Whitman to look upon some travelling salesmen and see a band of angels. There can be transcendence upwards (as when Coleridge studies the constitution of Church and State "according to the idea of each"). There can be transcendence downwards (as when, thinking of a Church, one speaks of it in terms of the sewer upon which a Church is necessarily built). And there can be a fluctuating between the two. (Cf. in E. M. Forster's novel *A Passage to India* the wavering as to whether India is a "muddle" or a "mystery.")

III

Emerson's essay is definitely an idealistic exercise in transcendence up. (There is also a down implicit in such a pattern—but as we proceed, we'll see how it differs from the angry or Beatnik downs.)

Since both tragic catharsis and dialectical transcendence involve *formal development*, by the same token both modes give us kinds of *transformation*.

In tragic catharsis (or, more generally, dramatic catharsis—for there are corresponding processes in comedy), the principle of transformation comes to a focus in *victimage*. The tragic pleasure requires a *symbolic sacrifice*—or, if you will, a *goat*. And the same is obviously true of the comic pleasure.

In dialectical transcendence, the principle of transformation operates in terms of a "beyond." It is like our seventh office, the "priestly" function, in that it pontificates, or "builds a bridge" between disparate realms. And insofar as things here and now are treated in terms of a "beyond," they thereby become infused or inspirited by the addition of a *new* or *further dimension*.

The Emerson essay is a delightful example of such a terministic process. But before we deal with it in particular, further preparatory considerations are in order, since they bear directly upon the distinction between tragic catharsis and dialectical transcendence. They concern Friedrich Nietzsche's *Birth of Tragedy*. Though the histories of philosophy usually stress Plato's quarrels with the Sophists, Nietzsche was exercised rather with the difference between the Socratic medicine (as interpreted by Plato) and the medicine of the tragic playwrights. Celebrating the cult of tragedy, the cult of the kill, resolution in terms of extreme victimage, Nietzsche attacked Socrates for being a *reformer* whose policies implied the *death* of tragedy.

You might recommend a cause by tragic dignification (by depicting people of worth who are willing to die for it). Or (along the lines of Aristotle's *Rhetoric*) you might recommend it by showing the advantages to be gained if the cause (or policy) prevails (that is, you might argue in terms of expediency). Or there are the resources of dialectical transcendence (by seeing things in terms of some "higher" dimension, with the spirit of which all becomes infused). In Nietzsche's case the situation was further complicated by the fact that, even while attacking Plato, Nietzsche attributed to Plato a large measure of tragic dignification, owing to the stress that Nietzsche placed upon the figure of the "dying Socrates," who willingly sacrificed himself as a way of bearing witness to the virtues of the Socratic (Platonic, dialectical) method.

Essentially, the dialectical operations in the Emerson essay are to be built around the traditional One-Many (unity-diversity) pair. Emerson states it succinctly: "ascent from particular to general"; for if we say "furniture" instead of "tables, chairs, and carpets," we spontaneously speak of the more general term as in some way "higher." The process is completed when one has arrived at "highly" generalized terms like "entities" or "beings"—whereupon all that is left is a further step to something like "Pure Being," or the One, or First, or Ultimate, or some such. When we arrive at this stage, the over-all term-of-terms or title-of-titles is so comprehensive it is simultaneously nowhere and everywhere. Hence, mystics can select just about anything, no matter how lowly and tangible, to stand for it (for instance, the enigmatic role of the wasp, as seen by Mrs. Moore and imagined by Professor Godbole in *A Passage to India*). Dialectical transcendence depends upon these quite pedestrian resources of terminology.

In the case of Emerson's essay, the underlying structure is as simple as this: The everyday world, all about us here and now, is to be interpreted as a *diversity of means* for carrying out a *unitary purpose* (or, if you will, the *principle* of purpose) that is situated in an ultimate realm *beyond* the here and now. The world's variety of things is thus to be interpreted *in terms of* a transcendent unifier (that infuses them all with its single spirit). And by this mode of interpretation all the world comes to be viewed as a set of *instrumentalities.* (Emerson more resonantly calls them "commodities.") For we should bear it in mind that Emerson's brand of transcendentalism was but a short step ahead of out-and-out pragmatism, which would retain an unmistakable theological tinge in William James, and furtive traces even in Dewey. I have in mind the ambiguity whereby, when Dewey pleads that people use their "capacities" to the fullest, he secretly means their *"good* capacities." He thus schemes to make a quasi-technical term serve a moralistic purpose.[1]

Where, then, are we? I am trying to do at least three things at once. I am trying to build up a contrast between transformation by victimage (dramatic catharsis) and transformation by dialectical "transcendence" (modes of "crossing") whereby something here and now is interpreted in terms of something beyond. I am trying to discuss precisely how these operations are performed in one particular essay, by Emerson, on "Nature." (In brief, he so sets up "Nature" that it is to be interpreted in terms of Supernature.) And I further hope to indicate that the design here being discussed is employed in all sorts of terministic schemes. For the same principle is involved (there are tiny "transcendences") every time an author, no matter how empirical his claims, mounts to a "higher" level of generalization and in effect asks that "lower" levels of generalization be interpreted in its terms.

The third thesis should especially concern anyone who, while spontaneously shifting back and forth between different levels of generalization, might incline not to see that all such procedures are operating within the same rules, but in a fragmentary way.

So, if one feels that Emerson's essay is not tough-minded enough (and I'd be the last to assert that it is, for all my love of it), I'd contend that such a judgment is not enough to dismiss it.

If only like loving a pleasant dream, love him for his idealistic upsurge. For *it reads well.* It is medicine. Even in those days, I feel sure, both he and Whitman suspected that they might be whistling in the dark. But they loved the gesture (if whistling is a gesture)—and it is an appealing gesture. Albeit a gesture much more plausible then than now. Emerson's scheme for transcendence (like Whitman's variant) was propounded before his fellow-townsmen had lost their sense of a happy, predestined future. There was not yet any crying need to turn, rather, and begin hoarding relics of the ancestral past, like an unregenerate Southerner's attic with its trunkload of Confederate money.

IV

Here is what I take to be the underlying form of the essay:

It treats of Society in terms of Nature—and it treats of Nature in terms of the Supernatural. Thereby even the discussion of Society in its most realistic aspects becomes transcendentally tinged (somewhat as though you had made a quite literal line-drawing with pen and ink, and had covered it with a diaphanous wash of cerulean blue).

In keeping with such an approach to the everyday materials of living, note how even the realm of the sensory can be interpreted as a kind of *revelation.* For whatever the world is, in its sheer brute nature as physical vibrations or motions it *reveals itself* to us *in terms* of sights, sounds, tastes, scents, touch, summed up as pleasure or pain. Thus you already have the terministic conditions whereby even the most material of sensations can be called "apocalyptic" (since the word but means "revealing")— and Emerson does apply precisely that word. In this respect, even the crudest of sensory perceptions can be treated as the revealing of nature's mysteries, though the revelations are confined to the restrictions imposed upon us by the physical senses that reveal them. Also, the resources of dialectic readily permit us to make a further step, insofar as particulars can be treated in terms that transcend their particularity. Within the Emersonian style, this convenience indigenous to terminology would be more resonantly stated: "when the fact is seen in the light of an idea."

If Nature is to be treated in terms of Supernature, another possibility

presents itself. There could be stylistic procedures designed to serve as *bridges* (or intermediaries) between the two sets of terms. The simplest instance of such a bridging device is to be seen in the dialectic of Christian theology. If you make a distinction between "God" and "Man," you set up the terministic conditions for an intermediate term (for bridging the gap between the two orders): namely, "God-Man." Similarly, in the dialectic of psychoanalysis, one might be advised to inquire whether the term "pre-conscious" can serve (at least on some occasions) as a bridge between the terms "conscious" and "unconscious." Fittingly, the major bridge of this sort in Emerson's essay comes in the chapter halfway through, containing the homily on "Discipline."

We'll discuss later how the chapter on Discipline operates as a bridge, a "pontificator." Meanwhile we should note another kind of bridge: the *imagistic*. There is such a profusion of images in the essay, at first I was puzzled about how I might discuss the imagery in the summarizing way needed for a presentation of this sort. For to deal with the images in their particularity, one would need the kind of line-by-line analysis that is possible only to a succession of sessions in the classroom.

So I propose a makeshift. Near the start of the essay, Emerson writes: "But if a man would be alone, let him look at the stars." Then he continues:

> The rays that come from those heavenly worlds will separate between him and what he touches. One might think the atmosphere was made transparent with this design, to give man, in the heavenly bodies, the perpetual presence of the sublime. Seen in the streets of cities, how great they are! [I fear that that line has become a victim of technological progress.] If the stars should appear one night in a thousand years, how would men believe and adore; and preserve for many generations the remembrance of the city of God which had been shown! [This passage presumably refers to a spot in the Introduction: "The foregoing generations beheld God and nature face to face; we, through their eyes." And at that point, of course, one might turn aside to mention the favored role of eye-imagery in Emerson's transcendental vision.] But every night come out these envoys of beauty, and light the universe with their admonishing smile.

Perhaps we should add the opening sentence of the next paragraph: "The stars awaken a certain reverence, because though always present, they are inaccessible; but all natural objects make a kindred impression, when the mind is open to their influence."

On the basis of these sentences, I would propose for purposes of essayistic efficiency to suggest that Emerson's imagery in general is "starry-eyed." Recall that in *The Divine Comedy* all three canticles *end* on references to the stars, and put that thought together with the fact that Emer-

son's essay thus *begins*. Note also that, in keeping with the quality of Emersonian individualism, he equates the stars with a desire to be *alone*. And when he refers to the atmosphere as being "made transparent with this design," we are advised to note the several other appearances of the term, thus:

I become a transparent eyeball. . . .

. . . the universe becomes transparent, and the light of higher laws than its own shines through it.

If the Reason be stimulated to more earnest vision, outlines and surfaces become transparent, and are no longer seen; causes and spirits are seen through them.

The ruin or the blank that we see when we look at nature, is in our own eye. The axis of vision is not coincident with the axis of things, and so they appear not transparent but opaque.

And in his essay "The Poet," with reference to reading a poem which he confides in "as an inspiration," he says: "And now my chains are to be broken; I shall mount above these clouds and opaque airs in which I live,—opaque though they seem transparent,—and from the heaven of truth I shall see and comprehend my relations."

Here is what I am aiming at: First, the essay involves a definite *crossing*, via the middle section on "Discipline," so far as the development of the *ideas* is concerned. But in the starry-eyed visionary imagery (as epitomized in the notion of the "transparent") the transcendence is *implicitly* or ambiguously there from the start, and permeates the style throughout the entire essay. To pick some instances almost at random:

. . . like an eagle or a swallow . . . the pomp of emperors . . . the live repose of the valley behind the mill . . . spires of flame in the sunset . . . the graces of the winter scenery . . . this pomp of purple and gold . . . the dewy morning, the rainbow, mountains, orchards in blossom, stars, moonlight, shadows in still water . . . the spells of persuasion, the keys of power . . . like travellers using the cinders of a volcano to roast their eggs . . . the azure sky, over whose unspotted deeps the winds forevermore drive flocks of stormy clouds . . . a leaf, a drop, a crystal, a moment of time . . . not built like a ship to be tossed, but like a house to stand . . . this transfiguration which all material objects undergo through the passion of the poet . . . the recesses of consciousness . . . faint copies of an invisible archetype . . .

[Nor should we omit mention of this resonant set in his Introduction: "language, sleep, madness, dreams, beasts, sex." And characteristically, at one point he gives us the equation: "The eye = the mind."]

35

And here would be the place to cite from the transitional chapter on "Discipline," and, at almost the mathematical center of the essay, his central bit of Uplift. In these tough times, I'd not even have the courage to repeat the passage, if I could not immediately hasten to propose a non-Emersonian translation:

> Sensible objects conform to the premonitions of Reason and reflect the conscience. All things are moral; and in their boundless changes have an unceasing reference to spiritual nature. Therefore is nature glorious with form, color, and motion; that every globe in the remotest heaven, every chemical change from the rudest crystal up to the laws of life, every change of vegetation from the first principle of growth in the eye of a leaf, to the tropical forest and antediluvian coal-mine, every animal function from the sponge up to Hercules, shall hint or thunder to man the laws of right and wrong, and echo the Ten Commandments. Therefore is Nature ever the Ally of Religion. . . .

Going beyond the specifically theological level here, one might note the sheerly "logological" fact that a strategic feature of the Decalogue is its urgent sprinkling of Negatives. Elsewhere I have dealt with the all-importance of the Negative in the development of language, in connection with the complex property-structures that depend upon the codifications of secular law (and its species of "thou-shalt-not's"), and with the modes of thinking that arise from the resources of Negativity (Alienation, or "Negativism," for instance).

But for present purposes I might offer a shortcut of this sort: You know of the great stress upon Negativity in much contemporary Existentialist philosophy. And you know of the ingenious talk about "Nothingness" (the Heideggerian concern with *nichten* and the Sartrian concern with *le Néant*). Well, in the last analysis when Emerson grows edified at the thought that all things, for man, are permeated with the spirit of the "thou shalt not," is he not talking about the same situation, except that his particular dialectic allows him to discuss it in the accents of elation, thereby (if we may apply one of his own words) endowing his statements with the quality of the "medicinal"?

Indeed, once the pattern gets established, you will find Emerson doing much the same with transcendentalism as Whitman did with his infectious cult of the glad hand. Accordingly, since Nature is viewed as disciplinary, and since (as we have already noted) the Social Structure is viewed in terms of Nature, it follows that even the discords of "Property and its filial systems of debt and credit" can be welcomed transcendentally as a primary mode of moral discipline, thus:

> Debt, grinding debt, whose iron face the widow, the orphan, and the sons of genius fear and hate;—debt, which consumes so much time, which so

cripples and disheartens a great spirit with cares that seem so base, is a preceptor whose lessons cannot be forgone, and is needed most by those who suffer from it most.

V

But I have not yet made wholly clear how the chapter on "Discipline" serves as a bridge between the *Hic et Nunc* and the "Beyond." To appreciate the dialectical maneuvers here, we should lay great stress upon the strategic sentence in the Introduction: "Let us inquire, to what end is nature?" This question sets the conditions for the pattern of development. Of all the issues that keep recurring in the maneuvers of dialectic, surely none is more frequent than the theme of the One and the Many. As I have said, I feel that it is grounded in the logological fact that terms for particulars can be classified under some titular head. And thus, when we say "the Universe," we feel that we really are talking about the Universe, about "everything," though the term certainly includes an awful lot that we don't know anything about. (And I leave it for you to decide whether you can talk about something when you don't know what it is that you may be talking about.)

Be that as it may, given the typical resources of terminology, the question "To what end is nature?" allows for a one-many alignment of this sort: The world of our empirical existence can be viewed not just as a great variety of *things,* but as a great variety of *means,* all related to some ultimate *end.* In this regard we can see how Emerson's dialectic pattern (of *manifold means* in the world of everyday experience emblematically or hieroglyphically announcing some *unitary end* in a realm beyond everyday experience) set up the conditions for transcendentalizing maneuvers that would be progressively transformed into William James's pragmatism and John Dewey's instrumentalism. Though work, in its *utilitarian* aspects, amasses *material* powers, in its *ethical* aspects work can be felt to *transcend* utility. Hence "Discipline" serves as the means of crossing from sheer expediency to edification.

Before the bridge, Emerson's stress is upon *uses* (a subject dear to his countrymen, who were to build, by their technology, the highest Babylonian tower of useful things the world has ever known, though many of the uses were to prove worse than useless). In his case, of course, the many resources of utility are moralized in terms of a transcendental purpose, itself in the realm *beyond* the bridge. On this side the bridge, there are "Commodity," "Beauty," and "Language." "Beauty" endangers the design, inasmuch as it is an end in itself. But Emerson preserves the

design by his concluding decision that "beauty in nature is not ultimate." It is "the herald of inward and eternal beauty."

Nothing could more quickly reveal the terministic resources of the Emersonian dialectic (or, if you will, the Emersonian unction) than contrasting his views on language with Jeremy Bentham's "theory of fictions." Bentham laid major stress upon the fact that all our terms for spiritual or psychological states are initially terms for sheerly physical things and processes. And by "fictions" he had in mind the thought that all moral or psychological nomenclatures are essentially metaphors carried over from the physical realm and applied analogically. But Emerson's transcendental dialectic allows him to apply a tender-minded mode of interpretation, thus:

> Words are signs of natural facts. The use of natural history is to give us aid in supernatural history; the use of the outer creation, to give us language for the beings and changes of the inward creation. Every word which is used to express a moral or intellectual fact, if traced to its root, is found to be borrowed from some material appearance. *Right* means *straight; wrong* means *twisted. Spirit* primarily means *wind; transgression,* the crossing of a *line; supercilious,* the *raising of the eyebrow.* We say the *heart* to express emotion, the *head* to denote thought; and *thought* and *emotion* are words borrowed from sensible things, and now appropriated to spiritual nature.

And so on. In any case, once you thus turn things around, you see why, if the things of nature are to serve us by providing us with terms which we can apply analogically for the development of a moral terminology, the whole subject then would come to a focus in a chapter on nature itself as a source of moral "discipline." Fittingly, the chapter begins by reference to the *"use* of the world" as a discipline. And at the beginning of the next chapter, "Idealism," we read: "To this one *end* of Discipline, all parts of nature conspire." (Italics in both cases mine.) Thus, when the chapter on "Discipline" is over, we have gone from the realm of *means* to the realm of *ends* or, more specifically, one unitary end (or, if you will, the sheer *principle* of purpose).

Fittingly, now that we have crossed the bridge, into the realm of "Reason" and "Spirit," Nature suffers what Emerson himself calls a "degrading." For whereas Nature rated high when thought of as leading towards the Supernatural, in comparison with the Supernatural it comes into question, even as regards its material existence. (Incidentally, this change of rating in Emerson's dialectic corresponds, in the Marxian dialectic, to a step such as the transformation of the bourgeoisie from the class that is the bearer of the future to the class that is to be buried by the future. In a ladder of developments, rung 5 is "progressive" with regard to rung 3, but "reactionary" with regard to rung 7.) However, in

this later "degrading" of nature, he pauses to admonish: "I do not wish to fling stones at my beautiful mother, nor soil my gentle nest." He wishes, in effect, but to complete the tracking down of the positions implicit in his dialectic.

One final development should be mentioned, since it throws a quite relevant light upon the essay's methods. In his final chapter, "Prospects," while zestfully reciting the many steps that man has taken through the course of history towards the affirming of what Emerson takes to be the ultimate supernatural Oneness, the essay has so built up the promissory that we scarcely note how airily the problem of evil is dismissed:

> Build therefore your own world. As fast as you conform your life to the pure idea in your mind, that will unfold its great proportions. A correspondent revolution in things will attend the influx of the spirit. So fast will disagreeable appearances, swine, spiders, snakes, pests, mad-houses, prisons, enemies, vanish; they are temporary and shall be no more seen. [This comes close to the line in "Lycidas": "Shall now no more be seen."] The sordor and filths of nature, the sun shall dry up and the wind exhale. As when the summer comes from the south the snow-banks melt and the face of the earth becomes green before it, so shall the advancing spirit create its ornaments along its path, and carry with it the beauty it visits and the song which enchants it. . . .

He envisions in sum "the kingdom of man over nature."

One can't do anything with that, other than to note that it disposes of many troublesome things in a great hurry. But the Marxist dialectic is not without an analogous solution, in looking upon the socialist future as "inevitable."

Two asides: As regards "the thinking of the body," there are strong hints of a fecal motive near the end of the section on "Language":

> "Material objects," said a French philosopher, "are necessarily kinds of *scoriae* of the substantial thoughts of the Creator, which must always preserve an exact relation to their first origin; in other words, visible nature must have a spiritual and moral side."

I have found that readers seldom look up the word *scoriae*. It comes from the same root as "scatological." Here it conceives the realm of matter as nothing other than God's *offal*. Such images are likely to turn up somewhere in the dialectics of transformation, especially where there is talk of "discipline." And thanks to an ambiguous use of the verb "betrays," I'd incline to see traces of it in Emerson's statement that the principle of Unity "lies under the undermost garment of Nature, and betrays its source in Universal Spirit." In his later and shorter essay on "Nature," where we are told that the universe "has but one stuff," the same tricky usage appears thus: "Compound it how she will, star, sand,

fire, water, tree, man, it is still one stuff, and betrays the same properties." Surely "stuff" here is synonymous with matter in the reference to Nature as God's *scoriae*. And thinking along the same lines, we find it noteworthy that, though Unity is the best of words when applied to the realm of the Supernatural, in the chapter "Prospects" it is called "tyrannizing" when applied to the earthly animal kingdom.[2]

VI

At the end of the chapter on "Discipline," just before we cross to the realm of the Beyond, we find traces of victimage, in his solemnizing references to separation from a friend:

> When much intercourse with a friend has supplied us with a standard of excellence, and has increased our respect for the resources of God who thus sends a real person to outgo our ideal; when he has, moreover, become an object of thought, and, whilst his character retains all its unconscious effect, is converted in the mind into solid and sweet wisdom,—it is a sign to us that his office is closing, and he is commonly withdrawn from our sight in a short time.

Is not this passage a euphemism for the death, or near-death, of a close friend? And thus, does not the bridge that carries us across to the Beyond end on strong traces of tragic dignification by victimage?

Similarly, I have tried elsewhere to show that James Joyce's story "The Dead" should be analyzed primarily in terms of transcendence. (See the section from "Three Definitions" reprinted in my *Perspectives by Incongruity*, edited by Stanley Edgar Hyman.) But the very title indicates that the purgative force of victimage also figures here.

Without considering the story in detail, we might note this much about it: The "transcending," or "beyonding," concerns the final transformation whereby the situation of the living is viewed in terms of the dead. For if the world of conditions is the world of the living, then the transcending of conditions will, by the logic of such terms, equal the world of the dead. (And the Kantian transcendental dialectic could get in the idea of God by this route: If God transcends nature, and nature is the world of conditions, then God is the realm of the unconditioned.)

The final twist, what Joyce would call an "epiphany," is contrived by the transforming of "snow" from a *sensory* image to a *mythic* image. That is, in the first part of the story, the references to snow are wholly realistic ("lexical" snow, snow as defined in a dictionary). But at the end, snow has become a *mythic* image, manifesting itself in the world of

conditions, but standing for transcendence above the conditioned. It is a snow that bridges two realms—but, as befits the behavior of snow, this Upward Way is figured in terms of a Downward Way, as the last paragraph features the present participle "falling."

There is an interesting variant in Chaucer's *Troilus and Criseyde*. The poem tells a pagan story in a pagan setting. But in the telling, Chaucer infuses the story with the mediaeval terminology of Courtly Love. Now, it so happens that this terminology is a *secular* analogue of the language applied to *religious* devotion. Accordingly the story as so told sets up the conditions for the use of this language in ways that transcend its application to a pagan love affair. Accordingly, the book closes on the picture of slain Troilus looking down upon "this litel spot of erthe" in the traditional Christian attitude of the *contemptus mundi*, in contrast with "the pleyn felicite/That is in hevene above"—thence finally to an outright Christian prayer involving Mary and the Trinity.

In the early part of his trip to the Underworld, Virgil encountered those of the dead who could not cross Cocytus and the Stygian swamps. Charon would not ferry them to their final abode because they had not been buried. Then comes the famous line:

Tendebantque manus ripae ulterioris amore.
And they stretched forth their hands, through love of the farther shore.

That is the pattern. Whether there is or is not an ultimate shore towards which we, the unburied, would cross, transcendence involves dialectical processes whereby something HERE is interpreted *in terms of* something *THERE*, something *beyond* itself.

These examples involve modes of "beyonding" that overlap upon connotations of victimage where symbolic fulfillment is attained in the ambiguities of death and immortality (with technical twists whereby, if "death" means "not-life," "immortality" compounds the negative, giving us "not not-life"). Obviously, Emerson's dialectic of a transcendent End involves similar operations. But I would here stress the fact that the principle of transcendence which is central to his essay is not confined to its use in such thorough-going examples.

The machinery of language is so made that, either rightly or wrongly, either grandly or in fragments, we stretch forth our hands through love of the farther shore. Which is to say: The machinery of language is so made that things are necessarily placed in terms of a range broader than the terms for those things themselves. And thereby, in even the toughest or tiniest of terminologies, terminologies that, on their face, are far from the starry-eyed Transcendentalism of Emerson's essay, we stretch forth our hands through love of a farther shore; that is to say, we consider

things in terms of a broader scope than the terms for those particular things themselves. And I submit that, wherever there are traces of that process, there are the makings of Transcendence.

Notes

¹Money being a kind of universal purpose (since it can serve for an almost endless variety of purchases), whereas one might ask, "Give our lives *meaning*," or "Give our lives *purpose*," you are more likely to hear the pragmatic reduction, "*Give us jobs*." It is well to keep such developments in mind when we read the Emerson essay. While affirming much the kind of moralistic utilitarianism that one finds in the *Discourses* of Epictetus, and with hankerings after the kind of moralistic "Progress" that one finds in Bunyan's idea of pilgrimage, the essay must now be seen as inevitably, inexorably placed along the way towards the confusions that beset the current combinings of technological and monetary rationalization. "Under the general name of commodity," Emerson writes, "I rank all those advantages which our senses owe to nature." Thus, under the head of "Commodity," he can refer to "Nature, in its ministry to man." While reading that section, perhaps we should not merely be sure to interpret "commodity" in a moralistic sense that has since dropped away. When reading it we should also have in mind the poignancy of the fact that, as we can now readily discern, since history is by nature a Damoclean sword, Emerson's use of the term already held in suspension the narrower contemporary meaning.

²The grounds for my speculations here are made clearer in my essay on "Thinking of the Body" (*The Psychoanalytic Review*, Autumn, 1963), particularly the section on the symbolism of "matter" in Flaubert's *La Tentation de Saint-Antoine*. Similar connotations flit about the edges of an expression such as "purge the eyes."

Emerson:
The Unconquered
Eye and the
Enchanted Circle

Tony Tanner

E merson unquestionably played a key role in the shaping of the American imagination, and yet he seems to have had some trouble in defining his own role in his own times. Once he ceased to be a minister he did not start to become an artist; his work has neither the intense passion or still serenity of the true mystic nor the intellectual rigour of the philosopher. He experimented with various characters or projections of parts of his own uncommitted imagination—the Scholar, the Seer, the Man of Genius, the Contemplative Man, the Student, the Transcendentalist, even the Reformer and the Hero. Professor Henry Nash Smith is surely correct in referring to these as "a collection of embryos" and in going on to suggest that we should understand the essays and addresses in which Emerson deploys these characters as "rudimentary narratives rather than as structures of discursive reasoning."[1] In his work, therefore, it is wiser to seek the suggestive drift of the whole than to attempt to establish a consistently developed system of thought. In his many characters he canvassed many problems, but recurringly, insistently, he returned to the discussion of the relationship between man and nature, "the marriage of thought and things." He saw no basic hostilities in nature and no radical evil in man. When he does turn his

Reprinted from *Reign of Wonder* (Cambridge: Cambridge University Press, 1965), pp. 26–45. Copyright 1965 by Cambridge University Press. Reprinted by permission of Cambridge University Press. Some of the endnotes have been cited in the text and the remainder renumbered.

attention to the problem of pain and suffering his tone remains suspiciously bland.[2] It is hard to feel that he has deeply registered some of the more rigorous paradoxes of existence; hard to feel that he ever experienced the chaos within. Evil was neither lasting nor real to Emerson. Thus the problem he addresses himself to is not how to restrain what is dark in man, but rather how to maintain a sense of the enveloping, involving divinity of the world. "What is life but the angle of vision"[3] he asserts, and much of his work is occupied with attempts to define the appropriate angle of vision. He felt that one of America's deepest needs was a "general education of the eye"[4] and it was just such an education that many of his essays and addresses attempted to give. I want to suggest that in the course of his "education" he procured special prestige for the angle of vision of the child.

In his diagnosis of what was wrong with contemporary attitudes towards the world, Emerson insisted that the fault was not in the world itself so much as in man's manner of regarding it. "The ruin or the blank that we see when we look at nature, is in our own eye. The axis of vision is not coincident with the axis of things, and so they appear not transparent but opaque. The reason why the world lacks unity, and lies broken and in heaps, is because man is disunited with himself" (I, 73–74). If things appeared to lack unity that was because of some disorder in the eye: a new eye would unify the world in a new way—salvation is visual. Emerson shifts attention from environment to spectator. In one way he was merely continuing the tradition of neo-platonic thought among the romantics. When he writes: "Not in nature but in man is all the beauty and worth he sees" (II, 147) we hear echoes of Blake and Goethe, and Coleridge. But in emphasizing the responsibilities and creative powers of "the eye of the beholder" he had a motive which the European romantics could not have had. For, as long as the interest of a locale was considered to be inherent in the place rather than the viewer, then Americans would be forever looking to Europe. By denying a hierarchy of significance among external objects he not only eliminated the special prestige of Europe (since everywhere is equally significant), he confronts the eye with an enormous, if exciting, task.

In the introduction to his earliest work he had written: "Why should not we also enjoy an original relation to the universe?" (I, 3) and he had started out with the resolution: "Let us interrogate the great apparition that shines so peacefully around us" (I, 4). Emerson wanted the eye to see the world from scratch, wanted to inculcate "the habit of fronting the fact, and not dealing with it at second hand, through the perceptions of somebody else" (III, 92). But from the start we should alert ourselves to a doubleness which is inherent in almost everything Emerson says about man's visual relationship with nature. Briefly this doubleness con-

sists of an emphasis which points both to the importance of particulars *and* the unmistakable presence of general truths. The world is full of isolated details which should command our equal attention and reverence, and yet ultimately it is all one vast simple truth: the world is both a mosaic *and* a unified picture which admits of no fragmentation. To pick up his own words the world is both opaque and transparent—it both resists and invites visual penetration. His complaint is that "as the high ends of being fade out of sight, man becomes near-sighted, and can only attend to what addresses the senses" (I, 127–28). The senses bring us indispensable particulars but to limit knowledge to the "sensuous fact" is to be a Materialist: the Idealist, by a deliberate "retirement from the senses" (I, 330), will discern truths of which material things are mere representations, truths of "the high ends of being."

> We live in succession, in division, in parts, in particles. Meantime within man is the soul of the whole; the wise silence, the universal beauty, to which every part and particle is equally related; the eternal ONE. . . . We see the world piece by piece, as the sun, the moon, the animal, the tree; but the whole, of which these are the shining parts, is the soul. (II, 269)

Man must see all the shining parts of the world anew, as for the first time with his own uninstructed eye: but this is merely the prelude to his discerning "the ONE." Emerson's work would seem to prescribe an ascent from materialism to idealism and thence to mysticism—a passionate scrutiny of the minute particulars of a world which suddenly turns transparent and gives us an insight into "the background of being," "the Over-Soul," "the ONE." This duality of vision Emerson himself recognized, noting in his journal: "Our little circles absorb us and occupy us as fully as the heavens; we can minimize as infinitely as maximize, and the only way out of it is (to use a country phrase) to kick the pail over, and accept the horizon instead of the pail, with celestial attractions and influences, instead of worms and mud pies."[5] Emerson is not consistent in his advice for he is quite as likely to recommend that a man should scrutinize the pail rather than kick it over. But the passage describes very graphically one of his own habitual practices; for both visually and stylistically he moves from the pail (the discrete detail) to the horizon (the embracing generalization). Sherman Paul, who has written so well on Emerson, shrewdly adopts an idea from the work of Ortega y Gasset, and makes a similar point about Emerson. "The eye brought him two perceptions of nature—nature ensphered and nature atomized—which corresponded to the distant and proximate visual powers of the eye."[6] Emerson, seeking a sense of the unity and inter-involvement of all things, felt there was a great value in focusing the eye on "an unbroken horizon":[7] not only because the unbroken horizon offers an image of an unbroken circle,

45

not only because at the horizon different elements meet and marry, but also because when the eye pitches its focus thus far, all things between it and the horizon fall into what Paul calls "a blur of relatedness."[8] Seen thus, individual things seem not to be discrete and unrelated but rather a part of one vast unifying process. The world appears as a concave container. On the other hand, when the eye fastens on to one single detail the rest of the world falls away and one is only conscious of the separateness and isolation of the thing: there is no hazy unity but only the encroaching fragment. The world becomes convex, thrusting out its differentiated particulars. The dangers of the close scrutinizing vision were clear to Emerson: "If you bury the natural eye too exclusively on minute objects it gradually loses its powers of distant vision."[9] The paradox is, I think, that Emerson himself effectively, if unintentionally, stressed the value of the close scrutinizing vision. In his case, of course, the detail seldom failed to reveal the divine spirit which rolls through all things. But Thoreau developed a habit of close scrutiny, a reverence for details, which occupied itself with "minute objects" to a degree never intended by Emerson. Thoreau was convinced that every fact, no matter how small, would flower into a truth, conveying to him a sense of the whole, the unity which maintained the details. Yet he seems to bear out Emerson's warning in a late melancholy complaint: "I see details, not wholes nor the shadow of the whole."[10] In such a phrase he seems to anticipate what could, and I think did, happen to subsequent writers. For many of them the eye got stuck at the surface, it was arrested among particulars. The mosaic stayed illegible with no overall, or underall, pattern discernible. Emerson himself gives intimations of such a possibility. "Nature hates peeping" (III, 59) and, more forcefully, "Nature will not be a Buddhist: she resents generalizing, and insults the philosopher in every moment with a million of fresh particulars" (III, 236). One of Emerson's natures is one divine unbroken process wherein all the teeming, tumbling details are seen as part of a flowing Unity, a Unity not described so much as felt, passionately, ubiquitously, empathetically. This is the nature that Whitman was to celebrate. But the other nature described by Emerson is a mass of discrete, clearly defined objects, a recession of endless amazing particulars—particulars which seem to quiver with hidden meanings but which never afford us the revealing transparency. This nature of clear contours and suggestive details is the nature of Anderson, Stein, Hemingway and many others.

As we noticed, the threat to the Transcendentalist lay precisely in the extreme generality of his assertions, his reliance on the all-explaining presence. For without a final mystical concept of nature Emerson confesses that he is left "in the splendid labyrinth of my perceptions, to wander without end" (I, 63). Without the affirmed presence of the Over-

Soul the world becomes a labyrinthine maze of perceptions which do not add up. The only way out of the maze was to look at it in a different way: this is why Emerson continually raises the question of how man should look at the world.

"Make the aged eye sun-clear" (IX, 181)—so Emerson appeals to Spring in one of his poems: it is an appeal which follows logically from his constant complaint that "we are immersed in beauty, but our eyes have no clear vision" (II, 354). The age of an eye is presumably its sum of acquired habits, its interpretative predispositions, its chosen filter through which it sieves the world even while regarding it. Emerson thought that a person could become fixed in his ways of looking just as we talk of people getting fixed in their ways of thinking. Consequently he wants the eye to be washed clear of those selective and interpretative schemata which prevent us from "an original relation to the universe." As we now think, without these acquired schemata vision would be impossible: we have to learn to see and a "washed" eye would be an eye blinded by undifferentiated confusion. But the important thing is not that Emerson did not understand the mechanics of sight but that he thought it possible and desirable to start looking at the world as though one had never seen or heard of it before. What Emerson wanted from man was a renewed faculty of wonder. "All around us what powers are wrapped up under the coarse mattings of custom, and all wonder prevented. . . . the wise man wonders at the usual" (III, 285). "The invariable mark of wisdom is to see the miraculous in the common" (I, 74). In this kind of visual relationship between the eye and the world, the eye stands completely passive and unselective while the surrounding world flows unbroken into it. Something like this was envisaged by Emerson when he described himself in the following way:

> Standing on the bare ground—my head bathed by the blithe air and uplifted into infinite space—all mean egotism vanishes. I am become a transparent eyeball; I am nothing; I see all; the currents of the Universal Being circulate through me; I am part or parcel of God. (I, 10)

The notable aspect of this visual stance is its complete passivity, its mood of pious receptivity. Unfocusing, unselecting, the eye is porous to the "currents of the Universal Being." Rather similar is Emerson's description of the delight he receives from a fine day which "draws the cords of will out of my thought and leaves me nothing but perpetual observation, perpetual acquiescence, and perpetual thankfulness."[11] Thus relieved of the active will and conscious thought, Emerson could feel himself reabsorbed into the flowing continuum of unselfconscious nature.

Of course it was because of his optimistic mysticism that Emerson endorsed this mode of seeing, for he was convinced that if man could

reattain a primitive simplicity of vision the ubiquitous divinity of the world would suddenly become clear to him. The wonder he advises is a form of visual piety: to see naively is to see religiously. This explains his interest in the animal eye and the child's eye—neither of which have been overlaid with the dust and dirt of custom and second-hand perception, both of which are free from the myopic interference of reason. The child sees better than the man. "To speak truly, few adult persons can see nature. Most persons do not see the sun. At least they have a very superficial seeing. The sun illuminates only the eye of the man, but shines into the eye and the heart of the child" (I, 8).

The desired point of view is one which allows nature unhindered, uninterrupted access to the eye, thence to the heart. Because for Emerson this meant capitulation to a superior source of virtue. "Man is fallen; nature is erect" (III, 178) and "all things are moral" (I, 40). It follows we must not try and impose our will on nature but rather "suffer nature to intrance us" (III, 170) for our own good. Man's fall is not into knowledge of evil—but into consciousness: for Emerson, as Yeats noted, has no "vision of evil" and maintains, rather incredibly, that what we call evil would disappear if we acquired a new way of looking at things: "the evils of the world are such only to the evil eye." How such evil finds its way into an intrinsically benign and moral universe is not clear—but the extremity of Emerson's position is. To be conscious is the curse, for to be conscious is to be alienated from our original home or womb (and Emerson often uses words like "cradle" and "nestle" and "embosomed" to describe the proper quasi-infantile relationship with nature), it is to have lost the comfort of our primary ties. The unselfconsciousness of animals is enviable. "The squirrel hoards nuts and the bee gathers honey, without knowing what they do, and they are thus provided for without selfishness or disgrace" (I, 338). Man's dilemma is based solely on his consciousness. "Man owns the dignity of the life which throbs around him, in chemistry, and tree, and animal, and in the involuntary functions of his own body; yet he is balked when he tries to fling himself into this enchanted circle, where all is done without degradation" (I, 339). Only the *involuntary* actions of man have any dignity: we hear nothing of "the dignity of judgment" in James's phrase, nothing of the enlightened will, of considered intent, of the disciplined pursuit of noble ends. Consciousness is seen only as an inhibitor—for what Emerson really wants is to get back into the enchanted circle, to regain what he calls "the forfeit paradise."

> And so, perchance, in Adam's race,
> Of Eden's bower some dream-like trace
> Survived the Flight and swam the Flood,
> And wakes the wish in youngest blood

> To tread the forfeit Paradise,
> And feed once more the exile's eyes: (IX, 166)

And he makes the point as strongly in prose: "Infancy is the perpetual Messiah, which comes into the arms of fallen men, and pleads with them to return to paradise" (I, 139). Not a change of heart but a change of eye, a new mode of access into nature, is the burden of Emerson's lay sermons. As exemplars he cites "children, babes, and even brutes" because "their mind being whole, their eye is as yet unconquered; and when we look in their faces we are disconcerted" (II, 48). Man's eye has been conquered—that was the fall: man has been "clapped into jail by his consciousness" (II, 49). This is why the child sees the sun properly and the adult does not. "Infancy, youth, receptive, aspiring, with religious eye looking upward, counts itself nothing and abandons itself to the instruction flowing from all sides" (II, 319). This is the child's genius: the openness to sensations, the visual abandon he is capable of. We are at our best when we too can "gaze like children" (II, 329). "It is very unhappy, but too late to be helped, the discovery we have made that we exist. That discovery is called the Fall of Man. Ever afterwards we suspect our instruments. . . . Once we lived in what we saw; now the rapaciousness of this new power, which threatens to absorb all things, engages us" (III, 75–76). "We suspect our instruments"—Emerson diagnoses a crisis of vision: we see, but we are not sure what we see and how correct is our seeing. There is perhaps something greedy and predatory about the conscious eye, which scans the panorama of creation with utilitarian intention, every glance of which is an act of visual spoliation. But the eye which seeks passively and humbly for true connection and orientation lacks confidence. However the child and the animal still seem to live in what they see with no subject–object dichotomy to haunt them, with none of the sense of severance which assaults the conscious eye. If the adult eye is glazed and dull and blind to the lessons of nature, still the naive eye—idiot, Indian, infant—seems to pay the most profitable kind of attention to things, to enjoy a lost intimacy with the world, to have the freshest, clearest perceptions. Thus Emerson seems to have seen the problem and located the salvation.

Whether or not Emerson felt he had any medical and anthropological evidence for his description of the naive eye of the child and native is not important: for ultimately he was using the notion as a metaphor. His conception of the naive eye is not scientific so much as religious. It was a prelude to worship rather than a preparation for action. It is in this light that such curious passages as the following should be read:

> The child with his sweet pranks, the fool of his senses, commanded by
> every sight and sound, without any power to compare and rank his
> sensations, abandoned to a whistle or a painted chip, to a lead dragoon or

a ginger-bread dog, *individualising everything, generalising nothing,* delighted with every new thing, lies down at night overpowered by the fatigue which this day of continual pretty madness has incurred. *But nature has answered her purpose with the curly dimpled lunatic. . . .* This glitter, this opaline lustre plays around the top of every toy to his eye to insure his fidelity, and he is deceived to his good. *We are made alive and kept alive by the same arts.* (III, 185–86; my italics)

It is the intellectual (not the mystical) generalization, so detrimental to a proper habit of awe, which Emerson is writing against; it is a new sort of naive wondering individualizing he is anxious to inculcate. And although he indulgently calls the child a "dimpled lunatic" he elsewhere talks more seriously of "the wisdom of children" (I, 73). Although he sometimes asserts a superior mode of vision which sees through all particulars to the Over-Soul, although he sometimes warns against the rapt attention to detail with which he credited the child, the savage and the animal; nevertheless he often returns to the superiority of the naive eye precisely because of the generous attentive wonder it displays in front of nature's multiple particulars.

Perhaps the child was ultimately Emerson's image for his own best intentions. "The first questions are always to be asked, and the wisest doctor is gravelled by the inquisitiveness of the child" (II, 325). Adult maturity is no real maturity since we have lost the right approach to nature, the knack of correct penetration: in fact we no longer ask the right questions. The child in his unencrusted innocence does. There is a dangerous form of extremism here: Emerson's rejection of the past includes not only a denial of the accumulated wisdom of the race but also the lessons of experience. The inquiry ideally should commence afresh each day. Nothing accrues, everything is always to be asked: such is the extreme implication of the Emersonian stance. And certainly since his time the habit of renewed wonder, the ever-novel interrogation of experience has become a recurring theme in American literature, a temperamental predisposition and a literary strategy. Naivety has become an important form of wisdom.

* * *

If we cannot make voluntary and conscious steps in the admirable science of universals, let us see the parts wisely, and infer the genius of nature from the best particulars with a becoming charity. (III, 244)

I have already suggested that although Emerson's vision alternated between detail and generalization, the "mud pies" and the "celestial influences," the overall effect of his work is to secure a new respect for close

vision. What I want to point out in this section is how Emerson, despite his own preference for "the admirable science of universals," focused unusual and exciting attention on "the best particulars." More remarkably he often equated the best particulars with low and commonplace objects and continually suggested that the need for "a language of facts" (II, 335) could best be answered by turning to the vernacular. These emphases alone make him a major figure in American literature and they merit special attention here. Only rarely does Emerson give the impression that it might be disconcerting if one could not make the pieces of the mosaic add up to one flowing, binding picture. We just have some hints. "But all is sour if seen as experience. Details are melancholy; the plan is seemly and noble" (II, 171). Having lost all sense of the "seemly and noble" plan Henry Adams, for one, found the remaining heaps of particulars not only sour and melancholy but terrifying. Emerson, to whom mystical generalizations came all too easily, could tie up the world in a sentence. "Our globe seen by God is a transparent law, not a mass of facts" (II, 302). Facts on their own were indeed "heavy, prosaic" and "dull strange despised things": but Emerson maintained that simply by wondering at them man would find "that the day of facts is a rock of diamonds; that a fact is an epiphany of God."[12] With such experience open to him Emerson could well afford to stress the value of a close regard for facts.

If you believe that the universe is *basically* such a perfect continuous whole then certain things follow. For a start every detail will be equally significant. "A leaf, a drop, a crystal, a moment of time, is related to the whole, and partakes of the perfection of the whole. Each particle is a microcosm, and faithfully renders the likeness of the world" (I, 43). "There is no fact in nature which does not carry the whole sense of nature" (III, 17). "The world globes itself in a drop of dew. The microscope cannot find the animalcule which is less perfect for being little" (II, 101).

Now the interesting aspect of this belief that "the universe is represented in every one of its particles" (II, 101) is that it can easily lead, not to the mystical generalization, but to an extreme of particularization, a devoted preoccupation with the minutiae of existence. It can encourage a prose devoted to ensnaring the crystalline fragments of momentary experience. Emerson works against his own intentions here by giving a tremendous prestige to the smallest details of the material world: his mystical enthusiasm is, as it were, diffused among all the details he sees. There is no hierarchy of value or significance operative: *all* details are worthy of the most reverent attention because all are equally perfect and equally meaningful. If Thoreau, as Emerson said, was "equally interested in every natural fact" (X, 474), then he was only putting into practice

an Emersonian prescription. The implications of this attitude are worth pondering. If every fact is equally interesting where does one find a criteria of exclusion, a principle of abridgement without which art cannot start to be art for it cannot leave off being nature? Emerson is endorsing an eye which refuses to distinguish and classify, which denies priorities of importance and significance, which refuses to admit of any sort of difference in import and value. From one point of view one could call this the egalitarian eye: an eye which affirms the equality of all facts. All facts are born equal and have an equal claim on man's attention. Yet in most art there is what we might call an aristocratic tendency: a claimed prerogative to exercise a lordly right of selection, omission, evaluation, and rearrangement. The aristocratic eye tyrannizes its facts: the egalitarian eye is tyrannized by them. This is not to say that the egalitarian or naive eye cannot discover things to which the aristocratic eye remains blind: it can, for it has that humility which makes new insights possible. It needed the naive eye as described by Emerson and adopted by Thoreau and Whitman, for America to be seen at all in its own right. But it is worth pointing out at this stage that there are distinct problems of organization and evaluation inherent in Emerson's concept of vision. What is completely absent is any sense of a scale of relative complexity, any feeling that small clusters of selected facts can yield a restricted amount of wisdom, any notion of a gradual increase of intelligence, any awareness of various modes of classification, any reference to the accumulating density of experience. There is the leaf—and there are the hidden laws of the universe: and nothing in between. Certainly not society, the notable omission in Emerson. For Emerson is a man talking metaphysics with his eye glued to the microscope, and plenty of American writers have taken their turn at the microscope after Emerson and his disciple Thoreau. This notion of Emerson's had far-reaching repercussions. For if the meaning of the world is to be found in a drop of dew, then the meaning of a given situation may be contained in the contingent objects which surround the participants. The lesson could be drawn from Emerson's thought that if the writer looks after the details the significances will look after themselves. A writer might construe his task to be a scrupulous itemizing of particulars, from the smallest to the largest with no accompanying distribution of significance, no perspective with its recession of priorities, no "comparison and ranking of sensations." Indeed he gives a clear warrant for such an attitude. Thus: "the truth-speaker may dismiss all solicitude as to the proportion and congruency of the aggregate of his thoughts, so long as he is a faithful reporter of particular impressions."[13] This means that a work of art depends for its form on the individual notation; no larger unit of meaning need be constructed. As he very revealingly wrote—"ask the fact for the form":[14] an attitude far

removed from that which relies on the form to assign meaning to the fact. Although Emerson talked of the importance of the "Intellect Constructive," the major emphasis of his work falls on the "Intellect Receptive" (II, 334).

Emerson's belief that the part contained the whole—by implication, or in shorthand as it were—leads quite naturally to his mystique of facts. We remember his instructions to "see the miraculous in the common": he goes on to arraign our blindness to the worth and significance of small everyday facts. "To the wise, therefore, a fact is true poetry, and the most beautiful of fables" (I, 75). Facts contain their own story if we will simply look at them afresh. "Pleads for itself the fact" (III, 88) he says in one of his poems and he means just that: things will "sing themselves" (I, 82) if we learn to listen in the right way. Again we note that the prescribed attitude is passive. We do not impose a meaning on facts, rather we try and make "facts yield their secret sense" (I, 9). "Every moment instructs and every object; for wisdom is infused into every form" (III, 196). Genius, then, will consist of "the habit of fronting the fact" (III, 92); the intellect is ravished "by coming nearer to the fact" (III, 28).

Emerson's emphasis was most important for American writers of the time: because among other things he was continually dragging eyes back to the worth and status of American facts. He scorned artists who could only discern beauty through the conventions of the old "sublime." "They reject life as prosaic, and create a death which they call poetic" (II, 367). Emerson was constantly canvassing for an artistic acceptance of prosaic everyday life. It is the instinct of genius, he affirmed,

> to find beauty and holiness in new and necessary facts, in the field and road-side, in the shop and mill. Proceeding from a religious heart it will raise to a divine use the railroad, the insurance office, the joint-stock company; our law, our primary assemblies, our commerce, the galvanic battery, the electric jar, the prism, and the chemist's retort; in which we seek now only an economical use. . . . The boat at St Petersburg which plies along the Lena by magnetism, needs little to make it sublime. (II, 369)

We can hear prophetic echoes of Whitman's enthusiastic listing of things here. It may sound naive to us but at the time this opinion of Emerson's rendered American literature a real service: his influence helped to make available whole areas of contemporary American life which had hitherto been considered all but ineligible for serious treatment. It was Emerson's insistence on "the worth of the vulgar" which made Whitman's work possible. He himself chooses the simplest of objects as carriers of sublime revelations. His prose often seems to create a still-life of separately attended-to particulars. It conveys a sense of the radiance of things seen. Emerson succeeded in vivifying the "common, the familiar, the low" (I, 111–12):

he dignified the details of "the earnest experience of the common day" (II, 290). He invokes a new respect for contingent, mundane particulars.

But in order to see details properly man has to separate one thing from another. So although Emerson believes that there are no walls or separating barriers in the flowing tide of nature he yet talks of "the cool disengaged air of natural objects" (III, 183) and affirms that "things are not huddled and lumped, but sundered and individual" (I, 38). Emerson the mystic talked on and on about the fluid inter-relatedness of all things, the transparency of nature to the ONE: but the Emerson whose influence is most marked in American literature was the man who asserted that "the virtue of art lies in detachment, in sequestering one object from the embarrassing variety" (II, 354), who approved "the power to fix the momentary eminency of an object" (II, 355). And if it be asked what connection this particular virtue has with the naive eye we should recall that Emerson said: "To the young mind everything is individual, stands by itself" (I, 85). The naive eye, as he depicted it, was likely above all others to be alert to the unique significance of the isolated random details of the material world.

In encouraging a new way of "seeing" Emerson also made some comments on "saying," on "the language of facts" which we must now examine.

First, the indictment: "The corruption of man is followed by the corruption of language. . . . new imagery ceases to be created, and old words are perverted to stand for things which are not; a paper currency is employed, when there is no bullion in the vaults. . . . But wise men pierce this rotten diction and fasten words again to visible things" (I, 29–30). Secondly, the precedent from which we should learn. "Children and savages use only nouns or names of things, which they convert into verbs, and apply to analogous acts" (I, 26). As well as the child and the savage, Emerson cites the "strong-natured farmer or backwoodsman" (I, 31) as exemplifying the proper use of language. This equating of the child, the savage, and the vernacular type is questionable if a serious attempt to analyse speech-habits is being offered. But they occur more as exemplars in a sermon. Emerson wants to communicate the notion of some sort of verbal intimacy with the stuff of nature, a state in which words and things are at their closest. We should see like children: we should also speak like children and vernacular types, or at least with the simple, specifying concreteness that Emerson imputes to them. Just as Emerson wanted the eye to concentrate on concrete facts, so he wishes language to be full of concrete factualness, and for the same reasons: a new or renewed intimacy with these facts affords us our quickest means of contact with the unifying sublime presence which runs through all things. So the concentration is always on the simplest forms of speech,

on the speech which arises from physical involvement with nature rather than the subtle refined concepts used by those who meditate on life through the mind's eye. "Life lies behind us as the quarry from whence we get tiles and copestones for the masonry of to-day. This is the way to learn grammar. Colleges and books only copy the language which the field and work-yard made" (I, 98).

An important by-product of this contention of Emerson's is his complete rejection of the classification of facts, things, and words into "high" and "low," a classification based on the dualism of spirit and body which was then still a major influence on New England thought. "The vocabulary of an omniscient man would embrace words and images excluded from polite conversation. What would be base, or even obscene, to the obscene, becomes illustrious, spoken in a new connection of thought" (III, 17). The effect of this enlightened passage is to offer a card of eligibility to a whole range of experience and vocabulary which had hitherto been considered inherently unfit for literature.

More central to Emerson's theory of language is his assertion that "It does not need that a poem should be long. Every word was once a poem," and the related idea that "bare lists of words are found suggestive to an imaginative and excited mind" (III, 17–18). Every word was once a poem because every word was once a thing, or at least a "brilliant picture" of a thing. ("Language is fossil poetry" [III, 22] wrote Emerson, thus anticipating Fenellosa's notion of language as a pyramid with an apex of generality and a base composed of "stunned" things.) Since every thing equally displays or hints at the divine plan of the universe, a list of words becomes a list of revelations, each noted fact an encountered epiphany. The influence of this belief on Emerson's own style can be discerned. His style, most characteristically, is composed of an effortless shifting from the suggestive list of facts and things to what he revealingly calls "casual" (III, 237) abstraction and generalization. In his own words: "There is the bucket of cold water from the spring, the wood-fire to which the chilled traveller rushes for safety—and there is the sublime moral of autumn and noon" (III, 171). The philosophy is revealed in the style: he ascends direct from "a crystal" to the "Universal Spirit" (I, 43–44). Clusters of unrelated facts occur continually, embedded in his discursive sentences, pegging them to the ground. Examples can be proliferated. "There is nothing but is related to us, nothing that does not interest us—kingdom, college, tree, horse, or iron shoe—the roots of all things are in man" (II, 17). His prose asserts but never analyses these relationships. We could recall the famous passage on the "worth of the vulgar" which employs a similar method of assembling "things," but things left separate and static: "The meal in the firkin; the milk in the pan; the ballad in the street; the news of the boat; the glance of the eye; the form and gait of

the body;" (I, 111–12)—details which reveal not any one man's world but God's world. Such passages in Emerson serve as the springboards for his sublime leaps: and obviously even as he is enumerating these "things," telling his beads of facts as we might say, they seem to reveal universal laws to him. As in Whitman, they "sing" to him. The more successful passages in Emerson are weighed down with concrete facts, laced with particulars which alert the mental eye. What has gone from his writing is almost all purposive complexity of syntax: his style is extremely para-tactic and his sentences often start with an unintroduced enumeration of things, things held up for our beholding in the belief that they will "plead for themselves." One final example must suffice:

> The fall of snowflakes in a still air, preserving to each crystal its perfect form; the blowing of sleet over a wide sheet of water, and over plains; the waving rye field; the mimic waving of acres of houstonia, whose innumerable florets whiten and ripple before the eye; the reflections of trees and flowers in glassy lakes; the musical, steaming, odorous south wind, which converts all trees to wind-harps; the crackling and spurting of hemlock in the flames, or of pine logs, which yield glory to the walls and faces in the sitting-room—these are the music and pictures of the most ancient religion. (III, 172)

This is writing of considerable visual sensitivity but which has no sense whatever of the relation and inter-relation of things and things, things and people, people and other people. It is a prose that stops before society and the problems of human behaviour start. His idea that "bare lists of words are suggestive" is crucial here. They are suggestive if the words are what he thought words should be—concrete facts, pictures of things—but even so such bare lists help us not at all in the problems of living among those facts and things. Emerson's prose feels its way over the surfaces and round the contours of parts of the empirical world but has no means of discussing the problems of action and interruption in that world. By way of meaning he can only produce the mystical gen-eralization, but as faith in such generalizations has diminished it is the former aspect of his prose, the respect for details, which seems to have had most influence in American literature.

Of the duality of his own vision he writes very clearly. "We are amphibious creatures, weaponed for two elements, having two sets of faculties, the particular and the catholic. We adjust our instruments for general observation, and sweep the heavens as easily as we pick out a single figure in the terrestrial landscape" (III, 229). Emerson found it easy to "sweep the heavens" but subsequent writers have found it less so. The heavens have changed for one thing—or rather man's relationship with them has. They now seem to mock, whereas to Emerson they seemed to smile on, the "casual" all-explaining generalization. But there remains

the "faculty" for particulars, and the ability to isolate "single figures in the terrestrial landscape" and this faculty has perhaps been cultivated as the other faculty has increasingly come under suspicion—though it has by no means disappeared. Not surprisingly Emerson admired Plato above all others, and in his essay on him he manages to tell us a good deal about himself. This is Emerson's Plato: "If he made transcendental distinctions, he fortified himself by drawing all his illustrations from sources disdained by orators and polite conversers; from mares and puppies; from pitchers and soup-ladles; from cooks and criers; the shops of potters, horse-doctors, butchers and fishmongers" (IV, 55). Plato, that is, obeyed Emerson and "embraced the common, explored and sat at the feet of the familiar, the low." Perhaps the most revealing thing that Emerson says about Plato is this: "Plato keeps the two vases, one of ether and one of pigment, at his side, and invariably uses both" (IV, 56). The pigment of low concrete facts and the ether of mystical generalization—they are both to be found in Emerson. And it is worth repeating that for him peculiar prestige attaches itself to the "low" in language and in facts and in people. "The poor and the low have their way of expressing the last facts of philosophy as well as you" (II, 315). As well as, and by veiled implication, perhaps better. There is actually a preference for those minds which "have not been subdued by the drill of school education" (II, 330). "Do you think the porter and the cook have no anecdotes, no experiences, no wonders for you? Everybody knows as much as the savant. The walls of crude minds are scrawled over with facts, with thoughts" (II, 330). This is an attitude which could endorse the vernacular as a literary mode; which could encourage the belief in the superior wisdom of the back-woodsman, the rural inhabitant, the person living outside any urban-civilized field of force. It is difficult to assess the influence of one writer. Emerson is perhaps as much symptom as cause. The point is that certain novel attitudes and predilections which recur in many American writers seem to emerge articulated in Emerson's work for the first time. Some of these might be summed up as follows: the emphasis on "seeing" things freshly; the prescription for the innocent non-generalizing eye; the concomitant preference for simple people and simple speech, whether that of the uneducated labourer, the savage or the child; the exhortation to accept *all* facts, the vulgar trivia of the world, as being potential harbingers of meaning; the celebration of details of the concrete world and the (more than intended, perhaps) prestige accorded to the particularizing faculty, that faculty which develops the closest relationships between man and the natural world. "We penetrate bodily this incredible beauty; we dip our hands in this painted element; our eyes are bathed in these lights and forms" (III, 173). Mysticism, yes: but a mysticism which encouraged a scrupulous yet wondering rediscovery of material appear-

ances, which attached maximum importance to a new intimacy with the basic undistorted "pigment" of "this painted element," the world. In encouraging men to "wonder at the usual" Emerson bestowed perhaps his greatest benefit on American literature.

Notes

[1]Henry Nash Smith, "Emerson's Problem of Vocation," *New England Quarterly*, 12 (March-December 1939).

[2]For more sympathetic treatment of Emerson's handling of the problem of pain and evil see "The House of Pain" by Newton Arvin (*Hudson Review*, 12, No. 1, Spring 1959) and "Emerson's Tragic Sense" by Stephen Whicher (*American Scholar*, 22, Summer 1953).

[3]Emerson, *Complete Works* (Boston and New York: Houghton Mifflin, 1903), Vol. XII, p. 10. Subsequent references will be to this edition and cited by volume and page numbers within the text. Roman numerals will be used for the volume and arabic numbers for the page. [Editors]

[4]*Journals*, VIII, p. 550.

[5]*Journals*, X, p. 238.

[6]Sherman Paul, *Emerson's Angle of Vision* (Cambridge: Harvard University Press, 1952), p. 73.

[7]*Journals*, V, pp. 310–11.

[8]Paul, *Emerson's Angle of Vision*, p. 75.

[9]A. G. McGiffert (ed.), *Young Emerson Speaks* (Boston: Houghton Mifflin, 1938), p. 48.

[10]Quoted by Leo Marx in his edition of Thoreau's *Excursions* (New York: Corinth Books, 1962), p. xiii.

[11]Quoted by F. O. Matthiessen, *The American Renaissance* (New York: Oxford University Press, 1941), p. 62.

[12]Quoted by Matthiessen, *American Renaissance*, p. 58.

[13]Quoted by Charles Feidelson, Jr., *Symbolism and American Literature* (Chicago: University of Chicago Press, 1953), p. 150.

[14]Quoted by Norman Foerster in "Emerson on the Organic Principle in Art," *PMLA*, 41 (1926).

The Problem
of Emerson

Joel Porte

"T he more we know him, the less we know him."
Stephen Whicher's wistfully encomiastic remark of two decades ago epit-
omizes the not entirely unhappy perplexity of a highly influential group
of scholars and critics, beginning perhaps with F. O. Matthiessen, who,
returning to Emerson's writings with enormous sympathy, intelligence,
and sensitivity, attempted to discover a real human figure beneath the
bland (or pompous, or smug) official portrait. Predictably, in view of the
compensatory biases of modernist criticism, they found a "new" Emerson
whose complexities belied that older optimistic all-American aphorist
once dear to captains of industry, genteel professors of literature, and
hopeful preachers in search of suitably uplifting remarks. Like the other
great figures of the American Renaissance, Emerson was now found to
be one of us—as richly evasive and enigmatic a figure, almost, as Haw-
thorne, or Melville, or Dickinson. Not only is Emerson incapable of being
"summed up in a formula," Whicher insisted, "he is, finally, impenetra-
ble, for all his forty-odd volumes."[1]

Though somewhat obscure, Whicher's statement is also highly in-
structive. I say obscure, because (as with Matthiessen and Perry Miller)
Whicher's discouragement about his failure to fathom the secret of one
of America's greatest authors implies not only an inability to get at the
meaning of American culture at large, but also a personal failure that
finally baffles speculation. What is instructive in the remark is its insist-
ence on penetrating to the heart of Emerson *the man* (since, surely, one

Reprinted from *Uses of Literature*, ed. Monroe Engel (Cambridge: Harvard University Press,
1973), pp. 85–114. Copyright 1973 by the President and the Fellows of Harvard College.
Reprinted by permission of Harvard University Press. Some of the endnotes have been
omitted and the remainder renumbered.

of the most astute Emersonians of the twentieth century was not admitting that he could make no sense of the master's works). Although I shall myself concentrate here on the problem of getting to the heart of Emerson's *writing*, I think there is something to be learned from Whicher's interest in Emerson's character, for it focuses attention on an important aspect of the Emerson problem.

For one thing, the meaning and value of Emerson's work have typically been overshadowed, and frequently undermined, by an emphasis on his example and personal force. Two of his most distinguished critics offer representative remarks in this regard. Henry James, Jr., speaking for those who had known Emerson, properly emphasized the manner in which he made his impression, "by word of mouth, face to face, with a rare, irresistible voice and a beautiful mild, modest authority."[2] This is an appealing portrait, suggesting an ethereal attractiveness that clearly made Emerson humanly persuasive. Santayana roughly seconds James's point, but his description of Emerson's authority sharpens the issue somewhat:

> Those who knew Emerson, or who stood so near to his time and to his circle that they caught some echo of his personal influence, did not judge him merely as a poet or philosopher, nor identify his efficacy with that of his writings. His friends and neighbors, the congregations he preached to in his younger days, the audiences that afterward listened to his lectures, all agreed in a veneration for his person which had nothing to do with their understanding or acceptance of his opinions. They flocked to him and listened to his word, not so much for the sake of its absolute meaning as for the atmosphere of candor, purity, and serenity that hung about it, as about a sort of sacred music. They felt themselves in the presence of a rare and beautiful spirit, who was in communion with a higher world.[3]

Santayana's clear impatience here with that atmosphere of high-minded religiosity that always vitiated the New England air for him is not intended, I think, to imply a disparagement of Emerson, to whom he was fundamentally sympathetic. Certain difficulties, nevertheless, are suggested in this description of Emerson's virtual canonization as one of the leading saints in the select American hagiology. ("He is a shining figure as on some Mount of Transfiguration," wrote George Woodberry in 1906.)[4] What would be the fate of Emerson's writings when that "fine adumbration," as James called him, should himself be translated to the higher world? Would his literary reputation endure the dissipation of his rare personal emphasis? Worse, could his writings weather the inevitable iconoclasm that tumbles every American idol from his pedestal? "I was never patient with the faults of the good," Emerson's own Aunt Mary Moody is quoted as saying.[5] And the mild saint seems to have written his own epitaph when he noted, in *Representative Men*, that "every hero becomes a bore at last."[6]

As we know, Emerson's fate, somewhat like Shakespeare's, was that he came to be treated as an almost purely allegorical personage whose real character and work got submerged in his function as a touchstone of critical opinion. More and more, the figure of Emerson merged with current perceptions of the meaning and drift of American high culture, and the emblem overwhelmed his substance. To the younger generation of the nineties, for example, notably John Jay Chapman and Santayana, certain aspects of Emerson represented the pale summation of that attenuated genteel tradition with which they had lost patience. As the polemical mood sharpened over the next quarter-century or so, Emerson became a kind of *corpus vile* useful mainly for the dissection of American culture. To the Puritan-baiting intellectuals of the twenties, he stood for little more than the final weak dilution in the New England teapot; but for the conservative New Humanists, who—like Fitzgerald's Nick Carraway—"wanted the world to be in uniform and at a sort of moral attention forever," Emerson was the pre-eminent voice of the American conscience and the patron saint, accordingly, of their rearguard action.[7] Even T. S. Eliot, though he sympathized with the general position of the school of Babbitt and More, wrote in 1919, while praising Hawthorne, that "the essays of Emerson are already an encumbrance";[8] and Eliot's key word suggests not so much a literary burden as a *monumental* physical weight—the Lares and Penates of Victorian culture which the brave new Aeneases of the twenties were determined to jettison:

> Matthew and Waldo, guardians of the faith,
> The army of unalterable law.

The American master seemed to keep watch over outmoded standards of conduct, not the new canons of poetry. As a result, "in those days [the twenties]," asserts Malcolm Cowley, "hardly anyone read Emerson."[9] Such a quirky exception as D. H. Lawrence only proved the general rule, for this self-admitted "spiritual drug-fiend," despite his odd personal taste for Emerson, summarized the temper of the times when he argued, in 1923, that "all those gorgeous inrushes of exaltation and spiritual energy which made Emerson a great man now make us sick. . . . When Professor [Stuart] Sherman urges us in Ralph Waldo's footsteps, he is really driving us nauseously astray." With a *"Sic transeunt Dei hominorum,"* Lawrence reluctantly ushered the tarnished deity from his niche.[10] The devils—Melville and Poe—were in, and the leading saint went marching out.

As I have noted, the "recovery" of Emerson that began largely in the forties and continues today is based on the sympathetic perception that beneath the seemingly ageless smiling public mask there lies a finite consciousness troubled with a tragic sense of contingency and loss—a

little-known Emerson, as James said in 1887, with "his inner reserves and scepticisms, his secret ennuis and ironies." Indeed, most recently the saint has been turned not only inside out but upside down and shown to have a demonic bottom nature. In an improbable context of Siberian shamans become Thracian bards, Harold Bloom argues for a Bacchicly wild and primitivistic Emerson: "The spirit that speaks in and through him has the true Pythagorean and Orphic stink. . . . The ministerial Emerson . . . is full brother to the Dionysiac adept who may have torn living flesh with his inspired teeth."[11]

The trouble with these strategies for redeeming Emersòn is that they, too, like the Victorian apotheoses, are rooted in the character of the man (though in this case it is a presumably more appealing, because more complex, figure) and therefore depend for their force on our assenting to a particular reconstruction of Emerson's personality which may have little to do with the common reader's literary experience of Emerson. While praising Stephen Whicher's *Freedom and Fate: An Inner Life of Ralph Waldo Emerson,* Jonathan Bishop notes that "in the midst of one's appreciation for the achievement of this book, and the other works whose assumptions are comparable, one can still feel that the point of view adopted involves a certain neglect of the literary particulars."[12]

Though many literary particulars are brilliantly illuminated in Bishop's own book, which is undoubtedly the best modern reading of Emerson we have yet had, it unfortunately does not escape some of the typical difficulties of Emerson criticism. Predicated, like Whicher's work, on the notion that there is a "true, secret Emerson" who is the real and really interesting man we are after, *Emerson on the Soul* tells us that the reader's job is "to distinguish the excellent moments," which scarcely ever "exceed a page or two of sustained utterance" (though Bishop is uneasy with the old commonplace which argues that Emerson was little more than a sentence maker or at best a paragraph maker, he, too, sees little organic form in whole essays or books). This authentic Emerson—sometimes, indeed, by a kind of typographical mystification, identified as "Emerson"—predictably exhibits himself most freely in the private journals or letters. To arrive at these "interesting moments" in the public utterances, "one makes a drastic selection," avoiding "the dull tones, the preacherly commonplaces, the high-minded vapid identity" which obviously does not express the genuine Emerson we are seeking. The ability to recognize this profounder, more complex, more valuable tone may also serve as a kind of moral test of honesty in the reader, for "a coward soul is always free to interpret what Emerson says in a way that does not allow it to reach through to the places in him where matters are genuinely in a tangle." Rising to a pitch of almost religious fervor, Bishop claims finally that the authentic Emerson discoverable to our best selves

can still serve as a hero and prophet for the American scholar. Thus, relying on a carefully controlled modern phenomenology of reading Emerson, Bishop reaches back fundamentally to join hands with the traditional notion that Emerson's highest value lies in the moral authority with which he utters permanent truths and thereby remains, as Arnold said, "the friend and aider of those who would live in the spirit."[13]

II

It was usual for Perry Miller, when initiating his survey of American authors, to insist on the notion that "writing is written by writers." This innocent tautology was intended to convey the idea that the great figures being studied were not primarily to be considered as landmarks in the growth of American culture nor as so many statues in an imaginary pantheon whom it was our patriotic duty to revere, but rather as *writers* whose continuing claim on our attention resides in their exhaustless *literary* vitality. Writing is not necessarily written by famous authors, with beards and visitable houses; it is the fruit of patient labor by men and women fundamentally, and often fanatically, devoted to their craft. Books, as Thoreau says in *Walden*, "must be read as deliberately and reservedly as they were written." And such a reading is encouraged by thinking of authors primarily as writers, and only secondarily as famous hermits, spinsters, he-men, statesmen, spiritual leaders, madmen, madwomen, or the like.

Now, it is a curious fact that Emerson, who is often acknowledged to be the greatest, or at least most important, author of the American Renaissance and even of American literary history altogether, has manifestly not been accorded that careful scrutiny of his work *as writing* which Poe, Hawthorne, Melville, Thoreau, Dickinson, Whitman, and other more minor figures, have received in superabundance. The heart of the problem seems to lie, as I have already suggested, in the overwhelming, indeed intimidating, emphasis on Emerson's personal authority, his example, his wisdom, his high role as the spiritual father and Plato of our race. Even so sharp a critic as Henry James, with his exquisitely developed sense of writing as a craft, was blinded from seeing any pervasive formal excellence in Emerson's work by the "firmness" and "purity," the "singular power," of Emerson's moral force—his "particular faculty, which has not been surpassed, for speaking to the soul in a voice of direction and authority." Though James assumed Emerson's "importance and continuance" and insisted "that he serves and will not wear out, and that indeed we cannot afford to drop him," he did so only as a special tribute to this great man, allowing him to be "a striking exception

to the general rule that writings live in the last resort by their form; that they owe a large part of their fortune to the art with which they have been composed." Despite occasional "felicities, inspirations, unforgettable phrases," James felt it was "hardly too much, or too little, to say of Emerson's writings in general that they were not composed at all." He never truly achieved "a fashion and a manner" and finally "differs from most men of letters of the same degree of credit in failing to strike us as having achieved a style." James concluded his survey of Emerson's career by positing a large and significant *if:* "if Emerson goes his way, as he clearly appears to be doing, on the strength of his message alone, the case will be rare, the exception striking, and the honour great."

It should be a matter of some interest, and no little amusement, for us to note that Henry's scientific brother was moved to make precisely the claim for Emerson, at the centenary celebration, which the distinguished novelist and critic had withheld. "The form of the garment was so vital with Emerson that it is impossible to separate it from the matter. They form a chemical combination—thoughts which would be trivial expressed otherwise, are important through the nouns and verbs to which he married them. The style is the man, it has been said; the man Emerson's mission culminated in his style, and if we must define him in one word, we have to call him Artist. He was an artist whose medium was verbal and who wrought in spiritual material."[14] Perhaps it was the unsatisfied artist in William James himself, as Santayana describes him,[15] who was enabled to make these observations about Emerson which, though almost universally ignored, have scarcely been bettered: his "thoughts . . . would be trivial expressed otherwise"; his "mission culminated in his style." William James's valuable hints have not been picked up, and Henry's prescient *if* has progressively exerted its force. Emerson, as any candid teacher of American literature can report, has manifestly *not* made his way "on the strength of his message." He has become the least appreciated, least enjoyed, least understood—indeed, least read—of America's unarguably major writers. Even most intelligent and willing students, dropped in the usual way into the great *mare tenebrum* of Emerson's weightier works, gratefully return to shore, dragging behind them only out of a sense of duty a whale of a précis of Emerson's "message," which, they will usually admit, contains little meaning and less pleasure for them. Nor have students of Emerson's writing received much practical help from well-intentioned critics who, while praising Emerson as a prophet of romanticism, or symbolism, or existentialism, or pragmatism, or organicism, sadly concede that the master's reach exceeded his grasp so far as exemplifying the particular *-ism* in successful works of literary art is concerned. Seen from this perspective as a flawed genius whose theory and practice were always disjunct, Emerson may

exasperate by seeming to promise more than he can perform. As Charles Feidelson says, "What he gives with one hand he takes away with the other."[16]

I have myself, to echo the conclusion of *Nature,* come to look at the world of Emerson with new eyes and been greatly gratified and exhilarated to discover a kind of verification of my views in the—surprisingly—delighted reactions of students. The Emerson we now see, I am convinced, has always existed; indeed it is the same Emerson whom William James was moved to praise as an artist. This Emerson's interest and appeal reside in the imaginative materials and structures of his writing—in his tropes and *topoi,* his metaphors and verbal wit, in the remarkable consistencies of his conceiving mind and executing hand. What I am prepared to state categorically is that the familiar rubrics of Emersonian thought, the stock in trade of most Emerson criticism, though undeniably there, are a positive hindrance to the enjoyment of Emerson's writing. Though some Emersonians will undoubtedly continue until the end of time to chew over such concepts as Compensation, the Over-Soul, Correspondence, Self-Reliance, Spiritual Laws, *et id genus omne,* the trouble with such things is that they are not very interesting. They make Emerson seem awfully remote, abstract, and—yes—academic. My experience has been that when these topics are mentioned the mind closes, one's attention wanders. . . . Similarly, the now standard debate over Emerson's presumed inability, or refusal, to confront evil (usually capitalized) has had the unfortunate effect first of making him seem shallow compared, say, to a Hawthorne or a Melville; and, second and more importantly, it has frequently shifted discussions of Emerson to a high plane of theological or metaphysical argument where one's ordinary sense of reality, and the powers of practical criticism, falter in pursuit. Evil with a capital has a way of teasing the imagination into silence.

My thesis then is simple: Emerson, as he himself frequently insisted, is fundamentally a poet whose meaning lies in his manipulations of language and figure. The best guide to change, or growth, or consistency in Emerson's thought, is his poetic imagination and not his philosophic arguments or discursive logic. The alert reader can discover, and take much pleasure in discovering, remarkable verbal strategies, metaphoric patterns, repetitions and developments of sound, sense, and image throughout Emerson's writing. One finds an impressively unified consciousness everywhere in control of its fertile imaginings.[17]

As an initial illustration of what I am claiming for Emerson's work, I would momentarily leave aside the juiciest plums—*Nature,* the "Divinity School Address," the great essays—and turn briefly to a book for which, probably, only the most modest assertions of imaginative unity can be made, hoping, nevertheless, that its example will prove instruc-

tive. Like most nineteenth-century travel books, *English Traits* cannot be expected to succeed entirely in transcending the somewhat episodic nature of its author's peregrinations and his own normal desire, with his varied audience in mind, to include something of interest to everyone. Typically, since such an omnium-gatherum will amiably avoid pushing toward overwhelming conclusions and let its appeal reside precisely in its miscellaneous character, any search for organic form seems defeated at the outset. Still, we are dealing with the inescapable consistencies of Emerson's shaping imagination.

In the preface to a recent edition of *English Traits*, Howard Mumford Jones confronts Emerson's difficulty in making a unified book of his heterogeneous materials and complains specifically that Emerson spoiled the natural form of his work by beginning with a chapter on his first, earlier visit to England and concluding, not logically with "Results," but anticlimactically with his "Speech at Manchester."[18] I believe, however, that the sympathetic reader of *English Traits* can supply some possible justifications for Emerson's procedure. The opening chapter is an expression of disappointment with England, and this is the keynote of the book. Here, the disappointment, though it has a personal basis, is emblematic of the young American's unfulfilled expectations of the Old World and prophetic of his developing hope for America. He goes abroad eager to meet certain great men—Landor, Coleridge, Carlyle, Wordsworth—and finds them sadly isolated, mutually repellent, and embittered, "prisoners . . . of their own thought" who cannot "bend to a new companion and think with him." They thus fail as poets in Emerson's own high sense (as "liberating gods," that is, who help men "to escape the custody of that body in which he is pent up, and of that jail-yard of individual relations in which he is enclosed"). Their vaunted originality somehow evaporates for the young seeker: Coleridge's talk falls "into certain commonplaces"; Wordsworth expiates his "departure from the common in one direction" by his "conformity in every other." Significantly, both Carlyle and Wordsworth talk much of America, turning Emerson's thoughts back whence he came and pointing us forward to Emerson's peroration in Manchester, where he will, as delicately as possible, summarize his negative reaction to this "aged England," this "mournful country," with its pathetically atomistic island mentality, its conformity to custom, its played out spirit, and suggest that if England does not find new vigor to restore her decrepit old age (as the weight of his whole book tends to prove it cannot), "the elasticity and hope of mankind must henceforth remain on the Alleghany ranges, or nowhere."

The huge, virtually endless American continent is the mysterious force against which Emerson measures the fixed, finite, island prison, the "Gibraltar of propriety," which is England. Here we have the central ima-

ginative structure of *English Traits*. Though initially England seems "a paradise of comfort and plenty," "a garden," we quickly learn that this miracle of rare device, like Spenser's Bower of Bliss, is a false paradise where "art conquers nature" and, "under an ash-colored sky," confounds night and day. Coal smoke and soot unnaturally make all times and seasons of one hue, "give white sheep the color of black sheep, discolor the human saliva, contaminate the air, poison many plants and corrode the monuments and buildings." This is the epitome of the fallen modern world of industry, where "a terrible machine has possessed itself of the ground, the air, the men and women, and hardly even thought is free." Everything, we are told, "is false and forged," "man is made as a Birmingham button," and "steam is almost an Englishman." The whole island has been transformed into the thoroughfare of trade where all things can be described, in Emerson's eyes, as either "artificial" or "factitious": the breeds of cattle, the fish-filled ponds and streams, the climate, illumination, heating, the English social system, the law, property, crimes, education, manners, customs—indeed, "the whole fabric." All is "Birminghamized, and we have a nation whose existence is a work of art—a cold, barren, almost arctic isle being made the most fruitful, luxurious and imperial land in the whole earth."

In this setting, we are not surprised to learn that the two most mysterious and imponderable of life's gifts, religion and art, are particularly vulnerable to the general fate. Since these two subjects touch the quick of Emerson's concern, it is especially fascinating to note in this regard how the fundamental paradigm of America (as revealed in and through its transcendental minister, Emerson) against which all is being tested palpitates within Emerson's language and metaphors. True religion is utterly missing from England, for it is an alien and frightful thing to the English: "it is passing, glancing, gesticular; it is a traveler, a newness, a surprise, a secret, which perplexes them and puts them out." We should keep this consciously orphic sentence in our ear as we glance at the next chapter, "Literature," on the way to Emerson's culminating vision of America. Speaking of English genius, Emerson notes: "It is retrospective. How can it discern and hail the new forms that are looming up on the horizon, new and gigantic thoughts which cannot dress themselves out of any old wardrobe of the past?" Now, the alert student of Emerson will recognize here an unmistakable echo of the opening paragraph of *Nature* ("Our age is retrospective. . . . why should we grope among the dry bones of the past, or put the living generation into masquerade out of its faded wardrobe. . . . There are new lands, new men, new thoughts"). What this echo should tell us is that the very same living, prospective, titanic American nature which, Emerson insisted in 1836, would inspire a new poetry and philosophy and religion of "revelation," as opposed

to the backward-looking, dead, limited British tradition—that "great apparition," as he terms it in *Nature,* is fully present to Emerson's imagination twenty years later in *English Traits* as he attempts to explain what the English spirit dares not face and isolates itself from. Walking the polished halls of English literary society, Emerson seems to find himself "on a marble floor, where nothing will grow," and he concludes that the English "fear the hostility of ideas, of poetry, of religion—ghosts which they cannot lay. . . . they are tormented with fear that herein lurks a force that will sweep their system away. The artists say, 'Nature puts them out.' " Recalling the opening paragraph of *Nature* and hearing still that orphic sentence from the preceding chapter on religion, we may now feel confirmed in our intuition about Emerson's real point: that great force which threatens the English and "puts them out" is equivalent to the religio-poetic mystery of American nature.

Emerson's metaphoric confrontation between England and America, which represents the true symbolic thrust of *English Traits,* culminates most forcefully and appropriately in the fourth chapter from the end, entitled "Stonehenge." Traveling with Carlyle, who argues that the English have much to teach the Americans, Emerson concedes the point but does not budge from his instinctive belief: "I surely know that as soon as I return to Massachusetts I shall lapse at once into the feeling, which the geography of America inevitably inspires, that we play the game with immense advantage; that there and not here is the seat and centre of the British race; and that no skill or activity can long compete with the prodigious natural advantages of that country, in the hands of the same race; and that England, an old and exhausted island, must one day be contented, like other parents, to be strong only in her children." Emerson's conviction that the English mind is simply rendered impotent by, and turns away self-defensively from, the enormously perplexing forces that embosom and nourish us seems strengthened by his visit to Stonehenge itself. "The chief mystery is, that any mystery should have been allowed to settle on so remarkable a monument, in a country on which all the muses have kept their eyes now for eighteen hundred years." Ignoring this strange and unsettling secret at the heart of its own island, the English mind leaves Stonehenge "to the rabbits, whilst it opens pyramids and uncovers Nineveh." Emerson completes this series of speculations and, in a very real sense, the point of his whole book in a fine paragraph toward the end of "Stonehenge" that at once expresses his own sense of America's ineffable power and his firm belief that the Englishman is unable to comprehend it:

> On the way to Winchester, whither our host accompanied us in the afternoon, my friends asked many questions respecting American landscapes, forests, houses,—my house, for example. It is not easy to answer these queries well. There, I thought, in America, lies nature

sleeping, overgrowing, almost conscious, too much by half for man in the picture, and so giving a certain *tristesse*, like the rank vegetation of swamps and forests seen at night, steeped in dews and rains, which it loves; and on it man seems not able to make much impression. There, in that great sloven continent, in high Alleghany pastures, in the sea-wide sky-skirted prairie, still sleeps and murmurs and hides the great mother, long since driven away from the trim hedge-rows and over-cultivated garden of England. And, in England, I am quite too sensible of this. Every one is on his good behavior and must be dressed for dinner at six. So I put off my friends with very inadequate details, as best I could.

In the face of such a passage as this, the critic of Emerson may be commended most for appreciative silence. I want only, with these lines in mind, to underline my previous point about this book and Emerson generally: namely, that the excellent moments in his writing are not, as has so often been said, incidental gems in a disjointed mosaic, but typically the shining nodal points in a carefully woven imaginative web.

III

Although some Emerson scholars in our own time have noticed that certain motifs or metaphors are central to Emerson's literary project, their perceptions have by and large been ignored in practical Emerson criticism. Three important examples, all from Emerson scholarship now more than two decades old, will illustrate my point. In *Emerson's Angle of Vision*, Sherman Paul taught us that "for Emerson the primary agency of insight was seeing"; the eye "was his prominent faculty." Another valuable perception was offered by Vivian C. Hopkins in *Spires of Form*, where she asserted that "Emerson's own term of 'the spiral' admirably hits the combination of circular movement with upward progress which is the heart of his aesthetic. Optimism controls Emerson's idea of the circle becoming a spiral, ever rising as it revolves upon itself." Finally, Stephen Whicher, writing on "Emerson's Tragic Sense," noted that "something resembling the Fall of Man, which he had so ringingly denied, reappears in his pages."[19] I want to suggest, very briefly, how useful an awareness of three such motifs as these, often in combination with one another, can be, not only for the illumination of individual essays and books, but also for an understanding of change or development overall in Emerson's work.

Although every reader of *Nature* since 1836 has taken special notice of the famous eyeball passage, either to praise or to ridicule its extravagance, surprisingly few students or even teachers of Emerson, in my experience, are aware that in this metaphor resides the compositional center of gravity of the essay.[20] Despite Emerson's insistence in this cru-

cial paragraph that his purpose is to "see all," to become nothing more nor less than *vision*, readers of *Nature* seem generally not to notice that in the magnificent opening sentence of the piece—"Our age is retrospective"—the key word means precisely what it says and is rhetorically balanced by the title of the last section—"Prospects." It is a question of seeing in a new way, a new direction. Emerson is inviting us to behold "God and nature face to face," with our own eyes, not darkly and obscurely through the lenses of history. *Nature* concerns the fall of man into perceptual division from his physical environment. Salvation is nothing less than perceptual reunification—true *sight* externally and *insight* internally. The Poet, the *seer*, as Emerson was to suggest in the essay of that name, is a type of the savior "who re-attaches things to nature and the Whole" through his vision:

> As the eyes of Lyncaeus were said to see through the earth, so the poet turns the world to glass, and shows us all things in their right series and procession. For through that better perception he stands one step nearer to things, and sees the flowing or metamorphosis. . . . This insight, which expresses itself by what is called Imagination, is a very high sort of seeing, which does not come by study, but by the intellect being where and what it sees; by sharing the path or circuit of things through forms, and so making them translucid to others.

The echoes of *Nature* in this passage from "The Poet" tell us that we can all become our own poet-savior by becoming pellucid lenses, transparent eyeballs, and perfecting our vision. "The eye is the best of artists"; "the attentive eye" sees beauty everywhere; wise men pierce the "rotten diction" of a fallen world "and fasten words again to visible things," achieving a viable "picturesque language"; "a right action seems to fill the eye"; "insight refines" us: though "the animal eye" sees the actual world "with wonderful accuracy," it is "the eye of Reason" that stimulates us "to more earnest vision." Mounting to his splendid peroration in "Prospects," Emerson reminds us that "the ruin or the blank, that we see when we look at nature, is in our own eye. The axis of vision is not coincident with the axis of things, and so they appear not transparent but opake." A cleansing of our vision is all that is required for "the redemption of the soul." In such a case, Emerson says at the start of his last paragraph, we shall "come to look at the world with new eyes." Since "what we are, that only can we see," we must make ourselves whole again. Emerson culminates his quasi-religious vision with a ringing sentence that catches up the Christian undertone of the essay and assimilates it to the naturalistic premise of America's nascent literary hopes: "The kingdom of man over nature, which cometh not with observation,—a dominion such as now is beyond his dream of God,—he

shall enter without more wonder than the blind man feels who is gradually restored to perfect sight." Emerson's last word, of course, underlines once again the point of the whole essay. And the important allusion here to Luke 17:20–21 (unfortunately not noted in the new Harvard edition of *Nature*) tells us that the visionary perfection we seek has stolen upon us unawares and lies waiting within.[21]

This heady faith, expressed in the controlling metaphor of *Nature*, which believes that clarified sight can literally reform our world, for the most part governs the first series of Emerson's *Essays* and is embodied in the opening sentence of "Circles": "The eye is the first circle; the horizon which it forms is the second." Emerson's meaning, enforced here by a favorite pun and emphasized throughout "Circles" (when a man utters a truth, "his eye burns up the veil which shrouded all things"; when the poet breaks the chain of habitual thought, "I open my eye on my own possibilities"), is that the self, represented here by the creative eye, is primary and generative: it *forms* the horizon—goal, world view—that it sees. This is the "piercing eye" of Uriel which, in the poem of that name, is described as "a look that solved the sphere." But, as we know, by the time Emerson came to write "Uriel" in the mid-1840's his "lapse" had already taken place and his own reference to the "ardent eye" (as Thoreau was to term it) is consciously ironic.[22] Indeed, and this is my central point, as we move into his second series of *Essays* and beyond, we may verify the fundamental shift in Emerson's optative mood brought about by his "sad self-knowledge" through simply observing the transformations that his visual metaphor undergoes. In the crucial "Experience," for example, Emerson accedes to the notion of the Fall of Man, redefining it as "the discovery we have made that we exist"—the discovery, that is, that the individual consciousness is limited and contingent. "Ever afterwards we suspect our instruments. We have learned that we do not see directly, but mediately, and that we have no means of correcting these colored and distorting lenses which we are." Emerson now has only a "perhaps" to offer concerning the "creative power" of our "subject-lenses," and he serves up his own optimistic perception from "Circles" in a new, markedly qualified, form: "People forget that it is the eye which makes the horizon." What we have created is no more than an optical illusion. Emerson further confirms his diminished sense of personal power later in the book, in the first paragraph of "Nominalist and Realist," when his trope reappears: "We have such exorbitant eyes that on seeing the smallest arc we complete the curve, and when the curtain is lifted from the diagram which it seemed to veil, we are vexed to find that no more was drawn than just that fragment of an arc which we first beheld. We are greatly too liberal in our construction of each other's faculty and promise." It is worth noticing, by the way, how the quin-

tessentially figurative nature of Emerson's imagination has unerringly guided him to the witty choice of "exorbitant" in this passage.

But an even more impressive example, in this regard, of the progressive metamorphosis of Emerson's metaphor as his perceptions changed may be found in "Fate." By 1852, when the essay was completed, Emerson had so qualified his views that Nature, which sixteen years before was the book of life and possibility, became now "the book of Fate." In 1836 Emerson asserted in "Prospects" that "nature is not fixed but fluid. Spirit alters, moulds, makes it. . . . Every spirit builds itself a house, and beyond its house a world, and beyond its world a heaven." Now he was forced tragically to concede that "every spirit makes its house; but afterwards the house confines the spirit." Faced with this crushing sense of limitation, Emerson returned to his favorite metaphor in a new, notably ironic, mood:

> The force with which we resist these torrents of tendency looks so ridiculously inadequate that it amounts to little more than a criticism or protest made by a minority of one, under compulsion of millions. I seemed in the height of a tempest to see men overboard struggling in the waves, and driven about here and there. They glanced intelligently at each other, but 'twas little they could do for one another; 'twas much if each could keep afloat alone. Well, they had a right to their eye-beams, and all the rest was Fate.

Here sight, as Jonathan Bishop has remarked well, "the sense especially associated with the intellectual freedom of the Soul, has dwindled until it can provide only a bare proof of impotence."[23] The rhetorical procedure in "Fate," to be sure, is insistently dialectic, but this old Emersonian game of yin and yang is rather mechanically worked out, and a balance is not struck for the reader, I think, because we sense clearly where the weight of Emerson's own imagination leans. When, a few pages later, he argues for the power of individual will by saying, of the hero, that "the glance of his eye has the force of sunbeams," we can hardly fail to recall the convincing paragraph I have quoted. Intelligent glances may serve as a kind of spiritual consolation to drowning men, but eyebeams and sunbeams alike seem insubstantial as levers against the overwhelming force of Fate.

An analogous indication of discouragement in Emerson's optimistic philosophy may be seen in the fortunes of another central metaphor— that of the ascending spiral or upward-pointing staircase (or ladder). In this case, I believe we can actually pinpoint the shift in Emerson's attitude as occurring somewhere between the composition of "The Poet" and "Experience" (which is to say somewhere between late 1842 and early 1844). I think it is even possible to assert in this regard that although "The Poet" stands first in the second series of *Essays*, the ebulliently

hopeful mood and metaphoric coordinates of that piece place it with the first book of *Essays*, whereas "Experience," which is printed directly following "The Poet," actually marks a new departure in both tone and imagery.

Emerson's first collection of *Essays* is largely controlled by figures of ascension. In "Self-Reliance" we read that "the soul *becomes*," that power "resides in the moment of transition from a past to a new state, in the shooting of the gulf, in the darting to an aim." The inchoate metaphor develops in "Compensation," where Emerson affirms that "the soul refuses limits," for "man's life is a progress, and not a station." The law of nature "is growth," and "the voice of the Almighty saith, 'Up and onward for evermore!'" The method of man is "a progressive arrangement," we are told in "Spiritual Laws"; and this means, as regards the affections (in "Love"), that we must pass from lower attractions to higher ones: "the lover ascends to the highest beauty, to love and knowledge of Divinity, by steps on this ladder of created souls." Since, in "Friendship," we "descend to meet," we must make room for one another's merits—"let them mount and expand"—parting, if need be, so that we may "meet again on a higher platform." This is the "spiritual astronomy" of love, as it is the law of the soul's progress in "The Over-Soul" ("the soul's advances are not made by gradations, such as can be represented by motion in a straight line, but rather by ascension of state"). Emerson's figure develops further, in the first series of *Essays*, with "Circles," which is essentially devoted to working out a set of variations on the notion of man as "a self-evolving circle," a rising spiral, who scales the "mysterious ladder" of upwardly mobile life. In a very real sense, however, the figure culminates in "The Poet," for he is the Christ-like hero whose *logos* breaks our chains and allows us to "mount above these clouds and opaque airs" in which we normally dwell. Poets are "liberating gods" who preach "*ascension*, or the passage of the soul into higher forms . . . into free space." Released by this extraordinary savior, we live the heavenly life of the redeemed imagination: "dream delivers us to dream, and while the drunkenness lasts we will sell our bed, our philosophy, our religion, in our opulence."

This divine bubble is punctured sharply in "Experience" as Emerson, in typical fashion, picks up his own language and places it in a startling new context: "Dream delivers us to dream, and there is no end to illusion." The imagination is now seen as a kind of devil of deceit who provokes the fall of man into a "middle region" of uncertainty and confusion:

> Where do we find ourselves? In a series of which we do not know the extremes, and believe that it has none. We wake and find ourselves on a stair; there are stairs below us, which we seem to have ascended; there are stairs above us, many a one, which go upward and out of sight. But the

Genius which according to the old belief stands at the door by which we enter, and gives us the lethe to drink, that we may tell no tales, mixed the cup too strongly, and we cannot shake off the lethargy now at noonday. Sleep lingers all our lifetime about our eyes, as night hovers all day in the boughs of the fir-tree. All things swim and glitter. Our life is not so much threatened as our perception. Ghostlike we glide through nature.

Vision is darkened here. Indeed, Emerson's mood is sinister, almost Poesque, as he, too, in a sort of "lonesome October," wanders "in the misty mid region of Weir" which we find in "Ulalume." Or, to use the terms of Wallace Stevens, Emerson is trapped in something like a "banal sojourn," a time of indifference, when man's depressed spirit dumbly mutters: "One has a malady, here, a malady. One feels a malady."[24] That malady can perhaps best be described as loss of affect, a contemporary version of acedia; a dejected state in which Emerson cannot even feel that this terrible threat to perception is a threat to life because his very sense of self is "ghostlike." This is the form evil takes in Emerson's lapsarian mood. The optimistic spiral has collapsed upon itself and Emerson, having set his "heart on honesty in this chapter," finds himself forced down his ladder into "the foul rag-and-bone shop of the heart." Though it would be more than mildly misleading to suggest that the Emerson of "Experience," and after, truly joins hands with Yeats in giving voice to a peculiarly modern sense of discouragement and dislocation, it is nevertheless fair to say that the Emerson who began to conceive of existence in such grayly tragic terms as these took a large step toward insuring that his writing could have a continuing life for twentieth-century readers.

IV

Most Emersonians would probably agree that to redeem Emerson by resorting to what Newton Arvin calls a "cant of pessimism" is to do him a disservice.[25] This is not to say that the expression we find, in such an essay as "Experience," of a kind of existential *nausea*, a feeling that reality eludes us and that we are all, as Sartre says, "*superfluous*, that is to say, amorphous, vague, and sad"[26]—that the expression of such things in Emerson is not particularly valuable. This side of Emerson deepens our interest in him, making us feel that his sense of the way life can be sometimes corresponds more nearly to our own. But, if we resist the temptation to overemphasize Emerson's journals and letters and pay attention mainly to those published works by which the world has known him for more than a century, the fact remains that the "House of Pain" was not Emerson's dominant structure and should not constitute his major claim on us.

My own intent has been to show that the problems which have perennially dogged Emerson's reputation and hindered a true appreciation of his work can largely be obviated if we focus our attention on his writing *as writing*. His work, I am saying, does have this kind of interest to a high degree; and a fundamentally literary approach to Emerson can yield surprising dividends of reading pleasure and a new understanding of what he was about. As a final short demonstration of my argument, I propose to examine a familiar—in some ways, too familiar—specimen brick from the Emerson edifice, the "Divinity School Address." Like most monuments of Emerson's prose, this piece has been so solidly in place for so long that we tend to overlook what is really in it. Though it is normally spoken of in terms of Emerson's evolving career, or the Unitarian-Transcendentalist controversy, or its doctrine (or the absence thereof), its real interest, it seems to me, lies in its exhibition of Emerson's skill as a literary strategist and of his mastery of organic form.

On the first of April preceding that momentous July evening when Emerson delivered his bombshell, he told a group of divinity students informally that "the preacher should be a poet."[27] That is precisely and totally the "doctrine" of his address, which is both an exposition and an enactment of that belief. The key concept, and word, in the address is *beauty*, for Emerson was determined to prove that "the institution of preaching—the speech of man to men" (which is also, we should note, the institution of literature) is utterly nugatory if moral truth is separated from the delight of living. The "new Teacher" whom Emerson called for in the last sentence of his speech was charged with showing "that the Ought, that Duty, is one thing with Science, with Beauty, and with Joy." Accordingly, those two final words, beauty and joy, govern Emerson's startlingly heretical portrait in the address of the archetypal preacher, Christ, who is offered to us as a kind of first-century aesthete, replete with "locks of beauty," who was "ravished" by the "supreme Beauty" of the soul's mystery and went out in a "jubilee of sublime emotion" to tell us all "that God incarnates himself in man, and evermore goes forth anew to take possession of his world." The man who is most enamored of the "beauty of the soul" and the world in which it is incarnated is called to serve as "its priest or poet," and Emerson urges such men to feel their call "in throbs of desire and hope."

It is precisely the absence of any evidence of such emotions that characterizes the unnamed formalist preacher whom Emerson describes in a striking *exemplum* about halfway through the address:

> I once heard a preacher who sorely tempted me to say, I would go to
> church no more. Men go, thought I, where they are wont to go, else had
> no soul entered the temple in the afternoon. A snowstorm was falling
> around us. The snowstorm was real: the preacher merely spectral; and the

eye felt the sad contrast in looking at him, and then out of the window behind him, into the beautiful meteor of the snow. He had lived in vain. He had no one word intimating that he had laughed or wept, was married or in love, had been commended, or cheated, or chagrined. If he had ever lived and acted, we were none the wiser for it. The capital secret of his profession, namely, to convert life into truth, he had not learned. Not one fact in all his experience, had he yet imported into his doctrine. This man had ploughed, and planted, and talked, and bought, and sold; he had read books; he had eaten and drunken; his head aches; his heart throbs; he smiles and suffers; yet was there not a surmise, a hint, in all the discourse, that he had ever lived at all. Not a line did he draw out of real history. The true preacher can always be known by this, that he deals out to the people his life,—life passed through the fire of thought.[28]

Emerson, the preacher, moves in thought down into the congregation and reminds himself of a typical parishioner's experience: boredom.[29] If habit had not brought him to the church, he would scarcely have gone, for there is nothing to attract him, no promise of reality, no pleasure. The true preacher, the true poet, bases his verbal art on personal experience in the actual world that surrounds us all, thus transmuting "life into truth." Otherwise, words are mere counters that leave us untouched. Emerson's real genius here, however, lies in the business of the snowstorm. Playing the role of listener, he allows his wandering attention to move outside the window and find its sole available pleasure in the "beautiful meteor of the snow."[30] Perhaps only a New England consciousness could invent such a phrase; but then Emerson is writing of what he knows and loves (as in his poem "The Snow-Storm"). The fine irony of the passage is that the preacher should seem *spectral* compared even to the frigid and ghostly reality of snow. What Emerson has done himself is to insist on some sort of interpenetration between that which goes on inside the church and the beautiful world outside. His example suggests that the skillful preacher will attempt to do the same.

Now, in our backward movement through the address, let us confront the magnificent strategies of the opening passage. On what was apparently a splendid Sunday evening in July 1838, Emerson mounted the pulpit in Divinity Hall to speak, nominally, to the senior class in divinity; but they were a small group, and the room was packed with faculty members and friends. Emerson's intent, as I have noted, was to *demonstrate* that "the preacher should be a poet," that religious truth and human pleasure must coexist, and that the two worlds of chapel and physical universe are mutually enriching. Accordingly, in a prose that is consciously purple, Emerson began his address by inviting this sternly theological audience to allow its attention to wander, as his own had

wandered on that boring Sunday in winter, beyond the chapel window
to the ripe world of nature outside:

> In this refulgent summer it has been a luxury to draw the breath of life.
> The grass grows, the buds burst, the meadow is spotted with fire and gold
> in the tint of flowers. The air is full of birds, and sweet with the breath of
> the pine, the balm-of-Gilead, and the new hay. Night brings no gloom to
> the heart with its welcome shade. Through the transparent darkness the
> stars pour their almost spiritual rays. Man under them seems a young
> child, and his huge globe a toy. The cool night bathes the world as with a
> river, and prepares his eyes again for the crimson dawn. The mystery of
> nature was never displayed more happily. The corn and the wine have
> been freely dealt to all creatures, and the neverbroken silence with which
> the old bounty goes forward, has not yielded yet one word of explanation.
> One is constrained to respect the perfection of this world, in which our
> senses converse.

An example of how inattentive even some of the most devoted Emer-
sonians have been to the master's art is provided by Stephen Whicher's
comment: "the address itself was calculated to give no offense, on grounds
of vocabulary at least, to a Unitarian audience."[31] It is precisely in its
vocabulary that the barefaced effrontery of Emerson's gambit resides.
There is probably not another place in all his writings where Emerson is
so consciously arch. The only astute comment I have found on this pas-
sage belongs to Jonathan Bishop: "the immediate rhetorical motive, evi-
dently enough, is shock: an address to a small group of graduating di-
vinity students is not supposed to begin by an appeal to the sensual
man."[32] Emerson's stance, as Bishop says, is that of a "voluptuary," and
the word is well chosen. Following the "unusually aureate" (Bishop's
term) *refulgent*—which suggests a kind of shining forth, or epiphany, in
the summer's beauty—Emerson explodes his real charge in the sentence:
luxury. We must remind ourselves that Emerson's audience, trained in
theology, was not likely to overlook the implications of that red flag, for
luxuria, one of the seven deadly sins, means lust. Although that technical
meaning, of course, is not Emerson's, a calculated air of aesthetic in-
dulgence permeates this opening remark.

In the sentences that follow, Emerson has measured out his language
with extreme care to one end: the creation in words of an unfallen world
of the senses where formal, traditional religion is unnecessary because
nature provides its own sacraments. It is hard to see how Emerson's
frank appropriation of religious terms and concepts could have failed to
offend much of his audience. The rays of the stars are *"almost* spiritual"
(Is not heaven then *really* above our heads? Conversely, can a natural
phenomenon *almost* approach spiritual truth?). Man, returned to the in-
nocence of childhood, is bathed by the cool night as in baptismal waters,

whereby his eyes are *prepared* for the dawn (a familiar type of the coming of Christ).[33] The technical term *mystery* is applied to nature; but unlike theological mysteries, this one is openly and happily "displayed." In the next sentence, Emerson announces that the central sacrament, the Eucharist (over which, of course, he had created a controversy when he left the Second Church of Boston six years earlier), is "freely dealt to all creatures" by nature—without condition or exclusion. Then, to a congregation still committed to the belief that the creation is fully expounded in the Bible, Emerson states that no "word of explanation" has been provided—and implies that none is needed. Finally, this Christian audience, all children of the Puritans, are told that they are "constrained to respect," not (as we should expect) the dogmas and duties of their faith, but rather the *perfection* of *this* world, a totally natural world, the one "in which our senses converse." Can we really doubt that to most of Emerson's listeners all of this seemed the sheerest effrontery (although to many others since it has seemed merely a flowery portal, the blandly poetic induction to a serious theological dissertation)? But it is clear that Emerson's aim was not fundamentally to offer an insult but to enact a meaning which would develop organically in the course of his address and to which he would "come full circle" at the end: namely, as we have noted, that Ought and Beauty, Duty and Joy, Science and Ecstasy, Divinity and the World, must merge in the new hypostatic unity of a living religion of the soul.

There is "a sort of drollery," Henry James remarks, in the spectacle of a society in which the author of the Divinity School address could be considered "profane." What they failed to see, James continues, is "that he only gave his plea for the spiritual life the advantage of a brilliant expression." Emerson, of course, has long since ceased to be thought profane (except perhaps in the curious pronouncements of such an eccentric critic as Yvor Winters). The problem is exactly the reverse: it is Emerson's pieties that have damned him. What I have tried to argue here is simply that we can, in search of a living Emerson, make much better use of the advantage of which James speaks. Emerson *is* a great writer. He has only to be read.

Notes

[1]Stephen E. Whicher, "Emerson's Tragic Sense," in *Emerson: A Collection of Critical Essays*, ed. Milton Konvitz and Stephen Whicher (Englewood Cliffs, N.J.: Prentice-Hall, 1962), p. 39.

[2]This and all subsequent quotations from Henry James are taken from "Emer-

son," in *The Art of Fiction and Other Essays* (New York: Oxford University Press, 1948), pp. 220–40.

[3]George Santayana, *Interpretations of Poetry and Religion* (New York: Scribner's, 1900), p. 217.

[4]George Edward Woodberry, *Ralph Waldo Emerson,* repr. (New York: Haskell House, 1968), p. 1. In his *American Prose Masters* (1909) W. C. Brownell said that Emerson's presence was "suggestive of some new kind of saint—perhaps Unitarian." Twelve years earlier John Jay Chapman commented on the irony that this radical, who believed that "piety is a crime," should have been "calmly canonized and embalmed in amber by the very forces he braved. He is become a tradition and a sacred relic. You must speak of him under your breath, and you may not laugh near his shrine."

[5]In Perry Miller, *The Transcendentalists: An Anthology* (Cambridge: Harvard University Press, 1950), p. 11.

[6]Since the interested reader will have no difficulty locating quotations from Emerson's standard works (cited by name in the text), I have avoided the pedantry of elaborate documentation. References to Emerson's less accessible publications are duly noted.

[7]For a detailed history of this debate, see Richard Ruland, *The Rediscovery of American Literature* (Cambridge: Harvard University Press, 1967). Also useful in this connnection is René Wellek's "Irving Babbitt, Paul More, and Transcendentalism," in *Transcendentalism and Its Legacy,* ed. Myron Simon and Thornton H. Parsons (Ann Arbor: University of Michigan Press, 1966), pp. 185–203.

[8]Cited by F. O. Matthiessen in *The Achievement of T. S. Eliot* (New York: Oxford University Press, 1959), p. 24.

[9]Malcolm Cowley, *Exile's Return* (New York: Viking Press, 1956), p. 227.

[10]*A Dial Miscellany,* ed. William Wasserstrom (Syracuse, N.Y.: Syracuse University Press, 1963), p. 151.

[11]Harold Bloom, "Emerson: The Glory and the Sorrows of American Romanticism," *Virginia Quarterly Review,* 47 (Autumn 1971), 550.

[12]Jonathan Bishop, *Emerson on the Soul* (Cambridge: Harvard University Press, 1964), p. 6.

[13]*Emerson on the Soul,* pp. 130, 15, 106, 184, 131, 151; Matthew Arnold, *Discourses in America* (London, 1889), p. 179.

[14]William James, "Address at the Emerson Centenary in Concord," in *Emerson: A Collection of Critical Essays,* p. 19. W. C. Brownell's comment manages to echo both Jameses at once. Though "no writer ever possessed a more distinguished verbal instinct, or indulged it with more delight" than Emerson, his style is that "of a writer who is artistic, but not an artist." Emerson had "no sense of composition; his compositions are not composed. They do not constitute objective creations. They have no construction, no organic quality—no evolution. . . . art in the constructive sense found no echo in Emerson's nature." See *American Prose Masters,* ed. Howard Mumford Jones (Cambridge: Harvard University Press, 1963), pp. 125–27.

[15]In *Character and Opinion in the United States* (1920).

[16]Charles Feidelson, Jr., *Symbolism and American Literature* (Chicago: University of Chicago Press, 1953), p. 150.

[17]There are some valuable observations on "Emerson as literature" in James M. Cox, "Emerson and Hawthorne: Truth and Doubt," *Virginia Quarterly Review*, 45 (Winter 1969), 88–107. Professor Cox writes of "metaphor as action" in Emerson's work.

[18]*English Traits*, ed. Howard Mumford Jones (Cambridge: Harvard University Press, 1966), p. xv. Though Philip Nicoloff, in his exhaustive study of *English Traits*, also sees little justification for the opening and concluding chapters (indeed, he claims that the whole book is "not so shapely a production as has often been suggested, either in its entirety or in its parts"), he does find an intellectual pattern in *English Traits* based on Emerson's belief in the necessity of racial and historical evolution—growth and decline. Emerson's theories thus led him to see England as an exhausted species passing on its genetic heritage to the country of the future, i.e., America. My argument here is that the metaphoric structure of *English Traits* precisely reinforces this doctrine. See Philip Nicoloff, *Emerson on Race and History* (New York: Columbia University Press, 1961). Cf. also Ralph Rusk, *The Life of Ralph Waldo Emerson* (New York: Columbia University Press, 1957), pp. 393ff.

[19]Sherman Paul, *Emerson's Angle of Vision* (Cambridge: Harvard University Press, 1952), pp. 72–73; Vivian C. Hopkins, *Spires of Form: A Study of Emerson's Aesthetic Theory* (Cambridge: Harvard University Press, 1951), p. 3; Stephen Whicher, "Emerson's Tragic Sense," in *Emerson: A Collection of Critical Essays*, p. 42.

[20]Notable exceptions are: Kenneth Burke, "I, Eye, Ay—Emerson's Early Essay on 'Nature': Thoughts on the Machinery of Transcendence," in *Transcendentalism and Its Legacy*, pp. 3–24; Tony Tanner, *The Reign of Wonder* (New York: Harper and Row, 1967), chapter 2, "Emerson: The Unconquered Eye and the Enchanted Circle"; Richard Poirier, *A World Elsewhere* (New York: Oxford University Press, 1966), chapter 2, "Is There an I for an Eye?: The Visionary Possession of America." See also Warner Berthoff, *Fictions and Events* (New York: Dutton, 1971), " 'Building Discourse': The Genesis of Emerson's *Nature*," especially pp. 209–13. This trenchant essay, much less restricted in scope than its title suggests, is the best general introduction to Emerson that I know.

[21]Emerson uses the same sentence from Luke in "Experience." Cf. M. H. Abrams, *Natural Supernaturalism: Tradition and Revolution in Romantic Literature* (New York: Norton, 1971), p. 47; see also pp. 411ff. For an understanding of the Romantic context of *Nature*, one could hardly do better than to study Professor Abrams' brilliant exposition of the central Romantic motifs (the transvaluation of religious "vision"; the reinterpretation of the fall of man; the significance of the Romantic spiral). Since I cannot quote as much of this absorbing book as I should like, I shall content myself with simply recommending it to all students of Emerson. Professor Abrams' key text, by the way—Wordsworth's "Prospectus" for *The Recluse*—might have served Emerson as doctrine for *Nature*.

[22]Compare my own "Transcendental Antics," in *Harvard English Studies 3*, ed. Harry Levin (Cambridge: Harvard University Press, 1972), pp. 180–82.

[23]*Emerson on the Soul*, p. 210.

[24]*The Collected Poems of Wallace Stevens*, p. 62. Cf. "The Man Whose Pharynx Was Bad," p. 96.

[25]Newton Arvin, "The House of Pain," in *Emerson: A Collection of Critical Essays*, p. 59.

[26]Jean-Paul Sartre, *Nausea*, trans. Lloyd Alexander (New York: New Directions, 1964), p. 177.

[27]See *The Journals and Miscellaneous Notebooks of Ralph Waldo Emerson*, ed. William H. Gilman, et al. (Cambridge: Harvard University Press, 1960–), V, 471 (this edition is abbreviated hereafter as *JMN*). A valuable treatment of the evolution of Emerson's notion of the preacher-poet, especially in relation to the Unitarian background, is Lawrence I. Buell, "Unitarian Aesthetics and Emerson's Poet-Priest," *American Quarterly*, 20 (Spring 1968), 3–20. See also Frederick May Eliot, "Emerson and the Preacher," *Journal of Liberal Religion*, 1 (Summer 1939), 5–18.

[28]The hapless preacher referred to here was actually Barzillai Frost, and Emerson's experience is recorded in *JMN*, V, 463. Conrad Wright's "Emerson, Barzillai Frost, and the Divinity School Address," *Harvard Theological Review*, 49 (January 1956), 19–43, contains an absorbing discussion of the event. Noticing that Frost was only one year younger than Emerson, Professor Wright conjectures that Emerson viewed Frost as the lifeless preacher he himself might have become had he not left the Unitarian ministry in 1832. The vehemence of Emerson's reaction to Frost in his journal certainly does suggest a complex personal dimension to what, in the address, is presented simply as a generic problem in contemporary preaching.

[29]Compare Robert Spiller's introduction to the address in *The Collected Works of Ralph Waldo Emerson*, vol. 1, *Nature, Addresses, and Lectures*, ed. Robert E. Spiller and Alfred R. Ferguson (Cambridge: Harvard University Press, 1971), p. 71.

[30]It is worth noting that the journal passage which Emerson worked up here for the address, though it parallels the finished paragraph rather closely, does not mention "the beautiful meteor of the snow." That represents the touch of the poet, shaping remarks into literature.

[31]*Freedom and Fate: An Inner Life of Ralph Waldo Emerson* (Philadelphia: University of Pennsylvania Press, 1953), p. 74. In "The Rhetoric of Apostasy," *Texas Studies in Literature and Language*, 8 (Winter 1967), 547–60, Mary Worden Edrich argues persuasively that Emerson's language throughout the address was carefully calculated to shock.

[32]*Emerson on the Soul*, p. 88.

[33]See, for example, Jonathan Edwards' *Images or Shadows of Divine Things*, ed. Perry Miller (New Haven: Yale University Press, 1948), entry nos. 40, 50, 54, 80, 85, 110, and 111.

Thoreau
Walden

The Successive Versions of *Walden*

J. Lyndon Shanley

T he immediate beginning of *Walden* was in 1846 when Thoreau learned that the audience at one of his Lyceum lectures—probably the one on Carlyle on February 4, 1846—had expected to hear about his life in the woods. People on the streets and in stores and parlors had asked him, "What's it like there?" "What do you eat?" "Aren't you lonesome?" They seemed incredulous concerning his life; some were clearly bewildered, like the man who came to the hut looking for his dog but was incapable of listening to Thoreau's attempts to help him; he kept repeating, "What do you do here?"[1] Thoreau discovered that all this was more than idle curiosity and that people did want answers and enlightenment if they could be had. Sometime before March 13, 1846, he wrote in his journal in preparation for a lecture, "After I lectured here before, this winter, I heard that some of my townsmen had expected of me some account of my life at the pond. This I will endeavor to give to-night."[2]

This was no encouragement for Thoreau to let pass; he wanted to lecture and write for money, and his journal already contained the beginnings of the two major elements in *Walden:* the story of how he lived at the pond, and the comparison of what he lived for with what many people of New England lived for. From the time he went to the pond, he had noted in his journal the events and thoughts of his days, undoubtedly with the idea of using the notes for lectures and essays as he was even then using earlier ones in writing *A Week*. And he was also thinking of a lecture on the mean and sneaking lives led by many people

Reprinted from *The Making of Walden* (Chicago: University of Chicago Press, 1957), pp. 18–33. Copyright 1957 by the University of Chicago Press. Reprinted by permission of the University of Chicago Press and J. Lyndon Shanley.

in Concord and New England. Sometime between December 23, 1845, and March 26, 1846, he wrote the opening lines of the lecture in his journal; they consisted of the first sentence of "Economy," 3, and all of "Economy," 7, and they began: "I wish to say something to-night not of and concerning the Chinese and Sandwich-Islanders, but *to* and concerning you who hear me."[3] With the stimulus of his townsmen's questions, he set out to develop and combine the two elements.

His first step in writing the first version was to gather the material which lay everywhere in his journals, not only those written at the pond but also the ones he had kept in earlier years. From notes of 1840 and 1841 he took items for his comments on clothes;[4] and from the journal he had kept while living at William Emerson's on Staten Island in 1843[5] he took the lyrical passage on the coming of spring, "Spring," 13. He used the material of successive entries or even the parts of a single entry at widely scattered points in the first and later versions of *Walden*. For example, eleven consecutive journal paragraphs written on or near July 16, 1845, dealt with Alek Therien and other visitors, the advantages of a frontier or primitive life, and the mice at Walden; in the first version Thoreau used them in "Visitors," in two places in "Economy," and in the section on animals. Frequently, as a comparison of journal entries and the text shows, he adopted material from the journal with little change. Often, however, a journal entry was only the germ of a longer passage. He developed the following unpublished interlineation as the first draft of "Economy," 56, in I; later he interlined the rest of the paragraph in III: "There is no place in the village for a work of art, or statue for instance if one had come down to us—for our lives our houses furnish no proper pedestal for it. It is more beautiful out of doors where there is no house—no man."[6]

In the cases just given, Thoreau took what he wanted from various journal entries and did not go back to them when he revised his work; in other cases, however, he used only some of the material at hand and later returned for more. In the first version he took over from his journal the material for "Economy," 7, but not until the third version did he take over the first sentence of "Economy," 3, which immediately preceded 7 in the journal.[7] He drew on the following journal entry of his third day at the pond, July 6, 1845, at five different times. He used three items in three widely separated places in the first version, and after writing the second version, he interlined two other items from this entry, again at some distance from one another:

> July 6. [Version I. Cf. "Where I Lived," 16:] I wish to meet the facts of life—the vital facts, which are the phenomena or actuality the gods meant to show us—face to face, and so I came down here. Life! who knows what it is, what it does? If I am not quite right here, I am less wrong than

before; and now let us see what they will have. [Interlined in version II. Cf. "Where I Lived," 20:] The preacher, instead of vexing the ears of drowsy farmers on their day of rest, at the end of the week,—for Sunday always seemed to me like a fit conclusion of an ill-spent week and not the fresh and brave beginning of a new one,—with this one other draggletail and postponed affair of a sermon, from thirdly to fifteenthly, should teach them with a thundering voice pause and simplicity. "Stop! Avast! Why so fast?" [At the beginning of "Reading" in version I, but not in text:] In all studies we go not forward but rather backward with redoubled pauses. We always study *antiques* [Thoreau's italics] with silence and reflection. Even time has a depth, and below its surface the waves do not lapse and roar. [Version I, "Economy," 8:] I wonder men can be so frivolous almost as to attend to the gross form of negro slavery, there are so many keen and subtle masters who subject us both. [Interlined in version II, "Economy," 8:] Self-emancipation in the West Indies of a man's thinking and imagining provinces, which should be more than his island territory,—one emancipated heart and intellect! It would knock off the fetters from a million slaves.

He did not always lift separable items and use them in more or less developed form. Sometimes he found suggestions for two or three different points in a single note. An unpublished leaf (HM 924), torn from a journal or notebook, contains a series of brief notes that Thoreau developed in "Visitors," "The Ponds," "House-Warming," and "The Pond in Winter"; one of the notes reads (unless otherwise noted, italics here and in subsequent quotations from manuscripts indicate material interlined by Thoreau):

> A place of pines—of forest scenes and events visited by successive nations of men all of whom have successively *admired &* fathomed it—but still its water is green and pellucid, not an intermittent spring—somewhat perennial in it—while the nations pass away *offering its perennial well to the animal nations.* A true well—a gem of the first water—which Concord wears in her coronet.
> looking blue as amethyst or solidified azure far off as it is drawn through the streets. Green in the deeps—blue in the shallows. Perhaps the grass is a denser deeper heaven.

He used "a place of pines," the "perennial" quality of the spring-well, and the observation on the green and blue of Walden's water in "The Ponds," 5, the color of the ice in "The Pond in Winter," 16, and the major part of the note in "The Ponds."[8]

When he was actually writing out the first version, Thoreau did not simply leaf through his journals and take what he wanted as he found it. He first gathered his material and ordered it. The evidence for this is clear, even though not extensive. In the back of one of his journals of 1845–47 he wrote out a preliminary list of topics for the later part of the

first version, and then he numbered the topics in the order in which he first intended to use them in *Walden*.[9] In the margin of the manuscript journal of July, 1845, he marked the order of the items on the advantages of a primitive and frontier life before he copied them in the first version.[10] In other cases, as with the following notes on clothing, he wrote out his material with the intention of working it over later. The phrase at the end indicates that he had previously assembled or written out other material on clothing.

> Comparatively speaking tattooing is not necessarily the hideous custom it is described to be. It is the same taste that prints the calico which the wearer put off and on, and the consistent objection is rather to the fashion of the print than to the practice itself. It is not therefore barbarous because it is skin deep. [Compare "Economy," 40.]
>
> When I meet a fine lady or a gentleman dressed at the top of the fashion I wonder what they would do if there should be an earthquake or a fire should suddenly break out; for they appear to have counted on fine weather & a smooth course only. Our dress should to some extent be such as will fit equally well in good & in bad fortune. [Compare "Economy," 37.]
>
> When our garments are worn out we hang them up in the fields to scare crows with, as if the reason why men scare crows was in their clothes. I have often experienced the difficulty of getting within gunshot of a crow. It is not because they smell powder. [This appears in the first and other versions but not in text.]
>
> It is true all costume off a man is grotesque. It is only the serious eye & the sincere life passed within it, which restrain laughter, and consecrate the costume of any people. Let Harlequin be taken with a fit of the colic in the midst of his buffoonery, and his trappings will have to serve that mood too. When the soldier is hit with a cannon ball rags are as becoming as purple. As soon in short as a man engages to eat walk work & sit & meet all the contingencies of life therein, his costume is hallowed, and may be the theme of poetry. [Compare "Economy," 39.]
>
> I have little hesitation in saying & [in the first version this phrase introduces material that is in "Economy," 41].[11]

In some cases he assembled notes on a topic by tearing pages out of his journals; hence the mutilation of the early manuscript journals and the presence of torn-out journal pages in the *Walden* manuscript and in miscellaneous manuscript gatherings.

As he took over his raw material, Thoreau broke it up, changed it in detail, developed it, and finally ordered it so that he might offer his hearers and readers, not the immediate, random, and intermittent notes of a journal, but a reflected-on and consciously shaped re-creation of his experience. A torn leaf in the *Walden* manuscript gives us a glimpse of how he roughed out such a piece as the story of investigating, wrecking,

and removing James Collins' shanty. He went over it at least twice, for he made one set of interlineations in ink and another in pencil (here and elsewhere, angle brackets ⟨ ⟩ indicate canceled material in manuscripts):

> [Torn; two words not clear] became a dead cat—and buried at last. Lintel none but perennial passage for hens *under the door board.* I threw down this dwelling ⟨next day⟩ [pencil:] *this morning*—drawing the nails— and removed it to the pond side in small cart loads *one early thrush gave me a note or two by the way—which was encouraging* [second interlining in pencil:] *as I drove along the woodland path.* Penurious[?] Seeley neighbor Irishman—as I was informed *by young Patrick treacherously* transferring in the intervals the still tolerable straight driveable nails—staples spikes to his pocket—and then stood to look on unconcerned *in the sun* and pass the time of day. ⟨There by the ponside [*sic*] they bleached—warped⟩ [pencil:] *&* *then spread the boards on the grass to bleach and warp* back again in the sun ⟨upon the grass⟩ Seeley *with his spring thoughts* gazing freshly up at the devastation seeking [for "seeing"?] there is a dearth of work—he *there* to represent spectatordom jingling his pockets lowly—a transaction of singular quietness.

Thoreau must have begun to write out the first version of *Walden* late in 1846 or early in 1847. He had finished part of it by February 10 and 17, 1847, when he lectured at the Concord Lyceum on his life at the pond;[12] but he was still at work later in the winter and spring, for in this version he wrote of the icecutters of the winter of 1846–47: "This winter [later changed to 'In the winter of 46 & 47'] as you all know there came a hundred men"; and "They have not been able to break up our pond any earlier than usual this year as they expected to—for she has got a thick new garment to replace the old." Speaking of his housekeeping earlier, he had said: "I trust that none of my hearers will be so uncharitable as to look into my house now—after hearing this, at the end of an unusually dirty winter, with critical housewife's eyes, for I intend to celebrate the first bright & unquestionable spring morning by scrubbing my house with sand until it is as white as a lily—or, at any rate, as the washerwoman said of her clothes, as white as a 'wiolet.' "[13] He wrote these passages with the possibility of reading them in lectures in 1847. They were not written, as were some later additions, merely as if he were at Walden.

There is no conclusive evidence that he completed this version before he left the pond in September, 1847, but since he was writing about the ice-cutters of "The Pond in Winter" by early spring,[14] it seems reasonable to conclude that he would have written the remaining twenty-seven pages of version I by September, or even earlier. The fact that he later interlined "Left Walden Sept. 6, 1847" at the end of this version also suggests that he had finished before that date.

Thoreau's own statements seem to imply that the first version was longer than it actually was. The first draft of the first paragraph of *Walden* (in version III, 1849) begins: "At the time the following pages were written I lived alone in the woods." Late in 1853 or very early in 1854 he changed this to read as it does in the published text, "the following pages, or rather the bulk of them." In the unpublished preface of version VII, 1854, he said: "Nearly all of this volume was written eight or nine years ago in the scenery & under the circumstances which it describes, and a considerable part was read at that time as lectures before the Concord Lyceum. In what is now added the object has been chiefly to make it a completer & truer account of that portion of the author's life." By the phrases "the bulk of them" and "nearly all of this volume" Thoreau may have meant that he had written more of *Walden* at the pond than at any other one time; certainly, the version of *Walden* he wrote at the pond was only about half as long as the final text.

A detailed description of the first version is given in the Appendix. Its general nature can be suggested here by comparing it briefly with the final text. The first version has the spirit and the style of *Walden*, but the spirit is not so strongly developed and the style is not so finished. Mark Van Doren said of *Walden*, "it was written in bounding spirits, with eyes twinkling and tongue in cheek."[15] So it was, and Thoreau wrote with the same joy and humor and challenging assurance at the beginning. There is a considerable difference, however, between the first and the last versions; the flavor is the same, but at the end it is much richer, since, as time went on, Thoreau added more and more of every element: for example, by far the greater part of the description of his immediate surroundings in "The Ponds," all the account of the friends who came to see him in "Winter Visitors," and the gay satire and poetry of all of "Conclusion." And he added the learning and authority of most of his quotations and specific references to earlier writers. Of fifty such items in the first half of *Walden*[16] only seven are in the first version; Thoreau added the others at various times in all the later versions.[17] He also improved the flavor significantly by cutting out the mediocre verse which bulks large in the first version.

The style of this version is recognizably that of the published text—homely and elaborate, witty and humorous, reflective and argumentative, scornful and gentle. And narrative, anecdote, lyric description, character sketch, satire, exposition—all kinds are here. But, understandably enough, in many places the writing does not have the clarity, force, and rhythms that we find in *Walden* itself; only by a long and untiring pursuit was Thoreau to win that perfection. A number of passages in the first version, if taken by themselves, may be superior in some respects to the revisions of them in the final text. The description of his partially finished

house, "Where I Lived," 8, and the advice of his "Good Genius," "Baker Farm," 6, for example, have a greater spontaneity and immediacy in the first version. But the later versions of such passages are more in keeping with the movement and tone of the final text. Thoreau inevitably sacrificed some liveliness and directness as he developed his lectures into a book which would give a fuller account of his experience.

Thoreau's quarrel with the ways of his contemporaries and the general outline as well as a large part of his story are in the first version, but it is by no means a "scale model" of *Walden* in either content or form. The major points of his criticism in "Economy" are laid out, but many illustrations and some reflections are missing, and there is little of "Higher Laws" and nothing of "Conclusion." As for his story, this version contains the greater part of his account of what he did in the summer and the description in the earlier chapters of the general quality of his life, but the account of the rest of the year is thin. Various parts of the final text are very unevenly represented, and the order and relations of the parts are quite different in many places, particularly in the second half, where the sequence of topics and of the events of the year is by no means so carefully worked out. Much was to be changed by later work.

When Thoreau left Walden Pond and returned to the village in September, 1847, he probably had a draft of *A Week* as well as the first version of *Walden*, and he also had material for several articles. If he was to realize his hopes of a career as a writer, he had to finish some of his pieces and publish them. At first, in the last months of 1847 and well into 1848, he seems to have been engaged on things other than *Walden*. By January 12, 1848, he lectured on the trip he had made to Ktaadn in the summer of 1846, and he sent off the completed essay "Ktaadn" to Horace Greeley by the end of March.[18] He had also prepared at least part of "Civil Disobedience" by January and February, 1848, when he lectured on the relation of the individual to the state.[19] And he worked on *A Week* in the spring and part of the summer of 1848, for in March he told Elliot Cabot that since he had not yet found a publisher for it, he was going to "mend it" and would "look at it again directly" when he had finished some other things; and in May he wrote to Greeley, "My book grows in bulk as I work on it."[20]

In view of all this, Thoreau probably did not return to any extended work on *Walden* until sometime after the middle of 1848. When he did so, he revised the first version in great detail not only to improve it for lectures such as those he gave in 1848–49 in Salem, Portland, and Worcester, as well as in Concord,[21] but also with an eye toward publication. He crowded in at the top of the first page of the first version: "Walden or Life in / the woods by Henry Thoreau / Addressed to my

Townsmen;" and later he put in a motto: "Where I have been / There was none seen." In a number of places he changed "lecture" to "book," "audience" to "readers," and "hear" to "read."

Having worked over the first version, Thoreau wrote version II.[22] He revised it and then wrote version III so close upon II that they almost seem one piece. At one point, a passage of II is on one side of a leaf and a passage of III on the other; at a second point, a passage of III that runs for five pages begins on the bottom of a page that has material of II on it. Furthermore, the pagination of the two versions runs in one series where Thoreau fitted the material of III into II. It is certain, however, that there are two versions here and that Thoreau wrote III after II: not only are the ink and handwriting different, but also III contains revisions of parts of II.

Neither version II nor III is much longer than I. The effect and apparent intention of his work in these versions was to tidy up and to increase the clarity and force of the first version, which he had written at the pond. And so he could properly write in III: "At the time the following pages were written I lived alone, in the woods."[23] There is no direct evidence as to when he wrote II and III, but all the circumstances indicate conclusively that he did so in 1848–49 and that he was preparing for early publication. Version II is essentially a fair copy of much of I with its corrections; the handwriting in II is the most carefully formed in the whole manuscript. In III, which consists almost entirely of rewriting of parts of I and II, the first page has in its upper half both title and author written out in a large hand, and it contains the first draft of the explanatory first paragraph of *Walden*.[24] The external evidence has been mentioned already: early in 1849 Thoreau asked Ticknor and Company about the possibility of their publishing *Walden;* on February 28, 1849, his Aunt Maria wrote that he was preparing *Walden* for the press;[25] and some copies of the first edition of *A Week* included a notice in the advertising pages that *Walden* would be published soon.

In 1849 Thoreau had a version of *Walden,* consisting of material in I, II, and III, which members of his family read and of which he could have made a fair copy; but there is no evidence in the manuscript that he made such a copy, although a letter of February 8, 1849, to Thoreau from Ticknor's might suggest that he had sent the publisher a manuscript of *Walden.* They wrote: "We find on looking over publishing matters that we cannot well undertake anything more at present. If however you feel inclined, we will publish 'Walden or Life in the Woods' on our own a/c, say One Thousand copies, allowing you 10 pr. ct. copyright on the Retail Price on all that are sold. The style of printing & binding to be like Emersons Essays."[26] On the other hand, there is no copy in the *Walden* manuscript that Thoreau could have sent to the publishers at this time;

and in view of all that is there, it seems most unlikely that, if there had been such a copy, it would not be in the manuscript.

I think the situation in February, 1849, was this. Thoreau had completed his work on *A Week* and was probably not very far from being able to complete a publishable version of *Walden*. We know that he had finished *A Week* and that he sent a fair copy of it to Ticknor's, for in a letter of February 16, 1849, they told him that they would publish the book at his expense, 1,000 copies in sheets for an estimated $381.24.[27] But it seems likely that he only inquired in advance about the possibility of their publishing *Walden*. Apparently the price quoted for *A Week*, and perhaps the terms offered for *Walden*, led Thoreau to seek another publisher, James Munroe, who published *A Week* in May, 1849, and at the same time announced in the advertising pages of *A Week* that *Walden* would "be published soon." But Thoreau never finished preparing *Walden* for publication at this time because *A Week* did not sell.

A publisher would hardly have risked Thoreau's second book immediately, and Thoreau could not put out a second book at his own expense— he did not settle his account with Munroe for publishing *A Week* until November 28, 1853.[28] Even had he had the money, perhaps Thoreau would not have finished *Walden* and published it at this time after seeing the reception given to *A Week*. How much the failure of *A Week* affected the course of Thoreau's life is a matter for conjecture, but the results for *Walden* are plain. William Charvat points out how the work of Poe, Melville, Hawthorne, Emerson, and others benefited in some respects because of "the pressures which contemporary readers and the booktrade exerted upon them."[29] The much-lamented plight of the artist in America may have its good effects. Indirectly, the public's lack of appreciation of *A Week* had a great deal to do with *Walden*'s being the masterpiece it is. The financial failure of *A Week* kept Thoreau from publishing *Walden* when he first wanted to, and when he did publish it five years later, he had enlarged and improved it almost beyond compare.

From 1849 until late 1851 or the beginning of 1852, Thoreau's work on *Walden* consisted only of revisions in the copy of versions I, II, and III. It is not possible to determine exactly when he made various corrections, but it was undoubtedly during 1850–51 that he put in all or most of the quotations from Chinese and Hindu writings that are interlined in II and III, for he commented in the journal for May 6, 1851: "Like some other preachers, I have added my texts—derived from the Chinese and Hindoo scriptures—long after my discourse was written." A few other scattered items in the journals of 1850–51 suggest that he thought of *Walden* from time to time, but it is certain that he did not write any significant amount of new material in the manuscript until January or February of 1852.[30]

By January 17, 1852, he was engrossed in *Walden* once more. On that day he wrote in his journal two items on visitors and a short paragraph on the date and manner of his moving to the hut, and he clearly intended to use them in his book.[31] Then in the journal for January 21 he wrote the draft of the battle of the ants which he was soon to add to "Brute Neighbors" in version IV; and more *Walden* material appears frequently in the journals of succeeding weeks and months.

Once Thoreau had taken up his work again, he wrote and rewrote and continually added to his book until he sent the final copy to the printer in 1854. There are four distinct groups of leaves in the manuscript marking four distinct stages of work (the lost copy for the printer was a fifth) between the beginning of 1852 and the late spring of 1854. The period during which Thoreau wrote each version can be determined by the dates of the journal material he used in it and by its relation to the versions preceding and following it, but we cannot tell exactly when he began or stopped working on any of them.

He wrote version IV at various times during 1852. He drew much of the new material for it from his journals for 1850, 1851, and the first half of 1852; there are also a few items from September, October, and November, 1852. He published two considerable pieces of this version in *Sartain's Magazine* of July, 1852: "A Poet Buys a Farm" and "The Iron Horse."[32] Late in 1852 or early in 1853 Thoreau dropped IV and fairly soon afterward began version V. In view of the extent of the new manuscript, Thoreau must have worked on V well into 1853, but it contains practically no material from the journals of 1853. Late in that year he began VI, and he probably did not complete it until the beginning of 1854. As he finished this version he wrote "The End," but he still had considerable work before him.

He undoubtedly wrote VII in February or March, immediately after finishing VI. The title page, table of contents, and preface in this version might suggest that its leaves were the remnants of a rewriting Thoreau prepared for the printer, but they were not. All the passages in VII are short, and Thoreau fitted them into the earlier groups, most into VI, but others into II, III, IV, and V.

His final draft, which is not in the manuscript and was apparently lost, was the copy for the printer. Thoreau must have sent off some of his copy in late February or early March, for he noted in his journal on March 28, 1854, "Got first proof of 'Walden.' " This referred to the first batch of page proof and not to a first set of proofs of the whole work. In the manuscript of VII, in the midst of a sentence in "Economy," 38, Thoreau noted, "end of 2nd proof"; and on page 64 of the page proof (HM 925) he wrote to the printer, "Will try to make the last part of the Ms. more legible." He sent the copy off in parts and received the page

proof in the same way.[33] He probably finished the copy for the printer in late April or May. He wrote of the breaking-up of the ice in 1854, "about the 7th of April," in "Spring," 3; and his observation on how long it took for Walden Pond to rise and fall in "The Ponds," 10, is from the journal entry for April 27, 1854; he first put it in *Walden* on a scrap of paper which he attached to a leaf of version VI.

Even when the copy for the printer was done, Thoreau could not rest. On March 31, 1854, he had written in the journal: "In criticising your writing, trust your fine instinct. There are many things which we come very near questioning, but do not question. When I have sent off my manuscripts to the printer, certain objectionable sentences or expressions are sure to obtrude themselves on my attention with force, though I had not consciously suspected them before. My critical instinct then at once breaks the ice and comes to the surface." The page proof allowed him one more opportunity to make a number of small changes for the published text.

And when it was too late for the benefit of others, he made a few corrections in his own copy of *Walden*.[34]

Notes

[1] *The Writings of Henry David Thoreau* (20 vols.; Boston: Houghton Mifflin Co., 1906), *Journal*, I, 398; entry is undated; whenever possible, journal entries are referred to by date. Unless otherwise indicated, all references to Thoreau's published writings are to this edition. [References to chapters of *Walden* are followed by a number indicating the paragraph of the chapter as it appears in the published version—Editors.]

[2] I, 485; entry is undated; it precedes by several pages an entry dated March 13, 1846. In slightly revised form it is the second paragraph of the first version. The reference is probably to his lecture on Carlyle, on February 4, 1846, at the Concord Lyceum; see Walter Harding, "A Checklist of Thoreau's Lectures," *Bulletin of the New York Public Library*, 52 (1948), 80.

[3] I, 395; entry is undated. The journal entry immediately preceding it is dated December 23, 1845, but many pages were torn out between the two entries. The first dated entry after the one quoted is for March 26, 1846; it is considerably farther on in the journal.

[4] See transcript of version I, "Economy," 36, 37, and 39, and the journal for July 12, 1840, February 5, and April 5, 1841. He did not use earlier journal items of April 8, 1839, and March 21, 1840, until later versions.

[5] HM 13182 in the Huntington Library; printed in *The First and Last Journeys of Thoreau*, ed. F. B. Sanborn (Boston: Bibliophile Society, 1905).

[6] See the transcript of version I, p. 122, and the manuscript journal, Vol. VII, in the Morgan Library, New York, N.Y.

[7]I, 395–96; entry is undated.

[8]Neither "an intermittent spring" nor "a gem . . . in her coronet" is in "The Ponds," 8, in version I; how much of paragraph 5 was in I is not certain because some of it was on a missing leaf.

[9]Volume VI of the manuscript journals in the Morgan Library.

[10]Compare *Journal*, I, 367–68, undated entry, and the transcript of version I, pp. 121–22.

[11]HM 924, on the verso of a leaf discarded from *A Week*.

[12]Harding, "A Checklist of Thoreau's Lectures," p. 80.

[13]See transcript of version I, pp. 153, 199, 200.

[14]On p. 209 of the 236 pages in the second sequence of Thoreau's numbering.

[15]*Henry David Thoreau*, p. 11.

[16]Counting separately the quotations from the Bible in "Economy," 47 and 48; and those (from Confucius?) in "Solitude," 7, 8, 9. Because of the leaves missing in the later part of the first version of *Walden*, it is not possible to tell what quotations were in it.

[17]In the first half of *Walden* he added quotations and specific references to authorities thus: he interlined two in version I; twelve in II; three in III; he wrote six in IV and interlined one; wrote three in V and interlined three; wrote six in VI and interlined one; wrote three in VII. Three quotations and references are not in the manuscript; either Thoreau added them in the copy for the printer, or they were on leaves missing from versions later than the first.

[18]*Familiar Letters*, p. 150; *The Maine Woods*, p. ix.

[19]Harding, "A Checklist," pp. 80–81.

[20]*Familiar Letters*, pp. 156, 172.

[21]Harding, "A Checklist," pp. 81–82.

[22]Thoreau made most of the revisions in version I before writing II and III, but he went over I at later times too; for example, he interlined material from the journal for November 3, 1852, in "Winter Animals," 3, in I.

[23]The nature of his additions, cancellations, and rearrangements of material from version to version makes it impossible to give descriptions of the contents of the various versions that would be accurate and at the same time clear.

[24]Thoreau thriftily thought of lectures even as he wrote versions II and III for publication; the manuscript of both versions has "book," "readers," etc.; but at several points it has "lecture" where version I had been revised to read "book." In version III in the first sentence of "Economy," 3, Thoreau wrote of his lecture in "this city" (later changed to "town"), probably Portland in March, 1849, or Worcester on April 20, 1849.

[25]*The Cost Books of Ticknor and Fields*, ed. W. S. Tryon and William Charvat (New York, 1949), p. 289; Canby, *Thoreau*, p. 248.

[26]*The Cost Books*, p. 289.

[27]*Ibid.*, p. 289.

[28]*Journal*, V, 521, see also p. 459.

[29]"Literary Economics and Literary History," *English Institute Essays, 1949* (New York: Columbia University Press, 1950), pp. 73–91.

[30]For example, see journal for November 8, 1850, and "House-Warming," 3 and 4. And such an item as "Economy," 31, on the Indian selling baskets, may

have been written up before 1852; it depends on undated journal material of 1850 (II, 84), and Thoreau wrote it out on a separate leaf for inclusion in *Walden*.

[31]"Visitors," 15; "Where I Lived," 8. On the same day he also wrote his comment on Madame Pfeiffer's clothes, "Economy," 35, and on January 11 he had written much of the passage on architecture, "Economy," 67, but he was not necessarily thinking of *Walden* as he put these two items in the journal.

[32]"Where I Lived," 1, 2, 3, and 5; and "Sounds," 5–13; Thoreau revised both passages before the final text of *Walden*.

[33]The page proof was the only proof he received; he could not have received anything before it. It was set up with three pages on a sheet. In the first batch of proof Thoreau received five sheets; the first sheet contained the title page and the copyright; each of the other four sheets contained three pages of proof. On the verso of the fifth sheet is written "duplicate proof for the editor." The second batch of proof consisted of four sheets—twelve pages—of proof. The end of the twenty-fourth page of text (the end of the ninth sheet of proof) coincides with the point in the manuscript at which Thoreau wrote "end of 2nd proof." On the verso of the ninth sheet is the direction "Henry D. Thoreau, Concord, Mass." There is no evidence as to the extent of later batches of proof.

[34]It is in the Abernethy Library, Middlebury College, Middlebury, Vermont. The corrections in it are given by Reginald L. Cook, "Thoreau's Annotations and Corrections in the First Edition of *Walden*," *Thoreau Society Bulletin*, 42 (1953), 1.

Scatology and Eschatology: The Heroic Dimensions of Thoreau's Wordplay

Michael West

I. THE INTELLECTUAL BACKGROUND OF WALDEN'S PUNS

. . . **E**arly in *Walden*'s chapter "Economy," while describing his self-appointed duties throughout the township, Thoreau remarks: "I have had an eye to the unfrequented nooks and corners of the farm; though . . . whether Jonas or Solomon worked in a particular field . . . was none of my business. I have watered the red huckleberry, the sand cherry and the nettle tree . . . which might have withered else in dry seasons."[1] No one seems to have noted precisely what Thoreau's insouciant claim to doing his "business" in lonely corners amounts to. Readers are reluctant to realize that he did not spend summers scurrying around with cupped hands to prevent cruelty to parched plants. He is playing on the reader's conception of him as a nature-loving crank, of course, while mischievously asserting that he has urinated widely in Concord. His discussion of shelter toward the end of the same chapter is similarly at the reader's expense: "As for a habitat, if I were not permitted still to

Reprinted from *PMLA*, 89 (October 1974), 1043–64. Abridgements are indicated by three ellipsis points within brackets. Some endnotes have been omitted and the remainder renumbered.

squat, I might purchase one acre [as cheaply as the land which I culti-
vated]. . . . But as it was, I considered that I enhanced the value of the
land by squatting on it" (p. 47). Very few readers catch the joke—that
Thoreau's privy, genteelly neglected in *Walden*'s account of his construc-
tion projects, was not always used, and that squatter's rites of any sort
served to manure and so improve Emerson's woodlot.[2]

In a fragmentary but stimulating discussion of Thoreauvian wordplay
as an attempt "to subvert the comfortable idioms that unite the com-
munities of finance capitalism or of the 'parlor,' " Richard Poirier has
sought to connect this stylistic device with the "excremental vision" he
finds in *Walden*.[3] Although this latter aspect of the book has received
some slight attention from Thoreau's ablest editor and biographer, the
issue has largely been avoided.[4] At stake is not merely a taste for occa-
sionally fanciful figurative language, such as the bizarre description in
"Winter Animals" of noisily icebound Walden as "my great bedfellow
. . . troubled with flatulency" (p. 206). This scatological metaphor is part
of a larger pattern of meanings in the book that calls for inspection. There
is, for instance, an obvious connection with Thoreau's complaint at the
end of "Higher Laws" that "we are so degraded that we cannot speak
simply of the necessary functions of human nature" (p. 168), where he
praises the Hindu lawgiver who "teaches how to eat, drink, cohabit, void
excrement and urine, and the like, elevating what is mean." But before
we conclude that these puns simply aim at undermining gentility, we
must ask why subversion should be so self-effacing, so willingly fore-
doomed. As Poirier remarks, "Thoreau's best jokes occur . . . precisely
where he sounds most harmless, most idiomatically familiar," and he
"was apparently willing to go to the grave without having anyone rec-
ognize" them (pp. 86–87). Although dirty jokes constitute only a small
proportion of Thoreau's covert wordplay, in what follows I hope to sug-
gest that they are central to our understanding of the man and his greatest
book.

II. Thoreau's Excremental Cosmology

Thoreau's scatological puns reflect more than a robust private sense of
humor, more than simple fear of Mrs. Grundy. Despite his nostalgia, he
is temperamentally estranged from those earlier Hindu ages "when every
function was reverently spoken of and regulated by law" (p. 168). He
agrees with the *Laws of Menu* in finding unclean "all excretions, that fall
from the body. . . . Oily exudations, seminal fluids, blood, dandruff, urine,
feces, earwax, nail parings, phlegm, tears, concretions on the eyes, and
sweat, are the twelve impurities of the human frame."[5] But lacking the

Hindu's assurance of the possibility of ritual purification, Thoreau remains haunted by a profound ambivalence toward the body and toward those excremental processes that he explicitly undertakes to defend in "Higher Laws." Unlike Whitman, whose phrenological ardor begat hymns to the body electric, Thoreau could not project a convincing vision of "the bowels sweet and clean."[6] Indeed, when he first visited Whitman in Brooklyn, nothing bothered him more than being received in Walt's bedroom while the chamber pot was still clearly visible beneath the bed—a fact that Thoreau's lengthy account of their meeting stresses with unusual exasperation. Although both the puns cited deal with excremental activity in an apparently beneficent natural context, fertilizing growth, Thoreau's instinct is still to conceal it.

By contrast, the triumphant conclusion of "Spring" depends precisely upon his assurance, prompted by the "dead horse in the hollow," that similar uncleanliness is purified through reabsorption into Nature in the larger process of rebirth: "We are cheered when we observe the vulture feeding on the carrion which disgusts and disheartens us and deriving health and strength from the repast. . . . The impression made on a wise man is that of universal innocence. Poison is not poisonous after all" (p. 240). Thoreau is reluctant to treat excrement similarly. The writer who could note in his Journal (8 Nov. 1858) that sunset "is pinkish, even like the old cow-droppings found in pastures," and then wryly add, "So universally does nature blush at last," was obviously not always inspired by a vision of "universal innocence." His references to manure in *Walden* all remain faintly pejorative.

We can begin to understand this by recalling that in "The Bean-Field" Thoreau quotes John Evelyn as an agricultural authority who disparages "all dungings and other sordid temperings" (p. 120) in raising crops. Similar ideas were held by William Alcott, Bronson's cousin, whose dietary ideals were current in Transcendental circles and whose advocacy of vegetarianism in *The Young House-Keeper* (1838) probably influenced Thoreau. In that book Alcott deplores watermelons "raised by the aid of the most offensive manures of which the imagination can well conceive" and warns that the effects of "strong fresh manures . . . according to the observations of Dr. Whitlaw and others, are very unfavorable. In some instances they render [vegetables] actually poisonous."[7] Such ideas lie behind Thoreau's repeated statement in "The Bean-Field" that he "did not give it any manure" (p. 118).

More important, they clarify the startling outburst in "The Ponds," where the purity of Walden is opposed to the comparative impurity of Flint's Pond. The latter's impurity is explained as a corruption derived from the avaricious and mean-spirited farming carried out on its shore—a notion that expands into this tirade:

Farmers are respectable and interesting to me in proportion as they are poor,—poor farmers. A model farm! where the house stands like a fungus in a muckheap, chambers for men, horses, oxen, and swine, cleansed and uncleansed, all contiguous to one another! Stocked with men! A great grease-spot, redolent of manures and buttermilk! Under a high state of cultivation, being manured with the hearts and brains of men! As if you were to raise your potatoes in the churchyard! Such is a model farm. (p. 149)

The exclamations and the lack of syntactic subordination suggest that this passage taps powerful feelings, but its imaginative and logical density is perhaps less readily apparent. Here, much as in Indian philosophy, we are invited to see most human beings locked into a vicious cycle of the senses. They have no comprehension of the means for escape or, indeed, of the need for escape. True transmigration of souls is not involved, but Thoreau does confront us with a similar vision of dead generations poisoning the living. More horribly still, the living poison themselves by consuming produce raised upon their own offal mingled with that of beasts. Their "high" state of cultivation is punningly viewed as putrescence. To slaughter the beasts is made part of the larger process of devouring death and is scarcely distinguishable from ingesting their manure. One result of both acts is, of course, man's imbrutement. But the most terrifying consequence, the ultimate horror, is that the living and the dead become virtually indistinguishable. Life, feeding upon its own waste, both physical and spiritual, becomes fungoid. Indeed, the word *fungus* itself reveals through its cognates how such parasitic life, always horrible for Thoreau, battens upon the bodily *functions* and the *defunct*.[8]

Here and elsewhere in Thoreau's work we are dealing with a homespun fecal cosmology created from his readings in agronomy and food faddism, from powerful anal drives, from his characteristic morbidity, and from the influence of those Hindu works he loved so well. For when he cut loose from traditional Christianity's emphasis on the transcendence of God and attempted to stress immanence, he was naturally bothered, like the Hindu, by the problem of contamination. His view of evil permitted no Emersonian serenity on this subject. How to preserve an immanent divinity from pollution is a recurring preoccupation in *Walden* and the journals, though it is often obscured by a more orthodox concern for augmenting the spiritual side of life. Perhaps the most completely articulated statement of this aspect of his excremental mythology is to be found in two lengthy Journal entries where these representative passages occur:

It is remarkable what a curse seems to attach to any place which has long been inhabited by man. . . . If, as here, an ancient cellar is uncovered, there springs up at once a crop of rank and noxious weeds, evidence of a certain

unwholesome fertility—by which perchance the earth relieves herself of the poisonous qualities which have been imparted to her. As if what was foul, baleful, grovelling, or obscene in the inhabitants had sunk into the earth and infected it. Certain qualities are there in excess in the soil, and the proper equilibrium will not be attained until after the sun and air have purified the spot. The very shade breeds saltpetre. Yet men value this kind of earth highly and will pay a price for it, as if it were as good a soil for virtue as for vice. (22 Sept. 1859)

Not only foul and poisonous weeds grow in our tracks, but our vileness and luxuriance make simple and wholesome plants rank and weed-like. All that I ever got a premium for was a monstrous squash, so coarse that nobody could eat it. "The evil that men do lives after them." The corn and potatoes produced by excessive manuring may be said to have, not only a coarse, but a poisonous quality. They are made food [for] hogs and oxen too. What creatures is the grain raised on the cornfield of Waterloo for, unless it be for such as prey on men? Who cuts the grass in the graveyard? I can detect the site of the shanties that have stood all along the rail-roads by the ranker vegetation. I do not go there for delicate wildflowers.

It is important, then, that we should air our lives from time to time by removals, and excursions into the fields and woods,—starve our vices. Do not sit so long over any cellar hole as to tempt your neighbor to bid for the privilege of digging saltpetre there.

So live that only the most beautiful wild-flowers will spring up where you have dwelt,—harebells, violets, and blue-eyed grass. (23 Sept. 1859)

The concept of human effluvia and exudations, nebulous in substance but inescapably physical to judge by their effects, is palliated somewhat in its ascetic harshness by a loose symbolic equation with man's moral vices and becomes a vehicle for rendering that familiar American myth, the curse conferred on an innocent continent by human society. We note the hallmarks of Thoreau's vision: dietary scrupulosity about the noxious effects of "excessive manuring," the morbidity that associates all offal with carrion, the veiled equations between excremental pollution and "what was . . . obscene" in former inhabitants, such as the quasi-sexual "vileness and luxuriance" (cf. Thoreau's punning objection to sexual impurity as "the *luxury* of affection," vi, 207). Finally, a corrupted Nature manifests a corresponding tendency to "relieve herself" in "unwhole-some fertility" by breeding saltpeter, that grotesque and lethal parody of healthy organic life.

In "Economy" Thoreau memorably criticizes ordinary houses as cof-fins, but the above passage suggests that an even more important con-ceptual model dominated his thinking about conventional New England architecture. As the injunction not to sit too "long over any cellar hole" hints, Thoreau could conceive of houses as basically outhouses. "Going by the shanty," he noted on 11 July 1851, "I smell the excrements of

its inhabitants." Roses in Concord front yards "do not atone for the sink and pigsty and cow-yard and jakes in the rear" (23 June 1852). Their dangerous miasma invites a "crusade" against "the great part of our troubles" which "are literally domestic and originate in the house" (26 April 1857). These ideas lend rather more probability to Poirier's seemingly implausible conjecture (p. 88) that when, in *Walden*, Thoreau punningly remarks, "What is a house but a *sedes*, a seat?—better if a country seat," the word *seat* includes the notion of a privy.

What is more important, these ideas provide the symbolic undergirding for one of *Walden*'s most beautifully achieved chapters, "Former Inhabitants; and Winter Visitors." In narrating the short and simple annals of the poor people who were his predecessors near the pond Thoreau manages, much like in Gray's "Elegy," to combine real tenderness with a complete lack of sentimentality. There is enormous pathos in the encounter with the revenant at Breed's hut, set in the desolate landscape, with its panorama of deserted cellar holes now slowly closing over. The erasure of these trivial domestic relics by Nature somehow lends them a momentary dignity that touches us profoundly. But Robert Frost, who perhaps better than anyone else has caught Thoreau's vision in this chapter, was right to epitomize such a scene in "Directive" with the cry, "Weep for what little things could make them glad."[9] There is tragedy in Thoreau's account of Cato Ingraham, Brister Freeman, Col. Quoil, and the rest, but it is the tragedy of stunted lives, and we are not allowed to forget that essential fact about the rude forefathers of the hamlet.

At one point Thoreau voices a musing wonder that commerce never throve here "where Wyman the potter squatted" (p. 198). But the question contains its own answer, for there is a principle of decay inherent in the nascent "stablebroom, matmaking . . . and pottery business" (p. 200). Thoreau himself, of course, deliberately rejected a doormat as a dirtcatcher (p. 49) and shunned the sustenance to which his histories of the former inhabitants frequently advert, from the witchlike Zilpha's pot of gurgling bones to Quoil's fondness for tobacco and liquor, more important to the Irishman than nearby Brister's spring, which he never bothered even to locate. "Alas! how little does the memory of these human inhabitants enhance the beauty of the landscape!" (p. 200). While despite the predominantly sterile soil, berries and the goldenrod grow "luxuriantly" (p. 195) around these cellar holes, profusions of Roman wormwood also spring up, together with that venomous family the sumachs, to exemplify the underlying theme of poison that only reaches articulate statement at the end of his meditation: "Deliver me from a city built on the site of a more ancient city, whose materials are ruins, whose gardens cemeteries. The soil is blanched and accursed there, and before that becomes necessary the earth itself will be destroyed" (p. 200). And

further to point the moral we are given the anecdote of "the vivacious lilac" by the door, playfully planted long ago by two innocent children "in the shadow of the house and daily watered," "blossoming as fair, and smelling as sweet, as in that first spring" (pp. 199–200). Thoreau's echo of his favorite lines by James Shirley completes the lesson, and reminds us that Christianity too had elements that lent themselves to his symbolic system: "Only the ashes of the just / Smell sweet and blossom in their dust."[10]

If Thoreau's excremental vision illuminates the apexes of his artistic achievement, it also leads him to the nadirs. There is perhaps no more unpleasant chapter in *Walden* than "Baker Farm." Not even "Higher Laws" exceeds it in unholy devotion to Spirit, and the consequences of this fanaticism seem more dangerous in "Baker Farm" insofar as they threaten other human beings, the Fields, and not simply Thoreau himself. The Yankee animus against philanthropy that provides Thoreau with some of his most brilliant and truthful pages in "Economy" functions well in the abstract, but this theme resists dramatic treatment. Poor John Field—that "hard-working, but shiftless man plainly" (p. 155), not lazy but not getting on—should have inspired more than the probable double pun by Thoreau for not wearing an undershirt. What may be a creditable revulsion from the charity of the welfare state as it seeks to embrace ourselves becomes less attractive when the state of ourselves and others is involved. The sight of the celibate Thoreau airily patronizing Field and his family in the name of philosophy, urging him to drop his job, change their diet, and go a-huckleberrying, is as unsettling and vaguely repellent as it would be to see Socrates persuading Phaedo and company to commit suicide.

However, Thoreau's attitude is explained if not palliated by the degree to which John Field is reduced to a merely symbolic entity. His last name is significant. Thoreau fails to see John Field in human terms because he is so determined to treat him as an allegorical John Farmer before his regeneration at the end of "Higher Laws." "Why should they eat their sixty acres, when man is condemned only to his peck of dirt?" Thoreau had inquired about farmers in "Economy" (p. 2). In his eyes Field becomes as dehumanized as his "too humanized" chickens—man and beast burdened with pecking at dirt because of the inability to transcend feeling peckish. Or, to cite another pun from "Economy," which Thoreau liked well enough to use twice (pp. 7, 47), the Irishman serves as an example of a life dedicated to "the grossest of groceries," for all the food in his diet, meticulously described—indeed, ultimately, all food—is viewed by Thoreau as *grossery* (cf. French *gros*, fat; *graisse*, grease), unctuously fattening and spiritually repugnant. This is especially true of Field, who "worked 'bogging' for a neighboring farmer, turning up the meadow

with a spade or bog hoe, at the rate of ten dollars an acre and the use of the land with manure" (p. 156).

To lure him from this life Thoreau opposes his own: "I did not use tea, nor coffee, nor butter, nor milk, nor fresh meat, and so did not have to work to get them; again, as I did not work hard, I did not have to eat hard," whereas when Field had worked hard to pay for his groceries, "he had to eat hard again to repair *the waste of his system*" (italics mine). This complex double pun implies that Thoreau regards Field's system of living as inefficient, destructive of his physical system, and ultimately dedicated simply to the replacement of his bodily wastes. When in the next breath he tells us that Field "wasted his life," we should sense not only the obvious meaning but a process where life is converted to excrement. His excessive daily requirements, from the dietary habits that make him happy to catch a "mess" of fish to the need for stout clothing and thick boots for his "poor bogtrotting feet," depend on the fact that "he worked so hard at bogging." The absence of quotation marks this time suggests that Thoreau may wish us to sense the obscene meaning of the verb *bog* common in the nineteenth century.[11] He views the Irishman as self-employed at defecation. Under the pressure of relentless punning on various forms of the word *bog*, repeated seven times in the account of the Irishman, bog-trotting John Field is symbolically assimilated to the boggy field in which he wallows. The bogtrotter becomes not only a clod but virtually an ambulatory turd (except that the word *trots* suggests diarrhea), the "culture" of whom, according to his Socratic interlocutor, requires "a sort of moral bog hoe" that Thoreau apparently did not possess.

He highlights his description of the Fields with a noteworthy display of punning pyrotechnics. A running exegesis of the multiple meanings in the passage is tedious but does suggest the extent of Thoreau's verbal skill, metaphoric vigor, and imaginative perversity:

John heaved [*breathed / dug up*] a sigh at this, and his wife stared with arms a-kimbo [*regarded me with hands on hips / regarded John without sharing his labor?*], and both appeared to be wondering if they had capital [*financial resources / heads*, from Latin *capita*] enough to begin such a course [*of action / of studies / of navigation*] with, or arithmetic [*bookkeeping skill / mathematics / reckoning*] enough to carry it through. It was sailing by dead reckoning [*strange navigational procedures / their dead minds*] to them, and they saw not clearly how to make their port so [*reach harbor / earn liquor?*]; therefore I suppose they still take life bravely [*bear up courageously / slaughter animals*], after their fashion [*in their way / as they see it / in pursuit of clothing*], face to face [*head on / facing each other across the table / confronting the ''too humanized'' stare of the chickens as they behead them?*], giving it tooth and nail [*fighting all out / tearing apart roasted chicken*

with fingernails and gnawing it / tooling it with sawteeth and hammered nails],
not having skill to split its massive columns [*military formations / pillars*]
with any fine entering wedge [*V-shaped body of troops / tool*], and rout it [*put
to flight / groove with a routing tool*] in detail [*squad by squad / with fine
handiwork*]—thinking to deal with it roughly, as one should handle a
thistle [*slight opposition / vegetable life (only)*]. But they fight at an
overwhelming disadvantage,—living, John Field, alas! without arithmetic
[*mathematics / reckoning (hence recklessly)*] and failing so [*flunking / going
bankrupt / declining physically*]. (p. 157) [. . .]

IV. ASCETIC HEROISM AGAINST DIRT, DISEASE, AND DEATH

Despite Thoreau's reputation as the patron saint of civil disobedience,
Walden's skeptical view of social reform is rather less congenial to his
modern disciples than many would like to imagine. Of course, it is nat-
ural enough that an author whose "pages are . . . particularly addressed
to poor students" (p. 1) should be somewhat ineptly interpreted, espe-
cially on campus barricades. Nonetheless, this is a pity, for his main
objection to charity—that "we should impart our courage, and not our
despair, our health and ease, and not our disease"—is founded upon
values of more persistent relevance than might at first appear to the
orthodox liberal imagination. Believing that "this sickly preaching of
love, and . . . sympathy . . . is the dyspepsia of the soul" (31 Dec. 1840),
Thoreau attacks all forms of softness as part of his larger effort to rean-
imate the heroic ethos of classical antiquity. No English writer since Mil-
ton and Pope has more assiduously sought to adapt the Greco-Roman
ideal of nobility to modern culture.

It was for making an analogous effort that Thoreau particularly valued
Carlyle; as he commented approvingly, all the Scotsman's works might
be summarized as one, "On Heroes, Hero-Worship, and the Heroic in
History." From his first effort at publication, "The Service: Qualities of
the Recruit," the essay that Margaret Fuller rejected for the *Dial* in 1840,
Thoreau sought to present a vision of life lived on heroic terms: "The
brave man is the elder son of creation who has stepped buoyantly into
his inheritance. . . . His bravery consists not so much in resolute action
as healthy and assured rest" (IV, 278). But this heroic morality differs
somewhat from that of those other nineteenth-century figures whom Eric
Bentley has christened Heroic Vitalists. Its fundamentally democratic
egalitarianism and individualism are opposed to Carlyle's and Nietzsche's
emphasis on charismatic leadership. The journals are full of Thoreau's
insistence that *every* man is potentially his own hero "without moving a
finger," his theater of action the circumstances of his daily life: "There
are in each the seeds of an heroic ardor, which need only to be stirred

in with the *soil where they lie,* by an inspired voice or pen, to bear fruit of a divine flavor" (13 July 1838).

To this vision his great book gives magnificent form, confronting life, daring to live it beyond daring, and so realizing the epic possibilities inherent in our ordinary existence. As Anderson remarks, the central plot of *Walden* embodies the archetypal myth of a hero's retreat from society, initiation, and triumphal return (*Magic Circle,* p. 261). Thoreau's reading of Mallet's *Northern Antiquities* taught him that the Scandinavian root of his surname, *thor,* probably signified *audacity,* and in both the Journal and *Cape Cod* he puns with whimsical delight upon the heroic Norse origins of his own identity. The man who can hoe beans heroically, in what becomes an act of symbolic fellowship with savage tribesmen of the past, or who can hail a mosquito as genuinely Homeric, has much to give an age with our fondness for almost any existential posturing, the more absurd the better.

At first sight, the ascetic strain in Thoreau strikes us as oddly discordant with his epic of the self. "Higher Laws" seems to confront us with an author whose response to a tureen of turtle soup or to a preserve pot is a nervous revulsion from "this slimy, beastly life, eating and drinking" (p. 166), an abhorrence that seems less courageous than eccentric and unhealthy. Thoreau himself was tempted to believe that "the hero . . . is the very opposite . . . of the ascetic."[12] But opposites meet. We should remember a fellow New Englander's penetrating defense of the ascetic impulse in religion as, at bottom, symbolic of "the belief that there is an element of real wrongness in this world, which is neither to be ignored nor evaded, but which must be squarely met and overcome by an appeal to the soul's heroic resources." The rather typical late Victorian coloration of William James's attitude toward "life as a tragic mystery" should not obscure this fundamental attitude that he shares with Thoreau:

> Mankind's common instinct for reality . . . has always held the world to be essentially a theatre for heroism. In heroism, we feel, life's supreme mystery is hidden. We tolerate no one who has no capacity whatever for it in any direction. On the other hand, no matter what a man's frailties otherwise may be, if he be willing to risk death, and still more if he suffer it heroically, in the service he has chosen, the fact consecrates him forever. Inferior to ourselves in this or that way, if yet we cling to life, and he is able "to fling it away like a flower" as caring nothing for it, we account him in the deepest way our born superior. Each of us in his own person feels that a high-hearted indifference to life would expiate all his shortcomings.
>
> The metaphysical mystery thus recognized by common sense, that he who feeds on death that feeds on men possesses life supereminently and

excellently, and meets best the secret demands of the universe, is the truth of which asceticism has been the faithful champion.[13]

As James can help us discern behind the faintly ridiculous ascetic the aspiring hero, so we may also come to understand just how literally Thoreau fed upon death. His symbology explains why all eating required of him in particular a truly heroic resolve. In his Journal for 9 April 1856, he described sitting by the sandbank in the railroad cut, where "I remarked how many old people died off at the approach of the present spring. It is said that when the sap begins to flow in the trees our diseases become more violent." The sap that supports life also saps and destroys it.[14] With dogged honesty his vision affirms the difficulty of distinguishing between the forces of life and death: "Is not disease the rule of existence? . . . Every shrub and tree has its gall . . . hardly to be distinguished from the fruit" (1 Sept. 1851). Forced to recognize that there could be beauty in "a disease, an excrescence" (1 June 1853), he was tempted to consider it "the prophecy of a *celestial* life" (3 Sept. 1851). His mind constantly revolved this theme in an effort to master its implications: "Man begins by quarreling with the animal in him, and the result is immediate disease" (3 Sept. 1851). Our aliments, as he puns in *Walden,* are our ailments (p. 81). Therefore, to live—when living is conceived of as the process of dying—always requires courage. And it required special courage of Thoreau. At the early age of twenty-four we find him musing thus in his Journal: "How much of my well-being, think you, depends on the condition of my lungs and stomach,—such cheap pieces of Nature as they, which, indeed, she is every day reproducing with prodigality. Is the arrow indeed fatal which rankles in the breast of the bird on the bough, in whose eye all this fair landscape is reflected, and whose voice still echoes through the wood?" (15 Dec. 1841).

Yes, the arrow was fatal, even for a romantic poet-naturalist seeking literary immortality through creative observation. Thoreau was too shrewd an observer not to connect his own bouts of "bronchitis" with the history of early death in his tubercular family. The Journal records his preoccupation with his health, his concern for whether relatives like his Uncle Charles Dunbar had strong lungs (VIII, 65), his interest in various unconventional remedies for phthisic. He shared the nineteenth century's fascination with the sinister epidemic that was believed responsible for nearly half of all adult deaths.[15] The medico Samuel Sheldon Fitch, who lectured throughout Massachusetts on the topic in the 1840's, describes with lurid accuracy the fear gripping those whose family background was consumptive: "No state of mind is more distressing than to live for years, from earliest recollection, in the constant apprehension and expectation of dying of pulmonary consumption. . . . This horrible phan-

tom, by night and by day, follows many. . . . All pleasures are marred by its horrid apparition. It haunts them in their dreams, and terrifies them in their waking hours. Never do they see a notice of death by consumption, than they experience a thrill of horror through every nerve; and a cough . . . and their minds are filled with the deepest distress and despair."[16]

To combat this inheritance Fitch counseled an ascetic regimen much like Thoreau's. As the offshoot of civilization consumption resulted, according to Fitch, chiefly from "effeminacy" (p. 38) and might be forestalled through plain living, avoidance of animal diet, daily walks, exercise, and regular cold bathing. Deliberate cheerfulness was a necessary strategy, for *"mental emotions . . .* incline to depress all . . . the system . . . in which the lungs must suffer" (p. 50). Dusty occupations (like the Thoreau family pencil factory) were especially proscribed. But most important of all, those predisposed by heredity to tuberculosis should especially beware "the BAD EFFECTS OF COSTIVENESS" (p. 291). Together with the lungs, kidneys, and sweat glands, the bowels purge the body of excrementitious poisons. When constipation interrupts this function, an extra burden devolves upon the lungs. Thus, the potential consumptive must wear light clothing to facilitate perspiration, maintain a "free flow of urine" (p. 59), and, above all, avoid costive dyspepsia, since in "the commencement of disease of the lungs, costiveness is almost always present" (p. 282). Nothing should ever discourage one from obeying a call of nature immediately, so as part of his campaign against tuberculosis Fitch calls for the construction of more comfortable outhouses (p. 287).

Such ideas were widely diffused. Patent medicines like Brandreth's Pills filled the newspapers with clamorous advertising tracing consumption (and most other human ills) to constipation. Considering the nineteenth-century mystique surrounding tuberculosis, it is understandable that digestion should haunt Thoreau, that he should hate food and try to avoid *consumption* by stringently limiting his nutritional intake. After all, precisely such a theoretical prophylaxis for lung disease is implicit in the analogy between fire and the vital heat, which he picked up from Liebig and develops early in "Economy": "Man's body is a stove, and food the fuel which keeps up the internal combustion in the lungs. . . . The animal heat is the result of a slow combustion, and disease and death take place when this is too rapid" (p. 8). Indeed, a superstition first recorded in Pliny's *Natural History* suggests that the same reason may underlie Thoreau's aversion to human contact. According to the Roman writer, "there are a sort of people . . . whose sweat if it chance to touch a man's body, presently he falleth into a phthisic or consumption of the lungs," a contagiousness that he goes on to link with a habit of feeding "upon the bowels and flesh."[17] Thus, the proprietor of a sanatorium for

consumptives in nearby Lexington was convinced that tuberculosis resulted from "effete and poisonous matter" exuded by the skin and allowed to remain there; he cautioned persons predisposed to phthisic to avoid contact with other consumptives, who comprised nearly half the adult population. Well might Thoreau insist in *Walden*'s "Solitude" that "the value of a man is not in his skin, that we should touch him" (p. 102).

We must understand such feelings to appreciate properly the grand description of the thawing sandbank that is the focal symbol of *Walden*'s "Spring." To be sure, the passage can be partially explained as a rather conventional vision of evolution and rebirth, in which such social excrescences as the railroad are suddenly revealed as transient modes through which Nature fulfills herself. Or we may regard it less congenially as a metaphor of the spirit sluicing away the body in order to percolate through the universe in a wild realization of the American dream of freedom. But such encapsulation neglects Thoreau's insistence that the hillside illustrated "*all* the operations of Nature" (italics mine). If the slope is "the creation of an hour" by "the Artist who made the world and me," this Artist occupies no studio, but a scientific "laboratory." The energy that manifests itself in "fresh designs" creates, yes, but in a charnel house where "the forms of sappy leaves or vines . . . of pulpy sprays . . . of some lichens . . . of coral, leopards' paws or birds' feet, of brain or lungs or bowels, and excrements of all kinds" are indiscriminately strewn about. As he confronts his own decadent lungs mirrored in the sand, Thoreau faces and accepts the harsh truth that freedom from the body's excrement will involve more than a "purgative" for "winter fumes and indigestions": to be free is to be disemboweled. The "excrementitious" phenomenon may make him pun wryly "that Nature has some bowels, and there again is mother of humanity" (pp. 231–33), but simultaneously another pun forces upon us a bleaker vision of human nature, the Augustinian *inter urinas et faeces nascimur*. As Perry Miller points out, Thoreau's vision of vernal rebirth is triggered by a scene that is actually destined to sandy sterility (*Consciousness*, pp. 126–27).

One might argue that the rigor of Thoreau's view is palliated by the promise of immortality. Although, as one scholar asserts, "Thoreau never articulated a complete eschatology," the passage does show him groping for an eternal principle.[18] Kraitsir and Whiter encouraged him to conceive of language as the mode of man's immortality—hence the philological comparisons (borrowed mainly from Kraitsir) that stud the description of the flowing sand. The pulpy heaps of discarded organs are joints and appendages that an essentially linguistic *weltgeist* may outgrow as it presses ever forward in an attempt to *articulate* itself more satisfactorily. Inverting the Transcendental dictum that language is fossil poetry,

Thoreau here envisions earth as poetry and fossils as incipient language. Like an outmoded grammar, the human body may eventually be superseded by purer spiritual forms. But, for any comfort afforded by such immortality Thoreau unflinchingly pays the full price: the forfeiture of all human individuality, terrifyingly suggested when he imagines the dissolving face of thawing clay, and the frank admission that compared to earth's great central life, "all animal and vegetable life is merely parasitic." These are staggering concessions from his major ideals, and they cost Thoreau dearly. Thus, even in the serenity of his deathbed flirtations with a fairer world, he contemplated with horrified fascination "the wasting away of his body, the going forth of his lungs . . . to Henry an inexplicably foreign event," according to his companion Ellery Channing. And when "words could no longer express these inexplicable conditions of his existence," there was "that dream he had of being a railroad cut, where they were digging through and laying down the rails—the place being in his lungs."[19]

V. HEROIC LANGUAGE GAMES: ART AND THE PLAY OF LIFE

Thoreau has been tasked by some critics with a tendency to evade the fact of death by turning it into a joke.[20] He clearly anticipated this charge when he claimed that "a great cheerfulness indeed have all great wits and heroes possessed, almost a profane levity to such as understand them not" (15 March 1841). The most sublime bravery conceivable, he felt, would show itself chiefly in "its abundant cheerfulness . . . and its infinite humor and wantonness" (27 July 1840). He believed, indeed, that "the most serious events have their ludicrous aspect, such as death; but we cannot excuse ourselves when we have taken this view of them only" (19 March 1858). Surely, to understand the thawing sandbank in its proper symbolic dimensions is to exonerate him from mere frivolity. What is the passage but an unblinking vision of the interdependence of life and death, hard-earned in human terms and completely achieved artistically?

True, some of the wordplay that we have been examining seems evasive. We might be tempted to adapt Thoreau's statement in "Higher Laws" and interpret such wordplay as a bid for absolution by secret confession, as a way of flaunting before an audience whose approval he was prepared neither to forgo nor to accept, feelings of sufficient ambivalence to be embarrassing: "I hesitate to say these things, but it is not because of the subject—I care not how obscene my *words* are—but because I cannot speak of them without betraying my impurity" (p. 168). As another episode dramatizing the return of the repressed in nineteenth-

century literature, the puns would then embody a mild obsessiveness like the covert and claustrophobic sexual allegory in Melville's "The Tartarus of Maids," or the tired jocularity of Twain's long-suppressed scatological sketch *1601*.

But Thoreau's excremental wordplay is neither primarily evasive nor primarily subversive. It is in the radical sense *elusive*. As he himself hinted, "You will pardon some obscurities, for there are more secrets in my trade than most men's, and yet not voluntarily kept, but inseparable from its very nature" (p. 11). *Walden* wages war against "the brain-rot, which prevails so . . . widely and fatally," by teasing us with obscurity while inviting us to fathom verbal and conceptual riddles (p. 246). Hence, the book's style relies so heavily upon paradox and covert wordplay, explanation of which would frustrate the aim of exercising the audience's mind. The unnoticed puns demonstrate that it is not Thoreau but his readers who duck the realities of life and death. And this defective sensibility underlying our "lives of quiet desperation" Thoreau, drawing upon Trench's etymological discussion of *amusement*, would relate directly to our stunted capacity for real fun: "A stereotyped but unconscious despair is concealed even under what are called the games and amusements of mankind. There is no play in them, for this comes after work" (p. 5)—as the *play* in a rope comes from its *working*.[21]

If the major theme of *Walden* is our need for rebirth, its natural corollary is the importance of genuine *re-creation*. "The child plays continually, if you will let it, and all its life is a sort of practical humor of a very pure kind, often of so fine and ethereal a nature, that its parents, its uncles and cousins, can in no way participate, but must stand aloof in silent admiration, and reverence even" (IV, 335). Although Concord's incomprehension of Thoreau more often manifested itself in scorn than in reverence, he could nonetheless insist, "I can see nothing so proper and holy as unrelaxed play and frolic in this bower God has built for us" (29 Dec. 1841). The best portal to "true wisdom" is "childlike mirthfulness," he felt: "If you would know aught, be gay before it" (23 June 1840). Not obsessive but fundamentally liberating, his wordplay is just that, *play*, the stylistic expression cultivated by a spirit that learned to cope with its isolation by imitating (albeit mainly in the medium of language) the flight of that supremely contented hawk who appears soaring over the marsh at the end of *Walden*, proudly "sporting there alone" in a gay war with gravity, repeatedly feigning descent to the swamp with "its free and beautiful fall," and accompanying all its feints with a "strange chuckle" (pp. 238–39). That Thoreau experienced this magnificent epiphany while standing uncertainly on "quaking" boggy ground watching a male marsh hawk play with itself, has no little relevance to the symbolic structure of the book. His more morbid puns reflect the playful

mentality of the Demiurge in the railroad cut, who, while "sporting on the bank," could sacrifice "myriads . . . of tender organizations" to be "serenely squashed out of existence like pulp" (pp. 231, 240).

First and foremost a reflection of his temperament, Thoreau's philosophy of play is also a pastiche of various thinkers, like Trench, whom he absorbed into the final version of *Walden*. He may have noted with pleasure that one of the myths of Hindu cosmology assumes that nothing could motivate an all-sufficient divinity to create the world—except sport. Indeed, Jonathan Edwards had brought American Puritanism to the verge of such a conclusion.[22] Significantly, when Thoreau coyly alludes to the Deity as "an old settler and original proprietor, who is reported to have dug Walden Pond," he calls him a "humorous friend" and stresses the "social mirth" of his occasional visits (p. 103). His conception of God is not unlike the myth of Vishnu playing hide-and-seek with himself by entering into the roles of his creatures. The concept of life as a game was also stressed by Victor Cousin, whose *History of Philosophy* Thoreau read in the Harvard College Library. With his dilute Hegelianism Cousin, who enjoyed a considerable vogue in Transcendental circles, was given to obiter dicta like, "History is a game in which all are losers, except humanity; which gains by all,—by the discomfiture of one, as by the victory of another."[23] Like Schiller's seminal concept of the *Spieltrieb*, Friedrich Schlegel's version of Fichtean idealism put the same central metaphor to esthetic purposes in emphasizing that "all holy plays of art are only distant imitations of the infinite play of the world, of the eternally self-creating work of art."[24] In *Work and Play*, his Harvard Phi Beta Kappa address of 1848, Horace Bushnell domesticated many of these ideas, equating purity, courage, and freedom with fundamentally sportive propensities and arguing that man is "a creature of play, essentially a poet in that which constitutes his higher life."[25] Emerson, who could likewise relish "intellectual play" as a kind of cerebral "football," was inspired by this address to bracket its author with Thoreau as representatives of a new spirit in American literature.[26]

All these intellectual currents contribute to Thoreau's famous description in *Walden*'s "Solitude" of being "either the driftwood in the stream, or Indra in the sky looking down at it." The passage's central metaphor is the theater. The self is "the scene, so to speak, of certain thoughts and affections," and while it *"may* be affected by a theatrical exhibition," on the other hand it *"may not* be affected by an actual event," but rather stand apart from it as a spectator-critic: "When the play, it may be the tragedy of life is over, the spectator goes his way" (p. 101). Considering the play element in drama, Bushnell had articulated a similar attitude: "We love to see life in its feeling and activity, separated from its labors and historic results. Could we see all human changes transpire poetically

or creatively, that is, in play, letting our soul play with them as they pass, then it were only poetry to live. Then to admire, love, laugh; then to abhor, pity, weep,—all alike were grateful to us" (*Work and Play*, p. 22). Thoreau's wordplay is an attempt to render stylistically this sense of life as detached drama. To pun, in "Solitude," about being "beside ourselves in a sane sense" with thinking, is indeed to enact verbally "that certain doubleness by which I can stand as remote from myself as from another" (p. 101).

But we cannot fully understand the significance of play for Thoreau without some familiarity with the book that he acknowledged as an artistic precursor of *Walden*, James John Garth Wilkinson's *The Human Body and Its Connection with Man, Illustrated by the Principal Organs* (Philadelphia, 1851). Although, while revising *Walden*, Thoreau declared that "Wilkinson's book to some extent realizes what I have dreamed of" (5 Sept. 1851), its importance as an influence upon his thought seems to have been overlooked. [. . .]

Subdividing the body into five spheres—brain, lungs, digestive organs, heart, and skin—Wilkinson pays nominal tribute to the brain as the apex of human development, but his most ardent affection is reserved for the lungs: "That which is the secret of the brains is the open lesson of the lungs. . . . The brains give us the free principles of life, and the lungs, its free play in nature. It is this idea of *the play of life* which is the principal point in our just knowledge of the lungs" (p. 83). [. . .] According to Wilkinson, the lungs "introduce . . . transcendent representation, and the moral virtues that inhabit this order of intelligence commune with the organs through their means. . . . They emancipate the mind . . . from the stimulus of the passions" (p. 117). By exhaling carbonic acid they dispose of the "excrements of the blood" (p. 88), which may receive injuries from "the passions of the mind" (p. 90). Elaborations upon the midcentury medical lore surrounding tuberculosis, these doctrines remain among the murkier tenets of Wilkinson's physiology. But in general we may say that emotion occupies no very high place in his scheme of things. Like Thoreau, he particularly connects feeling with the bowels: "The piteous and sentimental . . . act upon our intestine tenderness" (p. 233), and "women especially have such experiences" (p. 226). Not that the intestinal tube is without value: "It stands at the bottom, or it could not have the poor and needy for its objects" (p. 227). Nonetheless, we may feel that the quality of mercy is somewhat strained by the rectum. It is difficult to escape his implication that most passions, emotions, and feelings are better eliminated, according to what he elsewhere terms "the prime law of excrementitious rejection," a subject that requires another volume to exhibit "its rationale in our Saviour's casting out of the devils" (p. 154). On a higher level, the lungs apparently per-

form this function for the heart, an inferior organ that is insulated from "the immediate play of the mind" (pp. 173–74).

As Thoreau was quick to note, Wilkinson firmly believed that "it is good to look to the ordinary language of mankind, not only for the attestation of natural truths, but for their suggestion." The primary role of the lungs is confirmed by the fact that "most of the words expressive of life, are borrowed by analogy, either from the atmosphere, or its organ the lungs" (p. 127). He notes that the words *animal* and *animation*, the Latin *anima*, soul, and *animus*, mind, all derive etymologically from a root meaning *breath*; likewise, our *inspirations* and *aspirations* have made us *spirits*, ever since "the breath of life . . . was breathed into the nostrils of our first parents, and man became a living soul." He thus concludes that "life cannot be imaged save in words borrowed from the lungs and their august ministration" (p. 128). Particular importance attaches to the following linguistic fact: "The vulgar call the lungs *lights*, and so they are; for the belly gives us gravity and links us to the ground, but the lungs give us levity, and lift us towards the air" (p. 126). Common speech thus reminds us of their peculiar role in purging the emotions and gaily fostering *the play of life*. Everywhere in the body "the pulmonic levity . . . operates statically upon the fluids," playfully aerating our humors, and "this levity-giving is an intermediate function . . . of the lungs" (p. 95).

In *The Friend* Coleridge had echoed German idealism by calling "mythology the apex and complement of all genuine physiology."[27] Wilkinson's book encouraged Thoreau to develop a similar view: "The poet writes the history of his body" (29 Sept. 1851). During 1852 when he undertook his major revision of the manuscript that became *Walden*, he was pondering Wilkinson's ideas about the lungs. The Journal shows that his own uncertain health was also much on his mind. Comparison with the earlier versions suggests that most of the puns entered *Walden* at this time. As one might expect, they are an essentially reflexive product of the unusually long process of composition, expansion, and revision to which the book was subjected. And it seems probable that on some level we should interpret them as Thoreau's remedy for the vital principle of levity imperiled in his failing lungs. Wordplay is an effort to help that faltering organ sustain "the play of life" in Wilkinsonian terms. Likewise, the trancelike states of mind that Thoreau describes in "Solitude" may have therapeutic significance; for, like Whiter, Wilkinson believed that "in these conditions of suspended animation the chemical laws do not persist, but like the rest are *suspended*. . . . The tissues, particles and fluids, and the wind in the lungs, are entranced; the body is absent from chemical corrosions" (p. 116).

At first it may seem odd that Thoreau was not more explicit about these efforts at self-therapy. Why does he journalize constantly about his

health without ever asking himself directly, "Do I have consumption?" But, of course, such defenses are common among consumptives. We may be reminded of Madame de Malivert in Stendhal's *Armance,* who worries constantly about her son but carefully avoids mentioning the word *phthisis* lest it hasten his disease. Believing that "but for fear, death itself is an impossibility" (VI, 408), Thoreau, too, had good reason to avoid naming his dread. Indeed, he justified this defense in terms of his esthetic theory. Carlyle's tough and brawny humor embodied the vigor of an old Norse hero, Thoreau felt, but a grotesque and ailing one; for its obviousness and straining after effect only dramatized the difficulty of his conflict. In contrast, Thoreau formulated what amounts to a prescription for triumphantly self-occluding wit: "The poet will maintain serenity in spite of all disappointments. He is expected to preserve an unconcerned and healthy outlook over the world, while he lives. . . . For that other, *Oratoris est celare artem,* we might read *Herois est celare pugnam,*—the hero will conceal his struggles" (IV, 344). And conceal them the deft words do. No wonder that sometimes this hero seemed to himself more like a spineless squid writhing hidden behind his own ink: "Like cuttlefish we conceal ourselves, we darken the atmosphere in which we move; we are not transparent" (24 Aug. 1852).

Behind other compulsive punsters of the nineteenth century we can detect similar configurations of feeling. The wordplay of Oliver Wendell Holmes was a relief from the strains of the medical profession, and he himself pointed the connection by defining the pun as verbicide and equating *man's laughter* with *manslaughter.* In the bleak fall of 1820 the same impulse moved the dying Keats, who reported that he "summoned up more puns, in a sort of desperation, in one week than in any year of my life."[28] The painful spasms of gout that confined James Russell Lowell intermittently to his bed also stimulated his propensity for wordplay, allowing him to explain in one pun-filled letter that the disease was so named because the sufferer could not *go out.*[29] The English master punster Thomas Hood, a self-diagnosed consumptive, wisecracked sardonically about himself that "no gentleman alive has written so much Comic and spitten so much blood."[30] Physical misfortune or infirmity is the staple theme of his humor, in a way that suggests to one critic "morbid self-involvement," and the coruscating wordplay seems to express obliquely "a terror of mortality, and in its very frequency an unhealthy fascination with sickness."[31] Racked with diseases real and fancied, Nietzsche made Zarathustra pun indefatigably against his arch-foe, "the Spirit of gravity." Zarathustra's wordplay is the linguistic counterpart of the ecstatic dance of life that he envisions: "Whoever climbs the highest mountains laughs at all tragic plays and tragic seriousness." Yet the vitality of this stylistic habit is undercut by Nietzsche's conviction that "the characteristic of all

literary décadence . . . is that life no longer resides in the whole. The word gets the upper hand and jumps out of the sentence."[32]

As Eric Bentley has suggested, many Heroic Vitalists like Nietzsche were weak or sickly authors reacting against their own pronounced physical malaise. Decadence haunted them from within. Thus Carlyle compensated for his dyspeptic impotence by juggling words humorously while dreaming of great men. Not so much a creed as a faith rooted in despair, no two of its exponents represent exactly the same complex of attitudes. But though Heroic Vitalism is more easily exemplified than described, we can point to certain characteristics that recur often in such hero-worshipers as Carlyle and Nietzsche, Wagner and Spengler, Lawrence and Shaw, George and Yeats. Estranged from his lower-class or petty bourgeois origins, the Heroic Vitalist feels divided against himself, a fact that he sometimes elaborates into a doctrine of double personality. This split is augmented by an apparent dichotomy in his perceived world. He hungers to embrace the world in its totality, but would rather accept its differences than sacrifice any for metaphysical unity. Balked of a conventional religious belief, he borrows orthodox tropes and attempts to elaborate a new mythology from evolutionary Nature. The abstract pieties of an egalitarian and commercially minded liberalism, passionless except for its greed and fear of genuine excellence, strike him not only as contemptible but as historically and psychologically naïve. Instead, he cultivates an aristocratic radicalism. Facing up to the concrete realities of the body and brute fact, eventually he learns almost to relish their tyranny. He is something of a misogynist, and his watchword remains courage rather than compassion. Despite a reverence for men of action, he views history and politics fundamentally as esthetic performances. His sense of time is cyclical in the extreme. Obsessed with diurnal and seasonal metaphors, the Heroic Vitalist worships the sun, hails the twilight of the gods as prophesying a new dawn in human affairs, and yearns to be reborn in the spring like a phoenix. Often such rebirth is spasmodic, and evolution seems saltatory rather than regular. Sometimes this temporal flux is too much and he longs for escape, either by moments of mystic insight into eternity or by recourse to some jerry-built doctrine of immortality.

In the pragmatism of William James many positive features of Heroic Vitalism are fused with democratic ideology, and much the same may be said for Thoreau. But if the prophet of "Civil Disobedience" appears, in the twentieth century, mainly to have influenced Gandhi and Martin Luther King, similar premises made many Heroic Vitalists especially congenial to fascists. Joel Porte has justly noted some features that align Thoreau's estheticism with that of Walter Pater (*Emerson and Thoreau*, p. 176), and perhaps it behooves us to pay more attention to a strain of

decadence in Thoreau. "Is not Art itself a gall?" he inquired, while cherishing the lovely disease nonetheless (4 Sept. 1854). If he finally preferred the art of life to the life of art, he did so as a Yankee Doodle Dandy, the Poe of New England, a provincial American version of such figures as Stevenson and Wilde, Flaubert and Huysman. As Emerson wisely observed in his obituary tribute, though Thoreau scoffed at conventional elegance "he had many elegancies of his own."[33] While at times Emerson's young friend reminded him of the Aristotelian superman, in other contexts he shrewdly noted an odd resemblance to Beau Brummel. Fastidiously cultivating his senses, Thoreau could not abide the grit of gravel beneath his feet when walking; on evening strolls his nostrils picked up the odor of every dwelling-house, tainting the night air like an abattoir. Indeed, the flowers of evil that Baudelaire plucked from Parisian bordellos Thoreau found growing in Concord's swamps. The fungus known as Devil's Phallus was only one of many that fascinated him. Poison dogwood was "beautiful as Satan" (21 Dec. 1851). Wading in bogholes to contemplate its lurid berries Thoreau could feel a "certain excitement" (6 Jan. 1858) like the Baudelairean *frisson* of evil, the esthete's ultimate sensation. The pond lily became his central emblem of ethereal loveliness rooted in muck. Yet, from another angle, this icon of triumphant purity appears curiously like the Divine Artist's floral portrait of Dorian Gray.

This connoisseur of katydids possessed a side that has been obscured by his own legend. In making Thoreau into the prophet required of American adolescents, hagiography and political partisanship have done him a disservice. By ignoring his weaknesses we do violence to what is strongest in the man, forgetting what he himself finely said: "Every judgment and action of a man qualifies every other, i.e., corrects our estimate of every other. . . . For in this sense a man is awfully consistent, above his own consciousness. All a man's strength and all a man's weakness go to make up the authority of any particular opinion which he may utter. He is strong and weak with all his strength and weakness combined. If he is your friend, you may have to consider that he loves you, but perchance he also loves gingerbread" (16 Feb. 1854).

How then shall we consider Thoreau's wordplay? Not merely as an American's attempt to nationalize the language, not merely as an individual's attempt to transcend collective language, not merely as an unhealthy attempt to flee from life to language—though there is truth in all these interpretations. Certainly, the punster is the same man who described his "peculiar love" for Ellen Sewall as a form of "sober play," teasing his feelings out into sentimental verse; who journalized apropos of Mary Russell, "It is not easy to find one brave enough to play the game of love."[34] But the frustrated dandy who yearned for "a better opportunity to play life" (26 Oct. 1855) also wrote in his great book that

we "should not *play* life, or *study* it merely, while the community supports
. . . this expensive game, but earnestly *live* it from beginning to end" (p.
37). In the *Laws,* Plato punningly endorses a complex interplay between
gaiety and seriousness, in a seminal passage that helps to illuminate
Thoreau's own stance:

> I say that a man must be serious with the serious. God alone is worthy of
> supreme seriousness, but man is made God's plaything, and that is the best
> part of him. Therefore every man and woman should live life accordingly,
> and play the noblest games and be of another mind from what they are at
> present. . . . For they deem war a serious thing, though in war there is
> neither play nor culture worthy the name. [Out' oun paidia . . . out' au
> paideia], which are the things *we* deem most serious. Hence all must live in
> peace as well as they possibly can. What, then, is the right way of living?
> Life must be lived as play, playing certain games, making sacrifices, singing
> and dancing, and then a man will be able to propitiate the gods, and
> defend himself against his enemies, and win in the contest.

Yeats like Thoreau began as an esthete, and his poem "Lapis Lazuli"
stems like *Walden* from a concern for the heroic individual, for the artifact
of a shaped self, and for the value of art as ritual. The old Chinamen it
describes, who stare with Oriental delight "on all the tragic scene," might
serve as a symbol of the identity that Thoreau strove to forge for himself
through wordplay. His scatological jokes are the quintessential embodi-
ment in style of a life lived at its best and worst moments (though not
always) as a heroic game, as in Yeats's intense conviction that "Hamlet
and Lear are gay, / Gaiety transfiguring all that dread."[35] To a degree
paralleled in English only by Shakespeare, Milton, and Joyce, he made
the pun a vehicle for literary genius. As Mark Van Doren long ago wisely
remarked, Thoreau "will come fully into his own when there is no one
left who takes him literally and recommends his audacity as either pro-
found or ultimate."[36] That day, however, is still distant.

Notes

[1]*The Variorum Walden,* ed. Walter Harding (New York: Washington Square
Press, 1963), p. 12. Other works are cited by volume and page from *The Writings
of Henry David Thoreau,* ed. Bradford Torrey, 20 vols. (Boston: Houghton, 1906).
Subsequent references to Thoreau's Journal are by date of entry in this edition,
except for entries in the "lost" journal of 1840–41, ed. Perry Miller as *Conscious-
ness in Concord* (Cambridge: Harvard Univ. Press, 1958). [Editors]

[2]Noted by Allen Beecher Hovey, *The Hidden Thoreau* (Beirut: Catholic Press,
1966), p. 124.

[3]*A World Elsewhere: The Place of Style in American Literature* (New York: Oxford Univ. Press, 1966), pp. 85, 88. Such excrescences as footnotes can scarcely discharge the fundamental debt I owe both to this seminal book and to study with Poirier, although substantial differences of opinion and emphasis will become evident in the course of my argument. See also Stanley Cavell, *The Senses of Walden* (New York: Viking, 1972), for a suggestive but rather less persuasive account of Thoreau's punning.

[4]Walter Harding makes anality the subject of a laconic and gingerly annotation in the *Variorum Walden*, p. 315. But although, in *A Thoreau Handbook* (New York: New York Univ. Press, 1959), pp. 26–27, Harding approvingly summarizes some possible psychological interpretations as "problems that all serious future biographers of Thoreau must at least consider, if only to refute," in his fine *The Days of Henry Thoreau: A Biography* (New York: Knopf, 1965; hereafter cited as *Days*), the dean of Thoreauvian studies quite ignores this Freudian concept, first applied to Thoreau by Raymond Dante Gozzi, "Tropes and Figures: A Psychological Study of David Henry Thoreau," Diss. New York Univ. 1957. Gozzi reports inter alia that when Thoreau's description of the thawing sandbank was shown anonymously to two trained Rohrschach analysts, each classified its author as *anal-aggressive* (p. 117).

[5]Cited by Charles R. Anderson, *The Magic Circle of Walden* (New York: Holt, 1968), p. 166.

[6]*Leaves of Grass*, ed. Emory Holloway (New York: Book League, 1942), p. 86. See Arthur Wrobel, "Whitman and the Phrenologists: The Divine Body and the Sensitive Soul," *PMLA*, 89 (1974), 17–23.

[7]Cited by Joseph Jones, "Transcendental Grocery Bills: Thoreau's *Walden* and Some Aspects of American Vegetarianism," *University of Texas Studies in English*, 36 (1957), 146, and see Jones throughout.

[8]On Thoreau's attitude toward fungi and death, see esp. Joel Porte, *Emerson and Thoreau: Transcendentalists in Conflict* (Middletown: Wesleyan Univ. Press, 1965), pp. 181–90; also Perry Miller, *Consciousness*, pp. 55–79.

[9]*Complete Poems* (New York: Holt, 1949), p. 521.

[10]Thoreau transcribed these lines from Percy's *Reliques* into his poetical copybook, now in the Library of Congress, in 1842. See Ann Whaling, "Studies in Thoreau's Reading of English Poetry and Prose, 1340–1660," Diss. Yale 1946, pp. 101–02.

[11]See the *N.E.D.* s.v., and cf. the terms *boggard* and *boghouse*. For a similar exegesis of Thoreau's themes in this chapter see *Magic Circle*, pp. 131–43.

[12]*Sir Walter Raleigh*, ed. Henry A. Metcalf (Boston: Bibliophile Society, 1905), p. 86.

[13]James, *The Varieties of Religious Experience*, ed. Joseph Ratner (New York: University Books, 1963), pp. 363–64; the heroic character of James's own ethics emerges most prominently from his essay "The Moral Equivalent of War."

[14]See esp. *Magic Circle*, pp. 252–57; also Stephen Railton, "Thoreau's 'Resurrection of Virtue,' " *American Quarterly*, 24 (1972), 210–27.

[15]See Lawrence Willson, "Thoreau's Medical Vagaries," *Journal of the History of Medicine and Allied Sciences*, 15 (1960), 64–74; René Dubos and Jean Dubos,

The White Plague: Tuberculosis, Man, and Society (Boston: Little, 1952), esp. pp. 39–63.

[16]*Six Lectures on the Uses of the Lungs; and Causes, Prevention, and Cure of Pulmonary Consumption* (New York: Carlisle, 1847), p. 76. During Thoreau's life this best seller by a popular home medical authority went through some 40 editions, and at the century's end it was still selling.

[17]*Pliny's Natural History*, trans. Philemon Holland, ed. Paul Turner (Carbondale: Southern Illinois Univ. Press, 1962), p. 75.

[18]Arthur Christy, *The Orient in American Transcendentalism* (New York: Columbia Univ. Press, 1932), p. 214.

[19]Channing, *Thoreau: The Poet-Naturalist* (Boston: Roberts, 1873), pp. 321–22.

[20]So Porte, *Emerson and Thoreau*, pp. 183–88, following Miller, *Consciousness*, p. 68.

[21]Cf. *On the Study of Words*, p. 219, and Aristotle, *Nicomachean Ethics*, 10.6. See also Thomas Woodson, "The Two Beginnings of *Walden:* A Distinction of Styles," *ELH*, 35 (1968), 456; and for a clearer pun on *stereotyped*, see Journal, 1 July 1840.

[22]See Perry Miller, "From Edwards to Emerson," *New England Quarterly*, 13 (1940), 603–12; also *Magic Circle*, pp. 89–90.

[23]*Introduction to the History of Philosophy*, trans. Henning Gottfried Linberg (Boston: Hilliard, 1832), p. 187. See Kenneth Walter Cameron, *Emerson the Essayist* (Raleigh: Thistle Press, 1945), I, 303–19, and "Thoreau Discovers Emerson: A College Reading Record," *Bulletin of the New York Public Library*, 57 (1953), 328; also Emerson R. Marks, "Victor Cousin and Emerson," in *Transcendentalism and Its Legacy*, pp. 63–86; and Georges J. Joyaux, "Victor Cousin and American Transcendentalism," *French Review*, 29 (1955), 117–30.

[24]Cited by René Wellek, *A History of Modern Criticism* (New Haven: Yale Univ. Press, 1955), II, 17; see also I, 233.

[25]*Work and Play, or Literary Varieties* (New York: Scribners, 1871), p. 22.

[26]See Emerson, *Journals*, ed. Edward W. Emerson and Waldo Emerson Forbes, 10 vols. (Boston: Houghton, 1909–14), VII, 526, and IX, 88.

[27]Cited by Wellek, II, 175. On Thoreau's revisions see J. Lyndon Shanley, *The Making of Walden, with the Text of the First Version* (Chicago: Univ. of Chicago Press, 1957), pp. 28–31; also Broderick, "Movement of Thoreau's Prose," p. 141.

[28]Cited by Sylvan Barnet, "Coleridge on Puns: A Note to His Shakespeare Criticism," *Journal of English and Germanic Philology*, 56 (1957), 606, n., q.v.

[29]See Kathryn Anderson McEuen, "Lowell's Puns," *American Speech*, 22 (1947), 24–33.

[30]Cited by John Clubbe, *Victorian Forerunner: The Later Career of Thomas Hood* (Durham, N. C.: Duke Univ. Press, 1968), p. 34.

[31]See J. C. Reid, *Thomas Hood* (London: Routledge, 1963), pp. 235–37.

[32]*The Portable Nietzsche*, ed. and trans. Walter Kaufmann (New York: Viking, 1969), pp. 152–53; see also Kaufmann's comments, pp. 106–11; *The Case of Wagner*, trans. Thomas Common, in Nietzsche's *Works*, ed. Alexander Tille (New York: Macmillan, 1896), XI, 24–25.

[33]"Thoreau," in *Works*, X, 448. Since the esthetic interpretation of Thoreau

has been vigorously challenged by Hubert H. Hoeltje, "Misconceptions in Current Thoreau Criticism," *Philological Quarterly*, 47 (1968), 563–70, its origin in Emerson's own perceptions is worth noting.

[34]Cited by Harding, *Days*, pp. 102, 109, q.v.

[35]*Collected Poems* (New York: Macmillan, 1955), pp. 292–93.

[36]*Henry David Thoreau: A Critical Study* (Boston: Houghton, 1916), p. 109.

Portions

Stanley Cavell

T he opening visions of captivity and despair in *Walden* are traced full length in the language of the first chapter, the longest, which establishes the underlying vocabulary of the book as a whole. "Economy" turns into a nightmare maze of terms about money and possessions and work, each turning toward and joining the others. No summary of this chapter will capture the number of economic terms the writer sets in motion in it. There is profit and loss, rich and poor, cost and expense, borrow and pay, owe and own, business, commerce, enterprises, ventures, affairs, capital, price, amount, improvement, bargain, employment, inheritance, bankruptcy, work, trade, labor, idle, spend, waste, allowance, fortune, gain, earn, afford, possession, change, settling, living, interest, prospects, means, terms. But the mere listing of individual words gives no idea of the powers of affinity among them and their radiation into the remainder of language. They are all ordinary words that we may use, apparently literally, in evaluating any of our investments of feeling, or expenses of spirit, or turns of fortune. There is just enough description, in this chapter, of various enterprises we think of as the habitual and specific subjects of economics, to make unnoticeable the spillage of these words over our lives as a whole. It is a brutal mocking of our sense of values, by forcing a finger of the vocabulary of the New Testament (hence of our understanding of it) down our throats. For that is the obvious origin or locus of the use of economic imagery to express, and correct, spiritual confusion: what shall it profit a man; the wages of sin; the parable of talents; laying up treasures; rendering unto Caesar; charity. What we call the Protestant Ethic, the use of worldly loss and gain to symbolize heavenly standing, appears in *Walden* as some last

suffocation of the soul. America and its Christianity have become perfect, dreamlike literalizations or parodies of themselves.

The network or medium of economic terms serves the writer as an imitation of the horizon and strength both of our assessments of our position and of our connections with one another; in particular of our eternal activity in these assessments and connections, and of our blindness to them, to the fact that they are ours. The state of our society and the state of our minds are stamped upon one another. This was Plato's metaphysical assumption in picturing justice and its decline; it was the secret of Rousseau's epistemology. To let light into this structure of terms, to show that our facts and ideas of economy are uneconomical, that they do not meet but avoid true need, that they are as unjust and impoverishing within each soul as they are throughout the soul's society, *Walden* cuts into the structure of economic terms at two major points, or in two major ways: (1) it attacks its show of practicality by dramatizing the mysteriousness of ownership, and (2) it slips its control of several key terms.

I do not claim that Locke is the only or even the actual representative of the mystery of ownership that *Walden* encounters. But the *Second Treatise* is as formative of the conscience, or the unconsciousness, of political economy as any other work, and its preoccupations are coded into *Walden*. When we read that "the cost of a thing is the amount of what I will call life which is required to be exchanged for it" (I, 45),* it is inevitable that we should think of the so-called labor theory of value. The mysticism of what society thinks practical shows up nakedly in what anybody recognizes as the foolishness of Locke's justifications of ownership, in particular his idea that what originally entitles you to a thing is your having "mixed your labor" with it, and that what entitles you to more than you need is your "improvement" of the possession, your not wasting it. "Economy is a subject which admits of being treated with levity, but it cannot so be disposed of" (I, 44). The writer might at that point have had in mind Locke's argument that an individual's accumulation of vastly more money than he can spend is not a case of waste because money is metal and hence can be kept in heaps without being spoiled. The mysteries *Walden* goes into about buying and selling all the farms in his neighborhood, and about annually carrying off the landscape (II, 2), suggest that nobody really knows how it happens that anyone owns anything at all, or why it is that, as Locke puts it, though the earth was given

*References to *Walden* are independent of any particular edition. Citations are by chapter and paragraph, roman numerals for the former, arabic for the latter. [Editors]

to us in common, it is now so uncommonly divided and held. This is not to say that any of our institutions might not be practically justified (the writer of *Walden* describes and accepts a perfectly practical justification for the institution of money: that it is more convenient than barter). But in fact if you look at what we do under our pleas of economy, you see that no merely practical motives could inspire these labors.

Political economy is the modern form of theodicy, and our labors are our religious mysteries. This is an explicit meaning the writer gives, toward the end of "Economy," to his having spoken at its beginning of our "outward condition." He recounts an Indian custom described in Bartram, in which members of a community cleanse their houses and, having provided themselves with new clothes and utensils and furniture, throw the old together on a common heap, "consume it with fire," fast, and declare a "general amnesty" (I, 91). They are beginning again.

> The Mexicans also practiced a similar purification . . . in the belief that it was time for the world to come to an end . . .
> . . . I have scarcely heard of a truer sacrament, that is, as the dictionary defines it, "outward and visible sign of an inward and spiritual grace." (I, 94, 95)

So our labors, our outward condition, which he more than once describes as something to which we are "religiously devoted," are our sacraments, and the inward state they signal ("our very lives are our disgrace") is our secret belief that the world has already come to an end for us. Such actions are inspired, but not, as the writer says he believes in the case of the Mexicans, "directly from Heaven." We labor under a mistake. What will save us from ourselves is nothing less than salvation.

The second major strategy I said *Walden* uses to cut into the circling of economic terms is to win back from it possession of our words. This requires replacing them into a reconceived human existence. That it requires a literary redemption of language altogether has been a theme of my remarks from the beginning; and I have hoped to show that it simultaneously requires a redemption of the lives we live by them, religiously or politically conceived, inner and outer. Our words have for us the meaning we give to them. As our lives stand, the meaning we give them is rebuked by the meaning they have in our language—the meaning, say, that writers live on, the meaning we also, in moments, know they have but which mostly remains a mystery to us. Thoreau is doing with our ordinary assertions what Wittgenstein does with our more patently philosophical assertions—bringing them back to a context in which they are alive. It is the appeal from ordinary language to itself; a rebuke of our lives by what we may know of them, if we will. The writer has secrets to tell which can only be told to strangers. The secrets are not

his, and they are not the confidences of others. They are secrets because few are anxious to know them; all but one or two wish to remain foreign. Only those who recognize themselves as strangers can be told them, because those who think themselves familiars will think they have already heard what the writer is saying. They will not understand his speaking in confidence.

The literary redemption of language is at the same time a philosophical redemption; the establishment of American literature undertaken in *Walden* requires not only the writing of a scripture and an epic, but a work of philosophy. The general reason is as before: *Walden* proposes new mysteries because we have already mystified ourselves; it requires new literary invention because we have already made our lives fabulous; it requires theology because we are theologized. We have already philosophized our lives almost beyond comprehension. The more famous perception of this is assumed in Marx's eleventh slogan concerning Feuerbach: "Philosophers have only interpreted the world in various ways; the point, however, is to change it." The changes required have to be directed to the fact that it is not only philosophers who have interpreted the world, but all men; that all men labor under a mistake—call it a false consciousness; and that those who learn true labor are going to be able to do something about this because they are the inheritors of philosophy, in a position to put philosophy's brags and hopes for humanity, its humanism, into practice. Why this is or is not going to happen now, and where, and how, are other matters. Who knows what our lives will be when we have shaken off the stupor of history, slipped the drag of time?

I have alluded to some of the literary-philosophical claims *Walden* stakes out for "owning," "improvement," "account," "interest," "living," and "loss." The announced subject in the opening chapter is the idea of a "necessary of life"; the most frequent among its characteristic signs is that of "necessity." It is from this term that I will begin to sketch what I have in mind when I think of this writing as a work of systematic philosophy—at least as a work which acknowledges the centrality, and perhaps the present impossibility, of such an enterprise.

The Transcendentalists, as Emerson in 1842 said, got their title from the philosophy of Kant. What it meant to them was something, one gathers, to the effect that man lives in two worlds, in one of which he is free, in the other determined; and that an Idea of Reason is an Idea to be aspired to. Emerson calls Transcendentalism the current flowering of idealism, contrasting that with a perennial materialism,

> the first class [materialists] founding on experience, the second [idealists] on consciousness; the first class beginning to think from the data of the senses, the second class perceive that the senses are not final, and say, The senses give us representations of things, but what are the things

themselves, they cannot tell. . . . [The idealist] concedes all that the other affirms, admits the impressions of sense, admits their coherency, their use and beauty, and then asks the materialist for his grounds of assurance that things are as his senses represent them. But I, he says, affirm facts not affected by the illusions of sense. . . .

But because no one lives a perfectly spiritual existence, within the idealist "these two states of thought diverge every moment, in wild contrast. . . . The worst feature of this double consciousness is, that the two lives, of the understanding and of the soul, which we lead, really show little relation to one another." But the prevailing of the idea is his faith. "Patience is for us, is it not?"

The directly un-Kantian moment in Emerson's essay is his notion that the senses are the scene of illusions. This at a stroke misconceives the undertaking of the *Critique of Pure Reason,* an essential half of which was exactly to answer, by transforming, the skeptical question about the existence of the external world, to show that things (as we know them) *are* as the senses represent them; that nature, the world opened to the senses, is objective. I am convinced that Thoreau had the Kantian idea right, that the objects of our knowledge require a transcendental (or we may say, grammatical or phenomenological) preparation; that we know just what meets the *a priori* conditions of our knowing anything *überhaupt.* These *a priori* conditions are necessities of human nature; and the search for them is something I think Thoreau's obsession with necessity is meant to declare. His difference from Kant on this point is that these *a priori* conditions are not themselves knowable *a priori,* but are to be discovered experimentally; historically, Hegel had said. *Walden* is also, accordingly, a response to skepticism, and not just in matters of knowledge. Epistemologically, its motive is the recovery of the object, in the form in which Kant left that problem and the German idealists and the Romantic poets picked it up, viz., a recovery of the thing-in-itself; in particular, of the relation between the subject of knowledge and its object. Morally, its motive is to answer, by transforming, the problem of the freedom of the will in the midst of a universe of natural laws, by which our conduct, like the rest of nature, is determined. *Walden,* in effect, provides a transcendental deduction for the concepts of the thing-in-itself and for determination—something Kant ought, so to speak, to have done.

What philosophers, men in thought, call the "determinism" of nature is in fact (i.e., really fits our concept of) fate. "By a seeming fate, commonly called necessity, [men] are employed, as it says in an old book, laying up treasures which moth and rust will corrupt" (I, 5). It is an idea of something controlled from beyond itself, toward a predetermined end or within predetermined confines. We did not get such an idea from nature, because what we find in nature is recurrence and "resolution"

(xvi, 1); nature has no destiny beyond its presence; and it is completely autonomous, self-determined. So we must be projecting the idea into nature (it is an idea of reflection). Then the idea comes from our own sense of being controlled from outside. *Walden's* concept for this is that of the *track*, and the most extended image of it is the new railroad.

> When I meet the engine with its train of cars moving off with planetary motion—or, rather, like a comet, for the beholder knows not if with that velocity and with that direction it will ever revisit this system, since its orbit does not look like a returning curve—with its steam cloud like a banner streaming behind in golden and silver wreaths, like many a downy cloud which I have seen, high in the heavens, unfolding its masses to the light—as if this traveling demigod, this cloud-compeller, would ere long take the sunset sky for the livery of his train; when I hear the iron horse make the hills echo with his snort like thunder, shaking the earth with his feet, and breathing fire and smoke from his nostrils (what kind of winged horse or fiery dragon they will put into the new Mythology I don't know), it seems as if the earth had got a race now worthy to inhabit it. If all were as it seems, and men made their elements their servants for noble ends!
> (iv, 8)

What happens instead is that men will mythologize their forces, as they always have, project them into demigods, and then serve their projections. Their latest heathenism was that of predestination and election ("I . . . would fain fancy myself one of the elect" [x, 2]); with the passing of that one, the new mythology will make the railroad engine (their technology, their inventions) their fate. It is, you might say, their inability to trust themselves to determine their lives; or rather, their inability to see that they are determining them. The world is what meets the conditions of what we call our necessities—whether we have really found them to be ours or not. "The universe constantly and obediently answers to our conceptions" (ii, 21). In particular, we have determined that we shall be governed by fate—by something that denies for us the incessant exercise of our control. "We have constructed a fate, an *Atropos*, that never turns aside" (iv, 10). The writer recommends that as the name of the engine in our new mythology.

What we have constructed is fate itself. That it never turns aside is merely what the word fate, or rather Atropos, means. And we are not fated to it; *we* can turn. We can learn a lesson from the railroad, as we can from the rest of what happens, if we can for once learn something that does not merely confirm our worst fears instead of our confidence.

> Men are advertised that at a certain hour and minute these bolts will be shot toward particular points of the compass; yet it interferes with no man's business, and the children go to school on the other track. We live the steadier for it. We are all educated thus to be sons of Tell. The air is full

of invisible bolts. Every path but your own is the path of fate. Keep on your own track, then. (IV, 10)

"I too would fain be a track-repairer somewhere in the orbit of the earth" (IV, 6). The lesson is that we can turn from fate by keeping steady, keeping still. ("We have the Saint Vitus' dance, and cannot possibly keep our heads still" [II, 18]; and of course the other way around as well: as long as we do not learn to keep our heads still, we will persist in the dance—as if to account for our handicap. We must learn a "perpetual instilling" [II, 21].) Your own is the path he calls wisdom, confidence, faith: "It is by a mathematical point only that we are wise" (I, 99); one must advance "confidently in the direction of [one's] dreams" (XVIII, 5). Everybody more or less sees the sense of this. The question is how we are to find this path, have the trust to accept it, since everyone also more or less knows that it is an offer, a promise. We live by fate because we are "determined not to live by faith" (I, 15). Thus to determine ourselves requires constant vigilance and being on the alert. But how do we stop determining ourselves? How do we replace anxious wakefulness by a constant awakening?

Part of *Walden*'s answer we have already seen. We have to learn what finding is, what it means that we are looking for something we have lost. And we have to learn what acceptance is, what it means that we have to find ourselves where we are, at each present, and accept that finding in our experiment, enter it in the account. This is what requires confidence. To be confident of nature, at every moment, appears as willingness to be confided in by it. (". . . I was surprised to hear him express wonder at any of Nature's operations, for I thought that there were no secrets between them" [XVII, 4].) This is why the writer's readings of nature do not feel like moralizations of it, but as though he is letting himself be read by it, confessed in it, listening to it, not talking about it. Finding and accepting and confidence and trust require our interest in our experiment, in our experiences, in what happens to us. Each of these concepts (finding, trust, interest, etc.) will exit into the others, and must be adjusted by the others.

What they come to is the learning of resolution. This is what will replace our determination, or commitment, to fate, to the absence of freedom. It is not a matter of doing something new, of determining a course of action and committing ourselves to it, as to jail (II, 5) or to an asylum. Resolution has to do with stillness and with settling (a "clearing," he sometimes calls it). The summary of the writer's learning this is told in his myth of winter, by what happens to him on the ice. It is there that he finds the bottom of the pond, and it is in winter that the owls prophesy and the fox awaits his transformation.

"The Pond in Winter" opens with the writer's depiction of himself awakening, enacting mythically the thing he is weaving his doctrine about.

> After a still winter night I awoke with the impression that some question had been put to me, which I had been endeavoring in vain to answer in my sleep, as what—how—when—where? But there was dawning Nature, in whom all creatures live, looking in at my windows . . . and no question on *her* lips. I awoke to an answered question, to Nature and daylight. . . . Nature puts no question and answers none which we mortals ask. She has long ago taken her resolution. (xvi, 1)

He awakes twice. First to the impression of a question or questions which are the final recapitulation and placing of those questions with which his book begins. They are very like those Christ alludes to in the Sermon on the Mount: "Which of you by taking thought can add one cubit unto his stature? . . . Therefore take no thought, saying, What shall we eat? or, What shall we drink? or Wherewithal shall we be clothed? . . . But seek ye first the kingdom of God, and his righteousness." That they have been asked while asleep—by sleeping men to a man in a crisis of awakening—does not mean they have no answers. His second waking is to an answered question, i.e., to the fact that the questions have already been answered—or else that the answer is in vain and the question, therefore, not understood. This is why he has to get us to ask, in order to show that the answer is ours; we have given it, such as it is. We may give another. That two wakings are required he has indicated earlier, in "Reading":

> The at present unutterable things we may find somewhere uttered. These same questions that disturb and puzzle and confound us have in their turn occurred to all the wise men; not one has been omitted; and each has answered them, according to his ability, by his words and his life. (iii, 11)

Until the ice formed he had been answering by his words; now he will answer in his life, show his definition. One answer we have seen: you have to lie on the ice long enough not to settle upon hasty conclusions. And other things happen to him out there. In search of water, "if that be not a dream" [he is still awakening], "I cut my way first through a foot of snow, and then a foot of ice, and open a window under my feet"—which means, against the book's preceding paragraph, that he is allowing himself to be looked in at. Kneeling there to drink he sees summer preserved in the sanded floor; recalling his earlier notice that heaven is reflected in Walden's water—it is "Sky water"—he now says, "Heaven is under our feet as well as over our heads" (xvi, 2). He has arrived at his location; and it is a kind of literalized Galilean answer to a question which earlier arose about the other side of the earth; people

there are not upside down, because heaven is over their heads too, and under their feet. He has now "made some progress toward settling in the world" (II, 9), become "a track-repairer somewhere in the orbit of the earth," by realizing its planetary motion, surrounded by heaven. The locomotive seemed to have that motion when it suggested a race worthy to inhabit the earth; and it is his realization of "that farthest western way" he commends to us (XVIII, 2); for an earthling, diurnally, which is how it must happen, the direction to that way is eastward, i.e., toward dawn, increasingly.

The final event on the ice is this:

> Sometimes, also, when the ice was covered with shallow puddles, I saw a double shadow of myself, one standing on the head of the other, one on the ice, the other on the trees or hillside. (XVI, 15)

(He has added a cubit to his stature, and overcome himself. No doubt this is not the form in which we would have expected our doubleness to be projected.) This is an ecstatic vision of something he predicted in the mystical harmonies and dissonances of "Solitude":

> With thinking we may be beside ourselves in a sane sense. By a conscious effort of the mind we can stand aloof from actions and their consequences. . . . We are not wholly involved in Nature. . . . I only know myself as a human entity; the scene, so to speak, of thoughts and affections; and am sensible of a certain doubleness by which I can stand as remote from myself as from another. However intense my experience, I am conscious of the presence and criticism of a part of me, which, as it were, is not a part of me, but a spectator, sharing no experience, but taking note of it, and that is no more I than it is you. (V, 11)

This is not Emerson's idea of an Over-Soul, most importantly because Emerson locates that, among other places, *within* the self, as a unity, or *the* Unity; and he leaves me the habitual spectator of my world. That is where Emerson is always stuck, with his sense, not his achievement, of outsideness, the yearning for the thing to happen to him. In "Solitude," it is the double who is the spectator, and I who am the scene of occurrence. The impersonality, or impartiality, of *Walden*'s double is the spiritual breakthrough from yearning and patience which releases its writer's capacity for action. It is a mode of what he calls "being interested in." It is the state, so far as I am able to estimate it, of the conclusion of *Oedipus at Colonus*, the absolute awareness of self without embarrassment—consciousness of self, and of the self's standing, beyond self-consciousness. ("When the play, it may be the tragedy, of life is over, the spectator goes his way" [V, 11].) Or it is the reflection in consciousness of what Freud meant by calling the greater part of us the Id. Philosophy has reflected it in the idea of a transcendental ego. *Walden* some-

times refers to it as imagination—when, for example, it remarks that "[the imagination and the body] should both sit down at the same table" (xi, 6). The name we find for the writer's description of the double does not at the moment matter; what is essential is that he gives his own view of what is apparently an ancient and recurring intimation of the wholeness of the self ("holiness groping for expression") out of a present sense of incoherence or division or incompleteness.

Our imagination, or our capacity for images, and for the meaning or phenomenology of our images—of dawn and day and night, of lower and higher, of straight and curved, hot and cold, freezing and melting and moulting, of birds and squirrels and snakes and frogs, of houses and bodies of water and words, of growth and decay, of mother and father— are as *a priori* as our other forms of knowledge of the world:

> When the ground was partially bare of snow, and a few warm days had dried its surface somewhat, it was pleasant to compare the first tender signs of the infant year just peeping forth with the stately beauty of the withered vegetation which had withstood the winter—life-everlasting, goldenrods, pinweeds, and graceful wild grasses, more obvious and interesting frequently than in summer even, as if their beauty was not ripe till then; even cotton-grass, cat-tails, mulleins, johnswort, hard-hack, meadow-sweet, and other strong-stemmed plants, those unexhausted granaries which entertain the earliest birds—decent weeds, at least, which widowed Nature wears. I am particularly attracted by the arching and sheaflike top of the wool-grass; it brings back the summer to our winter memories, and is among the forms which art loves to copy, and which, in the vegetable kingdom, have the same relation to types already in the mind of man that astronomy has. It is an antique style, older than Greek or Egyptian. Many of the phenomena of Winter are suggestive of an inexpressible tenderness and fragile delicacy. We are accustomed to hear this king described as a rude and boisterous tyrant; but with the gentleness of a lover he adorns the tresses of Summer. (xvii, 11)

Human forms of feeling, objects of human attraction, our reactions constituted in art, are as universal and necessary, as objective, as revelatory of the world, as the forms of the laws of physics. This is the writer's faith—confidence that what we are accustomed to call, say, the "connotations" of words, the most evanescent of the shadows they cast, are as available between us as what we call their "denotations." That *in fact* we do not normally avail ourselves of them is a comment on our lives and shows our continuing need for art. (We have yet to learn to *live* undefined in front.) This is another way of seeing what I described as the writer's attempt to register within the writing of the word the entire language from which a word is woven.

The writer specifies my relation to the double as my being beside it.

Being beside oneself is the dictionary definition of ecstacy. To suggest that one may stand there, stay there in a sane sense, is to suggest that the besideness of which ecstasy speaks is my experience of my existence, my knowledge "of myself as a human entity," my assurance of my integrity or identity. This condition—the condition of "having" a self, and knowing it—is an instance of the general relation the writer perceives as "being next to":

> Any prospect of awakening or coming to life to a dead man makes
> indifferent all times and places. The place where that may occur is always
> the same, and indescribably pleasant to all our senses. For the most part
> we allow only outlying and transient circumstances to make our occasions.
> They are, in fact, the cause of our distraction. Nearest to all things is that
> power which fashions their being. *Next* to us the grandest laws are
> continually being executed. *Next* to us is not the workman whom we have
> hired, with whom we love so well to talk, but the workman whose work
> we are. (v, 6)

What is next to us is what we neighbor. The writer has spoken of finding himself suddenly neighbor to the birds; and he speaks of the pond in neighborly terms: "Of all the characters I have known, perhaps Walden wears best, and best preserves its purity" (IX, 25). Our relation to nature, at its best, would be that of neighboring it—knowing the grandest laws it is executing, while nevertheless "not wholly involved" in them.

> . . . I experienced sometimes that the most sweet and tender, the most
> innocent and encouraging society may be found in any natural object. . . . I
> was suddenly sensible of such sweet and beneficent society in Nature . . .
> an infinite and unaccountable friendliness all at once like an atmosphere
> sustaining me, as made the fancied advantages of human neighborhood
> insignificant, and I have never thought of them since. (v, 4)

(The idea that society is justified because it provides a set of "advantages"—an idea common to Locke's theory of a social contract and to Hume's criticism of that theory—is a fantasy. This of course does not mean that society's claims upon us are without authority.) You may call this mysticism, but it is a very particular view of the subject; it is not what the inexperienced may imagine as a claim to the union, or absorption in nature.*

*This is the place, but not the time, to try to make clearer what I mean by saying that *Walden* provides a transcendental deduction of the category of the thing-in-itself. I do not want to leave this claim without some explicit justification because it seems on the surface at best a play, at worst a contradiction in Kantian terms:

As we are to learn the neighboring of nature so we are to learn the neighboring not of the workman whom we have hired (which is a measure of the kind of distance at which most people stand to themselves, slave-drivers of themselves, beside themselves in an insane sense) but of the workman whose work we are—which some may call God, and which is that in ourselves, or that aspect of ourselves, whom the writer calls the indweller:

> What of architectural beauty I now see, I know has gradually grown from within outward, out of the necessities and character of the indweller, who is the only builder—out of some unconscious truthfulness, and nobleness, without ever a thought for the appearance; and whatever additional beauty of this kind is destined to be produced will be preceded by a like and unconscious beauty of life. (i, 67)

And later:

the concept of the thing-in-itself is the result, if not exactly the conclusion, of Kant's idea of a transcendental deduction of the categories; it stands for the fact that knowledge has *limits,* or conditions. The concept, so to speak, just says that it has no transcendental deduction, that its object is not an object of knowledge for us, so to ask for a deduction of it is, on Kant's program, senseless. But what is "a thing which is not an object of knowledge for us"? Everyone involved with Kant's thought recognizes a problem here, the implication that there are things just like the things we know (or features of the very things we know) which, not answering to our conditions for knowing anything, are unknowable by us. We oughtn't to be able to attach any meaning at all to such an implication. If something does not answer to our conditions of knowledge then it is not subject to what we understand as knowledge, and that means that it is not what we understand as an object. A thing which we cannot know is not a thing. Then why are we led to speak otherwise? What is the sense that something escapes the conditions of knowledge? It is, I think, the sense, or fact, that our primary relation to the world is not one of knowing it (understood as achieving certainty of it based upon the senses). This is the truth of skepticism. A Kantian "answer" to skepticism would be to accept its truth while denying the apparent implication that this is a *failure* of knowledge. This is the role the thing-in-itself ought, as it were, to have played. The idea of God is that of a relation in which the world as a whole stands; call it a relation of dependency, or of having something "beyond" it. The idea of the thing-in-itself is the idea of a relation in which we stand to the world as a whole; call it a relation of the world's externality (not each object's externality to every other—that is the idea of space; but the externality of all objects to us). When I said that Kant ought to have provided a deduction of the thing-in-itself, I meant that he had left unarticulated an essential feature (category) of objectivity itself, viz., that of *a world apart from me in which* objects are met. The externality of the world is articulated by Thoreau as its nextness to me.

Every man is the builder of a temple, called his body, to the god he worships, after a style purely his own, nor can he get off by hammering marble instead. We are all sculptors and painters, and our material is our own flesh and blood and bones. Any nobleness begins at once to refine a man's features, any meanness or sensuality to imbrute them. (xi, 14)

Here are the elements of *Walden*'s solution to the problem of self-consciousness, or the sense of distance from self, or division of self. What *we* know as self-consciousness is only our opinion of ourselves, and like any other opinion it comes from outside; it is hearsay, our contribution to public opinion. We must become disobedient to it, resist it, no longer listen to it. We do that by keeping our senses still, listening another way, for something indescribably and unmistakably pleasant to all our senses. We are to reinterpret our sense of doubleness as a relation between ourselves in the aspect of indweller, unconsciously building, and in the aspect of spectator, impartially observing. Unity between these aspects is viewed not as a mutual absorption, but as a perpetual nextness, an act of neighboring or befriending. "This doubleness may easily make us poor neighbors and friends sometimes" (v, 11), because we have bestowed elsewhere our extent of trust and freeing and aid and comfort—or what looks to be elsewhere, given our current poor ideas of distance and nearness. (Our manners have been corrupted by communication with the saints.) The neighboring of the self is also articulated as the self's companionability: "I have a great deal of company in my house; especially in the morning, when nobody calls" (v, 15). When his imagination and his body sit down at the same table to eat they are etymologically companions. Society, if it is ever to better itself, depends upon each person's companionability; but, as things stand, society cannot teach this to us; it can merely impose something in its place. "We have had to agree on a certain set of rules, called etiquette and politeness, to make . . . frequent meeting tolerable and that we need not come to open war" (v, 13). No doubt it is better that it not come to that, but ontologically the state of society is nevertheless war—the condition which Hobbes claimed to be the state of nature. (Locke was enraged by Hobbes's claim, but he did not really correct it; nor did he provide a fuller or alternate account of what our relations in society are to be.) This is understood in Rousseau's insight that a philosopher's description of the state of nature is a projection of his own secret knowledge of the state of his society. *Walden*'s underlying notion, in its account of doubleness—as opposed, say, to Plato's notion of the harmony of the soul—is one of integrity conceived as an activity.

To maintain nextness to ourselves, we require new, or newly conceived, capacities for constancy and for change. These are invoked in *Walden*'s depiction of resolution, which comprises both hardening and

melting, the total concentration of resources and the total expenditure of them; the suspension of winter and the progression of spring. This resoluteness is not merely an attitude one adopts in the face of others; that would merely amount to unneighborliness, and would still suggest that you were listening to the wrong thing. Our position toward others should be an effect, not a cause, of integrity. (Wordsworth, in "Resolution and Independence," apparently reverses this order: the poet voices his resolve to independence after he comes upon the old man. This may account for the anticlimax which readers have felt in the explicit resolution contained in the poem's closing lines: ". . . I'll think of the Leechgatherer on the lonely moor!" But this is to forget that the writing of the poem is the keeping of that resolution, and that it is within the poem that the old man appears, hence appears after the poet's resolution has been taken.) Our first resolve should be toward the nextness of the self to the self; it is the capacity not to deny either of its positions or attitudes—that it is the watchman or guardian of itself, and hence demands of itself transparence, settling, clearing, constancy; and that it is the workman, whose eye cannot see to the end of its labors, but whose answerability is endless for the constructions in which it houses itself. The answerability of the self to itself is its possibility of awakening.

Both the resolution of hardness and the resolution of progression are matters of leaving, anticipations of departure. At the winter of one's crisis one relinquishes the world one has constructed and "dies down to the root" (XVII, 13); and "the root is faith" (I, 87). At the crisis of spring one forgoes that assurance in favor of the labors of rehabitation. Each direction is an entrustment, or bequeathing, of the self.

I have come to the end of the questions I have wanted to pose about *Walden*. That I leave them incompletely explored will not matter if I have left them faithful and prompting enough for the book to take them out of my hands, to itself, for strangers. But there is a recurrent form of doubt about Thoreau's writing which may threaten the balance of any of my deliberations with his book and thereby take the heart out of the reader's efforts to try it further. The form of doubt is caused partly by the depth of the book's depressions and the height of its elevations, and, more nearly, by the absence of reconciliation between them, which may seem evasive or irresolute of the writer—as if we have been led once more only to the limits of one man's willingness to answer, not to the limits of the humanly answerable.

Does the writer of *Walden* really believe that the manner in which one conducts one's affairs can redeem their external meanness—that, for example, one could find one's Walden behind a bank counter, or driving a taxi, or guiding a trip hammer, or selling insurance, or teaching school?

Granted that one is unlikely to find one's own Walden by roaming around the vicinity of Concord, Massachusetts, isn't it dishonest to suggest that it may be found in any place very different from that? Is it the way we live that he despises, or human life as such? Is it merely governments that he scorns, or the human need and capacity for human society altogether? Is it the way we treat our bodies that makes them ugly to him, or is he repelled by existence itself? Each of these questions has answers, too many answers; the voice wavers and swallows its words just when it seems that it should be surest of itself. I think Thoreau expresses this, and assumes his readers will also know these doubts. As before, barriers to the book are not tracings of its outworks but topics of its central soil.

There is to be found in this testament, as one would expect, a revelation in which the paradoxes and ambiguities of its doctrine achieve a visionary union. It does not exactly conclude the book, but threads through it. As typical of this writer's procedures, he acknowledges his relation to the Christian vision by overturning it, "revising" it. It is his way of continuing it. The threat of vision, as of any fantasy, lies in its partialness, its keeping half of its surface in the dark. The overcoming of fantasy is not its extirpation, but its revision, together with the revision of our lives, in favor of one another—telling the myth whole of which our visions are fragments.

The limiting revision of *Walden* concerns the fact that God's creation of the world has from the beginning gone wrong, or wanted completion. The writer of *Walden* proposes himself many times and in many ways as the creator of his world. "I have my horizon. . . . I have, as it were, my own sun and moon and stars, and a little world all to myself" (v, 3). The artist from Kouroo, whose condition he aspires to, "had made a new system in making a staff, a world with full and fair proportions" (xviii, 11). And beyond his acts of publishing nature, and repeopling the woods, assisting the sun to rise (i, 25), giving the wind permission to howl (xiii, 12), and floating the earth (ii, 11), he is forever "making a day of it" (ii, 22; vii, 6). "To anticipate, not the sunrise and the dawn merely, but, if possible, Nature herself!" (i, 25)—that would mean to be in on the beginning. This is not special about him. We *are* creating the world, heaven is under our feet as well as over our heads—however much of it we have placed. The universe constantly and obediently observes answers to our conceptions—whether they are mean or magnanimous, scientific or magical, faithful or treacherous. Our choice is not between belief and unbelief, but between faith and idolatry—whether we will be metaphysicians or manikins. Specifically, the writer of *Walden* is as preoccupied as the writer of *Paradise Lost* with the creation of a world by a word. (A word has meaning against the context of a sentence. A sentence has meaning against the context of a language. A language has meaning against the

context of a form of life. A form of life has meaning against the context of a world. A world has meaning against the context of a word.) More specifically, the writer is preoccupied by the fact that the creation of the world, whether in the *Old Testament* or (say) in the *Vishnu Purana*, is a matter of *succession*, as words are. The creation of the world is a creation of new worlds, or new creations of the world. In the Wilson translation of the *Vishnu Purana*, a favorite text of *Walden*'s writer:

> Whilst he [Brahma] formerly, in the beginning of the Kalpas, was meditating on creation, there appeared a creation beginning with ignorance, and consisting of darkness. . . . Brahma, beholding that it was defective, designed another; and whilst he thus meditated, the animal creation was manifested to the products of which the term Tiryaksrotas is applied, from their nutriment following a winding course. . . .
>
> Beholding this creation also imperfect, Brahma again meditated, and a third creation appeared, abounding with the quality of goodness. . . . This, termed the creation of immortals, was the third performance of Brahma, who, although well pleased with it, still found it incompetent to fulfil his end. Continuing therefore his meditations, there sprang . . . the creation termed Arvaksrotas . . . from the downward current (of their nutriment). They abound with the light of knowledge, but the qualities of darkness and of foulness predominate. Hence they are afflicted by evil, and are repeatedly impelled to action. They have knowledge both externally and internally, and are the instruments (of accomplishing the object of creation, the liberation of soul). These creatures were mankind.

Apparently unlike the God of Genesis, Brahma does not, after each day of creation, see that it is good. But like Brahma, the God of Genesis requires time, fresh days. The first day of creation is creation of the day, giving time to himself—as though the author of nature is also its editor, or commentator, as though responsibility to the vision is the capacity for revision. The first reviser of mythology is God.

The winter visitor in whose company the writer kept faith with God by revising mythology was "One of the last of the philosophers—Connecticut gave him to the world. . . . I think that he must be the man of the most faith of any alive. . . . He is perhaps the sanest man and has the fewest crotchets of any I chance to know" (XIV, 21). The writer marks this man, Bronson Alcott, as "prompting God and disgracing man." Why does God need prompting? Perhaps because the quarrel of man and God has been an endless effort on each side to shift to the other the burden of the world's revision. What has God forgotten? What is he reluctant to do? In what direction is the story which God began, or which begins with God, to be revised? *Paradise Lost* spells out an answer within Milton's faithfulness to the story:

Know then, that after Lucifer from heaven

140

(So call him, brighter once amidst the host
Of angels than that star the stars among)
Fell with his flaming legions through the deep
Into his place, and the great Son returned
Victorious with his saints, the omnipotent
Eternal Father from his Throne beheld
Their multitude, and to his Son thus spake: . . .

. . . lest his heart exalt him in the harm
Already done, to have dispeopled Heaven,
My damage fondly deemed, I can repair
That detriment, if such it be to lose
Self-lost, and in a moment will create
Another World, out of one man a race
Of men innumerable, there to dwell,
Not here, till by degrees of merit raised
They open to themselves at length the way
Up hither, under long obedience tried,
And Earth be changed to Heaven, and Heaven to Earth,
One kingdom, joy and union without end.

("Whichever way we turned, it seemed that the heavens and the earth had met together, since he enhanced the beauty of the landscape" [xiv, 21].)

To repeople heaven and earth we have to go back to beginnings. In the beginning God meditated and the heaven and the earth were created. There was a war in heaven which God was forced to win by meditating hell. The meditation of man is made in the midst of these divisions. We must prompt another meditation (we may all one day become meditators, students). We are to settle and work and wedge down "below freshet and frost and fire." Below fire there is ice, as in Dante's meditation. To melt that ice, allowing its prisoner to moult, is to undergo spring, in which earth and the first man are made again, of one another. But first we must undergo winter. We must follow the Word to the underworld; this time it will descend not as hell's conqueror but as its redeemer. Lucifer is Satan only in hell. He is in us, in our awaiting transformation (the foxes were barking raggedly and demoniacally); but we expel him, more or less, instead of transforming ourselves. He is in our labors and hopes (the locomotive breathes fire and smoke, and it awakens the writer) and in our unrested imaginations (which see entrances into the Infernal Regions from the bottom of the pond). To reverse direction, keeping on our true course, is still to pass through the center of gravity ("I love to weigh, to settle, to gravitate"). The brightness of Lu-

cifer is our detraction from Christ. As we stand, in *Walden*'s last sentence, "The sun is but a morning star"; it reaches only a certain height and then declines. In Revelation the Son said that he will come as the bright and morning star, and that to him that overcometh he will give the morning star. The morning star is also, as in the meditation of Milton, Lucifer. The identity of Christ and Lucifer either is a curse, as in our lives as we lead them, or else it will eventually preside over our transformation. We dead will awaken not upon judgment, but because the day of judgment will be forgone, in favor of dawning. Until then, no fresh news will reach us. Thor must give way to Thaw (xvii, 10); so must Thoreau.

Poe
Short Stories

The House
of Poe

Richard Wilbur

A few weeks ago, in the *New York Times Book Review*, Mr. Saul Bellow expressed impatience with the current critical habit of finding symbols in everything. No self-respecting modern professor, Mr. Bellow observed, would dare to explain Achilles' dragging of Hector around the walls of Troy by the mere assertion that Achilles was in a bad temper. That would be too drearily obvious. No, the professor must say that the circular path of Achilles and Hector relates to the theme of circularity which pervades *The Iliad*.

In the following week's *Book Review*, a pedantic correspondent corrected Mr. Bellow, pointing out that Achilles did not, in Homer's *Iliad*, drag Hector's body around the walls of Troy; this perhaps invalidates the Homeric example, but Mr. Bellow's complaint remains, nevertheless, a very sensible one. We are all getting a bit tired, I think, of that laboriously clever criticism which discovers mandalas in Mark Twain, rebirth archetypes in Edwin Arlington Robinson, and fertility myths in everybody.

Still, we must not be carried away by our impatience, to the point of demanding that no more symbols be reported. The business of the critic, after all, is to divine the intention of the work, and to interpret the work in the light of that intention; and since some writers are intentionally symbolic, there is nothing for it but to talk about their symbols. If we speak of Melville, we must speak of symbols. If we speak of Hawthorne, we must speak of symbols. And as for Edgar Allan Poe, whose sesquicentennial year we are met to observe, I think we can make no sense

Reprinted from *Anniversary Lectures, 1959* (Washington: Library of Congress, 1959), pp. 21–38. Richard Wilbur's lecture was originally presented at the Library on May 4, 1959, under the auspices of the Gertrude Clarke Whittall Poetry and Literature Fund. Reprinted by permission of the Library of Congress.

about him until we consider his work—and in particular his prose fiction—as deliberate and often brilliant allegory.

Not everyone will agree with me that Poe's work has an accessible allegorical meaning. Some critics, in fact, have refused to see any substance, allegorical or otherwise, in Poe's fiction, and have regarded his tales as nothing more than complicated machines for saying "boo." Others have intuited undiscoverable meanings in Poe, generally of an unpleasant kind: I recall one Freudian critic declaring that if we find Poe unintelligible we should congratulate ourselves, since if we *could* understand him it would be proof of our abnormality.

It is not really surprising that some critics should think Poe meaningless, or that others should suppose his meaning intelligible only to monsters. Poe was not a wide-open and perspicuous writer; indeed, he was a secretive writer both by temperament and by conviction. He sprinkled his stories with sly references to himself and to his personal history. He gave his own birthday of January 19 to his character William Wilson; he bestowed his own height and color of eye on the captain of the phantom ship in "Ms. Found in a Bottle"; and the name of one of his heroes, Arthur Gordon Pym, is patently a version of his own. He was a maker and solver of puzzles, fascinated by codes, ciphers, anagrams, acrostics, hieroglyphics, and the Kabbala. He invented the detective story. He was fond of aliases; he delighted in accounts of swindles; he perpetrated the famous Balloon Hoax of 1844; and one of his most characteristic stories is entitled "Mystification." A man so devoted to concealment and deception and unraveling and detection might be expected to have in his work what Poe himself called "undercurrents of meaning."

And that is where Poe, as a critic, said that meaning belongs: not on the surface of the poem or tale, but below the surface as a dark undercurrent. If the meaning of a work is made overly clear—as Poe said in his *Philosophy of Composition*—if the meaning is brought to the surface and made the upper current of the poem or tale, then the work becomes bald and prosaic and ceases to be art. Poe conceived of art, you see, not as a means of giving imaginative order to earthly experience, but as a stimulus to unearthly visions. The work of literary art does not, in Poe's view, present the reader with a provisional arrangement of reality; instead, it seeks to disengage the reader's mind from reality and propel it toward the ideal. Now, since Poe thought the function of art was to set the mind soaring upward in what he called "a wild effort to reach the Beauty above," it was important to him that the poem or tale should not have such definiteness and completeness of meaning as might contain the reader's mind within the work. Therefore Poe's criticism places a positive value on the obscuration of meaning, on a dark suggestiveness, on a deliberate vagueness by means of which the reader's mind may be set adrift toward the beyond.

Poe's criticism, then, assures us that his work does have meaning. And Poe also assures us that this meaning is not on the surface but in the depths. If we accept Poe's invitation to play detective, and commence to read him with an eye for submerged meaning, it is not long before we sense that there *are* meanings to be found, and that in fact many of Poe's stories, though superficially dissimilar, tell the same tale. We begin to have this sense as we notice Poe's repeated use of certain narrative patterns; his repetition of certain words and phrases; his use, in story after story, of certain scenes and properties. We notice, for instance, the recurrence of the *spiral* or *vortex*. In "Ms. Found in a Bottle," the story ends with a plunge into a whirlpool; the "Descent into the Maelstrom" also concludes in a watery vortex; the house of Usher, just before it plunges into the tarn, is swaddled in a whirlwind; the hero of "Metzengerstein," Poe's first published story, perishes in "a whirlwind of chaotic fire"; and at the close of "King Pest," Hugh Tarpaulin is cast into a puncheon of ale and disappears "amid a whirlpool of foam." That Poe offers us so many spirals or vortices in his fiction, and that they should always appear at the same terminal point in their respective narratives, is a strong indication that the spiral had some symbolic value for Poe. And it did: What the spiral invariably represents in any tale of Poe's is the loss of consciousness, and the descent of the mind into sleep.

I hope you will grant, before I am through, that to find spirals in Poe is not so silly as finding circles in Homer. The professor who finds circles in Homer does so to the neglect of more important and more provable meanings. But the spiral or vortex is a part of that symbolic language in which Poe said his say, and unless we understand it we cannot understand Poe.

But now I have gotten ahead of myself, and before I proceed with my project of exploring one area of Poe's symbolism, I think I had better say something about Poe's conception of poetry and the poet.

Poe conceived of God as a poet. The universe, therefore, was an artistic creation, a poem composed by God. Now, if the universe is a poem, it follows that the one proper response to it is aesthetic, and that God's creatures are attuned to Him in proportion as their imaginations are ravished by the beauty and harmony of his creation. Not to worship beauty, not to regard poetic knowledge as divine, would be to turn one's back on God and fall from grace.

The planet Earth, according to Poe's myth of the cosmos, has done just this. It has fallen away from God by exalting the scientific reason above poetic intuition, and by putting its trust in material fact rather than in visionary knowledge. The Earth's inhabitants are thus corrupted by rationalism and materialism; their souls are diseased; and Poe sees this disease of the human spirit as having contaminated physical nature. The woods and fields and waters of Earth have thereby lost their first beauty,

and no longer clearly express God's imagination; the landscape has lost its original perfection of composition, in proportion as men have lost their power to perceive the beautiful.

Since Earth is a fallen planet, life upon Earth is necessarily a torment for the poet: neither in the human sphere nor in the realm of nature can he find fit objects for contemplation, and indeed his soul is oppressed by everything around him. The rationalist mocks at him; the dull, prosaic spirit of the age damps his imaginative spark; the gross materiality of the world crowds in upon him. His only recourse is to abandon all concern for Earthly things, and to devote himself as purely as possible to unearthly visions, in hopes of glimpsing that heavenly beauty which is the thought of God.

Poe, then, sees the poetic soul as at war with the mundane physical world; and that warfare is Poe's fundamental subject. But the war between soul and world is not the only war. There is also warfare within the poet's very nature. To be sure, the poet's nature was not always in conflict with itself. Prior to his earthly incarnation, and during his dreamy childhood, Poe's poet enjoyed a serene unity of being; his consciousness was purely imaginative, and he knew the universe for the divine poem that it is. But with his entrance into adult life, the poet became involved with a fallen world in which the physical, the factual, the rational, the prosaic are not escapable. Thus, compromised, he lost his perfect spirituality, and is now cursed with a divided nature. Though his imagination still yearns toward ideal beauty, his mortal body chains him to the physical and temporal and local; the hungers and passions of his body draw him toward external objects, and the conflict of conscience and desire degrades and distracts his soul; his mortal senses try to convince him of the reality of a material world which his soul struggles to escape; his reason urges him to acknowledge everyday fact, and to confine his thought within the prison of logic. For all these reasons it is not easy for the poet to detach his soul from earthly things, and regain his lost imaginative power—his power to commune with that supernal beauty which is symbolized, in Poe, by the shadowy and angelic figures of Ligeia, and Helen, and Lenore.

These, then, are Poe's great subjects: first, the war between the poetic soul and the external world; second, the war between the poetic soul and the earthly self to which it is bound. All of Poe's major stories are allegorical presentations of these conflicts, and everything he wrote bore somehow upon them.

How does one wage war against the external world? And how does one release one's visionary soul from the body, and from the constraint of the reason? These may sound like difficult tasks; and yet we all accomplish them every night. In a subjective sense—and Poe's thought is wholly subjective—we destroy the world every time we close our eyes.

If *esse est percipi,* as Bishop Berkeley said—if to be is to be perceived—then when we withdraw our attention from the world in somnolence or sleep, the world ceases to be. As our minds move toward sleep, by way of drowsiness and reverie and the hypnagogic state, we escape from consciousness of the world, we escape from awareness of our bodies, and we enter a realm in which reason no longer hampers the play of the imagination: we enter the realm of dream.

Like many romantic poets, Poe identified imagination with dream. Where Poe differed from other romantic poets was in the literalness and absoluteness of the identification, and in the clinical precision with which he observed the phenomena of dream, carefully distinguishing the various states through which the mind passes on its way to sleep. A large number of Poe's stories derive their very structure from this sequence of mental states: "Ms. Found in a Bottle," to give but one example, is an allegory of the mind's voyage from the waking world into the world of dreams, with each main step of the narrative symbolizing the passage of the mind from one state to another—from wakefulness to reverie, from reverie to the hypnagogic state, from the hypnagogic state to the deep dream. The departure of the narrator's ship from Batavia represents the mind's withdrawal from the waking world; the drowning of the captain and all but one of the crew represents the growing solitude of reverie; when the narrator is transferred by collision from a real ship to a phantom ship, we are to understand that he has passed from reverie, a state in which reality and dream exist in a kind of equilibrium, into the free fantasy of the hypnagogic state. And when the phantom ship makes its final plunge into the whirlpool, we are to understand that the narrator's mind has gone over the brink of sleep and descended into dreams.

What I am saying by means of this example is that the scenes and situations of Poe's tales are always concrete representations of states of mind. If we bear in mind Poe's fundamental plot—the effort of the poetic soul to escape all consciousness of the world in dream—we soon recognize the significance of certain scenic or situational motifs which turn up in story after story. The most important of these recurrent motifs is that of *enclosure* or *circumscription;* perhaps the latter term is preferable, because it is Poe's own word, and because Poe's enclosures are so often more or less circular in form. The heroes of Poe's tales and poems are violently circumscribed by whirlpools, or peacefully circumscribed by cloud-capped Paradisal valleys; they float upon circular pools ringed in by steep flowering hillsides; they dwell on islands, or voyage to them; we find Poe's heroes also in coffins, in the cabs of balloons, or hidden away in the holds of ships; and above all we find them sitting alone in the claustral and richly-furnished rooms of remote and mouldering mansions.

Almost never, if you think about it, is one of Poe's heroes to be seen

standing in the light of common day; almost never does the Poe hero breathe the air that others breathe; he requires some kind of envelope in order to be what he is; he is always either enclosed or on his way to an enclosure. The narrative of William Wilson conducts the hero from Stoke Newington to Eton, from Eton to Oxford, and then to Rome by way of Paris, Vienna, Berlin, Moscow, Naples, and Egypt: and yet, for all his travels, Wilson seems never to set foot out-of-doors. The story takes place in a series of rooms, the last one locked from the inside.

Sometimes Poe emphasizes the circumscription of his heroes by multiple enclosures. Roderick Usher dwells in a great and crumbling mansion from which, as Poe tells us, he has not ventured forth in many years. This mansion stands islanded in a stagnant lake, which serves it as a defensive moat. And beyond the moat lies the Usher estate, a vast barren tract having its own peculiar and forbidding weather and atmosphere. You might say that Roderick Usher is defended in depth; and yet at the close of the story Poe compounds Roderick's inaccessibility by having the mansion and its occupant swallowed up by the waters of the tarn.

What does it mean that Poe's heroes are invariably enclosed or circumscribed? The answer is simple: circumscription, in Poe's tales, means the exclusion from consciousness of the so-called real world, the world of time and reason and physical fact; it means the isolation of the poetic soul in visionary reverie or trance. When we find one of Poe's characters in a remote valley, or a claustral room, we know that he is in the process of dreaming his way out of the world.

Now, I want to devote the time remaining to the consideration of one kind of enclosure in Poe's tales: the mouldering mansion and its richly-furnished rooms. I want to concentrate on Poe's architecture and decor for two reasons: first, because Poe's use of architecture is so frankly and provably allegorical that I *should* be able to be convincing about it; second, because by concentrating on one area of Poe's symbolism we shall be able to see that his stories are allegorical not only in their broad patterns, but also in their smallest details.

Let us begin with a familiar poem, "The Haunted Palace." The opening stanzas of this poem, as a number of critics have noted, make a point-by-point comparison between a building and the head of a man. The exterior of the palace represents the man's physical features; the interior represents the man's mind engaged in harmonious imaginative thought.

> In the greenest of our valleys,
> By good angels tenanted,
> Once a fair and stately palace—
> Radiant palace—reared its head.
> In the monarch Thought's dominion,

It stood there!
Never seraph spread a pinion
 Over fabric half so fair!

Banners yellow, glorious, golden,
 On its roof did float and flow
(This—all this—was in the olden
 Time long ago),
And every gentle air that dallied,
 In that sweet day,
Along the ramparts plumed and pallid,
 A wingéd odor went away.

Wanderers in that happy valley,
 Through two luminous windows, saw
Spirits moving musically
 To a lute's well-tunéd law,
Round about a throne where, sitting,
 Porphyrogene,
In state his glory well befitting,
 The ruler of the realm was seen.

And all in pearl and ruby glowing
 Was the fair palace door,
Through which came flowing, flowing, flowing,
 And sparkling evermore,
A troop of Echoes, whose sweet duty
 Was but to sing,
In voices of surpassing beauty,
 The wit and wisdom of their king.

I expect you observed that the two luminous windows of the palace are the eyes of a man, and that the yellow banners on the roof are his luxuriant blond hair. The "pearl and ruby" door is the man's mouth— ruby representing red lips, and pearl representing pearly white teeth. The beautiful Echoes which issue from the pearl and ruby door are the poetic utterances of the man's harmonious imagination, here symbolized as an orderly dance. The angel-guarded valley in which the palace stands, and which Poe describes as "the monarch Thought's dominion," is a symbol of the man's exclusive awareness of exalted and spiritual things. The valley is what Poe elsewhere called "that evergreen and radiant paradise which the true poet knows . . . as the limited realm of his authority, as the circumscribed Eden of his dreams."

As you all remember, the last two stanzas of the poem describe the physical and spiritual corruption of the palace and its domain, and it was

to this part of the poem that Poe was referring when he told a corre-
spondent, "By the 'Haunted Palace' I mean to imply a mind haunted by
phantoms—a disordered brain." Let me read you the closing lines:

> But evil things, in robes of sorrow,
> Assailed the monarch's high estate.
> (Ah, let us mourn!—for never morrow
> Shall dawn upon him, desolate!)
> And round about his home the glory
> That blushed and bloomed,
> Is but a dim-remembered story
> Of the old time entombed.
>
> And travellers, now, within that valley,
> Through the red-litten windows see
> Vast forms that move fantastically
> To a discordant melody,
> While, like a ghastly rapid river,
> Through the pale door
> A hideous throng rush out forever,
> And laugh—but smile no more.

The domain of the monarch Thought, in these final stanzas, is dis-
rupted by civil war, and in consequence everything alters for the worse.
The valley becomes barren, like the domain of Roderick Usher; the eye-
like windows of the palace are no longer "luminous," but have become
"red-litten"—they are like the bloodshot eyes of a madman or a drunk-
ard. As for the mouth of our allegorized man, it is now "pale" rather
than "pearl and ruby," and through it come no sweet Echoes, as before,
but the wild laughter of a jangling and discordant mind.

The two states of the palace—before and after—are, as we can see,
two states of mind. Poe does not make it altogether clear *why* one state
of mind has given way to the other, but by recourse to similar tales and
poems we can readily find the answer. The palace in its original condition
expresses the imaginative harmony which the poet's soul enjoys in early
childhood, when all things are viewed with a tyrannical and unchal-
lenged subjectivity. But as the soul passes from childhood into adult life,
its consciousness is more and more invaded by the corrupt and corrupting
external world: it succumbs to passion, it develops a conscience, it makes
concessions to reason and to objective fact. Consequently, there is civil
war in the palace of the mind. The imagination must now struggle against
the intellect and the moral sense; finding itself no longer able to possess
the world through a serene solipsism, it strives to annihilate the outer
world by turning in upon itself; it flees into irrationality and dream; and

all its dreams are efforts both to recall and to simulate its primal, unfallen state.

"The Haunted Palace" presents us with a possible key to the general meaning of Poe's architecture; and this key proves, if one tries it, to open every building in Poe's fiction. Roderick Usher, as you will remember, declaims "The Haunted Palace" to the visitor who tells his story, accompanying the poem with wild improvisations on the guitar. We are encouraged, therefore, to compare the palace of the poem with the house of the story; and it is no surprise to find that the Usher mansion has "vacant eye-like windows," and that there are mysterious physical sympathies between Roderick Usher and the house in which he dwells. The House of Usher *is*, in allegorical fact, the physical body of Roderick Usher, and its dim interior *is*, in fact, Roderick Usher's visionary mind.

The House of Usher, like many edifices in Poe, is in a state of extreme decay. The stonework of its facade has so crumbled and decomposed that it reminds the narrator, as he puts it, "of the specious totality of old woodwork which has rotted for long years in some neglected vault." The Usher mansion is so eaten away, so fragile, that it seems a breeze would push it over; it remains standing only because the atmosphere of Usher's domain is perfectly motionless and dead. Such is the case also with the "time-eaten towers that tremble not" in Poe's poem "The City in the Sea"; and likewise the magnificent architecture of "The Domain of Arnheim" is said to "sustain itself by a miracle in mid-air." Even the detective Dupin lives in a perilously decayed structure: the narrator of "The Murders in the Rue Morgue" tells how he and Dupin dwelt in a "time-eaten and grotesque mansion, long deserted through superstitions into which we did not enquire, and tottering to its fall in a retired and desolate portion of the Faubourg St. Germain." (Notice how, even when Poe's buildings are situated in cities, he manages to circumscribe them with a protective desolation.)

We must now ask what Poe means by the extreme and tottering decay of so many of his structures. The answer is best given by reference to "The Fall of the House of Usher," and in giving the answer we shall arrive, I think, at an understanding of the pattern of that story.

"The Fall of the House of Usher" is a journey into the depths of the self. I have said that all journeys in Poe are allegories of the process of dreaming, and we must understand "The Fall of the House of Usher" as a dream of the narrator's, in which he leaves behind him the waking, physical world and journeys inward toward his *moi intérieur*, toward his inner and spiritual self. That inner and spiritual self is Roderick Usher.

Roderick Usher, then, is a part of the narrator's self, which the narrator reaches by way of reverie. We may think of Usher, if we like, as the narrator's imagination, or as his visionary soul. Or we may think of

him as a *state of mind* which the narrator enters at a certain stage of his progress into dreams. Considered as a state of mind, Roderick Usher is an allegorical figure representing the hypnagogic state.

The hypnagogic state, about which there is strangely little said in the literature of psychology, is a condition of semi-consciousness in which the closed eye beholds a continuous procession of vivid and constantly changing forms. These forms sometimes have color, and are often abstract in character. Poe regarded the hypnagogic state as the visionary condition *par excellence,* and he considered its rapidly shifting abstract images to be—as he put it—"glimpses of the spirit's outer world." These visionary glimpses, Poe says in one of his *Marginalia,* "arise in the soul . . . only . . . at those mere points of time where the confines of the waking world blend with those of the world of dreams." And Poe goes on to say: "I am aware of these 'fancies' only when I am upon the very brink of sleep, with the consciousness that I am so."

Roderick Usher enacts the hypnagogic state in a number of ways. For one thing, the narrator describes Roderick's behavior as inconsistent, and characterized by constant alternation: he is alternately vivacious and sullen; he is alternately communicative and rapt; he speaks at one moment with "tremulous indecision," and at the next with the "energetic concision" of an excited opium-eater. His conduct resembles, in other words, that wavering between consciousness and sub-consciousness which characterizes the hypnagogic state. The trembling of Roderick's body, and the floating of his silken hair, also bring to mind the instability and underwater quality of hypnagogic images. His improvisations on the guitar suggest hypnagogic experience in their rapidity, changeableness, and wild novelty. And as for Usher's paintings, which the narrator describes as "pure abstractions," they quite simply *are* hypnagogic images. The narrator says of Roderick, "From the paintings over which his elaborate fancy brooded, and which grew, touch by touch, into vaguenesses at which I shuddered the more thrillingly because I shuddered without knowing why—from these paintings (vivid as their images now are before me) I would in vain endeavor to educe more than a small portion which should lie within the compass of merely written words." That the narrator finds Roderick's paintings indescribable is interesting, because in that one of the *Marginalia* from which I have quoted, Poe asserts that the only things in human experience which lie "beyond the compass of words" are the visions of the hypnagogic state.

Roderick Usher stands for the hypnagogic state, which as Poe said is a teetering condition of mind occurring "upon the very brink of sleep." Since Roderick is the embodiment of a state of mind in which *falling*— falling asleep—is imminent, it is appropriate that the building which symbolizes his mind should promise at every moment to fall. The House

of Usher stares down broodingly at its reflection in the tarn below, as in the hypnagogic state the conscious mind may stare into the subconscious; the house threatens continually to collapse because it is extremely easy for the mind to slip from the hypnagogic state into the depths of sleep; and when the House of Usher *does* fall, the story ends, as it must, because the mind, at the end of its inward journey, has plunged into the darkness of sleep.

We have found one allegorical meaning in the tottering decay of Poe's buildings; there is another meaning, equally important, which may be stated very briefly. I have said that Poe saw the poet as at war with the material world, and with the material or physical aspects of himself; and I have said that Poe identified poetic imagination with the power to escape from the material and the materialistic, to exclude them from consciousness and so subjectively destroy them. Now, if we recall these things, and recall also that the exteriors of Poe's houses or palaces, with their eye-like windows and mouth-like doors, represent the physical features of Poe's dreaming heroes, then the characteristic dilapidation of Poe's architecture takes on sudden significance. The extreme decay of the House of Usher—a decay so extreme as to approach the atmospheric—is quite simply a sign that the narrator, in reaching that state of mind which he calls Roderick Usher, has very nearly dreamt himself free of his physical body, and of the material world with which that body connects him.

This is what decay or decomposition mean everywhere in Poe; and we find them almost everywhere. Poe's preoccupation with decay is not, as some critics have thought, an indication of necrophilia; decay in Poe is a symbol of visionary remoteness from the physical, a sign that the state of mind represented is one of almost pure spirituality. When the House of Usher disintegrates or dematerializes at the close of the story, it does so because Roderick Usher has become all soul. "The Fall of the House of Usher," then, is not really a horror story; it is a triumphant report by the narrator that it *is* possible for the poetic soul to shake off this temporal, rational, physical world and escape, if only for a moment, to a realm of unfettered vision.

We have now arrived at three notions about Poe's typical building. It is set apart in a valley or a sea or a waste place, and this remoteness is intended to express the retreat of the poet's mind from worldly consciousness into dream. It is a tottery structure, and this indicates that the dreamer within is in that unstable threshold condition called the hypnagogic state. Finally, Poe's typical building is crumbling or decomposing, and this means that the dreamer's mind is moving toward a perfect freedom from his material self and the material world. Let us now open the door—or mouth—of Poe's building and visit the mind inside.

As we enter the palace of the visionary hero of the "Assignation," or the house of Roderick Usher, we find ourselves approaching the master's private chamber by way of dim and winding passages, or a winding staircase. There is no end to dim windings in Poe's fiction: there are dim and winding woods paths, dim and winding streets, dim and winding watercourses—and, whenever the symbolism is architectural, there are likely to be dim and winding passages or staircases. It is not at all hard to guess what Poe means by this symbol. If we think of waking life as dominated by reason, and if we think of the reason as a daylight faculty which operates in straight lines, then it is proper that reverie should be represented as an obscure and wandering movement of the mind. There are other, and equally obvious meanings in Poe's symbol of dim and winding passages: to grope through such passages is to become confused as to place and direction, just as in reverie we begin to lose any sense of locality, and to have an infinite freedom in regard to space. In his description of the huge old mansion in which William Wilson went to school, Poe makes this meaning of winding passages very plain:

> But the house!—how quaint an old building was this!—to me how veritable a palace of enchantment! There was no end to its windings—to its incomprehensible subdivisions. It was difficult, at any given time, to say with certainty upon which of its two stories one happened to be. From each room to every other there were sure to be found three or four steps either in ascent or descent. Then the lateral branches were innumerable—inconceivable—and so returning in upon themselves, that our most exact ideas in regard to the whole mansion were not very far different from those with which we pondered on infinity.

Dim windings indicate the state of reverie; they point toward that infinite freedom in and from space which the mind achieves in dreams; also, in their curvature and in their occasional doubling-back, they anticipate the mind's final spiralling plunge into unconsciousness. But the immediate goal of reverie's winding passages is that magnificent chamber in which we find the visionary hero slumped in a chair or lolling on an ottoman, occupied in purging his consciousness of everything that is earthly.

Since I have been speaking of geometry—of straight lines and curves and spirals—perhaps the first thing to notice about Poe's dream-rooms is their shape. It has already been said that the enclosures of Poe's tales incline to a curving or circular form. And Poe himself, in certain of his essays and dialogues, explains this inclination by denouncing what he calls "the harsh mathematical reason of the schools," and complaining that practical science has covered the face of the earth with "rectangular obscenities." Poe quite explicitly identifies regular angular forms with everyday reason, and the circle, oval, or fluid arabesque with the otherworldly imagination. Therefore, if we discover that the dream-cham-

bers of Poe's fiction are free of angular regularity, we may be sure that we are noticing a pointed and purposeful consistency in his architecture and décor.

The ball-room of the story "Hop-Frog" is circular. The Devil's apartment in "The Duc de l'Omelette" has its corners "rounded into niches," and we find rounded corners also in Poe's essay "The Philosophy of Furniture." In "Ligeia," the bridal chamber is a pentagonal turret-room; however, the angles are concealed by sarcophagi, so that the effect is circular. The corners of Roderick Usher's chamber are likewise concealed, being lost in deep shadow. Other dream-rooms are either irregular or indeterminate in form. For example, there are the seven rooms of Prince Prospero's imperial suite in "The Masque of the Red Death." As Poe observes, "in many palaces . . . such suites form a long and straight vista"; but in Prince Prospero's palace, as he describes it, "the apartments were so irregularly disposed that the vision embraced but little more than one at a time. There was a sharp turn at every twenty or thirty yards, and at each turn a novel effect." The turret-room of "The Oval Portrait" is not defined as to shape; we are told, however, that it is architecturally "bizarre," and complicated by a quantity of unexpected nooks and niches. Similarly, the visionary's apartment in "The Assignation" is described only as dazzling, astounding and original in its architecture; we are not told in what way its dimensions are peculiar, but it seems safe to assume that it would be a difficult room to measure for wall-to-wall carpeting. The room of "The Assignation" by the way—like that of "Ligeia"—has its walls enshrouded in rich figured draperies which are continually agitated by some mysterious agency. The fluid shifting of the figures suggests, of course, the behavior of hypnagogic images; but the agitation of the draperies would also produce a perpetual ambiguity of architectural form, and the effect would resemble that which Pevsner ascribes to the interior of San Vitale in Ravenna: "a sensation of uncertainty [and] of a dreamlike floating."

Poe, as you see, is at great pains to avoid depicting the usual squarish sort of room in which we spend much of our waking lives. His chambers of dream either approximate the circle—an infinite form which is, as Poe somewhere observes, "the emblem of Eternity"—or they so lack any apprehensible regularity of shape as to suggest the changeableness and spatial freedom of the dreaming mind. The exceptions to this rule are few and entirely explainable. I will grant, for instance, that the iron-walled torture-chamber of "The Pit and the Pendulum" portrays the very reverse of spatial freedom, and that it is painfully angular in character, the angles growing more acute as the torture intensifies. But there is very good allegorical reason for these things. The rooms of "Ligeia" or "The Assignation" symbolize a triumphantly imaginative state of mind in which

the dreamer is all but free of the so-called "real" world. In "The Pit and the Pendulum," the dream is of quite another kind; it is a nightmare state, in which the dreamer is imaginatively impotent, and can find no refuge from reality, even in dream. Though he lies on the brink of the pit, on the very verge of the plunge into unconsciousness, he is still unable to disengage himself from the physical and temporal world. The physical oppresses him in the shape of lurid graveyard visions; the temporal oppresses him in the form of an enormous and deadly pendulum. It is altogether appropriate, then, that this particular chamber should be constricting and cruelly angular.

But let us return to Poe's typical room, and look now at its furnishings. They are generally weird, magnificent, and suggestive of great wealth. The narrator of "The Assignation," entering the hero's apartment, feels "blind and dizzy with luxuriousness," and looking about him he confesses, "I could not bring myself to believe that the wealth of any subject in Europe could have supplied the princely magnificence which burned and blazed around." Poe's visionaries are, as a general thing, extremely rich; the hero of "Ligeia" confides that, as for wealth, he possesses "far more, very far more, than ordinarily falls to the lot of mortals"; and Ellison, in "The Domain of Arnheim," is the fortunate inheritor of 450 million dollars. Legrand, in "The Gold Bug," with his treasure of 450 *thousand*, is only a poor relation of Mr. Ellison; still, by ordinary standards, he seems sublimely solvent.

Now, we must be careful to take all these riches in an allegorical sense. As we contemplate the splendor of any of Poe's rooms, we must remember that the room is a state of mind, and that everything in it is therefore a thought, a mental image. The allegorical meaning of the costliness of Poe's decor is simply this: that his heroes are richly imaginative. And since imagination is a gift rather than an acquisition, it is appropriate that riches in Poe should be inherited or found, but never earned.

Another thing we notice about Poe's furnishings is that they are eclectic in the extreme. Their richness is not the richness of Tiffany's and Sloan's, but of all periods and all cultures. Here is a partial inventory of the fantastic bridal-chamber in "Ligeia": Egyptian carvings and sarcophagi; Venetian glass; fretwork of a semi-Gothic, semi-Druidical character; a Saracenic chandelier; Oriental ottomans and candelabra; an Indian couch; and figured draperies with Norman motifs. The same defiance of what interior decorators once called "keeping" is found in the apartment of the visionary hero of "The Assignation," and one of that hero's speeches hints at the allegorical meaning of his jumbled decor:

> To dream [says the hero of "The Assignation"]—to dream has been the
> business of my life. I have therefore framed for myself, as you see, a bower
> of dreams. In the heart of Venice could I have erected a better? You behold
> around you, it is true, a medley of architectural embellishments. The

chastity of Ionia is offended by antediluvian devices, and the sphynxes of Egypt are outstretched upon carpets of gold. Yet the effect is incongruous to the timid alone. Proprieties of place, and especially of time, are the bugbears which terrify mankind from the contemplation of the magnificent.

That last sentence, with its scornful reference to "proprieties of place, and . . . time," should put us in mind of the first stanza of Poe's poem "Dream-Land":

> By a route obscure and lonely,
> Haunted by ill angels only,
> Where an Eidolon, named NIGHT,
> On a black throne reigns upright,
> I have reached these lands but newly
> From an ultimate dim Thule—
> From a wild weird clime that lieth, sublime,
> Out of SPACE—out of TIME.

In dream-land, we are "out of SPACE—out of TIME," and the same is true of such apartments or "bowers of dreams" as the hero of "The Assignation" inhabits. His eclectic furnishings, with their wild juxtapositions of Venetian and Indian, Egyptian and Norman, are symbolic of the visionary soul's transcendence of spatial and temporal limitations. When one of Poe's dream-rooms is *not* furnished in the fashion I have been describing, the idea of spatial and temporal freedom is often conveyed in some other manner: Roderick Usher's library, for instance, with its rare and precious volumes belonging to all times and tongues, is another concrete symbol of the timelessness and placelessness of the dreaming mind.

We have spoken of the winding approaches to Poe's dream-chambers, of their curvilinear or indeterminate shape, and of the rich eclecticism of their furnishings. Let us now glance over such matters as lighting, soundproofing, and ventilation. As regards lighting, the rooms of Poe's tales are never exposed to the naked rays of the sun, because the sun belongs to the waking world and waking consciousness. The narrator of "The Murders in the Rue Morgue" tells how he and his friend Dupin conducted their lives in such a way as to avoid all exposure to sunlight. "At the first dawn of the morning," he writes, "we closed all the massy shutters of our old building; lighting a couple of tapers which, strongly perfumed, threw out only the ghastliest and feeblest of rays. By the aid of these we then busied our souls in dreams. . . ."

In some of Poe's rooms, there simply are no windows. In other cases, the windows are blocked up or shuttered. When the windows are not blocked or shuttered, their panes are tinted with a crimson or leaden hue, so as to transform the light of day into a lurid or ghastly glow. This

kind of lighting, in which the sun's rays are admitted but transformed, belongs to the portrayal of those half-states of mind in which dream and reality are blended. Filtered through tinted panes, the sunlight enters certain of Poe's rooms as it might enter the half-closed eyes of a daydreamer, or the dream-dimmed eyes of someone awakening from sleep. But when Poe wishes to represent that deeper phase of dreaming in which visionary consciousness has all but annihilated any sense of the external world, the lighting is always artificial and the time is always night.

Flickering candles, wavering torches, and censers full of writhing varicolored flames furnish much of the illumination of Poe's rooms, and one can see the appropriateness of such lighting to the vague and shifting perceptions of the hypnagogic state. But undoubtedly the most important lighting-fixture in Poe's rooms—and one which appears in a good half of them—is the chandelier. It hangs from the lofty ceiling by a long chain, generally of gold, and it consists sometimes of a censer, sometimes of a lamp, sometimes of candles, sometimes of a glowing jewel (a ruby or a diamond), and once, in the macabre tale "King Pest," of a skull containing ignited charcoal. What we must understand about this chandelier, as Poe explains in his poem "Al Aaraaf," is that its chain does not stop at the ceiling: it goes right on through the ceiling, through the roof, and up to heaven. What comes down the chain from heaven is the divine power of imagination, and it is imagination's purifying fire which flashes or flickers from the chandelier. That is why the immaterial and angelic Ligeia makes her reappearance directly beneath the chandelier; and that is why Hop-Frog makes his departure for dream-land by climbing the chandelier-chain and vanishing through the sky-light.

The dreaming soul, then, has its own light—a light more spiritual, more divine, than that of the sun. And Poe's chamber of dream is autonomous in every other respect. No breath of air enters it from the outside world: either its atmosphere is dead, or its draperies are stirred by magical and intramural air-currents. No earthly sound invades the chamber: either it is deadly still, or it echoes with a sourceless and unearthly music. Nor does any odor of flower or field intrude: instead, as Poe tells in "The Assignation," the sense of smell is "oppressed by mingled and conflicting perfumes, reeking up from strange convolute censers."

The point of all this is that the dreaming psyche separates itself wholly from the bodily senses—the "rudimental senses," as Poe called them. The bodily senses are dependent on objective stimuli—on the lights and sounds and odors of the physical world. But the sensual life of dream is self-sufficient and immaterial, and consists in the imagination's Godlike enjoyment of its own creations.

I am reminded, at this point, of a paragraph of Santayana's, in which

he describes the human soul as it was conceived by the philosopher Leibniz. Leibniz, says Santayana, assigned

> a mental seat to all sensible objects. The soul, he said, had no windows and, he might have added, no doors; no light could come to it from without; and it could not exert any transitive force or make any difference beyond its own insulated chamber. It was a *camera obscura*, with a universe painted on its impenetrable walls. The changes which went on in it were like those in a dream, due to the discharge of pent-up energies and fecundities within it. . . .

Leibniz' chamber of the soul is identical with Poe's chamber of dream: but the solipsism which Leibniz saw as the normal human condition was for Poe an ideal state, a blessed state, which we may enjoy as children or as preexistent souls, but can reclaim in adult life only by a flight from everyday consciousness into hypnagogic trance.

The one thing which remains to be said about Poe's buildings is that cellars or catacombs, whenever they appear, stand for the irrational part of the mind; and that is so conventional an equation in symbolic literature that I think I need not be persuasive or illustrative about it. I had hoped, at this point, to discuss in a leisurely way some of the stories in which Poe makes use of his architectural properties, treating those stories as narrative wholes. But I have spoken too long about other things; and so, if you will allow me a few minutes more, I shall close by commenting briskly on two or three stories only.

The typical Poe story occurs *within* the mind of a poet; and its characters are not independent personalities, but allegorical figures representing the warring principles of the poet's divided nature. The lady Ligeia, for example, stands for that heavenly beauty which the poet's soul desires; while Rowena stands for that earthly, physical beauty which tempts the poet's passions. The action of the story is the dreaming soul's gradual emancipation from earthly attachments—which is allegorically expressed in the slow dissolution of Rowena. The result of this process is the soul's final, momentary vision of the heavenly Ligeia. Poe's typical story presents some such struggle between the visionary and the mundane; and the duration of Poe's typical story is the duration of a dream.

There are two tales in which Poe makes an especially clear and simple use of his architectural symbolism. The first is an unfamiliar tale called "The System of Dr. Tarr and Prof. Fether," and the edifice of that tale is a remote and dilapidated madhouse in southern France. What happens, in brief, is that the inmates of the madhouse escape from their cells in the basement of the building, overpower their keepers, and lock them up in their own cells. Having done this, the lunatics take possession of the upper reaches of the house. They shutter all the windows, put on

odd costumes, and proceed to hold an uproarious and discordant feast, during which there is much eating and drinking of a disgusting kind, and a degraded version of Ligeia or Helen does a strip-tease. At the height of these festivities, the keepers escape from their cells, break in through the barred and shuttered windows of the dining-room, and restore order.

Well: the madhouse, like all of Poe's houses, is a mind. The keepers are the rational part of that mind, and the inmates are its irrational part. As you noticed, the irrational is suitably assigned to the cellar. The uprising of the inmates, and the suppression of the keepers, symbolizes the beginning of a dream, and the mad banquet which follows is perhaps Poe's least spiritual portrayal of the dream-state: *this* dream, far from being an escape from the physical, consists exclusively of the release of animal appetites—as dreams sometimes do. When the keepers break in the windows, and subdue the revellers, they bring with them reason and the light of day, and the wild dream is over.

"The Masque of the Red Death" is a better-known and even more obvious example of architectural allegory. You will recall how Prince Prospero, when his dominions are being ravaged by the plague, withdraws with a thousand of his knights and ladies into a secluded, impregnable and windowless abbey, where after a time he entertains his friends with a costume ball. The weird decor of the seven ballrooms expresses the Prince's own taste, and in strange costumes of the Prince's own design the company dances far into the night, looking, as Poe says, like "a multitude of dreams." The festivities are interrupted only by the hourly striking of a gigantic ebony clock which stands in the westernmost room; and the striking of this clock has invariably a sobering effect on the revellers. Upon the last stroke of twelve, as you will remember, there appears amid the throng a figure attired in the blood-dabbled grave-clothes of a plague-victim. The dancers shrink from him in terror. But the Prince, infuriated at what he takes to be an insolent practical joke, draws his dagger and pursues the figure through all of the seven rooms. In the last and westernmost room, the figure suddenly turns and confronts Prince Prospero, who gives a cry of despair and falls upon his own dagger. The Prince's friends rush forward to seize the intruder, who stands now within the shadow of the ebony clock; but they find nothing there. And then, one after the other, the thousand revellers fall dead of the Red Death, and the lights flicker out, and Prince Prospero's ball is at an end.

In spite of its cast of one thousand and two, "The Masque of the Red Death" has only one character. Prince Prospero is one-half of that character, the visionary half; the nameless figure in grave-clothes is the other, as we shall see in a moment.

More than once, in his dialogues or critical writings, Poe describes the earth-bound, time-bound rationalism of his age as a *disease.* And that

is what the Red Death signifies. Prince Prospero's flight from the Red Death is the poetic imagination's flight from temporal and worldly consciousness into dream. The thousand dancers of Prince Prospero's costume ball are just what Poe says they are—"dreams" or "phantasms," veiled and vivid creatures of Prince Prospero's rapt imagination. Whenever there is a feast, or carnival, or costume ball in Poe, we may be sure that a dream is in progress.

But what is the gigantic ebony clock? For the answer to that, one need only consult a dictionary of slang: we call the human heart a *ticker*, meaning that it is the clock of the body; and that is what Poe means here. In sleep, our minds may roam beyond the temporal world, but our hearts tick on, binding us to time and mortality. Whenever the ebony clock strikes, the dancers of Prince Prospero's dream grow momentarily pale and still, in half-awareness that they and their revel must have an end; it is as if a sleeper should half-awaken, and know that he has been dreaming, and then sink back into dreams again.

The figure in blood-dabbled grave-clothes, who stalks through the terrified company and vanishes in the shadow of the clock, is waking, temporal consciousness, and his coming means the death of dreams. He breaks up Prince Prospero's ball as the keepers in "Dr. Tarr and Prof. Fether" break up the revels of the lunatics. The final confrontation between Prince Prospero and the shrouded figure is like the terrible final meeting between William Wilson and his double. Recognizing his adversary as his own worldly and mortal self, Prince Prospero gives a cry of despair which is also Poe's cry of despair: despair at the realization that only by self-destruction could the poet fully free his soul from the trammels of this world.

Poe's aesthetic, Poe's theory of the nature of art, seems to me insane. To say that art should repudiate everything human and earthly, and find its subject-matter at the flickering end of dreams, is hopelessly to narrow the scope and function of art. Poe's aesthetic points toward such impoverishments as *poésie pure* and the abstract expressionist movement in painting. And yet, despite his aesthetic, Poe is a great artist, and I would rest my case for him on his prose allegories of psychic conflict. In them, Poe broke wholly new ground, and they remain the best things of their kind in our literature. Poe's mind may have been a stronger one; yet all minds are alike in their general structure; therefore we can understand him, and I think that he will have something to say to us as long as there is civil war in the palaces of men's minds.

Poe's "Ligeia": I Have Been Faithful to You in My Fashion

Daniel Hoffman

T he very thought of a consummated marriage struck Poe's imagination with terror. As is plain from "The Spectacles" and "Loss of Breath," he was beset by redoubled fears of committing incest and of connubial non-performance—equally damned if he did and damned if he didn't. Poor Edgar responded by aggressively exhibiting himself to the view of the curious world. But such self-exposures proved a sort of send-up, like his voyages to the moon and into the maelstrom. Appearing in motley, Edgar commits burlesques so broad that the object lampooned can't be the author at all, but some other poor forked carrot with no more human reality in him than has the butt of a joke.

Still, not all the stories in Edgar Poe's "Marriage Group" are burlesques, the modern writer's approximation of fabliaux. No, these appear only in Poe's monogamous tales. When he contrives a plot involving not merely the marriage of a hapless Poetagonist but his *remarriage* also, then the gears, rods, and pistons of Poe's fictional *frisson*-machine shift from the bump and clatter of his Grotesques to the wilder, smoother rhythms of Arabesques. Then, then, his theme becomes too serious altogether for flummery or the release of fears in raucous laughter. Then, the fears are instead indulged, luxuriated in. They are savored, they are enjoyed.

Of the tales I have in mind, the finest and most fully articulated is

Reprinted from *Poe Poe Poe Poe Poe Poe Poe* (Garden City, N.Y.: Doubleday & Co., 1972), pp. 241–58. Copyright 1972 by Daniel Hoffman. Reprinted by permission of Daniel Hoffman.

surely "Ligeia." (Others include "Morella" and "Eleanora." The theme itself was one Poe had early tried to use in poetry, producing only the bathetic "Bridal Ballad.") And of all of Poe's tales "Ligeia" has been among the most frequently examined and explained, though to be sure its explainers seem to me systematically to have missed the point of the story, being diverted by whatever system of thought they attempt to impose on it. Controversialists in the learned journals have savaged one another over such questions as whether "Ligeia" is a tale of vampirism (drawing on the long roster of vampire fiction, legend, and belief) or a story of transmigration of souls (this involves the long history of soul-displacement in literature and fable). One scholar has recently proposed that in marrying Ligeia ("I met her first and most frequently in some large, old, decaying city near the Rhine") the narrator commits himself to Continental Romanticism; after Ligeia's demise, when he remarries Lady Rowena Trevanion of Tremaine, "fair-haired and blue-eyed," a girl apparently from Cornwall, narrator succumbs to the false lure of British Romanticism; in the end, however, his first and truer love reasserts her claim upon his intellectual fealty. I admit a case can be made for this. You'd be hard put to guess how convincing that case is, but if you've recently *read* Poe's "Ligeia," you may feel (as I do) that this theory about its "meaning" is too clever by half.

It's incontestable, though, that Ligeia herself is associated, in Narrator's mind, with *knowledge*. She is described, admired, adored, nay, worshipped, not so much for what she looks like, or for who she is, but for *what she knows,* what contemplation of her boundless mind makes Narrator (he nowhere names himself) think that he knows. The Beloved as Wisdom-Figure. One thing, though, which he *doesn't* know is rather surprising: "And now, while I write, a recollection flashes upon me that I have *never known* the paternal name of her who was my friend and my betrothed, and who became the partner of my studies, and finally the wife of my bosom." Husband, Husband, what, O what did you and your friend, your betrothed, the partner of your studies and the wife of your bosom talk about during the long hours in seminar which comprised your courtship? Did you never think to ask her her paternal name? Ah, Edgarpoe, you don't becloud *our* clear view of this romance with your obfuscations. You knew that name well, too well for remembrance. You caused yourself to pretend it was forgotten.

Deep as is his love for Ligeia, deeper still is a certain knowledge she possesses and represents to her adoring husband. Into this knowledge she seems to promise to initiate him. Nor should this surprise us, who have met Ligeia before—at least we have already met a *spirit,* if not a lady on the Rhine, who possessed that rather singular cognomen. The chief appeal of the name "Ligeia" to Edgarpoe was, I think—I have tried

to think as he thought and to hear with his ear—its chief appeal is, this is the only conceivable feminine name (assuming it to be such) which rhymes with the Great Key Word, *Idea:*

> Ligeia! Ligeia!
> My beautiful one!
> Whose harshest idea
> Will to melody run . . .
>
> Ligeia! wherever
> Thy image may be,
> No magic may sever
> Thy music from thee,

—as we remember from "Al Aaraaf," where this lady appears as the disembodied embodiment of Intellectual Beauty. In the tale, all her melodious wisdom seems to Husband to be concentrated in the expression of her eyes—

> How for long hours have I pondered upon it! What was it—that something more profound than the well of Democritus—which lay far within the pupils of my beloved? What *was* it? I was possessed with a passion to discover . . .
> There is no point, among the many incomprehensible anomalies of the science of mind, more thrillingly exciting than the fact—never, I believe, noticed in the schools—that in our endeavors to recall to memory something long forgotten, we often find ourselves *upon the very verge* of remembrance, without being able, in the end, to remember . . .

So, it appears, the knowledge all but revealed in Ligeia's luminous eyes is *something already known but forgotten,* a not-quite-vanished memory of some primal condition, anterior to this life. "I was sufficiently aware of her supremacy," says Husband, "to resign myself with a child-like confidence, to her guidance through the chaotic world of metaphysical investigation," knowing that "I might at length pass onward to the goal of a wisdom too divinely precious not to be forbidden."

Already we have the clues in hand to trace the parameters of an Archetype. The Archetype of the Fall of Man. Here are the elements: a Beloved Woman, Forbidden Knowledge, an irresistible compulsion to possess the latter by possessing the former. But we must not think that Poe is going to give us a Fortunate Fall. It is already subliminally clear that the forbidden wisdom, sought here under Ligeia's all-knowing tutelage, by the process of remembering back before the beginning of one's present existence, is of the same kind as that intellectual destination toward which the mariner hurtled, half unwitting, in "MS. Found in a Bottle": "It is evident that we are hurrying onward to some exciting

knowledge—some never-to-be-imparted secret, whose attainment is destruction.''

Ligeia's husband comes closer than did the mariner to defining that forbidden secret, since he has taken a cram course from his wife. "I have spoken of the learning of Ligeia: it was immense . . ." She epitomizes all knowledge, all wisdom, all learning. She is also the epitome of ideality, or spirit, a quality imparted to Husband by the haunting expression of her eyes. No merely human eyes, however lovely, ever held such mysteries, such clues to the unifying spirit which invisibly presides over the wayward chaos of our mortal world:

> And (strange, oh strangest mystery of all!) I found, in the commonest objects of the universe, a circle of analogies to that expression.

He finds analogies to the sentiment aroused within him "by her large and luminous orbs" (a term more apt for the moon than for the eye)—analogies in a growing vine, in "the contemplation of a moth, a butterfly, a chrysalis, a stream of running water." "I have felt it," he adds, "in the ocean—in the falling of a meteor. I have felt it in the glances of unusually aged people. And there are one or two stars in heaven. . . . I have been filled with it by certain sounds from stringed instruments, and not infrequently by passages from books. . . ."

In short, this is an anatomy of the universe, passing from the lowliest individual plant and animal lives through the life-giving element (water), into the outer spaces of the stars and meteors, thence beyond the fixities of matter into the existence of the spirit (in the "unusually aged," such as the crew of the spectral ship in "MS. Found in a Bottle"), and thence still farther outward to the music of the spheres, culminating in pure thought, as recorded in "passages from books." What a gaze had Ligeia! *Quels yeux!*

As I think again of this progression of analogies, it looks this time as though the *same ethereal quality* pervades the living creatures, inanimate things, the heavenly bodies, man's own sensations and his thought. By further analogy all of these are interchangeable with one another, partaking of the same ideality by which they resemble Ligeia's wondrous gaze. This interpenetration of the organic and the inorganic is perceptible only to the most highly organized sensibility, felt only by the most suprasensient nervous system, one in which the reactions of the body have become infused with the motions of the soul. Ligeia, it would seem, doesn't even have to make an effort so to perceive the world around her, it is her nature to make such perceptions visible to those—to one in particular—who truly love her, and who worship the reflection of her wisdom in her eyes.

The interpenetration of organic and inorganic, of matter and spirit by

each other's essence, is dramatized again in "The Fall of the House of Usher" and proves a principle of existence itself in "Eureka." There we will find that matter and spirit differ not in essence but in degree; their essence is in fact the same. This abstract postulate is essential to Poe's universe; because he really believes it to be true, both the terrors and the ecstasies of his tales are necessary and not to be avoided. But such speculations, in "Ligeia," are merely hinted at, presented analogically, referred to a still deeper, more secret mystery which they merely reflect.

Ligeia's husband, as we have been noticing, adores her, worships her, feels unworthy of her love, stands to her as a child before its mother, as an acolyte before his priestess. In fact Ligeia is herself a condensation of several relationships familiar in Romantic literature, as also in the literature of "*Romance* . . . that spirit which . . . presided, as they tell, over marriages ill-omened." Ligeia is both her husband's Muse and Sacred Mother. Now it is clear why Husband has never dared to ask her or remind himself of her "paternal name"; for if he did, he would have to face up to its being the same as his mother's. Nor would her married name be any better—hence we never learn *his* paternal name—since married to him, she bears the name of *his* father.

As Muse, as Mother-Figure, Ligeia resembles in several aspects that mythical abstraction come to life in a particular woman whom Robert Graves has revived yet again in our time and called The White Goddess. The algolagnic heroine is indeed a persistent visitant of literature, and in Ligeia we have Poe's fullest representation of "La Belle Dame Sans Merci." It is typical of Poe that her beauty is incarnate in an intellectual principle which unifies sensation and thought, matter and spirit, and—as we shall see—life and death. These are the gifts comprising her knowledge both sacred and forbidden, and intrinsic with her love at once all-giving and all-demanding. A dangerous woman to lose your heart to.

And this paragon of superhuman and metaphysical virtue is no seraph, as in "Al Aaraaf," but indeed a woman, "most violently prey to the tumultuous vultures of stern passion," a passion which her luckless husband quails to see in "the miraculous expansion of those eyes which at once so delighted and appalled me." Now, *vultures* (or condors), wherever met in Poe, signify, as in "Sonnet—To Science," our enslavement to Time in this real world where flesh is carrion. Passion, as we know from "Al Aaraaf" and "The Colloquy of Monos and Una," is the affliction of an impure nature, one not sufficiently devoted to the transcendence of its own fallen state to be worthy of inhabiting the paradisal star where purer spirits dwell. And Ligeia herself is "a prey to the tumultuous vultures of stern passion." It begins to seem as though this Muse and Sacred Mother is also an impassioned woman, covetous of her lover's body, desirous of his being prey to an equally tumultuous passion—for her.

But Poe was impotent. We have seen the evidence. We have the diagnosis from his psychiatrist, Dr. Princess Bonaparte. Professor Krutch anticipated her findings with his more cursory examination of the patient. I have to find their findings acceptable. The problem, in the story, in which the feckless husband represents some of the fantasies of Edgar Allan Poe, is this: What can an impotent lover do when his beloved is aroused to "the tumultuous vultures of stern passion"? A very interesting question, since he makes *her* the prey of the vultures, whereas in fact (were any of this a fact) she would make *him* the prey of her passions. Which would make *her* a vulture. Alas, what can he do?

He can solve everything by wishing her dead so hard that she dies. Apotheosized by both a "passage from books" and a poem on her lips, the poem of her own composing. Poe, always concentrating all the resources of his prose to the production of a unified effect, had prepared for the event. Perhaps, in Ezra Pound's phrase, he had "over-prepared the event." A passage from a book appears as epigraph to the tale. The same passage reappears at the end of the paragraph which itemized all the things, from chrysalis to the music of the spheres, of which Husband thought while gazing in Ligeia's "divine orbs":

> And the will therein lieth, which dieth not. Who knoweth the mysteries of the will, with its vigor? For God is but a great will pervading all things by nature of its intentness. Man doth not yield him to the angels, nor unto death utterly, save only through the weakness of his feeble will.

Quoted from Joseph Glanvill, according to Poe; though according to Edward Davidson the locus of such sentiments in Glanvill's work "has so far escaped detection" (*Poe: A Critical Study*, p. 77). No matter whether the attribution be apocryphal or not; Glanvill, "whom," says Saintsbury in his history of English literature, "the echoing magnificence of a sentence from him, prefixed to Poe's 'Ligeia,' may have made known to many more than have read him in his originals," provided Poe with as much glamor as Poe bestowed on him. For by attributing the above-quoted doctrine to Glanvill, Poe associates it with the seventeenth-century scholar who upheld both the objective study of Nature (he was an early defender of the Royal Society) and the truth of witchcraft (in *Sadducismus Triumphatus*). Not only does this suggest to the reader that he may take his pick, for all it matters, between science and witchcraft, reason and belief, to account for the anthropomorphism of the passage. It suggests also that Ligeia's wisdom encompasses all of the contrarieties and antinomies suggested by Glanvill's intellectual and supernatural pursuits.

Ligeia is apotheosized by a poem—her own poem—whispered by her dying lips. Dying, she wishes most of all for life; living, she had written

a poem in which the angels watch a troupe of mimes act out "the play [that] is the tragedy, Man / And its hero, the conqueror Worm." The Worm is Death, imagined by Ligeia as a serpent which writhes and devours men, amid

> . . . much of Madness, and more of Sin
> And Horror, the soul of the plot!

All this is done by actors emulating "God on high" and

> Mere puppets . . . who come and go
> At the bidding of vast formless things
> That shift the scenery to and fro,
> Flapping from out their condor wings
> Invisible Woe!

The poem is a condensation of the tale, and the philosophy—if it can be called one—which it presents tells us that life is an unassuaged disaster, an unequal battle between mankind and inexorable Death, enacted for the amusement of angels who make no move on man's behalf although the horror of the show makes even these angels "pallid and wan." Although *this* is life, Ligeia herself would rather live than die; and dying, she affirms (for the third time in the tale) the epigraph Poe claims to have borrowed from Glanvill:

> "O God!" half shrieked Ligeia, leaping to her feet and extending her
> arms aloft . . . "O God! O Divine Father!—shall these things be
> undeviatingly so!—shall this conqueror be not once conquered? Are we
> not part and parcel in Thee? Who—who knoweth the mysteries of the will
> with its vigor? Man doth not yield him to the angels, *nor unto death utterly,*
> save only through the weakness of his feeble will."

Even as she repeats again the sentence from Glanvill, "She died."

I must confess that Ligeia's performance as a poet casts a bit in doubt, for me, her prowess as Giantess of the Intellect. Assuming, that is, that she really is, as Husband thinks, equally gifted in all things. I mean, the author of "The Conqueror Worm" is hardly as divine a singer as Husband thought. Her poem, to be blunt about it, is a piece of fustian, not a patch on Blake's "O Rose, thou art sick," a mere eight-liner which suggests far, far more than it says. "The Conqueror Worm," on the contrary, says right out all that it could suggest, nor do its banal rhythm or obvious imagery leave anything—*anything*—to *our* imagination. So I take Ligeia-as-Poet as putative. Anyway, the poem is really only the prelude to her last words. Glanvill's.

Those words imply that if death is but a failure of our will, then our will can triumph over death if only volition be strong enough—that is,

as strong as God's. For, as Ligeia half-shrieked, "Are we not part and parcel in Thee?" So then, if we are, why can we not *will ourselves not to die?*

Or do Ligeia's last words mean, *We can will someone else not to die.* Ligeia, as everyone knows, comes back to this life again, taking over— *quel frisson!*—the body, the very corpse, of her husband's *second wife.* When Rowena is on her deathbed she arises and totters into the center of the chamber, looking, breathing, seeming for all the world like the Lady Ligeia. Although Rowena Trevanion of Tremaine was slight and fair-haired and Ligeia had been statuesque and dark, Rowena, dying, becomes raven-haired and tall, tall as Ligeia. Is this Ligeia willing her own metempsychosis, or is it her husband wishing her back to life-in-death a second time?

But we have left Husband bereft, after her first dying. We must see what he does with his life thereafter.

He's a rich widower now, for "Ligeia had brought me far more, very far more, than ordinarily falls to the lot of mortals." With this wealth he purchases an old abbey in England, and although prostrate with grief he somehow finds the energy completely to redecorate the interior of this capacious structure. The language here is revealing. The exterior of the abbey and its situation are described with almost every adjective in the Gothic repertoire: wildest, least frequented, gloomy and dreary grandeur, savage aspect, melancholy and time-honored memories, utter abandonment, remote and unsocial region, verdant decay. To this diction of the decadence wrought by ruin and time is joined the diction of decadence wrought by the human will, as Husband now describes the fitting-out of the interior in "a display of more than regal magnificence":

> Alas, I feel how much even of incipient madness might have been
> discovered in the gorgeous and fantastic draperies, in the solemn carvings
> of Egypt, in the wild cornices and furniture, in the Bedlam pattern of the
> carpets of tufted gold.

In the midst of all this wild opulence he "had become a bounden slave to the trammels of opium," and the description that follows is wilder still, as though the very architecture partook of the distorted involutions of his opium dreams. He describes the bridal chamber into which he led "the fair-haired and blue-eyed Lady Rowena Trevanion, of Tremaine":

> . . . and here there was no system, no keeping, in the fantastic display, to
> take hold upon the memory. The room lay in a high turret of the
> castellated abbey, was pentagonal in shape, and of capacious size . . .

It is a bizarre jumble of window-glass from Venice, a ceiling carved in Semi-Gothic, Semi-Druidical devices, from which hangs a Saracen cen-

sor, flickering over the Eastern ottomans and the Indian bridal-couch "with a pall-like canopy above." In each of the five corners stands a huge sarcophagus, "but in the draping of the apartment lay, alas! the chief fantasy of all": as the visitor to the apartment moved to the center of the room, "he saw himself surrounded by an endless succession of . . . ghastly forms . . . giving a hideous and uneasy animation to the whole."

Some readers have taken the décor in Lady Rowena's bower to represent Poe's ideal conception of the well-appointed chamber. But how different is this grotesque medley of sinister shapes, gloomy devices, and psychedelic shadows, from the tranquil bower of dreams in the Faubourg Saint Germain where we found Monsieur Dupin. No, Ligeia's successor and Husband are in a bower which externalizes the narrator's disordered mind, as does the earlier dream-chamber of Prince Mentoni in "The Assignation," that "apartment whose unparalleled splendor" made the observer "dizzy with luxuriousness" as "the senses were oppressed by mingling and conflicting perfumes." Mentoni's chamber anticipates the remarried husband's:

> In the architecture and embellishment . . . the evident design had been to dazzle and astound. Little attention had been paid to the decora of what is technically called *keeping,* or to the proprieties of nationality. The eye wandered from object to object, and rested on none . . .

Yet, in his "Philosophy of Furniture," Poe had created an ideal décor in which *"Repose* speaks in all" of the "effects," and where a single lamp with "a plain crimson-tinted ground-glass shade," hanging from the ceiling, "throws a tranquil but magical radiance over all." True, this chamber is, to our taste, rather opulent and it resembles in many particulars both the dream-bower of Mentoni and the bridal chamber made for Rowena. But the difference is all in the disarrangements there of the elements which are harmoniously unified in "Philosophy of Furniture." These disordered chambers are, like Poe's landscapes and the geography of his voyages, the projections outward into objects of the mind that both perceives and creates them.

Into such a chamber the husband now conducts his new bride. In so gloomily sinister a fashion has he furnished it that even he must ask, "Where were the souls of the haughty family of the bride, when, through thirst of gold, they permitted to pass the threshold of an apartment *so* bedecked, a maiden and a daughter so beloved?" The room which poor Rowena has entered is at once three *loci*: her bridal bower is her death chamber, and both, as I've said, are really in the mind—indeed, they *are* the mind, of the narrator.

What a marriage. Here, in this very chamber, he says, "I passed, with the Lady of Tremaine, the unhallowed hours of the first month of our

marriage." He notes with pleasure that his wife "shunned me and loved me but little"; for his part, "I loathed her with a hatred belonging more to a demon than to man." Now he can think of nothing but—Ligeia:

> Ligeia, the beloved, the august, the entombed. I revelled in recollections of her purity, of her wisdom, of her lofty—her ethereal nature, of her passionate, her idolatrous love.

And now he tells us that he's a habitual opium-eater. "In the excitement of my opium dreams," he says, he calls aloud Ligeia's name, "as if, through the wild eagerness, the solemn passion, the consuming ardor of my longings for the departed, I could restore her to the pathways she had abandoned—ah, *could* it be forever?—upon earth."

Need we be surprised that Ligeia is soon to reappear? Or that Rowena, so injured and insulted by Husband, will soon fall sick—with *the very same wasting disease* that carried off Ligeia? Or that once taken ill, Rowena will be terrified by the illusory movements of sinister shapes swirling about her?

We are now at the point in the tale where the unbelievable is about to happen. Unbelievable, that is, if you can believe any of what has happened thus far. The fact that we stay with Poe clear to the end, that despite the pompous inflation of style and the grotesqueness of situation and event, we read him through with enough suspension of disbelief to be ready for his final *frisson*—all this bespeaks Poe's success in mastering his obsessional materials by imposing upon them a coherent and necessary literary form. We give "Ligeia" enough credence not in spite of its stylistic grotesqueries but because of them. Poe, as we know, could write as clearly and as perspicuously as Defoe when he wanted to. But who would tolerate the plain style of Monsieur Dupin's sidekick in the mouth of Ligeia's husband? Each tells his own tale in the language, in the rhythms, in the rhetoric most appropriate to his own character. And that character is, for Poe, embodied in his mental, or as Poe calls it, his "psychal" state. The state of mind of the narrator in "Ligeia" is one of terrible, nearly insupportable exacerbation; he is living out compulsive fantasies which obtrude upon the opium trances in which he has sought refuge. But let's not mistake for this distraught and, I think, technically insane narrator, the mind of Edgar Poe. For it is Poe, with his equally tortured sensibility, who has exercised his intellectual and artistic faculties—has exhibited them in the fullness of their control—to make us aware of the mental disorder of his character, the husband of both Rowena and Ligeia.

Meanwhile, back in the deadroom, Rowena must die. She must recapitulate the death of Ligeia while Husband, half narcotized, looks on, helpless to save her from her death. Indeed, he may have caused, may

be causing it. Does he really murder Rowena? Some critics have approached this tale with the delicacy of the Prefect of Police, and disputations among them argue such points as this, as well as whether the tale is a ghost story or a love story (whose?). Besides, does Ligeia reappear in Rowena's body because *she* wills to come back to her husband, or because her husband wills her return? Roy Basler concluded that Husband poisons Rowena and imagines the rest. Mme Bonaparte identifies everybody in the tale, as is usual with her, with real persons: Husband = Edgar; Ligeia = Elizabeth Arnold; Rowena = Virginia Clemm but also Frances Allen. Were we to take Mme Bonaparte as literally as she takes Poe, would we have any right or reason to take either of them seriously?

Let there be light. If my mythologized interpretation of Ligeia as Muse and Mother-Goddess has any merit, then it follows that Rowena is the poor mortal woman whom the adept of the Mother Goddess loves, as a substitute or surrogate for the aforesaid Divine She. Her eyes do not fascinate Narrator; he barely mentions that they were blue—the wrong color, since Ligeia's orphic orbs were dark. She is all flesh, all flesh; no wonder he turns from her with loathing and "a hatred belonging more to a demon than to man," takes dope, and dreams of the unifying, tranquillizing, ethereal qualities of his lost tutelary spirit. And even Ligeia had become lost to him because, spirit though she was, she was also a mortal body, decaying, and "a prey to the tumultuous vultures of stern passion." Rowena resembles Ligeia only at the lower end of the spectrum of possible correspondences. Rowena rises to Ligeia-like spirituality only at the moment when she passes from life into death. Then, and only then, Ligeia's spirit passes into Rowena's body, and she looks like Ligeia. Several times, Narrator has examined her *eyelids* during her death-throes. Now, at the final moment, he at last mentions her *eyes*:

> "Here then, at last," I shrieked aloud, "can I never—can I never be mistaken—these are the full, and the black, and the wild eyes—of my lost love—of the Lady—of the LADY LIGEIA."

Terror, terror, terror grips us the first time we read this tale. A strange numbness at the heart, a willingness to be frightened at the very moment we would dismiss the spectre as a story-teller's audacious imposition. But we don't dismiss the imposition, we give in to the sensation of being terrified as though revelling in a voluptuous excitation. Why are we unwilling or unable to see through this most horrible trick of Hoaxiepoe's? Or, if able to see through it, unable to free ourselves from illusions exposed as illusions? Is it because we are reminded of something we are on the verge of remembering but cannot?

Later, after many readings in which the tale of "Ligeia" has never

lost its power to move me, I have asked myself what is the composition of that feeling which grips me now, as ever before, when I retrace the fantastic dreams of this narrator imagined by Edgar Poe. I recognized that terror contributes but half of the power that numbs the heart and makes the hackles rise. The other half comes from pity, pity, pity.

How sore, how mortal was the wound that left the *persona* through whom Poe speaks so bereft that after his first and primal love he could know no other? So overwhelmingly is he possessed by that first love that, should *he* choose to succeed the "raven-black" hair and brilliant black eyes of Ligeia with "the fair-haired and blue-eyed" Rowena, it first seems to him "a moment of mental alienation" when he betrayed his first love's memory by leading to the altar his second, so different in aspect. Then his love for her turns to hatred and loathing, a loathing and hatred he had unconsciously anticipated by decorating her bridal suite as a psychedelic torture-chamber. Whether the three drops of red liquid which fall into Rowena's wine-glass are *really* emanations from the spirit of the jealous Ligeia, or are poison placed there by the husband in his opium jag, or are his wild remembrance of the bloody sputum of the author's dying mother, Rowena must die—if indeed she ever lived save as a wraith in the guilt-haunted imagination of Ligeia's acolyte who could love no one, love nothing, but the almost-remembered actuality of Ligeia. Whether Rowena be wraith or woman, how can she sustain her own beauty, her own features, the color of her own eyes and hair, in the imagination of a lover who is so completely imprisoned by his first, his only, his only possible devotion?

It seems impossible to doubt that the prototypes of these experiences in the tale were the death of Eddie's mother, his guilty transference of love to Mrs. Allan, then later to various childhood sweethearts and at last to poor Virginia Clemm, each of whom died in the same lingering way and seemed no doubt to Edgar to be a resurrection of her predecessors only to re-enact her predecessors' death. Poor, poor Eddie Poe. But these hapless accidents of one miserable scrivener's biography are in "Ligeia" successfully mythologized, universalized, raised to the level of archetype. Strange though the combination seems, in Poe, of ideality with necrophilia, here he has imagined a condition of blessedness, its loss, the loser's search for its recurrence in another love-object, the intensification of that love into hatred for its substitute and longing for the lost love, and a final apotheosis in which the lost love seems to reappear.

Erotic interest is all but completely censored, is quite subsumed in Ligeia's metaphysics. Despite the one allusion to her "stern passion," there is no physical contact mentioned in either of Narrator's "marriages." This delicacy, or squeamishness, fooled several generations of readers into thinking that Poe was a spiritual writer—if they didn't take him for a fiend. Of course we can now read Poe with less prejudice, and

so we recognize that it is this suppressed erotic intensity which throbs and shudders throughout the tale. When Rowena is in her dying hours, Narrator cries,

> But why shall I minutely detail the unspeakable horrors of the night? Why shall I pause to relate how, time after time, until near the period of the gray dawn, this hideous drama of revivification was repeated; how each terrific relapse was only into a sterner and apparently more irredeemable death; how each agony wore the aspect of a struggle with some invisible foe. . . . Let me hurry to a conclusion.

Are these the throes of the dying body struggling to live, or of the living body struggling to die? What other experience does this description suggest than the repeated, excited violation of the body in successive, spasmodic orgasm? Death is usually a metaphor of sexual experience, all the more so for Poe because his own nature did not permit him to know, nor did the prurient mores of his class and time allow him to describe, sexual union in a normal way. Through the psychic identity of sexual extinction with death itself, Poe is enabled imaginatively to "possess" the beloved by experiencing the moment of her bodily dissolution.

I have already mentioned similarities between "Ligeia" and "The Assignation." In that story there are other interesting analogies to this one besides the décor of the dreamer's chamber. "The Assignation" is a tale of a consummated love—the consummation comes in the simultaneous suicides of the lordly dreamer-lover and his forbidden beloved, the Marchesa Aphrodite. Here, in this early tale, are some of the nascent images which will exfoliate in "Ligeia." The Marchesa, whose given name identifies her at once as indeed a Love Goddess, is, like Helen in the famous poem, and like Ligeia, described as having hyacinthine hair and hands of marble. These associations link all three beloved women with classic beauty, with the ideal purity of the ancient world, with the dignity of the earliest age of myth and epic. The Prince Mentoni achieves perpetual union with his Aphrodite by dying into her death. Ligeia's husband is not so fortunate, his beloved dies before him, and he must somehow summon her back, wish herself to will herself back, into life. But this cannot be. All that can be managed, while men suffer in their bodies and their spirits are tortured by the vultures of passion and the passage of time, is to bring her back to the instant of her leaving, as she slipped beyond the veil of the beyond. Closer than this we cannot come in this life to the mysteries of a knowledge which is forbidden to mortality, forbidden with a tabu as intense and as absolute as that which makes impossible a grown son's desire for the all-consoling love which as an infant he felt lavished on him by his mother, and which makes unthinkable his reciprocation.

Thus as fiction, as myth, as psychological archetype, the pattern of

imagined action in "Ligeia" is not only fantastic but self-consistent—and true, in its kinky way, to human experience as well as to the accidents of one particularly blighted life. Yet the myths of antiquity and the psychology of today do not fully elucidate this singular imaginative construct. For Poe, death is a metaphor of sexuality—and of something more. It is the multiple associations of death in Poe's work which lend his tales their particular fascination, their concatenation of terror and sublimity inextricably intermingled.

Death is personal extinction, the obliteration of this particular bundle of sensations and memories, and therefore terrifying. Death is also deliverance from the memories and sensations in which this particular person, this particular combination of atoms divided from the unity whence they came, is imprisoned—and thus death is welcome. Death is the necessitous apocalypse in which all divided creation hurtles toward instantaneous reunion in the oneness from which it had been sundered. Thus death, the most feared, is also the bringer of deliverance in a metapersonal ecstasy. But that is another story, as we see in the *Narrative of Arthur Gordon Pym* and in *Eureka*.

The Psychology of "The Murders in the Rue Morgue"

J. A. Leo Lemay

In the conclusion of "The Murders in the Rue Morgue,"
Edgar Allan Poe wrote three metaphors which challenge the reader. They
do not make literal sense. Dupin is explaining (for the final time) the
reason why the Prefect of Police failed to solve the mystery. Dupin says,
"in truth, our friend the Prefect is somewhat too cunning to be pro-
found." He illustrates the generalization with three paradoxical compar-
isons: "In his wisdom is no *stamen*. It is all head and no body, like the
pictures of the Goddess Laverna,—or, at best, all head and shoulders,
like a codfish."[1] I believe that if we fully understand the ways that these
three metaphors—and the final quotation—complement the story, then
we will understand the psychology of "The Murders in the Rue Morgue."

All three tropes point to a head-body dichotomy and all concern sex.
The first, "In his wisdom is no *stamen*," is an obvious paradox. What
does *stamen* have to do with wisdom? The *stamen*, of course, is a flower's
pollen-producing organ—comparable to the male genitalia. (Since the
stamen indicates one essential theme of the story, Poe may also have been
punning on the uncommon meaning of *stamen* as "the fundamental or
essential element of a thing."[2]) Literally, Dupin seems to be saying that
the Prefect failed to solve the mystery because he failed to take sex into
account—or because he failed to integrate the entire person, head and
body, intellect and sex. The second trope, "It is all head and no body
like the pictures of the Goddess Laverna," directly names the head-body

Reprinted from *American Literature*, 54 (May 1982), 165-88. Copyright 1982 by J. A. Leo
Lemay. Reprinted by permission of J. A. Leo Lemay.

dichotomy. In identifying the head with Laverna, Dupin reverses the normal, expected associations; for the head—the citadel of reason—is usually associated with intelligence and wisdom, as in the first trope. Laverna, however, is the classical goddess of the underworld, night, and thieves. She suggests crime and evil, not wisdom and good. This trope echoes at least two details in the story. The head-body dichotomy recalls the corpse of Madame L'Espanaye "with her throat so entirely cut that, upon an attempt to raise her, the head fell off" (p. 538). And the Goddess Laverna reminds us of an attribute of Dupin and the narrator, for the goddess of the night is evidently the "sable divinity" whom Dupin is "enamored of" (p. 532). The third trope is "or, at best, all head and shoulders, like a codfish." Does a fish have shoulders? Even by itself, the metaphor seems strained, since a fish appears to be an absurd choice. This comparison again reverses the normally positive associations of wisdom and instead identifies it with a fish-head, a monstrosity of mouth and jaws. The comparison again emphasizes the head-body dichotomy, thus reaffirming that "The Murders in the Rue Morgue" concerns this dualism. Further, the codfish reference, which calls attention to itself, probably does so for the sexual suggestion. Marlowe, Shakespeare, and other Renaissance writers frequently pun about cods and codfish, and Mark Twain's splendidly scurrilous poem "The Mammoth Cod" attests that the pun remained popular until well after Poe's time.[3] So when Poe drags in a reference to a codfish, I suspect that, as in the first trope, he alludes to sex, as well as to the head-body dichotomy.

The story's final sentence is at least as puzzling as these three comparisons. Poe ends with Dupin claiming that the Prefect has "attained his reputation for ingenuity" by a "master stroke of cant": "I mean the way he has *'de nier ce qui est, et d'expliquer ce qui n'est pas' "* (p. 568). The quotation, which Poe identifies as from Rousseau's *La Nouvelle Héloise*, may be translated "of denying that which is, and of explaining that which is not." But on a literal level, the quotation does not make good sense, for the Prefect neither explains nor denies what is or is not. . . . In its original context, Rousseau's statement concerns Plato's explanation of ghostly apparitions. The only direct mention of ghosts occurs when Dupin explains how he solved the mystery of the murderer's leaving the locked-room. "It is not too much to say that neither of us believe in praeternatural events. Madame and Mademoiselle L'Espanaye were not destroyed by spirits" (p. 551). The narrator of course agrees (and so, too, does the reader). Are we now supposed to think that the Prefect spent his time looking for ghosts?

Actually, throughout the story, Poe repeatedly suggests that it concerns psychology and sex, and particularly an opposition between the mind and the body.

In the tripartite introduction,[4] where Poe sets forth the story's themes and presents an analogue for its structure, the narrator begins by defining the nature of analysis. In doing so, he uses diction more appropriate to psychology and ethics than to science: "As the strong man exults in his physical ability, delighting in such exercises as call his muscles into action, so glories the analyst in that moral activity which *disentangles*" (p. 528). Notice the nature of the activity Poe's analyst "glories" in—the *moral* activity. Webster defined *moral* as "regarding vice or virtue, upright, good." But its usual meaning in Poe is the common one in eighteenth- and nineteenth-century "moral philosophy," i.e., "the knowledge or study of the principles of human nature or conduct; ethics."[5] Two points concerning the meaning of moral should be stressed: it refers exclusively to humans, and it concerns motivations rather than the results of action. Poe's analysis, therefore, specifically refers to the motivations and psychology of humans. The following sentences confirm this interpretation. The narrator comments that the analyst "derives pleasure from even the most trivial occupations bringing his talent into play" (p. 528). The examples of the "most trivial occupations" are "enigmas . . . conundrums . . . hieroglyphics." Poe thus directly tells the reader that although puzzles, mysteries, riddles, and detective stories (such as, on the plot level, "The Murders in the Rue Morgue") may be amusing for the analyst or creator, they are trivial in comparison with the "glorious" fascination of psychological investigation.[6] When, in the main story, Dupin begins the investigation by saying that "An inquiry will afford us amusement," Poe is again saying that the solution of the mystery is a trivial matter. Poe even calls our attention to Dupin's diction by having the narrator remark "[I thought this an odd term, so applied, but said nothing]" (p. 546). Dupin's later references to the mystery as a "riddle" (pp. 548, 560) also trivialize the undertaking, especially when Poe uses a polyptoton which calls attention to the diction: "The riddle, so far, was now unriddled" (p. 553). According to the narrator's statement on his introductory remarks, "The narrative which follows" should be read as "a commentary upon the propositions just advanced" (p. 531).

In addition to such necessary literal matters as bringing on stage the narrator and Dupin, describing their first meeting and subsequent relationship, and telling of their characters, Part Two of the introduction (pp. 531–33) begins the particular psychological explorations that are the major undercurrent. The narrator hints that "mere self" is the theme: "I was deeply interested in the little family history which he detailed to me with all that candor which a Frenchman indulges whenever mere self is his theme." The next paragraph's paradoxical conclusion repeats this theme and hints at the ultimate unity of the characters: "We existed within ourselves alone" (p. 532). The narrator describes the "peculiar

analytic ability" of Dupin. "He boasted to me, with a low chuckling laugh, that most men, in respect to himself, wore windows in their bosoms, and was wont to follow up such assertions by direct and very startling proofs of his intimate knowledge of my own" (p. 533). Poe here introduces the house-as-body metaphor ("windows in their bosoms")[7] and intimates that Dupin is a doppelgänger for the narrator. Dupin, of course, is the analyst; and the narrator, who tells the tale, is the creator. As Poe wrote in the introduction's Part One, the analyst is simply the reverse of the creator. Besides making Dupin (who, after all, tells much of the story and is thus the creator as well as the analyst) a doppelgänger for the narrator, Poe also makes Dupin a schizoid. His doubleness is directly stated after the narrator describes Dupin's voice and manner while analyzing. "Observing him in these moods, I often dwelt meditatively upon the old philosophy of the Bi-Part Soul, and amused myself with the fancy of a double Dupin—the creative and the resolvent" (p. 533). Poe thus implies that the persons in the story (or, at least, the narrator and Dupin) are symbolically (and psychologically) aspects of a single person.[8] And in saying that the narrator and Dupin create the story, Poe puns, for he means to imply that these two characters are also the murderers, the "creators" of the mystery. Our general idea of what is meant by the "old philosophy of the Bi-Part Soul" tends to confirm the identification of the "creators" or narrators with the murderer, for the "Bi-Part Soul" usually is thought of as a division existing within the soul itself, good and evil. (That Poe probably had in mind the Epicurean, especially Lucretian, philosophy is significant for the cosmological undercurrent of the story, with which I am not here concerned.)

Part Two of the introduction also presents three motifs that will recur in the story—the two voices, the similar details in the living arrangements,[9] and the suggested homosexual relationships.

The narrator says that during analysis, Dupin's "voice, usually a rich tenor, rose into a treble which would have sounded petulantly but for the deliberateness and entire distinctness of the enunciation" (p. 533). Dupin's two voices anticipate the two voices (which we later learn are the sailor and the orangutan) "heard in contention" (p. 549) in the locked room while the murders are taking place. Poe strategically emphasizes this repeated motif by describing the analysis-voice again (p. 548) just before Dupin examines the conflicting testimony concerning the voices. Dupin argues "what was *peculiar*" about "the whole testimony respecting" the voices was that while one was undoubtedly a Frenchman's "gruff voice," the other was an unidentifiable "shrill voice." Significantly, although Dupin already knows that an orangutan committed the murders and already believes that the Frenchman's voice was that of a sailor from "*a Maltese vessel*" (p. 560), he speaks of these two

voices as belonging to a single person: "the voices of this third party were those heard in contention" (p. 549). Poe thus suggests that the warring voices are the outward manifestation of the conflict between good and evil that existed within the murderer. Further, as I will show, Poe suggests that the dualism itself revealed by the "voices of this third party"—and not just the "evil" half of the "third party"—is responsible for the murders. The analogue, however, between Dupin's two voices and the voices of the sailor and the orangutan implies that the sailor and the orangutan are a double for Dupin. That also means, of course, that they are doubles for one another; and since Dupin is a double for the narrator, all four characters are symbolic doubles.

Second, as Richard Wilbur has pointed out, several details of the living arrangements of Dupin and the narrator are repeated for Madame and Mademoiselle L'Espanaye. Just as Dupin and the narrator live together in "perfect" seclusion (p. 532), so too do the L'Espanayes live "an exceedingly retired life" (p. 539). The narrator and Dupin admit "no visitors" (p. 532); and the L'Espanayes' neighbors testify that "No one was spoken of as frequenting the house" (p. 539). (In passing, I might note that the arrangements of the ape and the sailor also repeat this detail, for the sailor keeps the ape "carefully secluded," p. 564.) Both Dupin and the narrator and the L'Espanayes live in large houses otherwise empty (pp. 532, 539). The L'Espanayes occupy only two rooms in the house, and evidently Dupin and the narrator do also; and both couples' rooms are on the fourth and top story (pp. 537, 539). In view of the house-as-body allegory, the symbolic significance of occupying only the top floor is that both couples live only in the mind—therefore, both deny the body. (Significantly, this motif is not necessarily true of the sailor and the ape, although in making its escape from the sailor, the orangutan does flee "down the stairs," p. 565.) And just as Dupin and the narrator are "enamored of the Night" (p. 532), so the women have not yet gone to bed at three in the morning (p. 537). This group of similarities between the living arrangements of at least the two sets of characters suggests that they are doubles. In view of our earlier identification of Dupin and the narrator with the sailor and the orangutan, we may now conclude that on at least one thematic level, all three sets of characters are symbolic doubles. The murderer and those murdered, the solver of the mystery and the teller of the tale are, symbolically, one person. One result of this too-neat duplication is an aesthetic pleasure in the extraordinary unity of the tale's formal motifs and plot. But thematic reasons, as I shall show, also exist for the characters' final unity.

Third, Poe suggests that homosexual relationships exist between Dupin and the narrator, and between Madame and Mademoiselle L'Espanaye. The narrator frankly tells of his attraction to Dupin: "I felt my soul

enkindled within me by the wild fervor, and the vivid freshness of his imagination" (p. 532). The narrator says that "the society of such a man" was "to me a treasure beyond price." They decide to "live together during my stay in the city." The narrator assumes the traditional male economic role in a marriage: "I was permitted to be at the expense of renting and furnishing" the home (p. 532). And what is the narrator doing in Paris? Since he refers to Dupin as "The Frenchman" and explains in English the meaning of some French phrases, and since he is there only for a visit ("the spring and part of the summer of 18—," p. 531), the reader supposes he's an American or an Englishman.[10] Given the nineteenth-century American image of Paris, a common assumption would be that the narrator is there for a sexual fling. "Seeking in Paris the objects I then sought, I felt that the society of such a man would be to me a treasure beyond price." He adopts a supposedly traditional feminine role in submitting himself to Dupin: "into this *bizarrerie,* as into all his others, I quietly fell; giving myself up to his wild whims with a perfect *abandon.*" Here, the connotations of the diction ("bizarrerie," "wild whims," and "perfect abandon") suggest that the narrator submits to—and relishes—the strange sexual practices of Dupin. Further, the general description of the house, of the men's habits, and of their relationships (e.g., their "absolute seclusion"), all suggest a passionate love affair. When they do venture out (and it is only at night), they sally "forth into the streets, arm in arm" (p. 533). After this series of suggestions, Poe puns on Dupin's "intimate knowledge" of the narrator's bosom (p. 533). Typical of Poe's frequent thematic and symbolic irony,[11] he concludes Part Two: "Let it not be supposed, from what I have just said, that I am detailing any mystery, or penning any romance" (p. 533). (Oh no, not Poe.) But the real "mystery" is not the detective story (although it is on the plot level—and the main story is later repeatedly referred to as a "mystery," pp. 538, 547 (2), 548, 559), the real mystery for Dupin and especially for the reader ("him who contemplates it with a kindred art")[12] concerns the "moral activity which disentangles"—i.e., the psychological solution of the tale. And just as Poe puns about the two mysteries (the literal and thematic levels), so too he puns about the two romances (the story as romance and the homosexual romance).

Why did Poe introduce the homosexual suggestions? Partially because, I suspect, it amused him to slyly tweak his Victorian readers. But he also had good reasons. Homosexuality has psychological and symbolic meanings in Poe's fictive world that complement the story's major themes. Like the psychological reading of the story that I will advance, it suggests perverse psychology. (Indeed, on one level, homosexuality is the subject of Poe's "Imp of the Perverse.") For the union of the opposites, of male and female, suggests a complete whole, as in the archetypal symbolism

of a hermaphrodite. Poe repeated the theory of love Aristophanes advanced in the *Symposium* which held that the original humans, before Zeus split them, were both male and female, so that when humans as we know them joined together in sex, they were attempting to recapture their original unity (H, 14:44).[13] Perhaps Poe's most obvious allegory of the final unity of male and female is the masculine "Monos" and the feminine "Una" (who were formerly earthly lovers) in "The Colloquy of Monos and Una." But Poe repeatedly posits that the actual reality allows mankind only inadequate and fleeting glimpses of "the supernal Oneness." The existing state of things necessarily reveals "the Infernal Twoness" (M, 2:342). For Poe, homosexuality symbolizes mankind's imperfect and necessarily faulty attempt to achieve wholeness. It is the way things are. On the other hand, a satisfactory heterosexual relationship would symbolize completion and unity, yin and yang. The implied final unity of the three couples—Dupin and the narrator, Madame and Mademoiselle L'Espanaye, and the sailor and the orangutan—suggests the proper ingredients of what, in Poe's vision, constitutes an achieved unified life.

The homosexual motif is repeated in the story proper. The laundress testifies that the L'Espanayes "are very affectionate towards each other" (p. 539). The tobacconist indirectly says that Madame L'Espanaye was mannish, for he has been "selling small quantities of tobacco and snuff to Madame L'Espanaye for nearly four years" (p. 539). The truthfulness of the mother-daughter relationship is impugned by a clever sexual pun: "It was not known whether there were any *living connexions* of Madame L. and her daughter" (p. 539; my emphasis). Although they live in a large house and although another room on the fourth floor "was crowded with old Beds" (p. 542), yet the two women sleep in the same room and in the same bed (p. 539). Of course, like Dupin and the narrator, they live "an exceedingly retired life" together (p. 539). Poe even puns on their lack of male sexual relationships when he writes, "No one was spoken of as frequenting the house" (p. 539); for the phrase "to frequent a house" is often used for a house of prostitution. The rumor that "Madame L'Espanaye told fortunes" suggests that the neighbors found something not only unusual but also sexual about Madame L'Espanaye; for a fortune teller, like a masseuse, is often a cover for a prostitute; and perhaps Poe meant the name itself, L'Espanaye, to suggest the word *lesbian*.[14] At any rate, taken together, these details suggest a homosexual relationship.

The main plot of the story opens with the newspaper accounts of the "Extraordinary Murders." They describe at length a key symbolic action—the breaking-in of the door, which occurs "after some delay, occasioned by a fruitless attempt to procure admission in the usual manner"

(p. 537). If the action itself were not a possible symbol of rape (especially when accompanied by "a succession of terrific shrieks" and in the context of the house-as-body metaphor), the word *procure*[15] alone might alert the reader to a sexual interpretation. The second description of the breaking-in (contained in the gendarme's deposition) further emphasizes the action as a symbolic rape: "Forced it open, at length, with a bayonet—not with a crowbar. Had but little difficulty in getting it open, on account of its being a double or folding gate, and bolted neither at bottom nor top" (pp. 539–40). Just as the second description of the breaking-in more obviously suggests penetration of the vagina, so too, in the second description, the screams are contrasted with the panting moans of sexual intercourse: "The shrieks were continued until the gate was forced—and then suddenly ceased. They seemed to be screams of some person (or persons) in great agony—were loud and drawn out, not short and quick" (p. 540). If the reader—even unwittingly—suspects or feels that the forcible entry represents a symbolic rape, then Poe has accomplished several things.

First, the reader suspects—or at least feels—that something is going on in the story beside the obvious plot. Since sex in Victorian America was a taboo subject, the reader is slightly excited—and simultaneously fearful—at the prospect of a sexual undercurrent. The reader's response (the key element in Poe's esthetics) is similar to the narrator's when Dupin breaks into his thoughts with a comment proving that Dupin had read his mind. "I was even more startled than I would have been willing to express" (p. 534). Like the narrator, the normal reader (as the history of the interpretation of "The Murders in the Rue Morgue" proves) is fearful that his private thoughts may be exposed. Second, the reader begins to think (or at least to feel) in the right way—in terms of connotations, suggestions, and symbols. And third, the story's major subjects and themes are forced upon the reader. The house *is* a metaphor for the human body. The reader may have missed that implication in the introduction ("windows in their bosoms"), but he cannot avoid the emotional excitement generated by the symbolic rape. And if the doorway is the vulva, then the fourth and top floor—the area the women exclusively inhabit—is the mind. Poe believed that the reader should arrive at art's thematic truths by appreciating and analyzing his own emotional reactions. The emotions, Poe believed, pointed to the fundamental truth. Poe quoted Pascal approvingly: *"que tout notre raisonnement se réduit à céder au sentiment"* (M, 2:611). Poe's basic esthetic principle, unity of effect (his theoretical statements and practical demonstrations repeatedly reveal his overwhelming concern with the psychological response of the reader),[16] rests upon his fundamental ontological belief that emotions guided the reason—and even that emotions were truer than reason. Poe has Dupin

hint at this ontology: "But it is by these deviations from the plane of the ordinary, that reason feels its way, if at all, in its search for the true" (p. 548).[17]

Like the homosexual suggestions, the symbolic rape focuses the reader's attention upon sex. The rape should make the ideal reader wonder, what is Poe saying about sex? Poe gives two direct clues that the story should be read as an exploration in sexual psychology. The second day's newspaper account (which is the primary text which Dupin will subject to a critical analysis and which is given a title—"The Tragedy in the Rue Morgue"—that obviously makes it a microcosm of the entire story)[18] begins: "Many individuals have been examined in relation to this most extraordinary and frightful affair." Poe then has the narrator break into the newspaper report: "[The word *affaire* has not yet, in France, that levity of import which it conveys with us]" (p. 538). Obviously the interjected comment screams out the sexual denotation of *affair*.[19] The aside also stresses arbitrary cultural influences upon sexual attitudes, particularly the relatively liberal French customs in contrast to American ones. Later in the story, Dupin says, "By undue profundity we perplex and infeeble thought; and it is possible to make *even Venus herself* vanish from the firmament by a scrutiny too sustained, too concentrated, or too direct" (pp. 545–46; my emphasis).

Throughout the story, Dupin repeatedly says that the Parisian police overlook the obvious, and Poe repeatedly hints that the story concerns psychology and sex. So we return to our original question: what is the story saying about psychology and sex? How do the final tropes and the concluding quotation complement these themes? Actually, every reader believes, as he first reads the story, that he knows the nature of the murderer, and that he knows why the murderer killed the L'Espanayes. During Dupin's analysis, the thoughts of the reader are precisely guided and verbalized by the narrator, who functions as the reader/audience within the story. The role of the narrator as Dupin's naive companion and confidant is a brilliant technical achievement, for Poe puts the reader into the story in the narrator's place, and the reader discovers that the narrator verbalizes his own thoughts and reactions. The primary effect of Poe's tales of ratiocination is, of course, a delight in analysis—or, at least, a seeming delight in a seeming analysis. But as Poe wrote in defending Longfellow from a foolish criticism, no development is possible without subsidiary ideas and effects. He praised Longfellow for having "one *leading* idea which forms the basis of his poem; but to the aid and development of this one there are innumerable others, of which the rare excellence is, that all are in keeping, that none could be well omitted, that each tends to the one general effect" (H, 11:83). While Dupin questions the narrator and analyzes the newspaper report, we follow his

supposedly superior mental exertions with admiration—but we identify with the narrator, the ostensible dummy. Poe believed that "During the hour of perusal the soul of the reader is at the writer's control" (H, 11:108). And Poe harrows the reader's soul—even in the tales of ratiocination. The tone of "The Murders in the Rue Morgue" is primarily one of thoughtful analysis—but at the very time that Poe appeals to the reader's mind with analysis, he appeals to his emotions with frightening glimpses of the "Heart Laid Bare" (H, 16:128). It is the narrator who takes us through these emotions.

Repeatedly pressed by Dupin, the narrator is forced to confront the details of the murders and called upon for an explanation. In reply to Dupin's leads and questions, he finally blurts out, "A madman . . . has done this deed—some raving maniac, escaped from a neighboring *Maison de Santé*" (p. 558). At that moment, he voices every reader's confusion, despair, and conclusion. As Daniel Hoffman says after quoting this passage, "My very thoughts."[20] The narrator does not use our modern terminology and say that the murderer must have been a psychotic sex maniac—but that is clearly what he (and every one reading the story for the first time) must think. Poe deliberately creates this impression. The physician, Paul Dumas, suggests that the murderer of the young woman knelt on her: "A large bruise was discovered upon the pit of the stomach, produced, apparently, by the pressure of a knee." He testifies that the murderer of the older woman must have been a "very powerful man," wielding a "large, heavy and obtuse weapon" (pp. 543–44). Dupin repeatedly suggests that the crime must have been committed by a sex maniac. He asks the narrator if he "had observed anything *'peculiar'* at the scene of the atrocity." The narrator finds "something in his manner of emphasizing the word *peculiar*, which caused me to shudder." When we read the narrator's reaction, we too shudder at the peculiarity of the crime. And Dupin stresses the crime's outré character: "The police are confounded by the seeming absence of motive—not for the murder itself—but for the atrocity of the murder" (p. 547). This emphasis plunges us into a reasonless universe where madness and crime rage amidst chaos. Dupin alone seems able to order the universe through his superior analysis—but he is grotesquely naive. Dupin is himself the astronomer unable to see Venus because his scrutiny is too abstract.

Dupin subjects a statement in the newspaper account to analysis. "The drawers of the bureau, it is said, had been rifled, although many articles of apparel still remained within them" (p. 556). The narrator and the reader must therefore suppose that some "articles of apparel" had been taken. Evidently the police found it surprising that not all the "articles of apparel" had been taken. Dupin denies the implied conclusion. "The conclusion here is absurd"—but is it? In ostensibly proving his

point, Dupin relentlessly dwells on the "articles of apparel." "How are we to know that the articles found in the drawers were not all these drawers had originally contained?" By the repetition of the word *drawers,* Poe forces the reader to feel that what the police and Dupin are really talking about are panties or drawers, not a variety of "articles of apparel." Dupin continues his supposed refutation by characterizing the condition of the "apparel" stolen. "Madame L'Espanaye and her daughter lived an exceedingly retired life—saw no company—seldom went out—had little use for numerous changes of habiliment. Those found were of at least good quality as any likely to be possessed by these ladies. If a thief had taken any, why did he not take the best—why did he not take all?" . . . The reader knows. Dupin has told him that the only "articles of apparel" that remained in the drawers were those in good condition. The reader knows the murderer was not interested in such panties. That crazy wanted the worn ones. Dupin is blind to the facts of life—but, then, he inhabits only the fourth floor of his "Time-eaten and grotesque mansion" (p. 532). Dupin believes that breaking-and-entering, theft, gruesome mutilations and murders might well be committed for a few pieces of new linen worth a few francs—but not for psychotic sexual drives. Dupin is an incredible egghead, an intellectual, blind to the facts of life. His refutation concludes with the following triumphant statement of foolish logic: "In a word, why did he abandon four thousand francs in gold to encumber himself with a bundle of linen?" (p. 556). When he reads this statement, every reader is driven to conclude that he knows why. The murderer is a psychotic sex maniac.

Poe forces the reader to feel—and the careful reader to acknowledge—the reality and power of libidinous drives. Although the reader is rushed through Dupin's analysis by the rapid-fire verbal constructions ("saw no company—seldom went out"), he nevertheless impatiently assigns more force to the sexual psychosis than to the desire for money. The real point of Dupin's analysis is to make the reader *feel* the greater validity of the libidinous drives as a motive. For the reader can only know this truth by empathy—i.e., by putting himself in the place of the murderer. Throughout Dupin's analysis of the police deduction, Poe carefully shifts the implied question from whether or not the thief took anything at all from the room to why the murderer would abandon the money and steal worn panties. The reader's answer—that the murderer is a psychotic sex maniac—is at the same time a revelation that we all are potential psychotic sex maniacs, for the basic facts (that the "articles of apparel" were panties, and that the thief preferred to steal worn panties) have been supplied by the reader. To be sure, Poe intended we should make these associations and deductions, but they are certainly not stated by Dupin. Indeed, if we analyze his thinking in this passage, we must judge him a

complete naif. Poe thus succeeds in making the reader imaginatively guilty of the murders in the Rue Morgue. Further, the reader, through his combination of head and body, has entirely superior analytical powers to Dupin.[21]

For the following three paragraphs, Dupin continuously fastens our attention upon "the butchery itself": "Here is a woman strangled to death by manual strength, and thrust up a chimney, head downward. . . . In the manner of thrusting the corpse up the chimney, you will admit that there was something *excessively outré*—something altogether irreconcilable with our common notions of human action, even when we suppose the actors the most depraved of men" (p. 557). During the time that Dupin stresses the supposed abnormality of the crime, Poe deliberately makes the reader's flesh crawl. One high point in the reader's reaction occurs when Dupin finally finishes stressing the "*grotesquerie* in horror absolutely alien from humanity" which characterizes the murders and asks "What impression have I made upon your fancy?" (p. 558). In the manuscript, and in both the 1841 and 1843 printed versions, the narrator tells us "I shuddered as Dupin asked me the question." But Poe had used "shudder" for the narrator's reaction before (p. 547) and he wanted to intensify the effect, so in 1845 he revised the sentence to heighten the emotion and to force the reader to experience it: "I felt a creeping of the flesh as Dupin asked me the question" (p. 558). At the very time that Poe is making the reader experience the uncanny effect, he also makes the reader acknowledge—through Dupin's denial—that such crimes are *not* "irreconcilable with our common notions of human action." Similar crimes of mutilation and murder appear in every large-city newspaper nearly weekly. They are a fact of life—and of human nature. Dupin denies this gruesome reality. We want to agree, but we know better—and so we say that the murderer must have been a "raving maniac" (p. 558). Literally, the narrator is wrong, but as Dupin concedes, "In some respects . . . your idea is not irrelevant" (p. 558).

Poe's thematic irony expresses a symbolic truth. A psychotic sex maniac did murder the L'Espanayes. It is a great detective story—but the solution does not lie with the proof that an orangutan murdered the women. That solution, in terms of the story's own fictive world, is merely a "trivial" example of analysis. The "glorious" detective-work that Poe demands of the ideal reader is to solve the murders in terms of "that moral activity which *disentangles*" (p. 528). Poe challenges the reader to explain the murders as necessary outcomes of his characters' psychology. Dupin and the narrator, the sailor and the orangutan, and the L'Espanayes, are all the murderers—and the murdered. Indeed, every reader is made imaginatively to feel (and the ideal reader will ultimately perceive) that he is the murderer and the murdered.

The facts seem straightforward. A woman and her daughter live "an

exceedingly retired life" (p. 539). From a small income provided by "some property" (p. 541), the mother "made frequent deposits in small sums" in the same bank for eight years. For that entire time, she never withdrew any money until three days before her death "when she took out in person the sum of 4000 francs" (p. 541). Obviously Madame and Mademoiselle L'Espanaye planned a major change. Evidently they were about to give over their "exceedingly retired life." The normal reasons for great seclusion are extraordinary sensitivity and/or fear. The newspaper reports prove that Madame L'Espanaye possessed both these qualities. The tobacconist testified that the L'Espanayes' house "was formerly occupied by a jeweller, who under-let the upper rooms to various persons." But Madame L'Espanaye "became dissatisfied with the abuse of the premises by her tenant, and moved into them herself, refusing to let any portion." The tobacconist's common-sensical judgment is "The old lady was childish." Clearly Madame L'Espanaye was extraordinarily sensitive to "the abuse of the premises" (p. 539). The "abuse" was presumably the normal wear and tear caused by daily occupancy. The tobacconist judges her neurotic. Symbolically, in terms of the house-as-body allegory, Madame L'Espanaye objects to any use of the body. The underlying cause of her neurosis is also suggested by what we are told concerning the way she lives. The locked doors and windows, the seclusion, and the safe under the bed—all directly show her fear and all symbolically point to sexual suppression.

It may seem contradictory that Poe suggests both that the two women are extraordinarily fearful of sex and that they are homosexuals. But one nineteenth-century theory supposed that lesbianism often accompanied—indeed, was caused by—fear of heterosexuality.[22] Besides, Poe had other good reasons for including these seemingly conflicting implications. Like the homosexual suggestions, the fearfulness of the L'Espanayes calls the reader's attention to sexuality and (like the possible allusions to prostitution) emphasizes the L'Espanayes' lack of heterosexual activity. It also recalls the symbolic and psychological suggestions raised earlier by the implied relationship between the narrator and Dupin. But primarily, it suggests the nature of the transformation which the L'Espanayes are about to undergo. Madame L'Espanaye has withdrawn four thousand francs from the bank. The two women are doing something with the safe open (counting the money?) as they conclude their last-minute preparations for the coming change. Based upon what we have learned about them, we may predict the nature of that change. They are going to change from seclusion to an active participation in society; from fearfulness of heterosexual contacts to flirtation; and from an asexual or homosexual relationship to heterosexual relations. Yet, as all the evidence suggests, they greatly fear activity and heterosexuality.

Before drawing together the major strains of the story in a psycho-

logical solution to the murderer's identity, I should comment on the orangutan and the sailor. Both the sailor and the orangutan suggest unrestrained sexuality and animality. The idea of a sailor in port (like the old popular attitude toward a visit to Paris) has always been synonymous with gluttonous, abandoned sexuality. And the orangutan (commonly called the "wild man of the woods") is a version of the traditional "wild man," whose attribute is the club and who symbolizes lust and aggression.[23] The sailor and the orangutan are doubles. When the sailor enters Dupin's room, "He had with him a huge oaken cudgel" (p. 562). Although the orangutan has no club, the physician Paul Dumas testified that the mutilations of Madame L'Espanaye could have been caused by "A heavy club of wood" (p. 544). It may be symbolically significant that the gendarme (the representative of society's force and power) breaks in the door of the L'Espanayes' house "with a crowbar" (p. 537) or, as we later learn, "with a bayonet—not with a crowbar" (p. 539). For the club and other weapons recur in the story, forming a minor motif, always threatening violence. Even Dupin and the narrator prepare for violence, pistols ready (pp. 548, 562, 563). They will meet violence with violence. After Dupin shows his pistol, the sailor "started to his feet and grasped his cudgel" (p. 563). As Poe wrote in "The Philosophy of Composition," a change in mood on the part of the student was "intended to induce a similar one on the part of the reader" (H, 14:206). The pistols and the sailor's cudgel make the reader anticipate violence. The reader experiences an emotional heightening—an eagerness for violence—even if he does not acknowledge the possibility of violence lurking within himself.

The gendarme's breaking into the house with his bayonet is really the third symbolic rape, for the first and the second, as Marie Bonaparte has shown, are the orangutan's entry into the room and its subsequent murders.[24] The gendarme is thus identified with the orangutan (for both are symbols of lust and aggression), only the gendarme uses his bayonet/billy-stick/pistol to defend society, whereas the ape/sailor uses his razor/club against it. The symbolic reading of the story need not (contrary to Bonaparte) represent Poe's recapitulation of his infantile memories of his mother's love-making.[25] Instead, the symbolic reading reveals Poe's artful dramatization of characteristic and cultural ills within a context that presents Poe's remedy.

The sailor testified the events of that fearful night began when he returned "from some sailors' frolic on the night, or rather the morning of the murder" and "found the beast occupying his own bedroom, into which it had broken from a closet adjoining, where it had been, as was thought, securely confined" (pp. 564–65). This passage, suggesting confinement and repression, symbolically portrays the outbreaking of re-

pressed libidinal urges. It is of course a psychological truth that repressed drives will seek some outlet, perhaps with greater rigor because long repressed.[26] The orangutan, in imitation of its master, is shaving. Although this act had humorous and burlesque overtones (Mabbott notes that the story about a barber's pet monkey who shaves the customers is an old favorite of comics), it also admirably reinforces the story's main themes. The usual ending of the stories and broadside ballads about a monkey who shaves himself is that he cuts his own throat.[27] Symbolically, shaving is an act of castration.[28] In an ape's shaving himself, the symbolic castration becomes a literal decapitation. The orangutan's shaving in the denouement of the story recalls the gruesome description of Madame L'Espanaye "with her throat so entirely cut that, upon an attempt to raise her, the head fell off" (p. 538). And since, as I will show, Madame L'Espanaye psychologically and symbolically decapitated herself, the orangutan's shaving is thus a splendid analogue for the murders.

Poe even suggests that the Judeo-Christian ascetic tradition is responsible for the sexual illness of his characters and Western society. The sailor "had been accustomed, however, to quiet the creature, even in its fiercest moods, by the use of a whip" (p. 565). The image of whipping, used in connection with suppressing sexual symbols, calls up the masochistic repression of sexual desire by medieval ascetics. In his "Marginalia," Poe linked an absurd "*self*-infliction of punishment" with "the Dervishes, the Simeons, the monastic hair-cloths and shoe-peas, the present Puritanism and cant about the 'mortification' of the flesh" (H, 16:93). Poe's diction supports this interpretation, because *creature* ("to quiet the creature") in most Christian contexts means unregenerate man, that is, man viewed merely as a beast.[29] Poe's image of the sailor quieting the "creature" with a whip summons up the traditional Western—and specifically Christian—attitudes toward sex. Within the fictive world of "The Murders in the Rue Morgue," these ascetic attitudes are blamed for dividing man into body and soul and blamed for producing such symbolic grotesques as the ape and the sailor, who represent headless bodies, sheer sexuality and animality.

The other two sets of doubles, who live only in the fourth story, are also symbolic grotesques—bodiless heads. Dupin and the narrator, like the L'Espanayes, live in the fourth and top story of their house. In Poe's common house-as-body metaphor, they inhabit the mind only. Furthermore, in his analysis, Dupin completely denies the validity—and even ignores the existence of—sexual drives. Their denial of the body is their illness—and, in the case of the L'Espanayes, the cause of their death. The severed head of Madame L'Espanaye symbolizes both couples' psychological state. Poe presents us with a key to the psychological reading of the story in the three concluding metaphors—but they only serve as an

epilogue for the ideal reader, who has felt the truth of the symbols as they appear throughout the story and who applies analysis to the truth of the emotions. During his analysis, Dupin says "It is not too much to say that neither of us believe in praeternatural events. Madame and Mademoiselle L'Espanaye were not destroyed by spirits" (p. 551). Poe uses thematic irony as a clue to the truth. On the psychological level, they were indeed killed by spirits. Their mutilation and death enact the most grotesque possibility of their subconscious fears. Their nightmares come true. Madame and Mademoiselle L'Espanaye are killed by a psychotic sex maniac—but it lives within them, in their fears and in their dreams.

That is the significance of the story's final sentence. In Rousseau's *La Nouvelle Héloise*, Julia or the new Eloisa discusses the possibility of the soul's being separated from the body. As she lies on her death bed, the Enlightenment rationalist Julia ridicules the simplicity of those persons who have, in similar situations, promised to return to their friends to tell them about the other world. Julia claims that such promises are as absurd as the stories of ghosts and apparitions who are said to commit a thousand disorders and to torment credulous good women. In a note, Rousseau makes fun of Plato's psychological explanation of such fantasies, and ends by saying that such explanations are common to philosophers of all ages, who commonly deny what is, and explain what is not.[30] So "The Murders in the Rue Morgue" ends with Dupin saying he admires the Prefect G. for his "one master stroke of cant, by which he has attained his reputation for ingenuity. I mean the way he has *'de nier ce qui est, et d'expliquer ce qui n'est pas'* " (p. 568).

In the conclusion, Dupin (who has previously in the story been an egghead—a version of the Prefect G.) speaks for Poe, using thematic irony. Dupin and Poe are affirming the existence of spirits—in the subconscious.[31] By their mental illness, by their deliberate suppression of sexuality, by their denial of the body, the L'Espanayes have created the monster who kills them. The psychological level of the story suggests that a man's penis is the bludgeoning instrument of death. Not, to be sure, a real penis—but such a one as might exist in the imagination of a severely repressed female neurotic: "Any large, heavy, and obtuse weapon would have produced such results, if wielded by the hands of a very powerful man. No woman could have inflicted the blows with any weapon" (p. 544). When the narrator (and the reader) concludes that some psychotic sex maniac has committed the crime, he is right. The "raving maniac" (p. 558) exists in the L'Espanayes' minds. Their continual suppression of the body and sex, their heightened fears as they make their last preparations before breaking away from their old patterns of suppression, result in creating at this three A.M. climactic moment the monster who kills them. Psychologically, the L'Espanayes cut off their own heads. Poe por-

trays a violent and horrible murder, but it is not rare in Poe's or our own society. The literal murders symbolize common psychological murders. Perhaps, as Poe suggests, the traditions of Western and specifically Christian society are partly to blame. But Poe also suggests that archetypal symbols of separation and schizophrenia are found in classical times as well as modern, in France as well as America. They are an aspect of being human—and are characteristic of humanity.

The newspaper report stresses that Madame L'Espanaye's head was "fearfully mutilated . . . so much so as scarcely to retain any semblance of humanity" (p. 538), which might well make us wonder about Poe's definition of humanity. Dupin twice, in speaking of the peculiarity of the murders, claims that the crime contradicted "our common notions of human action" (p. 557), that it was "a *grotesquerie* in horror absolutely alien from humanity" (p. 558). But, as we have seen, the reader naturally assumes that the murderer was a psychotic sex criminal—a species perhaps unique to humanity and certainly one characteristic of humanity, as newspaper reports show. Further, every reader believes that a madman has committed the murder: not only because he knows that mankind is capable of such actions but because he finds himself excited by—and identifying with—the murderer. Poe proves that every reader will find that his own subconscious lusts and aggressions make the crime explainable. It is thematically ironic that the murderer is ostensibly non-human. We are, on the literal level of the story, relieved that mutilation and murder are perpetrated by something sub-human; that the *ingress* and *egress*, the shrill and gruff voices, may be so logically explained; but, actually, the symbolic and psychological truths of the story prove that we live in a non-rational, chaotic world, where man is the most inhuman of all animals. When Dupin reveals the ostensible truth to the narrator that the murderer was an orangutan, Poes drags in a reference to the "imitative propensities of these mammalia" (p. 559). Poe also stresses that the orangutan, after escaping from the closet, was imitating the sailor: "Razor in hand, and fully lathered, it was sitting before a looking-glass, attempting the operation of shaving, in which it had no doubt previously watched its master through the key-hole of the closet" (p. 565). Those very details which Dupin singled out as proving the mutilations to be "altogether irreconcilable with our common notions of human action" (p. 557) are the ones caused by the *humanness* of the orangutan's response when he sees the face of the sailor in the window. "The fury of the beast, who no doubt bore still in mind the dreaded whip, was instantly converted into fear. Conscious of having deserved punishment, it seemed desirous of concealing its bloody deeds, and skipped about the chamber in an agony of nervous agitation" (p. 567). Fear, shame, and consciousness are the human characteristics that cause the orangutan to

thrust the corpse of Mademoiselle L'Espanaye up the chimney and to hurl the old lady out the window. "In the manner of thrusting the corpse up the chimney, you will admit that there was something *excessively outré*— something altogether irreconcilable with our common notions of human action, even when we suppose the actors the most depraved of men" (p. 557). Dupin is wrong again. The thrusting of the corpse up the chimney is perfectly accounted for—in human terms. Only the strength necessary to do it is super- (or sub-) human. What is *peculiar* is that an orangutan would do it; but then, give the orangutan human characteristics, and his shame and fear perfectly explain the action.

The story proves that spirits exist—in man's subconscious—and the story attacks the Enlightenment enthroning of reason. It was poetic justice that caused Poe to set the story in Paris, for the guillotining of French intellectuals proved that the Enlightenment ideas inadequately defined man. Like Dupin, Rousseau is an emotional and psychological naif. Poe's story of decapitation, proving the fallacy of the Enlightenment ideal of man, recalls the French Revolution which, for the Romantics in general, was historical testimony to the psychological and ontological truth of "The Murders in the Rue Morgue."[32] Not that Poe believed man to be merely or even primarily body and emotions. He testifies elsewhere that he thought reason was man's distinguishing characteristic (H, 16:6–7). All three qualities should be integrated. A headless body is as grotesque— bears as little resemblance to true humanity—as a bodiless head. That is the ultimate significance of the characters all being doubles for one another. Dupin and the narrator represent the analyzing and creative intelligence—aspects of reason; the L'Espanayes represent the suppression of the emotions—another aspect of the head's supremacy; and the orangutan and the sailor represent animality and sexuality—the body alone. As the reader perceives the true nature of the murderous assailant (the breaking out of repressed libidinal drives), he also perceives the need for the integration of the entire self. Dupin frees Le Bon when he reveals that the murderer was an orangutan. Poe implies that we will free the good in man when we correctly identify the murderer as the repressed libido, for then we acknowledge it necessary to unify the opposing forces that exist in man.

Notes

[1] *The Collected Works of Edgar Allan Poe,* ed. Thomas Ollive Mabbott, 3 vols. to date (Cambridge: Harvard Univ. Press, 1969–), 2:568. Hereafter references to "The Murders in the Rue Morgue" will simply cite the page in Mabbott's edition. Other references to Mabbott's edition will use the formula M, 1:360 (i.e., Mab-

bott, vol. 1, p. 360). References to *The Complete Works of Edgar Allan Poe*, ed. James A. Harrison, 17 vols. (New York: T. Y. Crowell, 1902), will use the formula H, 8:170 (i.e., Harrison, vol. 8, p. 170).

[2]*OED*, s.v. "stamen," 2c. See Poe's usage at H, 11:146: "an absolute deficiency in basis, in *stamen*, in matter, or pungency."

[3]For example, *Faustus*, II, ii, 161–62; *Love's Labor's Lost*, III, i, 181; *Much Ado About Nothing*, III, iii, 133–35; and *Measure for Measure*, III, ii, 115–17. Mark Twain, *The Mammoth Cod*, intro. by G. Legman (Milwaukee: Maledicta, 1976).

[4]If we consider the main plot to be the murder mystery, then the story has a tripartite introduction: the observations on analysis (pp. 527–31), the introduction of the narrator and Dupin (pp. 531–33), and the anecdote of Dupin's "reading" the narrator's thoughts (pp. 533–37). Or one could argue that the introduction consists only of the observations on analysis.

[5]Noah Webster, *A Compendious Dictionary of the English Language* (New Haven: Hudson & Goodwin, 1806), p. 195. *OED*, s.v. *philosophy*, no. 4. Cf. Robert D. Jacobs, *Poe: Journalist and Critic* (Baton Rouge: Louisiana State Univ. Press, 1969), p. 132, n. 28, who suggests that Poe uses the word *moral* as "roughly equivalent to 'mental.' "

[6]The original first paragraph of the story (as written in the fair copy of the manuscript and as printed in the 1841 and the 1843 texts), made the psychological theme more obvious. Perhaps Poe found it too obvious, for he deleted the opening in his 1845 revision. For some implications of the deleted paragraph, see Donald Barlow Stauffer, "Poe as Phrenologist: The Example of Monsieur Dupin," in *Papers on Poe: Essays in Honor of John Ward Ostrom*, ed. Richard P. Veler (Springfield, Ohio: Chantry Music Press, Inc., at Wittenburg University, 1972), pp. 113–25.

[7]Poe's poem "The Haunted Palace" is perhaps his most obvious use of the house-as-body allegory. Richard Wilbur has commented on this motif in "The House of Poe," *Anniversary Lectures 1959* (Washington: Reference Department of the Library of Congress, 1959), pp. 21–38; reprinted in *The Recognition of Edgar Allan Poe*, ed. Eric Carlson (Ann Arbor: Univ. of Michigan Press, 1966), pp. 255–77.

[8]Wilbur has pointed out that the characters in a typical Poe story are "allegorical figures representing the warring principles of the poet's divided nature." "The House of Poe," in Carlson, pp. 274–75. And in Wilbur's "The Poe Mystery Case," he specifically claims that the "other 'persons' of the tale are to be taken allegorically as elements of one person, whereof Dupin is the presiding faculty." Richard Wilbur, "The Poe Mystery Case," *New York Review of Books*, 13 (July 13, 1967), 16, 25–28; reprinted in Wilbur's *Responses: Prose Pieces: 1953–1976* (New York: Harcourt Brace Jovanovich, 1976), pp. 127–37, at p. 136. See also Stauffer, p. 122.

[9]Richard Wilbur, "The Poe Mystery Case," first pointed out the repetitions of the voices and the similarity of the living arrangements and concluded that the repeated motifs indicated that the couples were doubles. *Responses*, pp. 135–37.

[10]Burton R. Pollin concludes that the narrator is "clearly . . . English or American." "Poe's 'Murders in the Rue Morgue': The Ingenious Web Unravelled," *Studies in the American Renaissance*, 1977, ed. Joel Myerson (Boston: Twayne, 1978), p. 238.

[11]I coin the term thematic/symbolic irony (on the analogy with dramatic irony) to describe the common literary presentation of an ostensibly foolish or wrong statement—that actually, on a thematic and/or symbolic level, points to a truth.

[12](H, 11:108). Poe repeatedly condemned the obvious presentation of a theme (or allegory/undercurrent, to use his own terms) and also repeatedly expressed the highest opinion of the ideal reader's responsibility. He even claimed that the ideal reader must possess all the literary ability of the author: "In fact, to appreciate thoroughly the work of what we call genius, is to possess all the genius by which the work was produced" (H, 16:66–67).

[13]Poe ignores Aristophanes' additional theories which hold that homosexuals also were originally double, and that their joining together also recaptures original unity. Plato, *Lysis, Symposium, Gorgias*, tr. W. R. M. Lamb (Cambridge: Harvard Univ. Press, 1967), pp. 135–47.

[14]The L'Espanaye/lesbian suggestion was made to me by Professor J. Gerald Kennedy at the conclusion of an oral version of this paper.

[15]*OED*, s.v. "procure," 5b.

[16]James Southall Wilson emphasized that Poe's "totality of effect" meant the "desired psychological effect" upon the reader. He aptly commented: "Singleness of idea, simplicity of design, and, in the story, directness and unity of plot, are means of attaining totality of effect, but they are not the end itself. It is the mind of the reader upon which he is working, not the texture and fabric of the thought expression." "Poe's Philosophy of Composition," *North American Review*, 223 (1926), 675–84, at 679 and 677. Walter Blair, "Poe's Conception of Incident and Tone in the Tale," *Modern Philology*, 41 (May, 1944), 228–40; Richard H. Fogle, "Organic Form in American Criticism, 1840–1870," in *The Development of American Literary Criticism*, ed. Floyd Stovall (Chapel Hill: Univ. of North Carolina Press, 1955), pp. 97–98; and George E. Kelly, "Poe's Theory of Unity," *Philological Quarterly*, 37 (1958), 34–44—all also emphasize Poe's concern with the reader's psychology.

[17]An indication of the importance of this hint may be found in *Eureka*, where Poe repeated the sentence and credited it to "The Murders in the Rue Morgue," H, 16:228. Poe also quotes Helvetius approvingly on the superiority of passion to reason, H, 10:131–32.

[18]The heart of the story is Dupin's analysis (pp. 547–62) of the evidence, beginning with his interpretation of the significance of some details in the newspaper reports. Dupin's analysis is, on one "undercurrent," a paradigm of how to read a story—but this is another major theme of "The Murders in the Rue Morgue" and cannot be discussed here.

[19]Poe repeated the word in the conclusion of the newspaper report ("affairs of this nature,"p. 544) and again in the fair copy and the 1841 and 1843 texts (p. 563).

[20]Daniel Hoffman, *Poe Poe Poe Poe Poe Poe Poe* (Garden City, N.Y.: Doubleday & Co., 1972), p. 112.

[21]Poe here exemplifies the criticism that he made of Macaulay's reputation. He claimed that the public was fooled into thinking Macaulay was a "profound thinker" because the public admired "logic for logic's sake," because the public confounded "the vehicle with the conveyed," and because the public could be

"so dazzled by the luminousness with which an idea is set forth as to mistake it for the luminousness of the idea itself" (H, 10:156). Compare Poe's observation on Dupin's logic in a letter to Philip P. Cooke: "These tales of ratiocination owe most of their popularity to being something in a new key. I do not mean to say that they are not ingenious—but people think them more ingenious than they are—on account of their method and *air* of method." *The Letters of Edgar Allan Poe*, ed. John Ward Ostrom (Cambridge: Harvard Univ. Press, 1948), 2:265.

[22]G. J. Barker-Benfield, *The Horrors of the Half-Known Life: Male Attitudes Toward Women and Sexuality in Nineteenth-Century America* (New York: Harper and Row, 1976), p. 39.

[23]James Hall mentions that the wild man's attribute is the club and identifies the ape with the wild man. *Dictionary of Subjects and Symbols in Art*, rev. ed. (New York: Harper and Row, 1979), pp. 22 and 341. See also Richard Bernheimer, *Wild Men in the Middle Ages* (Cambridge: Harvard Univ. Press, 1952).

[24]Marie Bonaparte, *The Life and Works of Edgar Allan Poe: A PsychoAnalytic Interpretation,* tr. John Rodker (New York: Humanities Press, 1971), pp. 454 and 447, respectively.

[25]Bonaparte, pp. 445–56.

[26]William Bradford offers this psychological explanation as one cause of the Plymouth colony's 1642 crime wave. *Of Plymouth Plantation,* ed. Samuel Eliot Morison (New York: Knopf, 1952), pp. 316–17.

[27]For numerous references to such broadside ballads, see G. Malcolm Laws, *American Balladry from British Broadsides* (Philadelphia: American Folksong Society, 1957), p. 279, no. Q14. Henry M. Belden first called attention to the ballad "The Monkey Turn'd Barber" as Poe's possible source in "The Vulgar Ballad," *Sewanee Review,* 19 (1911), 222–24. And Charles Clay Doyle, "The Imitating Monkey: A Folktale Motif in Poe," *North Carolina Folklore Journal,* 23 (1975), 89–91, pointed out that this folktale appears in various languages from the sixteenth century to the present and is common in the South.

[28]"To represent castration symbolically, the dream-work makes use of baldness, haircutting, falling out of teeth and decapitation." Sigmund Freud, *The Interpretation of Dreams,* v. 5 of *The Standard Edition of the Complete Psychological Works* (London: Hogarth Press, 1953), p. 357.

[29]Surprisingly, this common Christian meaning of *creature* is not defined in the *OED,* even though the examples (s.v. *creature*) under definition no. 2 for 1667 from Milton and under no. 3 for 1837 from Newman both illustrate it. The meaning descends from the Augustinian tradition wherein unregenerate man is viewed merely as a beast. The key Biblical text is 2 Corinthians v. 15: "Therefore if any man *be* in Christ, *he* is a new creature: old things are passed away; behold, all things are new" (King James version).

[30]Jean-Jacques Rousseau, *La Nouvelle Héloise,* ed. Daniel Mornet, 4 v. (Paris: Hachette, 1925), 4:314–15.

[31]Since Dupin earlier ignores the obvious sexual interpretation (see notes 15 and 19), he is thus an inconsistent character—or, rather, one whose basic principles for analysis are inconsistent. Of course he appears to be consistent. And even the most obvious allegories in Poe's tales, when closely examined, yield contradictory undercurrents. My reading of the psychological undercurrent in the tale strengthens the suggestion that Poe was influenced by "A Chapter on Gob-

lins," *Blackwood's*, 14 (1823), 639–46, where the writer argued for "the reality of apparitions"—on the basis that not to believe in apparitions is to give up romance. Poe goes that author one better—and proves that apparitions exist in every dreaming or subconscious mind. Benjamin Franklin Fisher IV, "Poe, Blackwood's, and 'The Murders in the Rue Morgue,' " *American Notes and Queries*, 12 (1974), 109–10.

[32]Brigid Brophy, "Detective Fiction: A Modern Myth of Violence," *Hudson Review*, 18 (1965), 11–30, and Albert D. Hutter, "Dreams, Transformations, and Literature: The Implications of Detective Fiction," *Victorian Studies*, 19 (1975), 181–209, have previously linked the French Revolution and the rise of the detective story, but they both believe that the genre embodies Enlightenment principles.

Hawthorne
The Scarlet Letter

Form and
Content in
The Scarlet Letter

John C. Gerber

In any competent literary work, we are often told, form and content are interdependent. And it is added, as a corollary, that the consistency and richness with which the two are adjusted to each other constitute the measure of artistic sophistication in the work. Our present interest is not so much with the theoretical possibilities of these two assertions as with their practical application to Hawthorne's *The Scarlet Letter*. For despite its early position in a substantial American literary tradition, the romance, when appraised by these standards, reveals itself to be a work of rather astonishing sophistication.

Some brief particularization is necessary for terms so general as "form" and "content." Form in *The Scarlet Letter* rises out of a basic division of the whole into four parts, each of which gains its distinctiveness from the character that precipitates or is responsible for the action that takes place within its limits.[1] Furthermore, the order of the parts is determined by the desires and capabilities of the characters. Thus the community, aside from the four main characters, is responsible for the action in the first part (Chapters I–VIII); Chillingworth for that in the second (IX–XII); Hester for that in the third (XIII–XX); and Dimmesdale for that in the fourth (XXI–XXIV). Within each part, moreover, there is a noticeable division between cause and effect, between material dealing primarily with the activating agent and material dealing primarily with the person or persons acted upon.

Reprinted from *New England Quarterly,* 17 (March 1944), 25–55. Copyright 1944 by *New England Quarterly*. Reprinted by permission of *New England Quarterly* and John C. Gerber. Professor Gerber wishes to express his indebtedness in this article for ideas suggested by Professors Gordon Roper, Clarence Faust, and Walter Blair.

Content in *The Scarlet Letter* consists of those three matters which dominate the thoughts and actions of the characters: sin, isolation, and reunion. Generally speaking, with Hawthorne isolation is inevitably the result of sin, and the desire for reunion is usually the result of isolation. But it is a mistake to suppose that any of these terms can be employed successfully in a general sense. No one of them is constant in meaning throughout the book.

There is, for example, no such thing as uniformity in the concept of sin. To assume this is to confuse the characters and to misinterpret most of the important speeches. Sin in *The Scarlet Letter* is a violation of only that which the sinner *thinks* he violates. To one character, adultery is transgression against God's law, to another, no more than a violation of the natural order of things. Likewise, to one character hypocrisy is a violation of his own nature, to another, a transgression against the moral code of the community. To speak, therefore, even of adultery or hypocrisy without discovering what they mean to each individual is to become hopelessly confused about what Hawthorne is doing. Furthermore, as the nature of the sin differs, so must the nature of the isolation which is its result.

More than anything else, probably, *The Scarlet Letter* is a study of isolation.[2] And just as one cannot generalize about sin in the book, so is it impossible to speak of isolation as though it were always one and the same thing. When a character feels isolated, he feels isolated from someone or something. Isolation, therefore, is a feeling of estrangement from those persons or elements whose code the individual feels that he has violated. By this definition, the study of isolation in *The Scarlet Letter* becomes a matter not only of comparing characters but also of ascertaining the successive degrees of estrangement within a single character.

The problem of reunion is even more complex. Given a sinful act, the consequent chain of cause and effect is something like this: sin brings isolation, isolation creates suffering, and suffering brings the desire to alleviate one's condition through reunion with the element from which one is isolated. At this point, however, an interesting paradox becomes apparent. Reunion in *The Scarlet Letter* is at once both highly individualized and strictly conventionalized. It is individualized in the sense that a character's attempts at reunion are obviously the result of his particular sense of sin and isolation; it is conventionalized in that Hawthorne allows only one pattern for its successful accomplishment. This pattern has three components: a personal sense of responsibility, repentance, and penance.[3] The first of these is essential to the second and third but does not necessarily create them, as Dimmesdale's suffering bears witness. The second is of supreme importance but seldom occurs. In *The Scarlet Letter* there

are only three examples of repentance, of which only the least important is presented in detail. The third, penance, is voluntary action designed totally to expiate the wrong. As such, it is not to be confused with the false type of penance which exists apart from repentance and which is wholly ineffectual. True penance must follow and be a manifestation of inward repentance. Ordinarily, it involves both confession and a plea for forgiveness. These, then, are the terms of reunion; and though isolation inevitably follows sin, reunion dispels isolation only when these terms are met.[4]

What should become progressively apparent in the following pages is that Hawthorne has so integrated form and content throughout *The Scarlet Letter* that they exist constantly in a state of interdependence. More specifically, he has so adjusted the two that in the first three parts of the book the activating character serves to multiply sin, intensify isolation, and diminish the hope of reunion. Only in the fourth does he allow the chief character, Dimmesdale, to reverse the process. How complex and yet precise is this adjustment can be realized only by a detailed examination of the book itself.

I

It is not surprising that Hawthorne should have the community directing events as the story opens. Indeed, once he has selected his main characters he can do little else, since none of them can logically create the social situation which is the necessary antecedent to the spiritual complication. Hester is indifferent to what the people think of her baby, Dimmesdale is afraid of what they think, and Chillingworth is too recent a newcomer to affect their thought. Hence, in no case can a social situation be forced unless the community forces it. When the story opens, therefore, the people of the town of Boston are the logical and necessary activators, and they remain such throughout the first eight chapters of the book.[5]

It is not entirely proper, however, to conceive of the community during this time as directly forcing the main characters into further sin. It does force isolation upon Hester. Otherwise, its function is to place the characters into such juxtaposition that new choices between good and evil must be made by each of them. If in every case the character chooses evil, the town can hardly be blamed except as an accessory before the fact. The rich irony of the situation is that the community while in the very act of abetting the spread of sin is complacently certain that it is stemming it.

Specifically, Boston places Hester upon the scaffold where she is seen

and recognized by Chillingworth; it compels Dimmesdale to speak about Hester before the entire town, thereby forcing the issue of confession; it throws Hester and Chillingworth together in prison, where Chillingworth, because of his wife's distraught condition, is able to extract a vow to conceal his identity; it requires Hester to wear the scarlet letter; and through a threat against Pearl it brings the main characters together in a scene at the Governor's hall in which Dimmesdale unwittingly betrays his feelings to Chillingworth. The effects of these acts in terms of sin and isolation can best be observed by considering the characters separately.

No one of the three main characters comes into the story guiltless. Of the three, however, Hester has the misfortune of being the only one unable to hide her guilt, and so it is upon her that the penalties of the community fall. It is unnecessary to go into detail about her public humiliation or her subsequent life in the small cottage at the edge of town. What interests us is the reaction which this enforced estrangement has upon her. And to understand this, we must first understand Hester's own attitude toward her misstep.

In the first place, it is evident that Hester does not feel that she has sinned against God. Partly this is so because God has never been a very real presence in her life. But chiefly, we are led to infer, it is because she experiences no new sense of estrangement from Him as the result of her adultery. She attends church "trusting to share the Sabbath smile of the Universal father" and undoubtedly would do so were the minister able to refrain from making her the topic of his sermon. Moreover, though man has punished her for her sin, God has given her "a lovely child, whose place was on that same dishonored bosom, to connect her parent for ever with the race and descent of mortals, and to be finally a blessed soul in heaven!" God, then, has not looked with unkindness upon her deed.

Hester is certain, too, that she has violated no law of her own nature. She is by nature affectionate, even passionate. Her relation with Dimmesdale, consequently, has been the almost inescapable result of her own nature, not a violation of it. As a matter of fact, it is this same affection which now holds her to Boston, even though she concocts for her conscience a pleasantly moral half-truth that she is remaining in order to effect a purification of her soul. Hawthorne does not make all of this completely clear in the first eight chapters. But later, when Hester speaks of her deed as having a "consecration of its own," we can see how firmly she believes that her own nature and the deed have been in harmony.

In the third place, it is plain that Hester does not feel that she has sinned against the community. Indeed, from the very beginning it is evident that the selectmen's attempt to induce inward repentance by outward penance is to result in failure. For though Hester submits to the

public exhibition and to the wearing of the scarlet letter, it is clear that her heart has not been touched. Even her dress on that first day seems to express "the desperate recklessness of her mood." With the passing of time, she tones down her dress and softens her attitude, but she continues to manifest rebellion in the bright and imaginative embroidery of the letter which the community intended as a heavy sign of guilt. Pearl, the other symbol of her error, she clothes in the gayest of colors. If any further evidence is needed, it is contained in the statement that she "was patient,—a martyr, indeed—but she forebore to pray for her enemies; lest, in spite of her forgiving aspirations, the words of the blessing should stubbornly twist themselves into a curse." The plain truth of the matter is that Hester feels she has not sinned against the community, and therefore that the community has no right to inflict penalties. The only real result, then, of the community's action is to isolate Hester from her neighbors in spirit as well as in person.

Yet in spite of all this, Hester knows that her deed has been wrong and that, somehow, the result cannot be good. This is manifest in her anxiety for Pearl, whom she watches constantly, fearful of detecting some "dark and wild peculiarity." Soon she finds it in Pearl's waywardness and unpredictability.

> The child could not be made amenable to rules. In giving her existence, a great law had been broken; and the result was a being whose elements were perhaps beautiful and brilliant, but all in disorder; or with an order peculiar to themselves, amidst which the point of variety and arrangement was difficult or impossible to be discovered.

The great law which Hester feels she has broken, therefore, is the law of order. Not conscious of being a sinner in the orthodox sense of the word, she is nevertheless bitterly aware of the fact that she and Dimmesdale have introduced an act of disorder into an orderly universe. And being aware of this, she can realize that some estrangement from the natural course of life is her due. That this estrangement should be forcibly meted out by the community, however, she can logically resent as being cruelly irrelevant.

The first act of the community with regard to Hester is a distinct failure. Its second is just as wide the mark when, in an attempt to bring some peace to her spirit after her ordeal in the market-place, it makes future peace almost unattainable. For by introducing Chillingworth into her prison apartment, the community through its jailer can be held at least indirectly responsible for the vow of secrecy which Chillingworth is enabled to extract. By natural inclination, Hester scorns deception. Consequently, to have become partner to a plot which surrenders her lover to his worst enemy is for her to commit an act which ultimately

she regards as an inexcusable violation of her nature.[6] The immediate result, of course, is to place an additional barrier between her and Dimmesdale; the ultimate result is to create that remorse which is a sign of division and estrangement within the soul.

Like Hester, Chillingworth does not come into the market-place of Boston guiltless. Formerly a brilliant and even kindly man, he erred first when he prevailed upon Hester to marry him. The nature of this act is plain to him. "Mine was the first wrong," he admits, "when I betrayed thy budding youth into a false and unnatural relation with my decay." With sure insight he is quick to see that out of this violation of the natural order only further falsity can result. "Nay, from the moment when we came down the old church steps together, a married pair, I might have beheld the bale-fire of that scarlet letter blazing at the end of our path!" But having admitted this responsibility, Chillingworth is unable or unwilling to go further.

Given the opportunity through the community's manipulation of events, Chillingworth chooses to intensify rather than to expiate his guilt. Hester he simply decides to ignore, and in so doing he sins again by setting up a relation which he, if forced, would have to admit to be false to his marriage vows and unnatural to human affection. To assert to Hester that "between thee and me, the scale hangs fairly balanced" is simply to deny the responsibility which he professed a moment before. One sin in Hawthorne's scheme never checks off another. Hester's lover, moreover, Chillingworth vows to have for himself. To achieve this, he must conceal his identity and thereby set up a false relation between himself and the community. In this fashion he prepares the ground for the "black flower" which is to be his third and greatest sin.

Dimmesdale is not a central figure in the first part of *The Scarlet Letter;* yet the effect of the community upon him is easily discernible and none the less profound. From the first it is obvious that Dimmesdale is a godly person. To his fellow townsmen he is their "godly pastor" or the "godly Master Dimmesdale." It is emphasized, moreover, that "so far as his duties would permit, he trod in the shadowy by-paths, and thus kept himself simple and child-like; coming forth, when occasion was, with a freshness, and fragrance, and dewy purity of thought, which, as many people said, affected them like the speech of an angel." It is not surprising, consequently, that when Dimmesdale finally comes to confess his act of adultery, he should consider it a violation of God's laws. This is, of course, anticipating a later part of the book, but the point to be made here is that when we first see Dimmesdale, we see a man already conscious of having sinned against his Lord. The resulting estrangement has already made its mark upon him.

Unfortunately for Dimmesdale, his sin cannot remain uncomplicated

so long as he remains in Boston. For the righteous colony of Massachusetts is a place "where iniquity is dragged out into the sunshine." To hide one's sin is to violate the basic principle of the community's moral code. Thus is a new issue raised for the unhappy minister. To refrain from confessing his adultery is to add sin against the community to sin against God. The issue, in fact, is more than raised; it is forced home. In view of the entire town he is compelled by the Reverend Mr. Wilson to exhort Hester to reveal the identity of the baby's father. Thus, before the whole community, by failing to confess his guilt Dimmesdale breaks the community's cardinal precept. Like Hester and Chillingworth, he becomes twice the sinner and twice the outcast. This is a sorry result, indeed, for the activities of so godly a place as Boston in the seventeenth century!

II

The transition from the first to the second part of *The Scarlet Letter* is so sound in motivation and so subtle in presentation that the reader is likely to be unaware until pages later that a fundamental break in the book has been passed. It occurs in this way. At the conclusion of Chapter VIII, the Reverend Mr. Wilson, as spokesman for the community, closes the case of Boston *versus* the unknown lover of Hester Prynne. In turning down Chillingworth's request for further investigation he says:

> "Nay; it would be sinful, in such a question, to follow the clew of profane philosophy. Better to fast and pray upon it; and still better, it may be, to leave the mystery as we find it, unless Providence reveal it of its own accord. Thereby, every good Christian man hath a title to show a father's kindness towards the poor, deserted babe."

It is abundantly clear, however, that so charitable a disposition of the case is not acceptable to Chillingworth. Not only has he vowed to discover the identity of Hester's lover, but already his mind has been kindled by the possibilities of "a philosopher's research" into the mystery. Confronted with this double urge to investigation on the one hand and the community's withdrawal from the case on the other, the old doctor is placed in a position where he must force the action or give up all but the slenderest hope of revenge. By this time, however, the reader knows enough about Chillingworth to realize that the second alternative is for him not really an alternative at all. The reader, therefore, is not at all surprised that in Chapter IX the responsibility for the main action of the story shifts from the community to him.

The happenings which Chillingworth precipitates in this second part

of the book can be quickly summarized. At first by frequent consultations and then by effecting an arrangement whereby he can live in the same house with Dimmesdale, the physician succeeds in becoming a daily and often hourly irritant to Dimmesdale's already sensitive conscience. Cautiously but surely, he succeeds in wearing down the young minister's defenses until in desperation Dimmesdale resorts to flagellation, fasts, and long vigils to ease the increasing torture. Generally, this section is a study of psychological cause and effect, with the victim frantically but ineffectively trying to deal with the effects rather than eliminating the cause. More particularly, it is a rich study in guilt and isolation. Before it is over, Chillingworth forces Dimmesdale into so deep a consciousness of sin that to the distracted minister it seems as if all the bonds which have held him to the forces for right have frayed beyond repair. But in so doing, Chillingworth breaks all his own connections with what Mr. Arvin calls "the redemptive force of normal human relations,"[7] and substitutes for them an ineluctable union with evil.

The astounding effects of Chillingworth's activities upon himself are telescoped largely into two chapters. At their beginning he is a learned and not unkind old man; at their end he is a fiend, ecstatic in petty triumph. Between these two extremes is a sequence of deliberately committed acts which can be understood only in terms of his character and beliefs. The main point to keep in mind is that Chillingworth never conceives of his own actions as righteous or sinful, but only as natural or unnatural. In so doing, he submerges moral values in the great physical processes of the universe. Truth for him, we may then infer, lies in these processes, and man's greatest task is to find it out. As we observe the earlier Chillingworth more closely, we discover that there are two means which he believes are essential to this end of man: intellectual zeal and social harmony. Of these the former is the more important, but any departure from either constitutes an unnatural act which is bound in the strict processes of life to bring undesirable consequences. With this in mind, we can turn again to his specific actions and observe how Hawthorne has him err by his own standards, not necessarily by those of Dimmesdale or of Hester or of the good people of Boston.

Several acts in Chapter IX and Chapter X, for instance, result in social disharmony inasmuch as they place Chillingworth in a false relation with those about him. He abandons Hester, his lawful wedded wife; he withdraws his name from "the roll of mankind"; he continues his investigation against the counsel of the authorized representative of Puritan Massachusetts; he practices the outward forms of the local religion with no inward conviction; and he cares ostentatiously for Dimmesdale's ailing body while plotting secretly against his soul. Such a formidable multiplication of "sins," however, seems to give the physician no immediate awareness that his relation with the community is, if anything, more

false than that of the man he is tracking down. The reason is simply that a more primary matter—a perversion of his zeal for intellectual truth—has driven these relatively secondary transgressions from his mind.

Once the idea of discovering the identity of Hester's lover takes hold of him, Chillingworth soon loses the "severe and equal integrity" of which he was originally so proud. His concepts, once characterized by "range and freedom," contract and become lost in a single petty, revengeful passion. All the potentialities and satisfactions of the scholar he foregoes for control over the soul of a weak and pathetic minister in the bleak little town of Boston. As a consequence, his moment of greatest triumph occurs when he makes the relatively trivial discovery that Dimmesdale is really the wretched sinner he has suspected him to be. In this sense, his sin is not the triumph of the intellect but the surrender of the intellect. Whatever suffering he eventually endures grows from the knowledge that he has been false to his own intellectual principles.

Hawthorne's handling of Dimmesdale in this second part of *The Scarlet Letter* is a masterpiece of organization and culmination. From the moment when Chillingworth begins his cunning attack upon the young minister, Dimmesdale is forced more and more upon the defensive, until he is driven to the very edge of insanity. For the penetration of the old physician's mind and the insidious method of his approach are far too much for a person hitherto shielded from intellectual combat by theological orthodoxy and from guile by the respect and adulation of his congregation. As a result, Dimmesdale's attempts at parry reveal more of his suffering than of his mental acumen. Chillingworth one day, while examining a bundle of weeds from a nearby graveyard, craftily suggests that "since all the powers of nature call so earnestly for the confession of sin . . . these black weeds have sprung up out of a buried heart, to make manifest an unspoken crime." Dimmesdale, sensing a personal thrust, opposes this idea. Keeping one's sins hidden, he replies, is not an act against the powers of nature. "The heart, making itself guilty of such secrets, must perforce hold them, until the day when all hidden things shall be revealed." Nor is the lack of confession essentially a violation of God's will. Confession on the Judgment Day, he protests, will be required not as retribution but only for the "intellectual satisfaction of all intelligent beings." Forced to speak further, he then defends his hypocrisy on much the same grounds as Hester defends her adultery: truth to his own nature. He and Chillingworth are speaking of sinful men who hide their sins:

> "True, there are such men," answered Mr. Dimmesdale. "But, not to suggest more obvious reasons, it may be that they are kept silent by the very constitution of their nature. Or,—can we not suppose it?—guilty as they may be, retaining, nevertheless, a zeal for God's glory and man's welfare, they shrink from displaying themselves black and filthy in the

211

view of men; because, thenceforward, no good can be achieved by them;
no evil of the past be redeemed by better service. So, to their own
unutterable torment, they go about among their fellow-creatures, looking
pure as new-fallen snow while their hearts are all speckled and spotted
with iniquity of which they cannot rid themselves."

If this speech is examined closely, it will be seen that Dimmesdale has
devised a three-point defense for his failure to confess: first, his silence
is natural to himself; second, his silence will enable him to further God's
glory and thus achieve penance for his adultery, which he considers a
sin against God; and third, his silence will enable him to promote man's
welfare and thus achieve penance for his hypocrisy, which he realizes is
a violation of the code of the community. In this last instance, his lack
of confession purports to be a means of expiating his lack of confession!
This is no argument, and down deep in his heart Dimmesdale knows it.
When pressed by Chillingworth, he waives the whole discussion as though
indifferent to it. And when confronted with Hester, he admits that she
is the better for being free to show her pain.

If his reasoned defense is incapable of coping with Chillingworth's
attack, however, his intuitive defense is more successful. For just as his
own nature inhibits confession before the community, whose "great heart"
would eventually pity and forgive, it prevents confession to Chilling-
worth, who would do neither. Any "backward rush of sinful thoughts"
directed toward the old physician would result only in placing Dimmes-
dale forever in the power of a malicious scoundrel who is aiming at just
such revenge. It is without conscious process, therefore, that Dimmesdale
is repelled when Chillingworth drives home his most direct question:
"Would you, therefore, that your physician heal the bodily evil? How
may this be, unless you first lay open to him the wound or trouble in
your soul?" "No!—not to thee!—not to an earthly physician!" cries Mr.
Dimmesdale passionately.

Although Chillingworth does not succeed in wringing a confession
from the hapless clergyman, he does manage to make him more and
more conscious of his sinfulness and loneliness, and by doing so, makes
him even more sinful and lonely. For, driven almost to distraction by the
physician's proddings, Dimmesdale begins to make frantic attempts at
expiation. He tries, for instance, the device of declaring himself before
his congregation to be the worst of sinners. But this is only to sin again,
for whereas his original silence, involving no overt act, was only a vio-
lation of the community's moral code, this specious act of penance be-
comes a violation of his own nature.

He had spoken the very truth, and transformed it into the veriest
falsehood. And yet, by the constitution of his nature, he loved the truth,
and loathed the lie, as few men ever did. Therefore, above all things else,
he loathed his miserable self!

On other occasions, he adopts practices which, since they succeed in alienating him from the natural order of things, can be considered only as violations of that order. He beats himself with a bloody scourge, fasts with a rigor unknown to other pious Puritans, and maintains vigils until his brain reels and physical reality becomes illusory.

The depths into which Dimmesdale has been thrust by Chillingworth are best demonstrated in the final chapter of this section, the midnight vigil scene on the scaffold. Here, Hawthorne makes it plain that the minister is not only incapable of changing his sinful course by the action of his own will but has been so weakened that he is incapable of right action even when assistance is offered by outside agents. The vigil itself is another of Dimmesdale's attempts at penance. There might, he feels, be a moment's peace in it. Once on the scaffold, the realization of his isolation sweeps across him, and he involuntarily shrieks aloud. In the moments that follow, three persons appear: Governor Bellingham, Mistress Hibbins, and the venerable Father Wilson. Here are three opportunities for him to break his loneliness and to establish connection with one of the great societies—earthly, hellish, or heavenly. But an involuntary shriek is not enough; before Dimmesdale can be admitted to one of these great companies, a voluntary confession or commitment must be made. One of these three persons must be hailed. For a man of average moral strength, the problem would be to choose among the three. For him the problem is whether he shall choose any. In the end, he cowers silent upon the scaffold and the figures disappear. Thus does Arthur Dimmesdale reach the extreme of his isolation. For the time being, seemingly, earth, hell, and heaven are all closed to him. Had he chosen hell, his eventual fate would have been more terrible, but his immediate suffering could not have been greater.

When his mind begins to give way under the impact of this new sense of alienation, he again reacts involuntarily, this time to burst into a peal of insane laughter. What follows is a series of four rapid occurrences, each of which serves to remind the distracted minister of a source of power which is denied him only because of his failure to expiate his guilt. But in each case, Dimmesdale fails to grasp the opportunity and succeeds only in sinning further. Hester and Pearl, first of all, bring a rush of new life to the collapsing man. Here, presumably, is the perfect reminder of that bond of human affection which strengthens the human heart and enables it to find the path to truth. But when Pearl reminds her father of the expiation which is necessary before the bond can be strong and lasting, he dodges her question by giving it an impersonal and stereotyped answer. Secondly, the meteoric flash across the sky should remind him of strength through union with the tremendous yet wholesome forces of nature. Instead, his diseased mind, extending its "egotism over the whole expanse of nature," sees only a large A, symbol of his

guilt. In the third place, the appearance of Chillingworth should remind him of the horror of union with evil and, by contrast, the glory of a courageous stand before God. But though his "soul shivers" at the old physician, he obediently follows him home. Finally, the following morning, his own rich and powerful discourse to his congregation should by its own "heavenly influences" catapult him into giving expression to the truth, that quality which by his nature he loves most of all. Yet when the sexton asks him so simple a question as whether he has heard of the A in the sky the preceding night, Dimmesdale answers, "No, I had not heard of it."

Four decisions are thus forced upon Dimmesdale: he must assert his position in relation to man, to nature, to God, and to his own original and better self. In each case, from sheer weakness and despair of spirit he only adds new falsity to that which already exists. Chillingworth has worked better than he knows. If Dimmesdale is to be saved, aid must come from some outside source.

III

In the transition from part two to part three of *The Scarlet Letter*, content has again created form. Hawthorne once more has brought his story to a point where only one character is in a position to force the action. The community has been provided no reason for reentering the story as an activating force; Chillingworth has rather obviously run his course; and Dimmesdale is clearly lacking in both physical and moral vigor. Only Hester is capable of action. It is Hester, moreover, who wants action. For the first time she has fully comprehended the result of her vow to Chillingworth, and her sense of responsibility for Dimmesdale's condition has thrust all thoughts of her own temporarily from her mind. It is not surprising, therefore, that Chapter XIII should begin with a summary of Hester's activities during the seven years since the scaffold scene and that the following pages should reveal her as the source of whatever action takes place.

The third part of *The Scarlet Letter* extends from Chapter XIII to Chapter XX. In form, it is almost an exact duplicate of the second part. Each sketches the immediate past of the main character, details the present action initiated by that character, and describes the results of that action upon another character. In each case, the other character is Dimmesdale.

Hester is sketched as independent and disillusioned. In some ways her isolation has been almost as complete as Dimmesdale's. For seven years now, heaven and earth "have frowned on her." Even though society has grown more benignant, it has never really accepted her save in

time of sickness or death; God, never really a great influence in her life, seems to have become less real; nature's sunlight vanishes on her approach; and her own personality has lost its womanly charm. In brief, shame, despair, and solitude have been her teachers just as they have for Dimmesdale.

Two elements, however, have strengthened her while Dimmesdale weakened: her intellectual speculation and her daughter Pearl. The former has been possible only because her sin has been public and her mind hence not cramped by fears of exposure. It has resulted in a latitude of thought which allows her to picture herself as the prophetess of a new order and which causes her to scorn the institutions of the old: "the clerical band, the judicial robe, the pillory, the gallows, the fireside, or the church." In the second place, Pearl has kept a sense of moral direction in Hester, even though Hester has never fully acted upon it. Once, Pearl saved her mother from the devil in the guise of Mistress Hibbins; constantly, she has saved her from complete surrender to her own cynicism. In a loose sense, Pearl performs the same service for Hester that Chillingworth does for Dimmesdale, since both serve as pricks to the conscience. When their functions are examined more closely, however, it can be observed that these services have opposite effects. For Dimmesdale, if let alone, might eventually get his spiritual house in order. His natural gravitation is heavenward, and he continues to move toward evil simply because Chillingworth keeps nudging him in that direction. But Hester's inclination is not so dominantly heavenward, and she is kept from an alliance with the Devil largely because Pearl keeps hold of her. Intellectual speculation, stimulating as it has been, has led Hester into moral confusion. It is Pearl who has kept this confusion from collapsing into surrender. This she has done by keeping alive the spark of human affection and by standing rigidly against falsity wherever in her precocious way she has sensed it. Given these complementary sources of power, Hester is easily the strongest character in the book at this point. Even Chillingworth can recognize a quality "almost majestic" which shines through her despair.

Her first act in this part of *The Scarlet Letter* is to extract from Chillingworth a release from her vow of silence. This is the first counter move of the story, and it serves to place the doctor immediately upon the defensive. Just as Dimmesdale had tried to explain away his position to Chillingworth, so the old physician now tries to account for his actions to Hester. Several revealing points come to light as he does so. It becomes clear, for example, that he is thoroughly aware of the cruelty of his actions. He cannot, therefore, be excused, even partly, on the grounds of ignorance. It becomes equally clear that Chillingworth, though he has suffered greatly, has never fully realized the tremendous moral change

which has taken place in himself. It is a dramatic and revealing moment in his life, consequently, when he discusses himself before Hester. A look of horror suddenly spreads across his face. "It was one of those moments—which sometimes occur only at the interval of years—when a man's moral aspect is faithfully revealed to his mind's eye." This, if ever, is the time for Chillingworth to repent. Even Hester is moved to beg him to purge himself "and be once more human." That repentance is necessarily impossible for him is apparent to anyone who has read the story closely up to this point.

Chillingworth's intellectual penetration is now nothing more than morbid rationalization. He can still see that events are bound together by a chain of cause and effect; what he cannot do, or refuses to do, is to recognize the beginning and ending of that chain. Once, he confessed that he had started the tragic sequence of circumstances by forcing Hester to marry him. Now, he pins complete responsibility on her and Dimmesdale. His own actions, he feels, have been necessary in order to exact a rightful vengeance. More than that, he could not have avoided them had he desired.

> "Peace, Hester, peace!" replied the old man, with gloomy sternness. "It is not granted me to pardon. I have no such power as thou tellest me of. My old faith, long forgotten, comes back to me, and explains all that we do, and all we suffer. By thy first step awry thou didst plant the germ of evil; but since that moment, it has all been a dark necessity. Ye that have wronged me are not sinful, save in a kind of typical illusion; neither am I fiend-like, who have snatched a fiend's office from his hands. It is our fate. Let the black flower blossom as it may!"

It is to be remembered that before his fall Chillingworth's study was not upon theology but upon the processes which make up the natural world. These he had come to see as harmonious yet inexorable: as man discovers increasingly more about them and stays in harmony with them through acts of benignity, these processes lead him to truth and happiness; when man ignores them for selfish pursuits of passion and comes into disharmony with them through acts of cruelty, the processes lead just as relentlessly to suffering and annihilation. These are the main elements of Chillingworth's philosophy, so far as we can discover them from what we are given. When he thinks he finds an explanation for "all that we do" in his "old faith," therefore, he is merely fooling himself. For what he discovers in his "old faith" is simply what he has believed all along. Were it otherwise, the "old faith" would certainly explain to him not only what we do and suffer but also what we can do to terminate that suffering. To put it another way, if Chillingworth can recall the doctrine of predestination, why cannot he also recall such other elements

of Calvinism (which is, presumably, his "old faith") as the mediation of Christ, sanctification, and repentance unto life and salvation? The answer is that he has not recalled his "old faith" at all but simply that part of it which enables him to defend and justify his own action. In short, since Chillingworth not only disavows his responsibility for starting the relentless chain of cause and effect but also can envision no possible means of stopping it, he can expect no amelioration of his unhappy state. What Hawthorne has done has been to establish one means of reunion and then to create in Chillingworth a character that can never logically utilize or even consider that means.[8] By Dimmesdale's standards, Chillingworth may be the greatest sinner of them all, but by his own he is understandable in his moral disintegration and wholly consistent in his method of explaining it.

That Hester is able to win release from her vow to Chillingworth is due primarily to his admiration for his wife's cynical independence and to his own surrrender to the course of events. The latter is the more important and represents the difference between the second and third parts of the book. In the second part the vow of secrecy was necessary so that he could direct events; now he is content merely to "let the black flower blossom as it may."

Hester's actions from this point break loosely into two lines, that directed toward expiation of her sin of hypocrisy and that directed toward escape from the consequences of her act of adultery. The two lines form an illuminating contrast between the proper and improper methods of dealing with guilt, the one leading to moral triumph and the other to moral failure. Fundamentally, the success of the first line is due to the fact that it arises out of a keen sense of responsibility for wrongdoing. To Hester this sense comes first when she sees Dimmesdale's emaciated figure upon the scaffold at midnight. Her later self-analysis is cuttingly honest. In all things else she has striven to be true. Truth has been the one virtue to which she might have held fast, and did hold fast "in all extremity" save in that one moment of weakness when she consented to deception. But now she finds that "a lie is never good, even though death threatens on the other side." In short, she has been false to her own nature, with the result that Dimmesdale has suffered possibly beyond repair. Realizing all this and recognizing at last the obligation which she owes Dimmesdale because of her love and her share in his crime, Hester becomes deeply and earnestly repentant.

Sincere repentance brings proper action. First, Hester obtains her release from Chillingworth, for any other procedure would merely have substituted one dishonesty for another. Then she waylays Dimmesdale in the forest in order to confess and implore his forgiveness. Confession can rectify the false relation which her silence has created, but only

forgiveness from the one who has suffered can bring her peace. "Wilt thou yet forgive me!" she repeats over and over again until her lover at length replies, "I do forgive you, Hester."

Although not generally recognized as such, this is one of the emotional and intellectual climaxes of the book. The emotional effect is definitely one of catharsis, for in a blackening world this is the first experience of purification. With Dimmesdale and Hester, the reader comes through the forgiveness scene feeling suddenly purged of stain. That the experience is not more compelling is due to Hester's inability to follow through on her other and more grievous guilt. Intellectually, the forgiveness scene represents the culmination of a pattern of action which not only is interesting in itself but prefigures the pattern leading up to the final climax of the book. As such it constitutes the only exception to the general statement made previously, that the function of each of the activating characters except the last is to multiply sin, intensify isolation, and reduce the chances for complete and lasting reunion.

Hester's second line of action is related to her sin of adultery and her attempt to overcome the isolation imposed by it. Ironically, the very element which led her to repent for her sin of hypocrisy—truth to her own nature—now provides her with a justification for her act of adultery. When Dimmesdale observes sadly that Chillingworth's sin has been blacker than theirs, Hester is quick to whisper, "What we did had a consecration of its own! We felt it so! We said so to each other!" Confident in this belief, she proposes that they dispel their sense of moral isolation by translating it into physical terms. She and Dimmesdale and Pearl must flee to Europe. And her insistence that Dimmesdale agree represents the highest point in her activities as a directing force in the story.

In the enthusiasm of the moment, Hester takes off her cap and scarlet letter, becoming once more the woman of affection and charm. As if in approval, nature suddenly bursts into sunny radiance. But nature, one should recall, is unsubjugated by human law or unillumined by higher truths in parcelling out its approval. A more accurate moral index of Hester's action is found in Pearl, who as always flatly refuses to countenance a relation based upon falsity. Nature can rejoice at love and ignore immorality; Pearl can see only immorality and ignore the love. Neither, however, has human sympathy or understanding, and both consequently have more in common with each other than either has with Hester or Dimmesdale. Momentarily, it is the moral law which prevails over both human desire and natural law: Pearl forces her mother to reassume her scarlet letter, and the sunshine disappears. But the child's further attempts to bring her parents back to a proper realization of their relationship are deflected, and instead of the confession and the true reunion she is working for, she gets a formal kiss from the minister, a

kiss which she immediately and appropriately washes off in the brook. Through Pearl, therefore, it becomes plain that Hester's proposed plan of action is no real solution. This becomes even plainer as one perceives the effects of the suggestion upon Dimmesdale.

As he appears in the early part of the forest scene, he is lonely, cowardly, and naive in the ways of deliberate sin. These attributes should not be taken as co-equal, however, for whereas the first keeps him conscious of the orthodox end of life, the second makes him incapable of employing the orthodox means toward that end, and the third makes him oblivious of alternative means and ends. Dimmesdale's loneliness is never more poignant. He feels himself so far isolated from his God that His choicest gifts have become only "the ministers of spiritual torment," so far removed from his people that their continued adulation brings only "bitterness and agony of heart," and so far torn within himself that his penance has brought not one whit of penitence. Thus do his lonely broodings constantly direct themselves toward that end of life from which sin has isolated him. For if the end of life has meant anything to Dimmesdale, it has meant eternal joy through a righteous union with God, His people, and the things of His universe. But cowardice continues to make it impossible for him to attain this end. Even when Hester divulges the true identity of Chillingworth, Dimmesdale's reaction is not one of compunction inspired by new understanding but one of fear that Chillingworth will betray him. Without the slightest shred of self-respect, he throws himself upon Hester for help. "Be thou strong for me," he pleads.

When Hester suggests a solution involving an easier means and an alternative end—temporal happiness—the solution appears so simple and so breathtaking to Dimmesdale that he wonders why they had never thought of it before. It offers a whole new realm of action, unchristianized and lawless but free and exciting. So exciting is it, in fact, that he is quick to put down any temporary misgivings. Reunion with God? He is irrevocably doomed anyway. Reunion with his people? Hester is all that he needs to sustain him. Union with his own spirit? Already he can feel life coursing through his veins without it. And so for the first time he consents with purpose and deliberation to something that basically he knows to be wrong. The immediate result is a sudden plunge into moral confusion. Like Hester before him, he has sinned against his own better nature.

What before was a depressing conflict between right and wrong has so developed that Dimmesdale is almost literally split in two. To put it another way, Dimmesdale was formerly an individual who had sinned against the synthesis of theology, custom, and personal goodness which made up his own code; now he is two individuals with two different codes. As Hawthorne phrases it, his new impulses can be accounted for

by "nothing short of a total change of dynasty and moral code." For the time being, it is the newer and baser nature which initiates action though the older and truer nature never ceases to assert itself in counter-action. The baser nature, for instance, rejoices over the prospect of flight; the truer nature is wistfully glad that flight will not interfere with the Election Sermon. The baser nature gives Dimmesdale unaccustomed physical energy on his walk back to Boston; the truer nature wonders and is frightened at the new aspect of familiar objects. The baser nature suggests shocking remarks to make to his parishioners; the truer nature just manages to keep him from saying them. The baser nature is appealed to by Mistress Hibbins as a kindred perverted spirit; the truer nature is appealed to by the Bible and God's voice. This, however, is the last contrast that can be made between the two. For as Dimmesdale stands within his room, viewing the Bible and the unfinished Election Sermon, the two natures unite. All that remains of the baser one is the knowledge of evil and of his own kinship with it. But that is the key to all that follows. Whatever contrast remains is between the innocent Dimmesdale that existed before Hester accosted him in the forest and the knowing Dimmesdale who is able to greet Chillingworth and tell him firmly that "touching your medicine, kind Sir, in my present frame of body, I need it not." It is out of this same new maturity that Dimmesdale is able to sit down to a new Election Sermon and to write "with earnest haste and ecstasy" throughout the night.

Since Hawthorne refuses to disclose what goes on in Dimmesdale's mind at this point, we are forced back upon deductions based on his actions. Obviously, his truer nature has become ascendant. Obviously, too, he has lost his loneliness, his cowardice, and his naivete about sin and his relation to it. His condition, therefore, has become the exact antithesis of what it was a few hours before. If we can guess at the cause from these results, repentance has presumably taken place. And if this is true, Dimmesdale will spare no effort to perform true penance and hence achieve reunion with the good and true. The expectation is, therefore, that, urged on by high desire and strengthened by spiritual rather than temporal resources, he will wrest the initiative from Hester and become the activating force in the story. In brief, the desires and capabilities of the characters should once more determine the form the book must take. From previous readings we know that they do.

IV

The fourth part of *The Scarlet Letter* offers an interesting variation from the other three parts. Whereas each of these gives immediate attention to the character which is to direct its action, the fourth part withholds

such attention for almost two chapters. Indeed, these chapters, "The New England Holiday" and "The Procession," might with some justice be considered a final section of the third part inasmuch as they deal chiefly with the results of Hester's activities as they operate upon Hester herself. There are other and more cogent reasons, however, for considering them as belonging to the fourth part of the book and as a kind of introduction for Dimmesdale's final act. The most obvious is that the background ties these chapters with Chapter xxiii, in which he takes control. Hawthorne is carefully setting the stage for his climax. In terms of content there are other elements to be considered. Dimmesdale's final action must not appear as something opposing Hester's desires but as something evolving from them and sublimating them. Hence, it must be made clear to the reader that Hester has lost confidence in her own scheme and will ultimately be favorably affected by Dimmesdale's expiation rather than antagonized by his seeming disregard for her plans and wishes. Another element is the character of his action. Whereas the community, Chillingworth, and Hester needed days, months, and even years to accomplish their purposes, Dimmesdale needs only moments. Theirs was a series of actions, each carefully plotted and integrated with every other; his is one bold stroke. Their actions created complexities; his removes them. Hence, his can be encompassed and should be encompassed in a much smaller space. But it is equally true that the setting must be carefully prepared, or the action will pass before the reader is prepared to comprehend its full significance. It seems useful and understandable, therefore, that Hawthorne should devote Chapters xxi and xxii to introductory material, Chapter xxiii to Dimmesdale's expiatory action, and Chapter xxiv to the consequences of that action.

By contrast with her previous aggressiveness, Hester's mood in the market place sinks from one of loneliness to one of almost complete despair. Seldom has she seemed so completely isolated. Her frozen calmness, we are told, is due to the fact that she is "actually dead, in respect to any claim of sympathy" and has "departed out of the world, with which she still seems to mingle." The good people of the town sidle away from her and strangers openly gawk. Nor has she come any closer to Pearl. When Pearl keeps asking about the minister, Hester shuts her off with "Be quiet, Pearl! thou understandest not these things." Even Dimmesdale she sees moodily as existing in a sphere remote and "utterly beyond her reach." Indeed, she can hardly find it in her heart to forgive him for "being able so completely to withdraw himself from their mutual world; while she groped darkly, and stretched forth her cold hands, and found him not." Finally, the news that Chillingworth is to take passage on the same ship transforms her loneliness into consternation and despair. "Hester's strong, calm, steadfastly enduring spirit almost sank, at last, on beholding this dark and grim countenance of an inevitable doom,

which . . . showed itself, with an unrelenting smile, right in the midst of their path."

Once Dimmesdale begins to direct the action, however, any effort of either Hester or Chillingworth becomes incidental. With a fine sense for dramatic contrast, Hawthorne has Dimmesdale reach his greatest success as a minister a few short minutes before he confesses his crime. Never has he been more uplifting and never more spiritually inclined. Already we know the Election Sermon as something born of new awareness and a sudden stiffening of the spirit. Since the world is no longer illusory or his own heart confused, Dimmesdale apparently has made his peace with the natural order and with himself. But he still feels estranged from God and from the community because of his sins of adultery and hypocrisy. His confession on the scaffold, therefore, is necessary as penance for both these sins, and its dual character Dimmesdale himself makes clear:

> "God knows; and He is merciful; He hath proved his mercy, most of all, in my afflictions. By giving me this burning torture to bear upon my breast! By sending yonder dark and terrible old man, to keep the torture always at red heat! By bringing me hither, to die this death of triumphant ignominy before the people! Had either of these agonies been wanting, I had been lost forever! Praised be his name! His will be done! Farewell!"

In such a manner does Dimmesdale perform true penance and emerge finally at the moment of his death into a true relation with all the elements against which he has sinned. It is vain for him to hope for "an everlasting and pure reunion," but he has made himself worthy of whatever reunion God grants to those who repent.

It remains only to observe the effects of Dimmesdale's action upon the other characters. Pearl, to begin, ceases to be simply a force for rectitude. Since her mission is fulfilled, she is set free to assume a normal place in the human family. Chillingworth, on the other hand, relinquishes whatever slim bonds with that family he still possesses. This does not mean that he becomes a disassociated being, for though *The Scarlet Letter* is a story of isolation Hawthorne never implies even the possibility of complete disassociation. In the end, one is either reunited with the good and true or he becomes the slave of the Devil. And so Chillingworth, now that there is no further material upon which his earthly nature can sustain itself, passes to whatever realms his evil master desires. The people of Boston are bewildered and confused by Dimmesdale's action, first as to the cause of the scarlet letter on the minister's breast, and then as to the reality of the letter itself. In either case, they forget the sin and dwell upon the nature and cause and greatness of the minister's expiation. Had he lived, they might have revered him only the more.

There is no immediate effect upon Hester of any profound significance. Her first reaction is one of despondency and hopelessness. When

Dimmesdale asks her whether his solution is not better than what they dreamed of in the forest, she replies, "I know not! I know not! Better? Yea; so we may both die, and little Pearl die with us." Nor does she yet see that any true reunion must ultimately rest upon voluntary expiation of her own. "Surely, surely, we have ransomed one another, with all this woe." But Dimmesdale knows better. "Hush, Hester, hush!" said he, with tremulous solemnity. "The law we broke!—the sin here so awfully revealed!—let these alone be in thy thoughts!"

Years pass in a foreign country before Hester comes to that full sense of personal responsibility which swells into repentance and the desire to do voluntary penance. When that happens, of her own free will she returns to Boston and resumes the scarlet letter. Though even then she does not conceive of her adultery as a sin against the community, she has lost her resentment and has come to feel that her sin can be fully expiated only when it is made known freely in the world, particularly in that part of the world which will recognize it and profit most from the presence of the repentant sinner. "There was a more real life for Hester Prynne here, in New England, than in that unknown region where Pearl had found a home. Here had been her sin; here, her sorrow; and here was yet to be her penitence." And as she still does not conceive of her adultery as a sin against God, she does not repent in the orthodox Calvinistic fashion. Plainly, she still thinks of her guilt in terms of a natural or this-world order. Her vision is of a brighter period when the whole relation between man and woman will be established "on a surer ground of mutual happiness." But her repentant spirit no longer allows her to picture herself as the prophetess of the new order. Rather, she admits that guilt has incapacitated her for such a role and that her penance must be to accept whatever lowly position in the present order she can best fill. In such a manner she finally overcomes—insofar as that is possible for the repentant sinner—the consequences of her act of disorder and wins back a useful and even honorable place in the great scheme of things. That Hester is allowed to overcome her isolation in her own way is Hawthorne's final act of faith in a book in which the integrity of the individual viewpoint is scrupulously maintained. That she should be able to find some peace in so doing comes as the ultimate result of Dimmesdale's confession and represents, therefore, the closing act in *The Scarlet Letter*'s fourth and final section.

Notes

[1]Other analyses of the form of *The Scarlet Letter* stress its succession of highly wrought tableaux, its unifying symbol of the scarlet A, and its recurrent scaffold scene. See, for example, George E. Woodberry, *Nathaniel Hawthorne* (Boston,

1902), pp. 189–91; Carl Van Doren, *The American Novel* (New York, 1940), pp. 66–67; and F. O. Matthiessen, *American Renaissance* (New York, 1941), p. 275. Such technical devices, however, are valuable chiefly because they give coherence to the form, not because they create the form. Mr. Matthiessen comes closer to what seems to me to be the real source of the book's form when he speaks of *The Scarlet Letter* as growing "organically out of the interactions between the characters."

[2]Mr. Paul Elmer More makes this even more emphatic in "The Solitude of Nathaniel Hawthorne," *Shelburne Essays*, First Series (New York, 1904), p. 33: "From the opening scene at the prison door, which, 'like all that pertains to crime, seemed never to have known a youthful era,' to the final scene on the scaffold, where the tragic imagination of the author speaks with a power barely surpassed in the books of the world, the whole plot of the romance moves about this one conception of our human isolation as the penalty of transgression."

[3]Mr. Walter Blair mentions these three elements as being involved in Hawthorne's concept of sin in "Hawthorne's Color, Light, and Shadow," *New England Quarterly*, 15 (March, 1942), 82.

[4]It must be conceded immediately that these terms do not constitute a process which fully reestablishes the original union. Reunion is not Christian salvation, and the two terms should not be used interchangeably. Indeed, Dimmesdale in his dying moment warns that it is vain to hope to meet even in the hereafter in "an everlasting and pure reunion." It is such a statement that gives support to Mr. Woodberry's assertion in *Nathaniel Hawthorne* (Boston, 1902), p. 193, that "the idea of salvation, of healing, is but little present and is not felt." To this, Mr. Austin Warren, in *Nathaniel Hawthorne* (New York, 1934), p. xl, adds: "Certainly Hawthorne has no hope in his creative mind. This is a sorry world; but we can really do nothing about it. Men necessarily sin; but they must be held strictly accountable for their sins all the same. They must repent, but repentance cannot raise the fallen." These gloomy aspects to the story, however, should not blind one to the fact that reunion constitutes a major theme, and that though it does not bring the joy of Christian salvation it does bring relief from suffering in those instances when it is achieved.

[5]Henry James, in *Hawthorne* (New York, 1879), pp. 110–11, speaks of the people of *The Scarlet Letter* as being not characters but "representatives, very picturesquely arranged, of a single state of mind." This seems eminently true if one excepts the four main characters. It is this single-mindedness that makes it possible to speak in the singular when referring to the community as an activating force.

[6]To avoid confusion, it is necessary to keep in mind that "nature" as applied by Hawthorne to a character's essential constitution refers to the original constitution which the character possesses before sin or circumstance warps it. For Hester to be true to her nature is for her to look, to feel, and to think in harmony with her original attributes: her feminine, almost voluptuous, appearance, her warmly personal affection, and her scrupulous regard for simple truthfulness. None of her later attributes are ever characterized as "natural": her colorless, statuelike appearance, her self-effacing benevolence, her radical speculation. These, according to Hawthorne, are the result of her innate tenderness' being so deeply crushed into her heart that only some "magic" can effect a transformation, *i.e.*,

224

a return to the "natural." The same principle operates with respect to Dimmesdale and Chillingworth. When Hawthorne speaks of the "constitution of his nature" he is referring to Dimmesdale's original nature, in which human affection and timidity are the dominant emotions, and truthfulness, as refined by Calvinistic theology, the dominant trait of his thinking. And, as pointed out later, Chillingworth by "nature" is gifted with kindness and a rigorous scientific integrity.

[7]Newton Arvin, *Hawthorne* (Boston, 1929), p. 189.

[8]This may seem to confuse Hawthorne's principle of reunion with the orthodox principle of salvation. At this point, however, we are considering means, not ends, and in means the two are not dissimilar, inasmuch as both involve a personal sense of responsibility, repentance, and voluntary penance or good works. We can justifiably say, therefore, that since Chillingworth refuses to recognize the regenerative elements in his "old faith," he can never win relief from suffering by the process which Hawthorne thinks necessary in order to achieve reunion.

The Scarlet Letter: Through the Old Manse and the Custom House

James M. Cox

My title should be explained. I wish to approach Hawthorne's masterpiece through "The Old Manse" and "The Custom House," the two great prefaces he wrote. In those prefaces, the one composed by way of introduction to *Mosses from an Old Manse* (1846) and the other as "introductory to *The Scarlet Letter*" (1850), Hawthorne unforgettably sketched himself as author. In terms of actual composition, *The Scarlet Letter* lies somewhat between the prefaces, for, although Hawthorne did not write all of *The Scarlet Letter* before composing "The Custom House" (as once was thought), he clearly wrote enough of it so that it could be said to lie between the two in the order of writing. Yet chronology of composition is not so important as the order of form. The one is the life of the artist; the other is the life of art.

When we think of the life of art we are thinking about what for Hawthorne was primary and causal, not secondary and resultant. It is just this audacity of Hawthorne which Frederick Crews in *The Sins of the Fathers*, an excellent book on Hawthorne, does not fully face. He will have Hawthorne's life the cause of his art, even though his book is primarily concerned with Hawthorne's fiction, not his life. Thus, for all his illuminating treatment of the fiction, Crews is probing the motives behind the characters' action, peering through the veil to read the unwritten

Reprinted from *Virginia Quarterly Review*, 51 (Summer 1975), 432–47. Copyright by *Virginia Quarterly Review*. Reprinted by permission of *Virginia Quarterly Review* and James M. Cox.

scroll, and as he fixes on the motives of the characters he is both implying and implicating a shadowy Oedipal figure of Hawthorne behind the tales.

I have no intention of complaining about these implications. Crews has made his interpretation, an interpretation is a choice, and the tangled area of dark prior motive, will, decision, and doubt is precisely the world which Hawthorne invented. If Hawthorne himself could read Crews, were he not too shy to offer a comment, he would welcome the interpretation as a distinct possibility, for he would find in Crews' peering scrutiny something of the passionate fixation of an Ethan Brand looking for the Unpardonable Sin. The same Hawthorne, were he to read my version of his art, would surely cast upon it a veiled eye of similar intent—for I too have an interpretation, though the Hawthorne I am seeking is the one before, not behind, his art.

Having acknowledged so much, I may as well begin by seeing my Hawthorne as a man whose art caused his life—whose art, in other words, was the primary cause of the world he invented. The best way to see what I mean is to begin with the shape of his career up to the time of *The Scarlet Letter*. He began by retiring into his room for twelve years. There he became a writer, beginning with the anonymous publication of *Fanshawe*, a brief and thoroughly conventional novel, and then contracting his form for the remainder of his time in the dismal chamber. The contraction may have been there from the beginning for all that we know, since it has not been determined whether Hawthorne wrote *Fanshawe* before he wrote a group of tales he intended to publish under the title *Seven Tales from My Native Land*. In any event, not until *The Scarlet Letter* itself did he expand his form anywhere near the length of what may well have been his first sustained effort as a writer. Hawthorne's contraction and concentration, aside from journalistic excursions into hack writing, took two forms, as everyone knows: the sketch and the tale. Although there was no great distinction between the two forms in Hawthorne's time (after all, Irving had included what we would call tales in a book of sketches, and Hawthorne was to include what we would call sketches in a book of tales), it is nevertheless true that Hawthorne's own work defines a distinct difference between them. He even makes them represent poles of his imaginative experience—the one inclined toward genial light, the other toward shadowy gloom.

More important, his power, at least to subsequent generations, has seemed to gravitate toward one pole and not the other. This does not mean that the sketches are unnatural for him. They are utterly characteristic and are generatively related to his dark side. Yet the sketches seem to be withdrawals of power, as if they themselves were disclaiming ambiguity and attempting to subdue the gloom of the tales. Missing in the sketches is the presence of an inner action of a character which the

style pictures, pursues, analyzes, and judges. Substituted for such an action is the *activity* of the author seeking for, perceiving, and sketching his subject. The sketches are thus miniature portraits of the artist. But they portray the artist as author, not the artist as Hawthorne. Though the sketches, unlike the tales, almost always employ first-person narration, that person is the Conventional Author, genteel and circumlocutory, whom the style indulgently, even ironically, patronizes. The indulgence is not extravagant, as it often is in Irving, but it is pronounced enough to disclose and socialize the Author in a kind of rôle playing. It would be very wrong to dismiss the sketches as trifles. Again and again—as in "Fancy's Show Box," "Earth's Holocaust," "The Haunted Mind"—the Author is brought to the verge of dark reflections, as if he were at the threshold of imagining an action. Yet the style and structure of the sketch tend always to convert the incipient action into a fantasy or a whimsical speculation—the exaggerated, even trivial, play of a delicate and hypersensitive mind.

In the tales quite another kind of play takes place. The frivolous attitudinizing, the whimsical teasing, and the defensive ironies of the indulgent Author dissolve into their powerful counterparts—tentative speculation, suggestive ambivalence, and haunting doubt. Gone is the Conventional Author, displaced by a quietly powerful narrator occupied in both seeing and overseeing the action. The hypothetical speculation, ambivalence, and pervasive doubt, far from being the sensitive narrator's characteristic picture of experience, disturb the reader's willing suspension of disbelief by projecting a rational consciousness to question and enlarge the fictive realm.

"The Minister's Black Veil" will serve as a perfect emblem of Hawthorne's art of the tale. Though the tale is about a minister, who, for some reason, puts on a veil and thus arouses his congregation to suspicion about, speculation upon, and penetration into the tangled region of motivation, the tale is, in effect, itself the veil between the act it represents and the meanings it suggests. By obscuring the meanings, it creates a multiplicity of interpretations, converting fixed intention into dubious possibility. The veil thus causes the story, almost as if it were itself the author, and the reader is doomed to follow every member of the congregation, fixing upon one or another of the Minister's possible motives. To attempt such an interpretation is to fulfill the action of the story; it is to perceive intellectually, and from a privileged position, what the members of the congregation feel as a threat, a symptom, an enigma, or an affliction.

The emblem thus precedes and causes experience, just as art is itself the cause of experience for Hawthorne. To see this priority of art for Hawthorne is to begin to understand the twelve years he spent in what he called his "dismal chamber." He went in Hathorne the man and native

of Salem and for twelve years made his inventions his primary experiences. Those inventions he published in an anonymous trickle during all that time, and when he had published enough from which to choose a volume he emerged into the sunlight with a collection of tales and a signature: Hawthorne. He thus had recovered the old spelling of his name which the American experience had deleted. The recovery did not mean that he had returned into the past—there is never a whit of nostalgia in Hawthorne, nor is he antiquarian in outlook—but that he had laid claim to an aspect of the past which another and more dominant aspect of the past had suppressed. The point is important, for unless we see that Hawthorne did not return into the past we shall continue to see him as a Puritan rather than what he had become, an Artist. As artist, his claim on the past involved a transformation of history into fiction—a transformation both powerful and dubious. Indeed, it was Hawthorne's genius to make the doubtful truth of fiction a momentous moral question and an inescapable part of his power.

The next great step in his career after *Twice-Told Tales* was his second great collection of tales, *Mosses from an Old Manse,* which appeared eight years later. What distinguishes this second collection from the first is the presence of an extended preface to the volume entitled "The Old Manse." If with *Twice-Told Tales* the artist had stepped into public light with a signature, in the preface to his Mosses, he decisively sketched the character of himself as author. Indeed, "The Old Manse" represents the fulfillment of the sketch form, since it clearly is an extended sketch, though it is not integrally related to the tales and sketches which follow it. As a matter of fact, the collection itself could, in the absence of the introductory sketch, have constituted a third volume of *Twice-Told Tales,* Hawthorne having in the years between already added to his original collection a second and much larger edition. But the sketch, if it fails to make a great difference in the contents of the volume, does represent a revelation of the artist. It is a measure of the deficient aesthetic of our own age that this exquisite piece of writing has received so little attention. The list of interpretations of "Young Goodman Brown" is all but endless; commentary on "The Old Manse" is all but nonexistent. Such a state of affairs may indicate many things; it certainly indicates that this generation of readers hardly knows what to do with a sketch other than to leave it out of consciousness. The following remarks do not begin to suggest the supple strength of Hawthorne's prose or the extraordinary poise, amounting to a grace of mind, with which the author takes the reader on a tour of his house and grounds. Hawthorne's adroitness lies in his capacity to establish an intimacy of tone without being confessional. Thus he can insist at the end of the sketch that, for all his generous welcome of the reader into the terrain at the edge of Hawthorne's inner life, he has not really told about himself. Insofar as he is a man of indi-

vidual attributes, he claims that "he veils his face." Thus the introductory sketch puts the veiled figure of the writer before the tales as a consciousness through which the reader may pass (or over which he may skip) in order to reach the tales. Seen in such a light, the preface is the veil, the glimmering light and shadow through which the reader may perceive the tales and sketches—those concentrated yet somehow casual disclosures which might be seen to represent the individual attributes of the man behind the veil. Such a vision would be, of course, nothing but a metaphor.

A look at the sketch itself will take us through the metaphor toward Hawthorne's act of imagination as he was defining it in 1846, the time of his entry into the Salem Custom House. As a matter of fact, Hawthorne ends "The Old Manse" with the announcement that he is entering a Custom House, lamenting as he does so his failure to find an imaginative treasure in the Old Manse. He had gone there, he says, with the expectation of finding in that structure pervaded by theological and moral sentiments, a genuine sense of the past, but after rummaging through the attic he found nothing but lumber and hopeless tracts—monuments to the futility of the past and reminders that even old newspapers with their eye on the present of their own time were more valuable pieces of literature than the antiquarian efforts of the theological and academic imagination. And so he ends his sketch with the acknowledgment that the novel he had hoped to find there had eluded him, leaving him only the tales and sketches he had continued to write along with some of his earlier work which had not hitherto been collected.

If he had not found the novel he sought, he had found peace of mind—a dreamy ease and freedom from care such as he had never known. His description of life beside the somnolent river, a stream too lazy to suffer the slavery to which wild free mountain streams are subject, makes clear that the dream-like reflection literally embodied in the sluggish stream offered a freedom which so lingered in his imagination that he felt he could never be a slave again. Rowing on the bosom of the Concord with Ellery Channing he had heard Nature whisper from her very depths, "Be free! Be free!" Memorable and powerful as that whisper was, Hawthorne nonetheless was glad at the end of such a day to return to the fireside of the Old Manse beside which he could retire into the society as well as the solitude of a home. It is just this dominant value of society which Hawthorne conveys throughout the sketch by dramatizing himself as a genial host conducting a guided tour of the Old Manse and its environs. He tells nothing of his life there with his wife—they had come there four years earlier as newlyweds—but he has a great deal to say about planting his garden and watching the nature under his care come to fruition.

But there is a moment in the sketch when Hawthorne literally dis-

231

closes himself as a writer of tales by actually including a tale within the introductory sketch. Approaching the battlefield of Concord on his ramble about the premises, Hawthorne pauses beside the mossgrown grave of two British soldiers:

> Lowell, the poet, as we were once standing over this grave, told me a tradition in reference to one of the inhabitants below. The story has something deeply impressive, though its circumstances cannot altogether be reconciled with probability. A youth in the service of the clergyman happened to be chopping wood, that April morning, at the back door of the Manse, and when the noise of battle rang from side to side of the bridge he hastened across the intervening field to see what might be going forward. It is rather strange, by the way, that this lad should have been so diligently at work when the whole population of the town and country were startled out of their customary business by the advance of the British troops. Be that as it might, the tradition says that the lad now left his task and hurried to the battle-field with the axe still in hand. The British had by this time retreated, the Americans were in pursuit; and the late scene of strife was thus deserted by both parties. Two soldiers lay on the ground— one was a corpse; but, as the young New Englander drew nigh, the other Briton raised himself painfully upon his hands and knees and gave a ghastly stare into his face. The boy—it must have been a nervous impulse, without purpose, without thought, and betokening a sensitive and impressible nature rather than a hardened one—the boy uplifted his axe and dealt the wounded soldier a fierce and fatal blow upon the head. I could wish the grave might be opened; for I would fain know whether either of the skeleton soldiers has the mark of an axe in his skull. The story comes home to me like truth. Oftentimes, as an intellectual and moral exercise, I have sought to follow that poor youth through his subsequent career, and observe how his soul was tortured by the blood stain, contracted as it had been before the long custom of war had robbed human life of its sanctity, and while it still seemed murderous to slay a brother man. This one circumstance has borne more fruit for me than all that history tells us of the fight.

Here in miniature, Hawthorne literally reveals his act of art. First, the tale he recounts is itself a part of the history of the fight, yet it is a tale and therefore cannot altogether be reconciled with probability. Moreover, it is a twice-told tale, since Lowell had told it to Hawthorne. But this is only the beginning. It is a tale of an innocent youth who suddenly and inexplicably commits a crime of violence out of a sensitive and tender heart—an original sin from an innocent heart, in other words. That is much, and it is characteristic of Hawthorne. But there is more, for Hawthorne's active imagination joins itself to the original "tradition" (as if his imagination hadn't been joined from the outset!)—in the form of his morbid desire first to corroborate the truth by opening the grave and

then to pursue the boy through life to observe the torturous effect of guilt upon his sensitive nature.

Even this is not all, for there is also the historic place where the act of imagination is wrought: the Concord Battlefield, where Emerson's embattled farmers stood and "fired the shot heard round the world." Hawthorne discovers at the site of battle the original sin and consequent guilt of an unknown life. That possibly imaginary event is what Hawthorne claims for himself in an act of certain imagination. It is at once the seed and the fertility of his art.

Although it would be possible to go back through Hawthorne's tales and show how his vision had borne fruit, I want to go forward to "The Custom House," Hawthorne's second great preface. For if Hawthorne in "The Old Manse" was defining the nature of his accomplishment, he was also making possible his own future work. Thus "The Custom House" is in large measure a sequel to "The Old Manse." It is about the same length, it refers back to the earlier preface, and it is a second intrusion of the author into public view. This time, however, there is a continuity between the preface and the tale which follows, for here at the height of his power, Hawthorne was able to write his greatest sketch and his greatest tale and put the two forms inseparably together.

He had found in the Custom House at Salem what he could not find in the Old Manse at Concord: a novel, which he carefully subtitled *A Romance*. At least that is the fiction of his preface, and however inappropriate the preface may be for the novel (Austin Warren and others believe that it is) it is a little miracle to watch Hawthorne move imperceptibly from the fact of the Custom House into the fiction of his discovery of the Scarlet Letter. If one claimed nothing else for the introductory sketch he could claim that it does something with the ancient convention of the manuscript found in a bottle or a barrel or a cellar or a trunk which no author before Hawthorne had imagined. But there is so much more to claim for it. The sketch once again places the Author before his work, not as a friendly guide to the home he loves, but as surveyor of a house in which he has worked and been rejected. This house is not the home of dead Puritan ministers, but an arm of the Federal Government, a house which imposes not moral but fiscal duties upon goods imported into the country. Here in this house of the working present, Hawthorne wants to feel that he has been condemned to work for the country which has dismissed or ignored him as a writer. He *wants* to feel the abuse and the rejection, yet he knows in that self-critical way of his that he entered the Custom House by choice, just as he knows that, since his was a political appointment of the party which had inaugurated the spoils system, his expulsion from office is but the just working of the law of politics which got him his job. He also wants to feel a certain self-pity for the fact that

he is a poor author in a country enamored of the material present, but again he knows that work in a custom house is, in a democracy of all places, as honorable as writing.

Yet there is a vengeance in Hawthorne, for he has suffered decapitation—to use his indulgent metaphor—at the hands of his country, and has thus felt the predatory impulse of the American eagle, emblem of his nation's freedom. In that rejection, he can feel sympathy for his Puritan forebears who were themselves rejected by the history which produced America. Yet whatever sympathy he feels for them is tempered by his knowledge that they too had rejected those before (or above) them and those after (or below) them—had really decapitated a king in England and had scourged dissenters in New England, and would condemn him as no more than an idle scribbler. Thus if he is rejected by the present, he knows that he would be even more fiercely rejected by the past. Yet because he can feel their eyes upon him, he admires the stern morality of his forefathers, the Puritans, and willingly takes the shame of their guilt upon himself. That is the fine balance of Hawthorne's style and vision. For every criticism he directs outward upon the Custom House, his country, and his ancestral past, he directs an equal criticism upon himself. This self-judgment, instead of paralyzing him, enables him to feel a bond of sympathy for the past; it tempers every line of Hawthorne's prose with a fine equilibrium between sympathy and judgment, between author and community, between present and past.

For if Hawthorne feels a bond of sympathy for the past, he feels one also for the present. Despite the satiric impulse Hawthorne directs toward the gallery of customs officers he sketches, there is one figure he unmistakably admires. I mean of course General Miller. Whatever weak dependence on their country tends to debase the nature of men in Custom Houses, Hawthorne knows that the Old General fully deserved the post his country has given him. Observing him intently, Hawthorne knows that deep within the man there still must be the glowing heart, the immortal moment of his past heroism, when in the battle of Lundy's Lane he had been asked by his superior to make a desperate charge upon a difficult position and had given his famous reply, "I'll try, Sir." That act had been for his country, not against it, and whatever vengeance Hawthorne might wish to feel or take against his country is monitored by the very presence of General Miller.

Actually, the presence of the General represents for Hawthorne another possibility—the possibility of the past hidden within the present, the very possibility which awakens Hawthorne's torpid imagination. For it is well to remember that in the fiction of the Custom House, it is not in the romancer's chamber—that unforgettable spot where moonlight from the window coupled with firelight from glowing embers casts a

light at once warm and cold upon objects which are in turn reflected in a mirror for the romancer's imagination—it is not, I repeat, in this imagined chamber that Hawthorne finds the Scarlet Letter. He finds it rather in the attic, or as Hawthorne so beautifully puts it, in the *second story* of the Custom House. It is a manuscript which old Surveyor Pue, the British Surveyor of Customs, had collected and begun editing, only to leave it behind in his flight before the approaching forces of the American Revolution. Like the legend of the youth on the battlefield at Concord, it is the story which was left behind, but this time it is embodied (which is to say imaginatively realized) as a manuscript the artist is to edit. With the manuscript is the faded Scarlet Letter, the emblem of the narrative, which, when placed upon his breast, causes his heart to burn and glow. Here is not the hearth fire of romance, but the very impulse of the story leaping toward the letter, for the glow of the artist's heart is the throb of sympathetic identity with the discovered manuscript.

Hawthorne is not, however, finished with his fiction. There remains the needed sanction from the past, and Hawthorne imagines the ghostly presence of Surveyor Pue commissioning him, just as the general officer had once commissioned the brave young Miller, to undertake the difficult assignment of bringing the manuscript from the recesses of the Custom House into the light. And Hawthorne, like Miller before him, replies: "I will." Thus the active will of the artist undertakes its own heroic work. And the work surely is heroic, for Hawthorne the Artist, who was suppressed and held in check by Hawthorne the Surveyor of Customs, is released to bring through the Custom House the narrative which would not pass the Customs of his country. This too is of course a metaphor, but a metaphor which brings us face to face with Hawthorne's act of the imagination.

The novel which would not pass the customs! What are the consequences of such a metaphor for *The Scarlet Letter*? Before sketching the shadowy outlines of my vision, I want to use as a background two generalizations about Hawthorne's conception of fiction. First, he sees fiction as the experience suppressed by history. The whole of history is, from the time of the classical world forward, the record of man's steady effort to free himself from the past: The Christians from the pagans; the Puritans from the Catholics; and finally the state from the church, in the form of America. Second, Hawthorne accepts this record as progression, just as he approves of the American Revolution. But each act of man's progression in history suppresses an element of the past, and thus recorded history is attended by its suppressed shadow, which takes the form of oral tales and legends. These tales are precisely the aspect of the past which actual history has rendered unreal and imaginary, and it is just this shadowy inheritance which the artist seizes upon to bring through

the Custom House of the present. Such an act is not so much taken against the present as to complete the present, the present which Hawthorne believes in and enjoys. It is his belief in the present which acts as his inner resistance to the imaginary past which he inherits, and he thus sets himself as the editor of the inherited manuscript to comment upon it, resist it, check it, and even censor it.

His censorship takes the form of moralizing and editorializing upon the narrative. Hawthorne's awareness that he is bringing to light something which the history he approves had lodged in the Custom House makes him need the moral not only as a protection against charges of subversion but also as a reality which both causes and justifies the tale. Morals in Hawthorne are not simply complacent masks to disguise the real operations of his imagination; they are rather the priorities which, like the Minister's Black Veil or the Scarlet Letter itself with its clear original meaning, make the tale possible. They are the approved values resulting from the experience they necessarily negate, and thus operate in the present in the same way that the actuality of history does: to reject the very past out of which they came. Every experience for Hawthorne is either a deviation from a moral convention or an eventuation into a moral conclusion which condemns the experience from which it arises.

These are generalizations. There is still the book itself. The book is about the consequences of an original sin of adultery committed in the unseen foreground. In an effort to bring the sin into the light of day, the Puritan community fixes the blame and shame upon the visible sinner, the Mother with her Child. Yet each act of judgment, in the relentless plot of the novel, both discloses and increases the guilt within the society until the Scarlet Letter seems to be in every heart and can be seen against the very heavens. That is what the book is about.

But the book is literally Hawthorne's incarnation of the Scarlet Letter into an action which makes the reader reenact the scapegoating process he condemns in the Puritan community. Thus out of the sympathy which he is made to feel for Hester, the reader fixes his own Scarlet Letter on someone else—indicting at first Dimmesdale, then Chillingworth, and finally the worst sinner of all, the Puritan settlement. To act out these indictments in the form of interpretations is to recommit the sin—or at least half the sin—of *The Scarlet Letter*, which is scapegoating one person or institution in the defense of another. Having recommitted the sin, the fortunate reader can, in an act of self-judgment, begin to release himself from re-enacting the repression *in* the past to which he has previously felt superior. That release takes the shape of judging Hester somewhat as the Editor judges her, thereby tempering with sympathy the judgment of the other characters and the past. The reader who has thus consciously committed the sin of the Scarlet Letter can begin to take something of

the shame Hawthorne gladly took upon himself and join by act of sympathy and judgment not only all the characters and the Puritan past, but also the artist who conceived them. To have joined that community and to have realized that it is a community of equal guilt—a world in which the guilt is truly democratized—is to have truly experienced *The Scarlet Letter*.

We as readers do not feel the *sin* of our reading; we simply have the experience in the form of a new interpretation—an *original* interpretation—and an interpretation is an act of knowing. Even if we carry out all the successive indictments in the form of successive interpretations, we hardly feel *guilty* about recapitulating the process of scapegoating which the book so searingly exposes. Even to say that we do feel guilty is likely to put us no farther forward than the Puritans who spoke of all men's depravity yet continued to judge others as if they were mysteriously elect. All we do is move from interpretation to interpretation in transcendent acts of pride. If art makes experience possible (and may make it dubious or false), knowing makes feeling possible (and may corrupt it from the beginning). These twin truths constitute the fate of the artist and the fall of man.

Just here we might want to say, "Aha! Hawthorne is at last a Calvinist!" But no, he is an artist; that is his progression in time. In the past, he would or might have been the guilty Puritan who scourged Quakers and Witches, in acts of judgment which could or could not have been true. But now he is an artist, involving his reader in an action which may or may not be real. Though he is not committing real crimes, he may be committing unreal ones. With just this irony in mind we can at last see both the form and meaning of the Custom House preface. For in writing the actual book, Hawthorne put the adultery in the foreground, making many a modern reader feel that his squeamishness couldn't depict the actual thrill of sexuality, which very well may have been true. Yet Hawthorne still could have written a sentimental novel in which the adultery would have been the climactic action, however veiled and circumlocutory his description of the momentous event might have been. Such novels were being written then; they are being written now. But Hawthorne saw the adultery as fertile, not sterile. Thus, instead of repressing the fact of the child—as a host of writers of supposedly passionate yet actually sterile amours have done—he begins with the Mother and Child emerging from the Prison House. Moreover, he gives us the matriarchal queen, the real witch, whom not only Puritanism but Christianity itself had repressed or reduced to a virgin. Not only had the Puritans repressed her; so had the Church fathers before them, and so had the Founding Fathers afterward. Hawthorne is both sane enough and strong enough to question his act of releasing her through the Custom

House. She is the emblazoned, aristocratic, matriarchal spirit which he at once boldly and guardedly brings into the present as a fiction of the past.

Hawthorne makes his question and his act the very conception of *The Scarlet Letter* and the Custom House preface, for the preface literally displaces the original sin of Hester and Dimmesdale in the forest. It *is* the foreground, for it was in the Artist Hawthorne's mind and heart, and not in some Colonial Forest, that the original act of adultery took place, and Hawthorne is once again sane enough and strong enough to put himself as Artist before his fiction, disclosing the act of self-conception which projects the original sin through the Custom House upon the innocent republic and upon the innocent reader. That, then, is Hawthorne's original sin: the sin of art itself, and Melville was not far from the mark when he felt the diabolism of *Mosses from an Old Manse*. For original sin is nothing if it merely seems inherited; it must seem as new as an invented story if the author is to feel its originality, or it must seem as thrilling as a new interpretation if the reader is to feel the passion of his insight. When it does, then the *A* would stand for Art, for Author, and for America. The best we can say, and the best that I think Hawthorne could say, is that it would stand for and not against them.

The Ruined Wall

Frederick Crews

The golden sands that may sometimes be gathered (always, perhaps, if we know how to seek for them) along the dry bed of a torrent, adown which passion and feeling have foamed, and past away. It is good, therefore, in mature life, to trace back such torrents to their source.

—HAWTHORNE, *AMERICAN NOTEBOOKS*

Hester Prynne and Arthur Dimmesdale, in the protective gloom of the forest surrounding Boston, have had their fateful reunion. While little Pearl, sent discreetly out of hearing range, has been romping about in her unrestrained way, the martyred lovers have unburdened themselves. Hester has revealed the identity of Chillingworth and has succeeded in winning Dimmesdale's forgiveness for her previous secrecy. Dimmesdale has explained the agony of his seven years' torment. Self-pity and compassion have led unexpectedly to a revival of desire; "what we did," as Hester boldly remembers, "had a consecration of its own,"[1] and Arthur Dimmesdale cannot deny it. In his state of helpless longing he allows himself to be swayed by Hester's insistence that the past can be forgotten, that deep in the wilderness or across the ocean, accompanied and sustained by Hester, he can free himself from the revengeful gaze of Roger Chillingworth.

Hester's argument is of course a superficial one; the ultimate source of Dimmesdale's anguish is not Chillingworth but his own remorse, and this cannot be left behind in Boston. The closing chapters of *The Scarlet Letter* demonstrate this clearly enough, but Hawthorne, with characteristic license, tells us at once that Hester is wrong. "And be the stern

and sad truth spoken," he says, "that the breach which guilt has once made into the human soul is never, in this mortal state, repaired. It may be watched and guarded; so that the enemy shall not force his way again into the citadel, and might even, in his subsequent assaults, select some other avenue, in preference to that where he had formerly succeeded. But there is still the ruined wall, and, near it, the stealthy tread of the foe that would win over again his unforgotten triumph" (pp. 200f.).

This metaphor is too striking to be passed over quickly. Like Melville's famous comparison of the unconscious mind to a subterranean captive king in Chapter XLI of *Moby-Dick,* it provides us with a theoretical understanding of behavior we might otherwise judge to be poorly motivated. Arthur Dimmesdale, like Ahab, is "gnawed within and scorched without, with the infixed, unrelenting fangs of some incurable idea," and Hawthorne's metaphor, inserted at a crucial moment in the plot, enables us to see the inner mechanism of Dimmesdale's torment.

At first, admittedly, we do not seem entitled to draw broad psychological conclusions from these few sentences. Indeed, we may even say that the metaphor reveals a fruitless confusion of terms. Does Hawthorne mean to describe the soul's precautions against the repetition of overt sin? Apparently not, since the "stealthy foe" is identified as *guilt* rather than as the forbidden urge to sin. But if the metaphor means what it says, how are we to reduce it to common sense? It is plainly inappropriate to see "guilt" as the original assailant of the citadel, for feelings of guilt arise only in *reaction against* condemned acts or thoughts. The metaphor would seem to be plausible only in different terms from those that Hawthorne selected.

We may resolve this confusion by appealing to Arthur Dimmesdale's literal situation. In committing adultery he has succumbed to an urge which, because of his ascetic beliefs, he had been unprepared to find in himself. Nor, given the high development of his conscience and the sincerity of his wish to be holy, could he have done otherwise than to have violently expelled and denied the sensual impulse, once gratified. It was at this point, we may say—the point at which one element of Dimmesdale's nature passed a sentence of exile on another—that the true psychological damage was done. The original foe of his tranquility *was* guilt, but guilt for his thoughtless surrender to passion. In this light we see that Hawthorne's metaphor has condensed two ideas that are intimately related. Dimmesdale's moral enemy is the forbidden impulse, while his psychological enemy is guilt; but there is no practical difference between the two, for they always appear together. We may understand Hawthorne's full meaning if we identify the potential invader of the citadel as a libidinal impulse, *now necessarily bearing a charge of guilt.*

This hypothesis helps us to understand the sophisticated view of Dimmesdale's psychology that Hawthorne's metaphor implies. Dimmesdale's conscience (the watchful guard) has been delegated to prevent repetition of the temptation's "unforgotten triumph." The deterrent weapon of conscience is its capacity to generate feelings of guilt, which are of course painful to the soul. Though the temptation retains all its strength (its demand for gratification), this is counterbalanced by its burden of guilt. To readmit the libidinal impulse through the guarded breach (to gratify it in the original way) would be to admit insupportable quantities of guilt. The soul thus keeps temptation at bay by meeting it with an equal and opposite force of condemnation.

But let us consider the most arresting feature of Hawthorne's metaphor. The banished impulse, thwarted in one direction, "might even, in his subsequent assaults, select some other avenue, in preference to that where he had formerly succeeded." Indeed, the logic of Hawthorne's figure seems to assure success to the temptation in finding another means of entrance, since conscience is massing all its defenses at the breach. This devious invasion would evidently be less gratifying than the direct one, for we are told that the stealthy foe would stay in readiness to attack the breach again. Some entry, nevertheless, is preferable to none, especially when it can be effectuated with a minimum resistance on the part of conscience. Hawthorne has set up a strong likelihood that the libidinal impulse will change or disguise its true object, slip past the guard of conscience with relative ease, and take up a secret dwelling in the soul.

In seeking to explain what Hawthorne means by this "other avenue" of invasion, we must bear in mind the double reference of his metaphor. It describes the soul's means of combating both sin and guilt—that is, both *gratification* of the guilty impulse and *consciousness* of it. For Dimmesdale the greatest torment is to acknowledge that his libidinous wishes are really his, and not a temptation from the Devil. His mental energy is directed, not simply to avoiding sin, but to expelling it from consciousness—in a word, to repressing it. The "other avenue" is the means his libido chooses, given the fact of repression, to gratify itself surreptitiously. In psychoanalytic terms this is the avenue of compromise that issues in a neurotic symptom.

Hawthorne's metaphor of the besieged citadel cuts beneath the theological and moral explanations in which Dimmesdale puts his faith, and shows us instead an inner world of unconscious compulsion. Guilt will continue to threaten the timid minister in spite of his resolution to escape it, and indeed (as the fusion of "temptation" and "guilt" in the metaphor implies) this resolution will only serve to upset the balance of power and enable guilt to conquer the soul once more. Hawthorne's metaphor demands that we see Dimmesdale not as a free moral agent but as a victim

of feelings he can neither understand nor control. And the point can be extended to include Chillingworth and even Hester, whose minds have been likewise altered by the consequences of the unforgotten act, the permanent breach in the wall. If, as Chillingworth asserts, the awful course of events has been "a dark necessity" from the beginning, it is not because Hawthorne believes in Calvinistic predestination or wants to imitate Greek tragedy, but because all three of the central characters have been ruled by motives inaccessible to their conscious will.

The implications we have drawn, perhaps over-subtly, from Hawthorne's metaphor begin to take on substance as we examine Arthur Dimmesdale in the forest scene. His nervousness, his mental exhaustion, and his compulsive gesture of placing his hand on his heart reveal a state that we would now call neurotic inhibition. His lack of energy for any of the outward demands of life indicates how all-absorbing is his internal trouble, and the stigma on his chest, though a rather crass piece of symbolism on Hawthorne's part, must also be interpreted psychosomatically. Nor can we avoid observing that Dimmesdale shows the neurotic's reluctance to give up his symptoms. How else can we account for his obtuseness in not having recognized Chillingworth's character? "I might have known it!" he murmurs when Hester forces the revelation upon him. "I did know it! Was not the secret told me in the natural recoil of my heart, at the first sight of him, and as often as I have seen him since? Why did I not understand?" (p. 194). The answer, hidden from Dimmesdale's surface reasoning, is that his relationship with Chillingworth, taken together with the change in mental economy that has accompanied it, has offered perverse satisfactions which he is even now powerless to renounce. Hester, whose will is relatively independent and strong, is the one who makes the decision to break with the past.

We can understand the nature of Dimmesdale's illness by defining the state of mind that has possessed him for seven years. It is of course his concealed act of adultery that lies at the bottom of his self-torment. But why does he lack the courage to make his humiliation public? Dimmesdale himself offers us the clue in a cry of agony: "Of penance I have had enough! Of penitence there has been none! Else, I should long ago have thrown off these garments of mock holiness, and have shown myself to mankind as they will see me at the judgment-seat" (p. 192). The plain meaning of this outburst is that Dimmesdale has never surmounted the libidinal urge that produced his sin. His "penance," including self-flagellation and the more refined torment of submitting to Chillingworth's influence, has failed to purify him because it has been unaccompanied by the feeling of penitence, the resolution to sin no more. Indeed, I submit, Dimmesdale's penance has incorporated and embodied the very urge it has been punishing. If, as he says, he has kept his gar-

ments of mock holiness *because* he has not repented, he must mean that in some way or another the forbidden impulse has found gratification in the existing circumstances, in the existing state of his soul. And this state is one of morbid remorse. The stealthy foe has re-entered the citadel through the avenue of remorse.

This conclusion may seem less paradoxical if we bear in mind a distinction between remorse and true repentance. In both states the sinful act is condemned morally, but in strict repentance the soul abandons the sin and turns to holier thoughts. Remorse of Dimmesdale's type, on the other hand, is attached to a continual re-enacting of the sin in fantasy and hence a continual renewal of the need for self-punishment. Roger Chillingworth, the psychoanalyst *manqué*, understands the process perfectly: "the fear, the remorse, the agony, the ineffectual repentance, the backward rush of sinful thoughts, expelled in vain!" (p. 139). As Hawthorne explains, Dimmesdale's cowardice is the "sister and closely linked companion" (p. 148) of his remorse.

Thus Dimmesdale is helpless to reform himself at this stage because the passional side of his nature has found an outlet, albeit a self-destructive one, in his present miserable situation. The original sexual desire has been granted recognition *on the condition of being punished,* and the punishment itself is a form of gratification. Not only the overt masochism of fasts, vigils, and self-scourging (the last of these makes him laugh, by the way), but also Dimmesdale's emaciation and weariness attest to the spending of his energy against himself. It is important to recognize that this is the same energy previously devoted to passion for Hester. We do not exaggerate the facts of the romance in saying that the question of Dimmesdale's fate, for all its religious decoration, amounts essentially to the question of what use is to be made of his libido.

We are now prepared to understand the choice that the poor minister faces when Hester holds out the idea of escape. It is not a choice between a totally unattractive life and a happy one (not even Dimmesdale could feel hesitation in that case), but rather a choice of satisfactions, of avenues into the citadel. The seemingly worthless alternative of continuing to admit the morally condemned impulse by the way of remorse has the advantage, appreciated by all neurotics, of preserving the status quo. Still, the other course naturally seems more attractive. If only repression can be weakened—and this is just the task of Hester's rhetoric about freedom—Dimmesdale can hope to return to the previous "breach" of adultery.

In reality, however, these alternatives offer no chance for happiness or even survival. The masochistic course leads straight to death, while the other, which Dimmesdale allows Hester to choose for him, is by now so foreign to his withered, guilt-ridden nature that it can never be put

into effect. The resolution to sin will, instead, necessarily redouble the opposing force of conscience, which will be stronger in proportion to the overtness of the libidinal threat. As the concluding chapters of *The Scarlet Letter* prove, the only possible result of Dimmesdale's attempt to impose, in Hawthorne's phrase, "a total change of dynasty and moral code, in that interior kingdom" (p. 217), will be a counter-revolution so violent that it will slay Dimmesdale himself along with his upstart libido. We thus see that in the forest, while Hester is prating of escape, renewal, and success, Arthur Dimmesdale unknowingly faces a choice of two paths to suicide.

Now, this psychological impasse is sufficient in itself to refute the most "liberal" critics of *The Scarlet Letter*—those who take Hester's proposal of escape as Hawthorne's own advice. However much we may admire Hester and prefer her boldness to Dimmesdale's self-pity, we cannot agree that she understands human nature very deeply. Her shame, despair, and solitude "had made her strong," says Hawthorne, "but taught her much amiss" (p. 200). What she principally ignores is the truth embodied in the metaphor of the ruined wall, that men are altered irreparably by their violations of conscience. Hester herself is only an apparent exception to this rule. She handles her guilt more successfully than Dimmesdale because, in the first place, her conscience is less highly developed than his; and secondly because, as he tells her, "Heaven hath granted thee an open ignominy, that thereby thou mayest work out an open triumph over the evil within thee, and the sorrow without" (p. 67). Those who believe that Hawthorne is an advocate of free love, that adultery has no ill effects on a "normal" nature like Hester's, have failed to observe that Hester, too, undergoes self-inflicted punishment. Though permitted to leave, she has remained in Boston not simply because she wants to be near Arthur Dimmesdale, but because this has been the scene of her humiliation. "Her sin, her ignominy, were the roots which she had struck into the soil," says Hawthorne. "The chain that bound her here was of iron links, and galling to her inmost soul, but never could be broken" (p. 80).

We need not dwell on this argument, for the liberal critics of *The Scarlet Letter* have been in retreat for many years. Their place has been taken by subtler readers who say that Hawthorne brings us from sin to redemption, from materialistic error to pure spiritual truth. The moral heart of the novel, in this view, is contained in Dimmesdale's Election Sermon, and Dimmesdale himself is pictured as Christ-like in his holy death. Hester, in comparison, degenerates spiritually after the first few chapters; the fact that her thoughts are still on earthly love while Dimmesdale is looking toward heaven is a serious mark against her.

This redemptive scheme, which rests on the uncriticized assumption

that Hawthorne's point of view is identical with Dimmesdale's at the end, seems to me to misrepresent the "felt life" of *The Scarlet Letter* more drastically than the liberal reading. Both take for granted the erroneous belief that the novel consists essentially of the dramatization of a moral idea. The tale of human frailty and sorrow, as Hawthorne calls it in his opening chapter, is treated merely as the fictionalization of an article of faith. Hawthorne himself, we might repeat, did not share this ability of his critics to shrug off the psychological reality of his work. *The Scarlet Letter* is, he said, "positively a hell fired story, into which I found it almost impossible to throw any cheering light."

All parties can agree, in any case, that there is a terrible irony in Dimmesdale's exhilaration when he has resolved to flee with Hester. Being, as Hawthorne describes him, "a true religionist," to whom it would always remain essential "to feel the pressure of a faith about him, supporting, while it confined him within its iron framework" (p. 123), he is ill-prepared to savor his new freedom for what it is. His joy is that of his victorious libido, of the "enemy" which is now presumably sacking the citadel, but this release is acknowledged by consciousness only after a significant bowdlerization:

> "Do I feel joy again?" cried he, wondering at himself. "Methought the germ of it was dead in me! O Hester, thou art my better angel! I seem to have flung myself—sick, sin-stained, and sorrow-blackened—down upon these forest leaves, and to have risen up all made anew, and with new powers to glorify Him that hath been merciful! This is already the better life! Why did we not find it sooner?" (pp. 201f.)

Hawthorne's portrayal of self-delusion and his compassion are nowhere so powerfully combined as in this passage. The Christian reference to the putting on of the New Man is grimly comic in the light of what has inspired it, but we feel no more urge to laugh at Dimmesdale than we do at Milton's Adam. If in his previous role he has been only, in Hawthorne's phrase, a "subtle, but remorseful hypocrite" (p. 144), here he is striving pathetically to be sincere. His case becomes poignant as we imagine the revenge that his tyrannical conscience must soon take against these new promptings of the flesh. To say merely that Dimmesdale is in a state of theological error is to miss part of the irony; it is precisely his theological loyalty that necessitates his confusion. His sexual nature must be either denied with unconscious sophistry, as in this scene, or rooted out with heroic fanaticism, as in his public confession at the end.

On one point, however, Dimmesdale is not mistaken: he has been blessed with a new energy of body and will. The source of this energy is obviously his libido; he has become physically strong to the degree that he has ceased directing his passion against himself and has attached it to

his thoughts of Hester. But as he now returns to town,[2] bent upon renewing his hypocrisy for the four days until the Election Sermon has been given and the ship is to sail, we see that his "cure" has been very incomplete. "At every step he was incited to do some strange, wild, wicked thing or other, with a sense that it would be at once involuntary and intentional; in spite of himself, yet growing out of a profounder self than that which opposed the impulse" (p. 217). The minister can scarcely keep from blaspheming to his young and old parishioners as he passes them in the street; he longs to shock a deacon and an old widow with arguments against Christianity, to poison the innocence of a naïve girl who worships him, to teach wicked words to a group of children, and to exchange bawdy jests with a drunken sailor. Here, plainly, is a return of the repressed, and in a form which Freud noted to be typical in severely holy persons.[3] The fact that these impulses have reached the surface of Dimmesdale's mind attests to the weakening of repression in the forest scene, while their perverse and furtive character shows us that repression has not ceased altogether. Hawthorne's own explanation, that Dimmesdale's hidden vices have been awakened because "he had yielded himself *with deliberate choice,* as he had never done before, to what he *knew* was deadly sin" (p. 222; my italics), gives conscience its proper role as a causative factor. Having left Hester's immediate influence behind in the forest, and having returned to the society where he is known for his purity, Dimmesdale already finds his "wicked" intentions constrained into the form of a verbal naughtiness which he cannot even bring himself to express.

Now Dimmesdale, presumably after a brief interview with the taunting Mistress Hibbins, arrives at his lodgings. Artfully spurning the attentions of Roger Chillingworth, he eats his supper "with ravenous appetite" (p. 225) and sits down to write the Election Sermon. Without really knowing what words he is setting on paper, and wondering to himself how God could inspire such a sinner as himself, he works all night "with earnest haste and ecstasy" (p. 225). The result is a sermon which, with the addition of spontaneous interpolations in the delivery, will impress its Puritan audience as an epitome of holiness and pathos. Nothing less than the descent of the Holy Ghost will be held sufficient to account for such a performance.

Yet insofar as the Election Sermon will consist of what Dimmesdale has recorded in his siege of "automatic writing," we must doubt whether Hawthorne shares the credulous view of the Puritans. Dimmesdale has undergone no discernible change in attitude from the time of his eccentric impulses in the street until the writing of the sermon. Though he works in the room where he has fasted and prayed, and where he can see his old Bible, he is not (as Male argues) sustained by these reminders of his

faith. Quite the contrary: he can scarcely believe that he has ever breathed such an atmosphere. "But he seemed to stand apart, and eye this former self with scornful, pitying, but half-envious curiosity. That self was gone! Another man had returned out of the forest; a wiser one; with a knowledge of hidden mysteries which the simplicity of the former never could have reached" (p. 223). In short, the Election Sermon is written by the same man who wants to corrupt young girls in the street, and the same newly liberated sexuality "inspires" him in both cases. If the written form of the Election Sermon *is* a great Christian document, as we have no reason to doubt, this is attributable not to Dimmesdale's holiness but to his libido, which gives him creative strength and an intimate acquaintance with the reality of sin.

Thus Dimmesdale's sexual energy has temporarily found a new alternative to its battle with repression—namely, sublimation. In sublimation, we are told, the libido is not repressed but redirected to aims that are acceptable to conscience. The writing of the Election Sermon is just such an aim, and readers who are familiar with psychoanalysis will not be puzzled to find that Dimmesdale has passed without hesitation from the greatest blasphemy to fervent religious rhetoric.

There is little doubt that Dimmesdale has somehow recovered his piety in the three days that intervene between the writing of the sermon and its delivery. Both Hester and Mistress Hibbins "find it hard to believe him the same man" (p. 241) who emerged from the forest. Though he is preoccupied with his imminent sermon as he marches past Hester, his energy seems greater than ever and his nervous mannerism is absent. We could say, if we liked, that at this point God's grace has already begun to sustain Dimmesdale, but there is nothing in Hawthorne's description to warrant a resort to supernatural explanations. It seems likely that Dimmesdale has by now felt the full weight of his conscience's case against adultery, has already determined to confess his previous sin publicly, and so is no longer suffering from repression. His libido is now free, not to attach itself to Hester, but to be sublimated into the passion of delivering his sermon and then expelled forever.

The ironies in Dimmesdale's situation as he leaves the church, having preached with magnificent power, are extremely subtle. His career, as Hawthorne tells us, has touched the proudest eminence that any clergyman could hope to attain, yet this eminence is due, among other things, to "a reputation of whitest sanctity" (p. 249). Furthermore, Hester has been silently tormented by an inquisitive mob while Dimmesdale has been preaching, and we feel the injustice of the contrast. And yet Dimmesdale has already made the choice that will render him worthy of the praise he is now receiving. If his public hypocrisy has not yet been dissolved, his hypocrisy with himself is over. It would be small-minded

not to recognize that Dimmesdale has, after all, achieved a point of heroic independence—an independence not only of his fawning congregation but also of Hester, who frankly resents it. If the Christian reading of *The Scarlet Letter* judges Hester too roughly on theological grounds, it is at least correct in seeing that she lacks the detachment to appreciate Dimmesdale's final act of courage. While she remains on the steady level of her womanly affections, Dimmesdale, who has previously stooped below his ordinary manhood, is now ready to act with the exalted fervor of a saint.

All the moral ambiguity of *The Scarlet Letter* makes itself felt in Dimmesdale's moment of confession. We may truly say that no one has a total view of what is happening. The citizens of Boston, for whom it would be an irreverent thought to connect their minister with Hester, turn to various rationalizations to avoid comprehending the scene. Hester is bewildered, and Pearl feels only a generalized sense of grief. But what about Arthur Dimmesdale? Is he really on his way to heaven as he proclaims God's mercy in his dying words?

> "He hath proved his mercy, most of all, in my afflictions. By giving me this
> burning torture to bear upon my breast! By sending yonder dark and
> terrible old man, to keep the torture always at red-heat! By bringing me
> hither, to die this death of triumphant ignominy before the people! Had
> either of these agonies been wanting, I had been lost for ever! Praised be
> his name! His will be done! Farewell!" (pp. 256f.)

This reasoning, which sounds so cruel to the ear of rational humanism, has the logic of Christian doctrine behind it; it rests on the paradox that a man must lose his life to save it. The question that the neo-orthodox interpreters of *The Scarlet Letter* invariably ignore, however, is whether Hawthorne has prepared us to understand this scene only in doctrinal terms. Has he abandoned his usual irony and lost himself in religious transport?

The question ultimately amounts to a matter of critical method: whether we are to take the action of *The Scarlet Letter* in natural or supernatural terms. Hawthorne offers us naturalistic explanations for everything that happens, and though he also puts forth opposite theories—Pearl is an elf-child, Mistress Hibbins is a witch, and so on—this mode of thinking is discredited by the simplicity of the people who employ it. We cannot conscientiously say that Chillingworth *is* a devil, for example, when Hawthorne takes such care to show us how his devilishness has proceeded from his physical deformity, his sense of inferiority and impotence, his sexual jealousy, and his perverted craving for knowledge. Hawthorne carries symbolism to the border of allegory but does not cross over. As for Dimmesdale's retrospective idea that God's mercy has been respon-

sible for the whole chain of events, we cannot absolutely deny that this may be true; but we can remark that if it *is* true, Hawthorne has vitiated his otherwise brilliant study of motivation.

Nothing in Dimmesdale's behavior on the scaffold is incongruous with his psychology as we first examined it in the forest scene. We merely find ourselves at the conclusion to the breakdown of repression that began there, and which has necessarily brought about a renewal of opposition to the forbidden impulses. Dimmesdale has been heroic in choosing to eradicate his libidinal self with one stroke, but his heroism follows a sound principle of mental economy. Further repression, which is the only other alternative for his conscience-ridden nature, would only lead to a slower and more painful death through masochistic remorse. Nor can we help but see that his confession passes beyond a humble admission of sinfulness and touches the pathological. His stigma has become the central object in the universe: "God's eye beheld it! The angels were for ever pointing at it! The Devil knew it well, and fretted it continually with the touch of his burning finger!" (p. 255). Dimmesdale is so obsessed with his own guilt that he negates the Christian dogma of original sin: "behold me here, the one sinner of the world!" (p. 254). This strain of egoism in his "triumphant ignominy" does not subtract from his courage, but it casts doubt on his theory that all the preceding action has been staged by God for the purpose of saving his soul.

However much we may admire Dimmesdale's final asceticism, there are no grounds for taking it as Hawthorne's moral ideal. The last developments of plot in *The Scarlet Letter* approach the "mythic level" which redemption-minded critics love to discover, but the myth is wholly secular and worldly. Pearl, who has hitherto been a "messenger of anguish" to her mother, is emotionally transformed as she kisses Dimmesdale on the scaffold. "A spell was broken. The great scene of grief, in which the wild infant bore a part, had developed all her sympathies; and as her tears fell upon her father's cheek, they were the pledge that she would grow up amid human joy and sorrow, nor for ever do battle with the world, but be a woman in it" (p. 256). Thanks to Chillingworth's bequest—for Chillingworth, too, finds that a spell is broken when Dimmesdale confesses, and he is capable of at least one generous act before he dies—Pearl is made "the richest heiress of her day, in the New World" (p. 261). At last report she has become the wife of a European nobleman and is living very happily across the sea. This grandiose and perhaps slightly whimsical epilogue has one undeniable effect on the reader: it takes him as far as possible from the scene and spirit of Dimmesdale's farewell. Pearl's immense wealth, her noble title, her lavish and impractical gifts to Hester, and of course her successful escape from Boston all serve to disparage the Puritan sense of reality. From this distance we look

back to Dimmesdale's egocentric confession, not as a moral example which Hawthorne would like us to follow, but as the last link in a chain of compulsion that has now been relaxed.

To counterbalance this impression we have the case of Hester, for whom the drama on the scaffold can never be completely over. After raising Pearl in a more generous atmosphere she voluntarily returns to Boston to resume, or rather to begin, her state of penitence. We must note, however, that this penitence seems to be devoid of theological content; Hester has returned because Boston and the scarlet letter offer her "a more real life" (p. 262) than she could find elsewhere, even with Pearl. This simply confirms Hawthorne's emphasis on the irrevocability of guilty acts. And though Hester is now selfless and humble, it is not because she believes in Christian submissiveness but because all passion has been spent. To the women who seek her help "in the continually recurring trials of wounded, wasted, wronged, misplaced, or erring and sinful passion" (p. 263), Hester does not disguise her conviction that women are pathetically misunderstood in her society. She assures her wretched friends that at some later period "a new truth would be re-vealed, in order to establish the whole relation between man and woman on a surer ground of mutual happiness" (p. 263). Hawthorne may or may not believe the prediction, but it has a retrospective importance in *The Scarlet Letter*. Hawthorne's characters originally acted in ignorance of passion's strength and persistence, and so they became its slaves.

"It is a curious subject of observation and inquiry," says Hawthorne at the end, "whether hatred and love be not the same thing at bottom. Each, in its utmost development, supposes a high degree of intimacy and heart-knowledge; each renders one individual dependent for the food of his affections and spiritual life upon another; each leaves the passionate lover, or the no less passionate hater, forlorn and desolate by the with-drawal of his object" (p. 260). These penetrating words remind us that the tragedy of *The Scarlet Letter* has chiefly sprung, not from Puritan society's imposition of false social ideals on the three main characters, but from their own inner world of frustrated desires. Hester, Dimmesdale, and Chillingworth have been ruled by feelings only half perceived, much less understood and regulated by consciousness; and these feelings, as Hawthorne's bold equation of love and hatred implies, successfully resist translation into terms of good and evil. Hawthorne does not leave us simply with the Sunday-school lesson that we should "be true" (p. 260), but with a tale of passion through which we glimpse the ruined wall— the terrible certainty that, as Freud put it, the ego is not master in its own house. It is this intuition that enables Hawthorne to reach a tragic vision worthy of the name: to see to the bottom of his created characters, to understand the inner necessity of everything they do, and thus to pity and forgive them in the very act of laying bare their weaknesses.

Notes

[1] Nathaniel Hawthorne, *The Scarlet Letter*, The Centenary Edition of the Works of Nathaniel Hawthorne, vol. I (Columbus: Ohio State Univ. Press, 1962), p. 195. All page references are to this edition and will be cited parenthetically within the text. [Editors]

[2] Note, incidentally, the implicit sexuality of his cross-country run, as he "leaped across the plashy places, thrust himself through the clinging underbrush. climbed the ascent, plunged into the hollow. . . ." (p. 216).

[3] See, for example, *Collected Papers*, III, 331, 599f.

Melville
Moby-Dick

The Universal Thump: Jehovah's Winter World

Robert Zoellner

Ishmael always goes to sea, he tells us, "as a simple sailor, right before the mast." As such, he becomes the target for directives emanating from everyone over him in the ship's hierarchy. "True, they rather order me about some, and make me jump from spar to spar, like a grasshopper in a May meadow." At first he finds all this "unpleasant enough": to be everybody's lackey "touches one's sense of honor," especially if one comes from an "old established family," and "if just previous to putting your hand into the tar-pot, you have been lording it as a country schoolmaster, making the tallest boys stand in awe of you. The transition is a keen one, I assure you, from a schoolmaster to a sailor, and requires a strong decoction of Seneca and the Stoics to enable you to grin and bear it." But Ishmael commands such humorous stoicism:

> What of it, if some old hunks of a sea-captain orders me to get a broom and sweep down the decks? . . . Who aint a slave? Tell me that. Well, then, however the old sea-captains may order me about—however they may thump and punch me about, I have the satisfaction of knowing that it is all right; that everybody else is one way or other served in much the same way—either in a physical or metaphysical point of view, that is; and so the universal thump is passed round, and all hands should rub each other's shoulder-blades, and be content. (1: *14–15*)*

*The number before the colon in all parenthetical references in the text indicates chapter, which will be the same for most American editions of *Moby-Dick;* the

Reprinted from *The Salt-Sea Mastodon* (Berkeley: University of California Press, 1973), pp. 53–71. Copyright 1973 by the Regents of the University of California. Reprinted by permission of the University of California Press and Robert Zoellner.

This characteristically casual passage would be of no importance were it not that the "universal thump," on both the "physical" and "metaphysical" levels, is a central preoccupation of *Moby-Dick* from first page to last. Ishmael encounters it in one of its most pedestrian forms, the physical kick, before the voyage is well begun. When he makes the mistake of mentioning his experience in the merchant service to old Peleg, that old hunks makes it clear that he is accustomed to communicating his desires to the ship's underlings in ways other than purely verbal. "Marchant service be damned," he roars. "Talk not that lingo to me. Dost see that leg?—I'll take that leg away from thy stern, if ever thou talkest of the marchant service to me again. Marchant service indeed!" (16: *68–69*). Peleg means what he says. Manning the capstan that cold Christmas day as the *Pequod* gets under way, Ishmael gets a taste of that physical suasion which is part of life on a whaler. "I felt a sudden sharp poke in my rear, and turning round, was horrified at the apparition of Captain Peleg in the act of withdrawing his leg from my immediate vicinity. That was my first kick":

> "Is that the way they heave in the marchant service?" [Peleg] roared. "Spring, thou sheep-head; spring, and break thy backbone!" . . . And so saying, he moved along the windlass, here and there using his leg very freely. . . . Thinks I, Captain Peleg must have been drinking something to-day. (22: *95*)

A "situational" version of the universal thump occurs earlier, when Peter Coffin tricks Ishmael into sharing a bed with a cannibal. Ishmael recognizes that the landlord has been "skylarking with me not a little," but again he draws upon Seneca and the Stoics:

> However, a good laugh is a mighty good thing, and rather too scarce a good thing; the more's the pity. So, if any one man, in his own proper person, afford stuff for a good joke to anybody, let him not be backward, but let him cheerfully allow himself to spend and be spent in that way. (5: *35*)

During the first lowering, when Starbuck's boat, with Ishmael aboard, is separated from the *Pequod* during a squall, the crew is recovered from almost certain death by sheer luck. In the subsequent chapter entitled "The Hyena," and as a consequence of this brush with death, Ishmael develops a "free and easy sort of genial, desperado philosophy," the central premise of which is that a man must take "this whole universe

italicized numbers after the colon indicate page in the Norton Critical Edition of *Moby-Dick*, edited by Harrison Hayford and Hershel Parker (New York: W. W. Norton & Company, 1967).

for a vast practical joke, though the wit thereof he but dimly discerns, and more than suspects that the joke is at nobody's expense but his own." Death and destruction become wryly comic expressions of the "universal thump." "And as for small difficulties and worryings, prospects of sudden disaster, peril of life and limb; all these, and death itself, seem . . . only sly, good-natured hits, and jolly punches in the side bestowed by the unseen and unaccountable old joker"—which cosmic funnyman, the chapter title suggests, laughs at man's plight as the hyena laughs, a sort of scavenger humor with, perhaps, a trifle too much tooth to it (49: *195–96*).

This preoccupation with the physical and metaphysical "hits" and "punches" of life furnishes another of the Yankee simplicities of *Moby-Dick,* the dramatic relation we may somewhat inelegantly call the proto-dynamic of *thumper: thumpee.* Melville does not achieve the definitive statement of the relation until Billy Budd delivers a consummate thump to Claggart's forehead some forty years after *Moby-Dick.* But "The Town-Ho's Story" provides the requisite parallel. The "brutal overbearing" of Radney, and the "bitterly provoked vengeance" of Steelkilt are expressed in a series of thumps and counter-thumps. Radney demands that Steel-kilt, who has just finished an exhausting turn at the ship's pumps, sweep down the planks and clean up after a pig running loose on the decks, tasks normally reserved for the lowly ship's boys. This is precisely the humiliating situation which Ishmael anticipated in Chapter I, when he asked what it would really matter "if some old hunks of a sea-captain orders me to get a broom and sweep down the decks? . . . Who aint a slave?" (1: *15*). The answer must be: Steelkilt aint. He quietly refuses Radney's command, whereupon the enraged mate pursues him around the windlass with an "uplifted cooper's club hammer" in his hand until Steelkilt warns "that if the hammer but grazed his cheek he (Steelkilt) would murder him. . . . Immediately the hammer touched the cheek; the next instant the lower jaw of the mate was stove in his head; he fell on the hatch spouting blood like a whale" (54: *209–14*). Steelkilt does *not* react to the thumps of life with the stoical good humor which Ishmael cultivates. This difference in attitude highlights one of the central concerns of *Moby-Dick,* the thumpish nature of life and the question of what reactive stance the individual, in the role of *thumpee,* ought to take toward the "unaccountable old joker" or whatever else in the cosmos appears to play the role of *thumper.*

Ahab, for example, consistently images his thoughts as physical blows. He will "strike through the mask"; he will be like the prisoner "thrusting through the wall"; he would "strike the sun if it insulted [him]" (36: *144*). In an especially vivid articulation of the *thumper: thumpee* proto-dynamic, the *Pequod's* Captain makes topical reference to Jem ("Deaf")

Burke, English boxing champion in 1833, and William Thompson, called "Bendigo," champion from 1839 to 1845, using these figures to express the thumpish stance of the "great gods" of the universe.[1]

> I laugh and hoot at ye, ye cricket-players, ye pugilists, ye deaf Burkes and blinded Bendigoes! I will not say as schoolboys do to bullies,—Take some one of your own size; don't pommel *me*! No, ye've knocked me down, and I am up again; but *ye* have run and hidden. (37: *147*)

But if the bully-gods of the universe mask themselves behind phenomena, great Leviathan is a visible articulation of the untrammeled power they invisibly possess. Ishmael devotes a whole chapter to just the tail of the whale, whose "Titanism of power" can, when "smiting the surface" of the sea, produce a "thunderous concussion [which] resounds for miles"; the "gigantic tail" is "simply irresistible": nothing in this world can stand before "the measureless crush and crash of the sperm whale's ponderous flukes" (86: *315–17*). Another chapter is devoted to the "Battering-Ram" of the whale's head, an "enormous boneless mass" of "compacted collectedness," a "dead, impregnable, uninjurable wall" displaying such "concentrations of potency" that "though the Sperm Whale stove a passage through the Isthmus of Darien, and mixed the Atlantic with the Pacific, you would not elevate one hair of your eye-brow" (76: *284–85*). A third chapter, "The Affidavit," is devoted to the whale's historical ability to "stave in, utterly destroy, and sink" large ships by "vertical bumps," cosmic "thwacks," and "terrible shocks" of "great power and malice" (45: *178–81*). All this prepares one for the climactic thump when "the solid white buttress" of Moby Dick's forehead crushes the *Pequod*'s starboard bow, "till men and timbers reeled" (135: *468*). But even this predestinated shock is not the last thump of the novel. As the *Pequod* sinks beneath the surface, out of the waves in mute gesture rises Tashtego's "red arm and a hammer hover[ing] backwardly uplifted in the open air, in the act of nailing the flag faster and yet faster to the subsiding spar." The final *thumpee* is the "sky-hawk" which interposes "its broad fluttering wing between the hammer and the wood," and, victim of Tashtego's last defiant blow at the cosmos, is pulled down with the ship into the abyss (135: *468–69*).

This concentration in *Moby-Dick* on the *physical blow as philosophical analogue* takes on moral significance when articulated as *vengeance*. Bildad and Peleg are "Quakers with a vengeance" (16: *71*); the "vengeful" Radney of the *Town-Ho* faces the "bitterly provoked vengeance" of Steelkilt, who has "complete revenge" when the White Whale himself becomes his "avenger," seizing Radney in his jaws and taking him to the bottom (54: *209, 221*). Starbuck tells Ahab that he has shipped on the *Pequod* "to hunt whales, not my commander's vengeance. How many barrels

will thy vengeance yield thee even if thou gettest it, Captain Ahab?" he asks. When Ahab retorts that "my vengeance will fetch a great premium *here!,*" smiting his breast, Starbuck is appalled. "Vengeance on a dumb brute . . . that simply smote thee from blindest instinct! Madness!" (36: *143–44*). The supreme expression of insensate and unbridled vengeance in *Moby-Dick,* however, is the Christian God Himself. The vast ocean He has made and on which the *Pequod* sails is a visible, pervasive symbol for the vengeful retribution which He visits on those who offend Him. Noah's Ark, Ishmael reminds us, "the first boat we read of, floated on an ocean, that with Portuguese vengeance had whelmed a whole world without leaving so much as a widow." To Ishmael that vast ocean is daily and hourly reminder of the enormity and cosmic totality of God's vengefulness. "That same ocean rolls now; that same ocean destroyed the wrecked ships of last year. Yea, foolish mortals, Noah's flood is not yet subsided; two thirds of the fair world it yet covers" (58: *235*).

The Christian God thus becomes a central source of the "universal thump." He bears, in fact, a suspicious resemblance to Ishmael's "unaccountable old joker" delivering "hits" and "punches" to man—except that man's relation to God is no joking matter. The pivotal statement of this relationship is Father Mapple's sermon on Jonah, which offers the Christian explanation of the pervasive tragedy of life, the universality of the "universal thump." Mapple's God is a God "chiefly known to me by Thy rod" (9: *51*), and Jonah, after three days' encounter with the "hard hand of God" (9: *48*), is the archetypal thumpee. The hymn which prefaces the sermon suggests why Ishmael would listen with focused intensity to the paradigm of life's meaning which Father Mapple offers. Ishmael's soul is full of "damp, drizzly November," his "hypos" have gotten the "upper hand" of him, he is obsessively fascinated by coffin warehouses and funerals (1: *12*)—and so he would be certain to identify with Jonah, himself in "black distress" and "plunging to despair." It would inevitably occur to Presbyterian Ishmael that his "unbidden infidelities" (7: *41*) might be the result of his failure to find, as Jonah finds, the "Deliverer God" of the hymn, in all His "mercy and . . . power" (9: *44*). Melville may, as Lawrance Thompson suggests, have written the sermon tongue-in-cheek—we will probably never know about that—but it is unlikely that Ishmael would have *listened* tongue-in-cheek.[2]

Instead, as Jonah takes his dive, Ishmael, raptly attentive to Mapple's rhetoric, would dive with him, to surface at the end of the sermon with some truths different from what the orthodox Mapple intended or what the sermon overtly conveys. Ishmael, because he was telling his story to a nineteenth-century American audience, does not take us into his confidence concerning these insights. In fact, one of the most significant things in these early chapters is Ishmael's refusal to comment upon the

sermon, even though he is generally the most garrulous and digressive of narrators. As Mapple waves a final benediction, Ishmael simply tells us that "He said no more, but . . . covered his face with his hands, and so remained, kneeling, till all the people had departed, and he was left alone in the place" (9: *51*). Nothing could be more devastatingly eloquent than this lack of comment. It signals the failure of the last attempt Ishmael will make to achieve intellectual repose through the orthodox Christian explanation of the Leviathanism of the cosmos, a Leviathanism which Ishmael sees as a constitutive element of all external nature, in the ocean, the land, the mountains, and even the stars (57: *231–33*). Father Mapple's sermon has if anything probably intensified—rather than meliorated— those hypos which drove Ishmael to the Whaleman's Chapel in the first place. Nor is there anything mysterious about how the intended words of consolation and delight which Father Mapple delivers could fall with such leaden coldness upon Ishmael's heart. For the sermon is actually the supreme statement in *Moby-Dick* of the protodynamic of *thumper: thumpee.* Ishmael, obsessively concerned with the problem of the "universal thump," and particularly with its Leviathanic manifestations, would find the sermon profoundly engrossing—and profoundly disappointing. The reason is simple: the prefatory hymn speaks of a God of "mercy"— but the sermon itself is about a God of vengeance. The Christian explanation, or at least Father Mapple's explanation, is that the Leviathanism which surrounds man and so often overwhelms him is simply God's vengeful response to man's guilt. The sermon is only a superbly articulated version of that deific "Portuguese vengeance" of which the boundless diluvian ocean is perpetual reminder.

This vengeful aspect of the Jonah sermon is not apparent so long as one reads it from the vantage-point of a comfortable Christian orthodoxy. All one has to do is suspend critical judgment and marshal an habitual acceptance when Mapple asserts that his sermon will retail the story of "the sin, hard-heartedness, suddenly awakened fears, the swift punishment, repentance, prayers, and finally the deliverance and joy of Jonah" (9: *45*). Since Ishmael says nothing which might serve as a guide in evaluating the sermon, we might be inclined to settle for a conventional reading, were it not for the fact that we know that Ishmael never views anything with conventional eyes. He has just finished reading the despairing cenotaphs masoned into the Chapel walls, graveless gravestones which document in "lines that seem to gnaw upon all Faith" (7: *41*) the violence, the titanic power of the whale, resulting so often in the "speechlessly quick chaotic bundling of a man into Eternity" (7: *41*). He would almost certainly be struck by a parallel violence at work in the Jonah story. With "endless processions of the whale" (1: *16*) floating through his soul, Ishmael would be bound to ponder Father Mapple's assertion that "God came upon [Jonah] in the whale," so that Leviathan, by sheer

brute power plunging Jonah all helpless into "living gulfs of doom . . . ten thousand fathoms down," becomes the direct, concrete expression of an equivalent brute power in God.

Similarly, Ishmael would inevitably be struck by the gross disproportion between means and ends which seems to characterize the activities of the Christian God. Jonah's "wilful disobedience" of God's "hard command" is in the deific moral economy sufficient to justify a "dreadful storm," a maelstrom of "black sky and raging sea" and "reeling timbers" which brings not only the guilty Jonah to the brink of destruction, but a ship, "like to break," and her innocent crew as well. Ishmael tells his story a century before the development of nuclear-war technology and its special, ghastly nomenclature, but we may borrow a pair of terms from that technology to characterize the storm-brewing and whale-dispatching God of Father Mapple's sermon. He is an *overkill* God, a *megaton* God, achieving His ends by the broadcast application of brute power in quantities nearly sufficient to destroy a world, and therefore certain to reduce "frighted Jonah" to the "cringing attitudes" which are the only possible response of minuscule man to Jehovah's moral imperatives. It is no wonder that "Terrors upon terrors run shouting through [Jonah's] soul." Neither would the analytical Ishmael be likely to overlook the fact that the "true and faithful repentance" which "aghast Jonah" discovers in the belly of the whale is the direct consequence of the animal terror which God's storm and God's whale have generated in him. Father Mapple's God is, like the God of the sharks and in Queequeg's phrase, "one dam Ingin."[3]

The correlation of Father Mapple's Whale-God with Queequeg's Shark-God is more than superficial. The Ishmael who listens to the sermon is the same Ishmael who later will speak of the "universal cannibalism" of the sea (58: *235*), who will see much of human life as a "shocking sharkish business," and who, watching the "countless numbers" of sharks ravaging the whale tied alongside the *Pequod,* will obliquely suggest that there may after all be a certain "propriety" in "conciliating the devil" (64: *249–50*). Surely *this* Ishmael, neurotically sensitive to whatever "half-formed, foetal suggestions" (41: *156*) may lie under the surface of Father Mapple's rhetoric, would have experienced a rising sense of horror, an exacerbation of an already almost psychotic hypo, when he realized that the vehicle of God's vengeance upon Jonah is a sharkishness of which file-toothed Queequeg, sitting a few pews away, is a visible emblem. Jonah is *eaten alive* by God, or at least by God's agent. In the midst of "masterless commotion" Jonah "drops seething into the yawning jaws awaiting him," whereupon "the whale shoots-to all his ivory teeth, like so many white bolts, upon his prison." "Swallowed down to living gulfs of doom," Jonah is *devoured* by God.

This is an admittedly neurotic reading of the sermon, but Ishmael,

our "only true lamp," *is* neurotic. If we define neurosis as the capacity to realize certain truths with an incandescent verity from which most of us are protected, then we can conclude that hypo-ridden Ishmael arrives at a level of truth concerning the Christian explanation of Leviathanism from which Father Mapple's less perceptive auditors are happily insulated. That this truth which Ishmael almost certainly perceived is also what Melville himself intended is suggested by the mute presence of Queequeg. Melville brings the cannibal to the Whaleman's Chapel for the sermon, even though he has no dramatic function in the scene, and never refers to the sermon he has shared with Ishmael. Concerning the Christian cannibal-God, cannibal Queequeg is as silent as Christian Ishmael.

On the most fundamental level, however, the wrathful Jehovah of the sermon is a special sort of primal form. It may be objected that the Christian God can hardly be included among the other primal forms of *Moby-Dick* because, unlike the anteformal squid or the White Whale, Jehovah is visually inaccessible and therefore perceptually formless. But this is just the point: existing outside the "sensuous manifold," beyond nature, inaccessible, invisible, and incomprehensible, Jehovah is the primal form reduced to formlessness by the transcendentalism implicit in the Christian world-view. Because He *is* transcendental, Jehovah becomes the central statement of the agentistic problem which is part of the Christian world-view. Since *Moby-Dick* is a book about the natural world and man's relation to it, and since Ishmael's sensibility is so overwhelmingly nature-oriented, the question of the place of nature in Father Mapple's sermon is relevant. Viewed through the vehicle of Ishmael's sensibility, it becomes obvious that nature, both animate and inanimate, must act and does act in the Christian world-view as the *agent* of a transcendentally conceived God who cannot act for Himself in this world because He is so radically and intractably in another. Hence, in Father Mapple's sermon, sea and storm are God's agents, and the whale is God's agent. The consequence is the alienation and separation of *man from nature*. Nature, viewed agentistically, inevitably becomes the antagonist of man. Jonah coming on deck during the height of the storm is "sprung upon by a panther billow"; and the storm itself is a consequence of nature's revulsion: "The sea rebels; he will not bear the wicked burden" of Jonah.

Just as important is the way in which the agentistic world-view implicit in the Christian paradigm causes the alienation and separation of *man from man*. Steeped like Ahab in agentism, the crew of Jonah's beleaguered ship cast lots to discover "for whose cause this great tempest was upon them." When the lot falls to Jonah, the terrified crew them-

selves become part of the agentistic continuum: ". . . then, with one hand raised invokingly to God, with the other they not unreluctantly lay hold of Jonah," flinging him overboard and into the whale's maw. Being God's agents, the crew cannot be Jonah's friends, much less his brothers—although before God's "hard hand" forces them into the agentistic role the crew, while listening to Jonah's story, are "still . . . pitiful," and "mercifully turn from him, and seek by other means to save the ship." The Christian Jehovah apparently finds this merciful response to Jonah's plight intolerable, for immediately "the indignant gale howls louder" until the crew is forced to knuckle under to megaton force. "Woe to him," Father Mapple later warns, "who seeks to pour oil upon the waters when God has brewed them into a gale!" Human brotherhood and human mercy have no place in Mapple's sermon-world.

On the deepest level of all, the need of a transcendentally conceived God for agents in a world above which He must stand, results in the separation and alienation of *man from himself*.[4] If man must be God's agent, then he cannot be his own agent. To the extent that he is true to God, he must be untrue to himself—although Father Mapple phrases the idea somewhat differently. "And if we obey God," the preacher insists, "we must disobey ourselves; and it is in this disobeying ourselves, wherein the hardness of obeying God consists." Guilt, in this schema, is man's awareness of the extent to which he has failed to subordinate his inner and personal voice to an outer and transcendental voice. With guilt comes self-alienation: Jonah, waiting in a windowless cabin while the ship takes on cargo, is appalled by the way a gimbal-lamp appears to be hanging out-of-true in the heeled-over vessel. His sense of guilt and fear cause him to take the misalignment of the cabin walls as symbolic of a similar misalignment or disjunction within himself. "Oh! so my conscience hangs in me! . . . straight upward, so it burns; but the chambers of my soul are all in crookedness!" The inexorable pressures of the "hard hand of God" result in a deep and debilitating inner malaise, a pervasive sense of psychic distortion, of "crookedness" of self.

Thus the Christian imperatives demand the unequivocal dissociation of man from nature, from other men, and from himself. It is no accident that this triple alienation precisely describes Captain Ahab, Christian and Quaker, the "crooked" or "ugly" Narcissus. As recompense for such terrible distortions, Father Mapple can only offer an eventual, otherworldly "Delight"—a word that with thudding repetitiveness he uses ten times in the closing paragraph of the sermon, and a word which takes on bitterly ironic overtones when, in Chapter 131, the *Pequod* finally encounters a vessel called the *Delight*. All of this suggests that the central intention of the opening "land" chapters of *Moby-Dick*, that substantial portion of the book which takes place before the *Pequod* makes its sym-

bolic break with the Christian shore, has to do with these distortions, this "crookedness," this denaturalizing of man which Christian belief, centered on a transcendental Godhead as primal form, makes possible. For if the Christian Jehovah is not Himself perceptually accessible, His world—Christian New England—is entirely so. Wintry, ice-locked, snow-covered New England—typified in New Bedford and Nantucket—is as much a noumenally pallid primal form as the squid or the spirit-spout.

Ishmael is aware that summer-time New Bedford is "sweet to see; full of fine maples—long avenues of green and gold." "So omnipotent is art," he continues, that the phenomenal flower-curtain is exquisitely developed in this prosperous whaling town. In "many a district" in the summer months "bright terraces of flowers" match the beauty of New Bedford women, who "bloom like their own red roses" (6: *38–39*). But Ishmael chooses to make his break with the land in December when the vernal flower-curtain is stripped away by Euroclydon's cold blasts so that we may glimpse the noumenal verities which lie hidden beneath the sensuous surface. In winter New Bedford (and Nantucket) become these "Puritanic sands," this "scraggy scoria of a country," composed of "the barren refuse rocks thrown aside at creation's final day" (6: *38–39*). The "packed snow and ice" of a bitter New England winter, with the whole country locked in "congealed frost lay[ing] ten inches thick in a hard, asphaltic pavement" of "flinty projections" (2: *17*) turns this Christian stronghold into a kind of geographical noumenon, an impression which Ishmael reinforces when, gliding down the Acushnet river aboard the *Moss* on their way to Nantucket, he and Queequeg look back on the "terraces of streets" of New Bedford, "their ice-covered trees all glittering in the clear, cold air" (13: *59*).

In fact, Johovah's New England is unutterably inhospitable. Ishmael arrives in New Bedford on a "howling night," finds himself in a "dreary street" with "gloom towards the north" and "darkness towards the south," finally discovers the Spouter-Inn standing on a "sharp bleak corner, where that tempestuous wind Euroclydon kept up a worse howling than ever it did about poor Paul's tossed craft," proceeds to "scrape the ice from [his] frosted feet," pauses in the entry-way to contemplate a picture which reminds him of a "Hyperborean winter scene" or "the breaking-up of the ice-bound stream of Time," and is shortly ushered with others into a dining room "cold as Iceland" where "We were fain to button up our monkey jackets, and hold to our lips cups of scalding tea with our half frozen fingers." After this polar meal he spends some time in the bar-room, where the crew of the *Grampus* appears like "an eruption of bears from Labrador," with their beards "stiff with icicles" (2: *17–20*; 3: *20–23*). On the Sunday morning following Ishmael goes to the Whale-

man's Chapel through "driving sleet and mist" (7: 39), listens to the "howling of the shrieking, slanting storm" while Father Mapple delivers his sermon (9: 49), and brings to a close this frigid encounter with the arctic Christian world when the *Pequod* sails on a "short, cold Christmas." As "the short northern day merged into night, we found ourselves almost broad upon the wintry ocean, whose freezing spray cased us in ice, as in polished armor" (22: 95).

This repetitive stress on coldness is more than merely meteorological. The boreal frigidity of Jehovah's Christian world is visual and tactile analogue of a deeper, far more terrible coldness in the hearts of New England's people. Physical iciness in *Moby-Dick* is a correlate of moral iciness. Ishmael speaks of the "ice of indifference" between himself and Queequeg which a brief acquaintance "soon thawed," leaving them "cronies," in bed together on a "hearts' honeymoon, . . . a cosy, loving pair." "I felt," Ishmael confesses, "a melting in me." But the thaw is due to Queequeg's tropical pagan warmth. Ishmael stresses that "Christian kindness has proved but hollow courtesy," nothing more than "civilized hypocrisies and bland deceits" (10: 53–54). The extracetological evidence reinforces this reading. William H. Gilman has pointed out that Melville's "principal target" in writing *Redburn* "was the appealing dearth of real brotherhood, human sensitivity and charity in the Christian world of mid-nineteenth century,"[5] a point confirmed by Redburn's assertion that "We talk of the Turks, and abhor the cannibals; but may not some of *them*, go to heaven, before some of *us*? We may have civilized bodies and yet barbarous souls."[6] Certainly, Melville saw a frightening reality lurking under the surface of Christianity. Tyrus Hillway remarks on how Melville was struck by the "dull barrenness and unfruitfulness of [the] land of the Gospel" during his tour of the Middle East; "its atmosphere seemed not godly but somehow diabolic"[7]—a diabolism prefigured in the New England of *Moby-Dick*. Before Ishmael meets his pagan roommate at the Spouter-Inn, landlord Peter Coffin explains that this yet-to-be-seen harpooner has returned from the South Seas with a large stock of embalmed "New Zealand heads" which are "great curios, you know," in Christian New Bedford. Trade has been brisk, the landlord assures Ishmael, "and he's sold all on 'em but one, and that one he's trying to sell to-night, cause to-morrow's Sunday, and it would not do to be sellin' human heads about the streets when folks is goin' to churches." Apparently Jehovah's people freely engage with Queequeg in such "cannibal business," as Ishmael calls it—except, of course, on the Lord's Day (3: 26–27).

If the Christians of New Bedford and Nantucket are willing to engage in "cannibal business" ashore, they are much more so inclined when at sea. The Quakers of Nantucket "are the most sanguinary of all sailors

and whale-hunters. They are fighting Quakers; they are Quakers with a vengeance" (16: *71*). Pious Captain Bildad has been, as Ishmael tells us, "originally educated according to the strictest sect of Nantucket Quakerism," and has remained true to these rigid principles throughout his life and despite many temptations. Ishmael remarks, however, a certain "lack of common consistency" in the Bible-reading and hymn-singing Bildad who, though "refusing, from conscientious scruples, to bear arms against land invaders, yet himself had illimitably invaded the Atlantic and Pacific; and though a sworn foe to human bloodshed, yet had he in his straight-bodied coat, spilled tuns upon tuns of leviathan gore" (16: *72*).

What Bildad is, is *sharkish*. Significantly, this word is furnished us by Bildad's Quaker partner, Captain Peleg, who expresses his suspicion to Ishmael that the latter's lungs may be soft: ". . . thou dost not talk shark a bit," the old whaleman complains (16: *69*). Peleg uses the same term again when Bildad attempts to introduce Queequeg to the Christian religion. "Avast there, avast there, Bildad, avast now spoiling our harpooneer," Peleg roars. "Pious harpooneers never make good voyagers—it takes the *shark* out of 'em; no harpooneer is worth a straw who aint pretty *sharkish*" (18: *85;* italics mine). Old Bildad and Peleg, Quakers though they are, in finding a crew for the *Pequod* have made sharkishness their prime criterion. Horrified Starbuck describes the men they have signed for the voyage as "a heathen crew that have small touch of human mothers in them! Whelped somewhere by the sharkish sea" (38: *148*). Nor is the sharkishness of the *Pequod*'s owners confined to the professional and dispassionate pursuit of whales. Ishmael tells us that crabbed Bildad, during his sea-days, had the reputation of an "incorrigible old hunks" and a "bitter, hard task-master" whose crews "were mostly all carried ashore to the hospital, sore exhausted and worn out." With characteristic understatement, Ishmael adds: "For a pious man, especially for a Quaker, [Bildad] was certainly rather hard-hearted, to say the least" (16: *72*). There is a strong resemblance between Bildad's hard-handed treatment of his crews, and Jehovah's hard-handed treatment of "bruised and beaten" Jonah. If Bildad and Peleg are sharkish, they can refer to a well-established, indeed unimpeachable, precedent for a severity which is hardly distinguishable from unabashed brutality.

All of this comes to sharp focus in that central symbol of Christian sharkishness in *Moby-Dick*, the *Pequod* herself. The name is no accident. In his initial description of this "cannibal of a craft," Ishmael makes explicit references to the Pequod War and its consequences. "*Pequod,* you will no doubt remember, was the name of a celebrated tribe of Massachusetts [actually Connecticut] Indians, now extinct as the ancient Medes" (16: *67*). From various sources,[8] both Melville and Ishmael would have

known of the overkill vengeance which Jehovah's people wreaked upon the Pequods for relatively minor depredations, and in particular the attack by these Christians upon the Indian fort near Mystic, Connecticut. All the wigwams were set on fire, most of the Indians burning to death, and the rest, with the exception of a few girls, being put to the sword as they attempted to flee. Estimates indicate that between 500 and 800 warriors were slain in a single night. Not satisfied with this butchery, the English pursued those Pequods not caught in the Mystic massacre into the Unquowas swamp near Fairfield and exterminated them. The result was, in Timothy Dwight's words, a "tribe . . . so far annihilated as to be thenceforth without a government and without a name."

Ishmael stresses that the *Pequod* is even more sharkish than her name. For "more than half a century," the vessel has been engaged in the "wild business" of whaling. During his own term as chief mate, Peleg, indulging a cannibal taste which belies his Quakerism, had decorated and fitted her with a barbarity which makes this "rare old craft" the external symbol of an internal moral condition:

> She was apparelled like any barbaric Ethiopian emperor, his neck heavy with pendants of polished ivory. She was a thing of trophies. A cannibal of a craft, tricking herself forth in the chased bones of her enemies. All round, her unpanelled, open bulwarks were garnished like one continuous jaw, with the long sharp teeth of the sperm whale, inserted there for pins, to fasten her old hempen thews and tendons to. (16: 67)

The *Pequod* is one great, predacious *jaw*, expressive of a savagery underlying Christianity which the savages themselves would be hard-pressed to emulate. Moreover, Melville exploits the pallid connotations of the word *ivory* to turn the *Pequod* into another primal form. While her "old hull's complexion was darkened like a French grenadier's," the overall impression is one of whiteness. Her rigging-sheaves are of "sea-ivory," and so is her tiller, carved "from the long narrow lower jaw of her hereditary foe" (16: 67). Ahab's cabin-table is "ivory-inlaid" (34: *131*); so indeed are the cabins (81: *302*). As the *Pequod* plunges into the frigid Atlantic on Christmas night "The long rows of teeth on the bulwarks glistened in the moonlight; and like the white ivory tusks of some huge elephant, vast curving icicles depended from the bows" (22: *95*). Ishmael again recalls this picture of tusked ferocity in the next chapter, speaking of the *Pequod*'s "vindictive bows" thrusting into the "cold malicious waves" (23: *97*). Approaching Cape Horn, it is the "ivory-tusked Pequod [which] sharply bowed to the blast, and gored the dark waves in her madness" (51: *201*). Repeatedly, the ship is for Ishmael the "ivory Pequod" (48: *193*; 51: *199*; 67: *257*).

Because all of this ivory and noumenal whiteness is the work of Peleg,

the *Pequod* is another example of the illuminating and shaping lamp-mind at work, and an instance of the metaphor of the sculptured noumenon. Just as Queequeg by his carving imposes his bodily *self* upon the carpenter's "box," endowing its rough-hewn noumenal neutrality with definitive moral meaning and final ontological finish, so does Peleg shape the original *Pequod* to a sharkishness which is a projection of the predacious imperatives of his own moral being. Just as Peleg shapes the *Pequod* in his own moral image, so do the Christians of Jehovah's New England shape God to *their* image. Captain Peleg's *Pequod* suggests that if predatory Jehovah is "one dam Ingin," it is because the people who worship him are mostly dam Ingins.

Sharkish Jehovah is not the only god who moves through the early "land" pages of *Moby-Dick*. There is also Queequeg's little god Yojo, a radically different product of man's tendency toward anthropomorphic projection. Nothing could be more symbolically eloquent than the scene which greets Ishmael when he returns to the Spouter-Inn after Father Mapple's sermon. He discovers Queequeg (who had rather impolitely left the Chapel in the middle of the sermon) ensconced in the bar-room:

> He was sitting on a bench before the fire, with his feet on the stove hearth, and in one hand was holding close up to his face that little negro idol of his; peering hard into its face, and with a jack-knife gently whittling away at its nose, meanwhile humming to himself in his heathenish way. (10: 51)

As in the case of Queequeg's coffin and Captain Peleg's *Pequod*, a carving metaphor is used to express the projective and shaping powers of the lamp-mind. The language of the passage is carefully structured to stress the face-to-face, *vis-à-vis* relationship between Queequeg and Yojo, so that the little "Congo idol" (3: 30), his nose being reshaped to Queequeg's satisfaction, becomes an expressive bit of Kantian skrimshander. Yojo is what Queequeg wants him to be, and nothing more.

Yojo is another primal form, and in fact part of a tripartite cluster of primal forms. It is no accident that like humpbacked Moby Dick, Yojo is a "curious little deformed image with a hunch on its back" (3: 30)—and it is even less of an accident that Yojo shares this deformity with yet another primal form, the "badger-haired old merman, with a hump on his back" of Stubb's "Queen Mab" dream (31: 115). Unlike most of the other primal forms in *Moby-Dick*—the squid, the spirit-spout, and the White Whale—Yojo is an intense *black* instead of noumenal white, a fact which Ishmael stresses. Yojo is, he tells us, "exactly the color of a three days' old Congo baby" (3: 30), a "bit of black wood" (10: 54). This blackness places Yojo in man's epistemological color-world, the world of natural, sensuous, immediate, often Adamic apprehension. Yojo is a deific projection accessible to touch and sight, to feel and heft, to tactile reali-

zation, so that he stands in polar opposition to the transcendental Je-
hovah, invisible and metaphenomenal, arrogantly above and beyond the
world that man actually knows. Yojo is, like the Tahiti ocean-island
image, counter-transcendental. Accustomed by his Christian and Pres-
byterian background to a God who is separated from nature, Ishmael
cannot as yet see that Yojo is expressive of a healthy union with the
physical world which sets Queequeg apart from all the Christians in the
novel. Queequeg derives his humanizing warmth from Yojo: the "shrine"
or "chapel" which Queequeg chooses for Yojo at the Spouter-Inn is the
fireplace; Yojo is ensconced, "like a tenpin, between the andirons"
(3: 30). Similarly, just as wooden Yojo sustains the union of Queequeg
with nature, so he sustains the union of Queequeg with his fellow men.
Ishmael in the Whaleman's Chapel worshipped, if that is the word, in
isolation. But back at the Spouter-Inn when he decides to "turn idolator"
at Queequeg's behest, the result is human union rather than disunion:

> So I kindled the shavings; helped prop up the innocent little idol; offered
> him burnt biscuit with Queequeg; salaamed before him twice or thrice;
> kissed his nose; and that done, we undressed and went to bed, at peace
> with our own consciences and all the world. (10: 54)

Yojo thus brings Ishmael the peace his hypo-ridden psyche seeks, a unity
with both man and nature which is in sharp contrast to the alienation
he found in the Whaleman's Chapel.

Most significant is the contrast between Jehovah and Yojo in terms
of the protodynamic of *thumper: thumpee*. Jehovah's power is transcen-
dental and unlimited; He is an overkill God whose "Portuguese venge-
ance" swamps the world with megaton force. Little Yojo is subject to the
same contingencies with which man himself must cope. He is no om-
nicompetent deity, but instead, as Queequeg explains to Ishmael, "a
rather good sort of god, who perhaps meant well enough upon the whole,
but in all cases did not succeed in his benevolent designs" (16: 66). He
is a human god—and because he is human, he keeps Queequeg human,
just as Jehovah, being inhuman, forces His worshippers to inhumanity.
That Yojo is no terrifying thumper is suggested by the casual way in
which, worship over, Queequeg dumps him into his grego pocket, "as
carelessly as if he were a sportsman bagging a dead woodcock" (3: 30).

While the point is not developed in *Moby-Dick*, Yojo probably stands
in about the same relation to his worshippers as the Polynesian gods of
the early *Typee* stood in relation to theirs. A typical instance is the doll-
god Moa Artua who, when he did not promptly come up with answers
to the questions posed to him by Kolory, was beaten about the head,
stripped of his tappa and red cloth, and covered from sight; he was a
"poor devil of a deity, . . . cuffed about, cajoled, and shut up in a box."

When another island deity, a "grotesquely shaped log," accidentally fell over on Kory-Kory, the latter "leaped furiously to his feet, and seizing [a] stick, began beating the poor image: every moment or two pausing and talking to it in the most violent manner, as if upbraiding it for the accident." The gods of *Typee* are "luckless idols, . . . receiv[ing] more hard knocks than supplications." The narrator concludes: "I do not wonder that some of them looked so grim, and stood so bolt upright as if fearful of looking to the right or the left lest they should give anyone offense."[9] *Typee* gives us a total reversal of the protodynamic of *thumper: thumpee,* with natural man thumping his gods rather than the other way around. Similarly, it has never occurred to Queequeg that he should *fear* Yojo. The Congo idol, contingent deity that he is, will never force Queequeg into those "cringing attitudes" (9: *48*) which characterize Jonah's relation to Jehovah. Jehovah is man's enemy. Yojo is his friend.

Notes

[1]See the notes to the Hendricks House edition of *Moby-Dick,* ed. Luther S. Mansfield and Howard P. Vincent (New York, 1952), p. 689.

[2]*Melville's Quarrel With God* (Princeton: Princeton Univ. Press, 1952), pp. 10–11. Even if Melville quarreled with God, there is very little evidence to suggest that *Ishmael* ever did. After Father Mapple's sermon, the Christian Jehovah never again figures in any significant way in Ishmael's on-going consciousness except for some suspiciously conventional and possibly satiric references to the Deity such as the panegyric to the "Spirit of Equality," the "great democratic god," which concludes Chapter 26 *(105).* Once at sea, the *Pequod* sails deeper and deeper into a metanaturalistic cosmos where the conventional God simply does not exist—a fact which would account for Ishmael's failure to quarrel with Him. Ahab, of course, is another matter.

[3]Nathalia Wright points out that Melville's treatment of the Jonah story is highly selective: "There is nothing in [Father Mapple's] sermon about Jehovah's compassion for the repentent city, his pardon, and his gentle remonstrance with his harsh prophet" (*Melville's Use of the Bible* [New York: Octagon, 1969], p. 83). This selectivity is apparently the consequence of an "outraged conclusion" which Howard C. Horsford sees Melville, Ahab, and Ishmael all making: "The creation, we have the highest assurance, manifests the Creator; but his creation is notorious for its suffering, its indifferent injustice, its ruthless energy and merciless, predatory nature; therefore, such must be its Creator" ("The Design of the Argument in *Moby-Dick,*" *Modern Fiction Studies* [Autumn, 1962], p. 240). I do not think such "outrage" accurately describes Ishmael, for whom the Christian God simply ceases to exist, but it is nevertheless evident in those crew-members who *do* retain to the end at least a residually Christian world-view. Stubb tells open-mouthed Flask how the Devil once sauntered into the "old flagship" and de-

manded a hapless mortal upon whom he had cast his evil eye. "I want John," says the Devil. "Take him," says the "old governor." Thus casually does the Christian God turn over us mortals to the powers of evil. Stubb hints that the Devil has such freedom because the "old governor" actually fears him. "Who's afraid of him, except the old governor who daresn't catch him and put him in double-darbies, as he deserves, but lets him go about kidnapping people; aye, and signed a bond with him, that all the people the devil kidnapped, he'd roast for him?" And then, with vast irony: "There's a governor!" (73: *276–77*).

⁴See T. Walter Herbert, Jr., "Calvinism and Cosmic Evil in *Moby-Dick*," *PMLA*, 84 (1969), 1613–19: "Since man's nature is contaminated by original sin, and since God is absolutely righteous, a man must reject his own nature totally before he can be reconciled to God" (p. 1614). The Calvinistic ideas which Mr. Herbert persuasively applies to Father Mapple's sermon are less persuasively applied to the White Whale. If Moby Dick is taken Calvinistically, then all the naturalistic meanings which attach to him go by the board.

⁵*Melville's Early Life and Redburn* (New York: New York Univ. Press, 1951), p. 235.

⁶Northwestern-Newberry *Redburn: His First Voyage*, p. 293.

⁷*Herman Melville* (New York: Twayne, 1963), p. 55.

⁸For a full discussion of the various sources from which Melville may have derived his knowledge of the Pequod Indians' tragic history, see the Hendricks House edition of *Moby-Dick*, ed. Luther S. Mansfield and Howard P. Vincent (New York, 1952), pp. 631–33, and also Kenneth W. Cameron's "Etymological Significance of Melville's *Pequod*," *Emerson Society Quarterly*, No. 29 (1962), pp. 3–4. Mansfield and Vincent, in attempting to relate the Pequod War to the Book of Job miss, it seems to me, the essential meaning of the ship's name for all of *Moby-Dick*.

⁹Northwestern-Newberry *Typee: A Peep at Polynesian Life*, pp. 177–79. There also is some evidence that Melville intended Yojo to carry phallic overtones. In Chapter 95, ironically entitled "The Cassock," Ishmael describes what he delicately calls the "grandissimus" of the male Sperm Whale, "that unaccountable cone,—longer than a Kentuckian is tall, nigh a foot in diameter at the base, and jet-black as Yojo, the ebony idol of Queequeg." The "pelt" is removed from this prodigy, stretched and shaped, and donned like a cassock by the mincer as he slices the "horse-pieces" of blubber into "bible leaves" for the try-pots (95: *351*). The phallicism, if it is there, would be in consonance with Yojo's meaning as a naturalistic life-relation, as fertile as the transcendental Jehovah-relation is sterile.

The Nature and Forms of Despair

Paul Brodtkorb

" Call me Ishmael," we are told. But that name is equivocally stated, despite the abruptly imperative form of its declaration. The narrator precisely does *not* say that his name *is* Ishmael; or even that he is called Ishmael as a kind of nickname. "Call me Ishmael," he says, and immediately the diction of affable informality followed by the shock of the biblical name which is both formal and highly unlikely puts us in the presence of someone who for reasons of his own would rather not say who he really is.

If "Ishmael" is self-adopted, it is, with all its allusiveness, doubtless a more accurate designation of him than its sayer's real name, for it clearly signifies his sense of himself and his world. But because behind the show of affability a real name is withheld, Ishmael remains to some extent a stranger, and a man in a false position; and because he does, as soon as the self-bestowed name is spoken, the shadow of nothingness is upon the book.

That shadow lengthens when we note the contradictory details that slips of memory betray the narrator into. The playful but ultimately serious hyperbole, intended to win us over; the authoritative reporting of unknowable or imaginary events; the fanciful lies, such as the Town-Ho's story—these darken the shadow. "Ishmael," we soon discover, is a storyteller in every sense; he tells us a fish story that, like most fish stories, is partly true and partly false.

Yet he is not especially anxious to conceal this from us. On the contrary, "storyteller" is the first and continuing guise in which he presents

Reprinted from *Ishmael's White World* (New Haven: Yale University Press, 1963), pp. 123–39. Copyright 1963 by Yale University. Reprinted by permission of the publisher. Endnotes have been renumbered.

273

himself. At times he explicitly discusses the problems of a storyteller in creating atmosphere and plausibility. At other times he shows himself manipulating the truth:

> "Do tell, now," cried Bildad, "is this Philistine a regular member of Deacon Deuteronomy's meeting? I never saw him going there, and I pass it every Lord's day."
>
> "I don't know anything about Deacon Deuteronomy or his meeting," said I, "all I know is, that Queequeg here is a born member of the First Congregational Church. He is a deacon himself, Queequeg is."
>
> "Young man," said Bildad sternly, "thou art skylarking with me— explain thyself, thou young Hittite. What church dost thee mean? answer me."
>
> Finding myself thus hard pushed, I replied . . . (XVIII)

Caught out in a lie, Ishmael eludes Bildad's wrath by enthusiastic embroidery of his story's loose ends.[1] In content and circumstances, the incident is typical of Ishmael's lies, the facts of which if based on actuality are already highly interpreted by self-interested exegesis. More important, however, is what this sort of incident—the Town-Ho's story, though a more disinterested, virtuoso lie, is similar in this respect—suggests about the audience of an Ishmaelean lie: Ishmael lies to those who invite his mockery. He lies to the earnest ones of the earth: the owners, aristocrats, and authorities; the stern, the righteous, or the self-satisfied; all who because of the pompous security they command are gullible. He lies, in short, to the Bildads who in being false comforters take false comfort. He lies because he strongly suspects either that their truths are lies also; or that they use their truths like lies, for their own ends.

Similarly, Ishmael lies to us: the comfortable readers of adventure stories like *Typee, Omoo,* and *Moby Dick* who kill our boredom by distorting what boredom means. We are all in false positions, his attitude seems to say; and it says this at the same time that it says that *his* false position, because it is consciously chosen in full awareness of the alternatives, is more responsible and therefore, perversely, truer than the received and unexamined false positions of others; and in this attitude we may understand a major basis of Ishmael's respect for Ahab, whose defiant despair creates a personal truth so passionately thought-out and passionately willed that often reality crucially seems to conform to it. Like Kierkegaard, Ishmael is despairingly left with the idea that for man, in many complicated ways, subjectivity is truth; or, rather, the only truth is in subjectivity.

One result of all this is that for the pragmatic reader the prevalence of Ishmaelean lies, once recognized, must permeate with nonbeing everything that Ishmael says. Because anything is potentially untrue, the single and final reality of the events of the Pequod's last voyage is to be found

in Ishmael's not wholly trustworthy mind. For such a reader, *Moby Dick*'s foundations in the actuality that Ishmael pretends to report are very shaky ones: he can never lose his awareness that he is reading a *novel,* not something solid like the history or biography that Captain Veres prefers; moreover, he is reading a peculiarly self-subverting novel that pretends to be true (but clearly isn't) autobiography, which in turn disconcertingly combines features of epic, romance, and Menippean satire. Nowhere is there dry land. Nothing can be trusted to be what it seems, and the reader, if only for self-preservation, must have "doubts of all things earthly" (LXXXV). In a curious way, the reader is forced even against his will to share Ishmaelean attitudes.

But the situation is perhaps not so desperate. Consider the case of Bulkington, the account of whom provides a reassuring example of Ishmael's manipulation for his own purposes of reality. Bulkington is the man "who in mid-winter just landed from a four years' dangerous voyage . . . unrestingly" pushes "off again for still another tempestuous term" (XXIII) as the helmsman of the outsetting Pequod. "A huge favorite" (III) with his previous shipmates aboard the Grampus, Bulkington is a natural leader of men, and a man of singular physique and mentality.

Yet after his appearance as the Pequod's helmsman in the "six-inch chapter" called "The Lee Shore," he inexplicably disappears: "So far as this narrative is concerned," Ishmael says of him, he will be "but a sleeping-partner" (III). Given Bulkington's initial presentation, his noble integrity and intelligence, he ought to have had, like Chekhov's pistol, a major function in the drama: leading the men against Ahab, or, if convinced that Ahab is right, becoming a source of strength for his captain. Yet Bulkington, who ought to be as weighty as his name and body, disappears. Perhaps he died early in the voyage, so that he was absurdly unable to assume the role implied for him; but even this is not recorded. Why not?

The formal answer seems to lie in what *is* given of Bulkington's role: he is the helmsman at the outset of the voyage, and thereafter a "sleeping-partner." A helmsman directs the ship; a sleeping-partner is commonly a partner whose existence is kept secret from the general public, and who takes no overt part in the enterprise with which he is involved even though his capital may dominate it.[2] Ishmael admits (or makes it up out of nothing) Bulkington's existence to us but thereafter suppresses his presence, which finally exists as a "deep" memory embodied in the "six-inch chapter" which is his "stoneless grave" (XXIII). Because that memory is an explanation of Bulkington's motivation, his motivation is what, for purposes of the narrative, Bulkington becomes; as sleeping-partner, that is what he *is*. The motivation attributed to him is a kind of eternal drive toward knowing the truth: up until his last voyage always

voyaging, on this last voyage Bulkington faced conclusively his own "ocean-perishing," and facing this final human reality has, according to Ishmael, allowed Bulkington to see "glimpses . . . of that mortally intolerable truth; that all deep, earnest thinking is but the intrepid effort of the soul to keep the open independence of her sea; while the wildest winds of heaven and earth conspire to cast her on the treacherous, slavish shore." Because his motivation here resembles that of both Ishmael and Ahab, comprehending the latter's will to absolute, ultimate knowledge as well as the former's compulsive mental integrity that must admit all contradictory speculation; and because this motivation is what Bulkington *is;* and because his Being-in-this-mode is the helmsman of the outsetting Pequod, thereafter becoming a sleeping-partner whose secret capital is part of the Pequod's value, Bulkington's literary existence is as a kind of animating and directive principle of the voyage. His being expresses that "the highest truth" resides only in the condition of "landlessness"—which is to say that it either (as Ahab thinks) may be found within landlessness, or (as Ishmael suspects) may be landlessness itself. Like Ishmael, Bulkington finds no final answers, but experiences the spirit in which the questions must be framed; like Ahab, he dies and becomes a grim "demigod," whose "apotheosis" is the chapter, as Ahab's is the book.

Bulkington is *used* by Ishmael allegorically. In this use he finds the role wherein, as far as the narrative is concerned, lies his chief reality. If Bulkington's literary existence is given us for the sake of what it means to Ishmael, and if that meaning "is" his spiritual presence, then his *actual* presence must be suppressed; for any one of his three probable roles in actuality would have conflicted with his Ishmael-conferred meaning: if Bulkington supported Ahab, he became the partisan of a delimited portion of the principle he reflects; if he fought Ahab, he similarly denied validity to what by virtue of Ishmael's initial presentation of him is part of himself, as well as competing with the white whale for the office of Ahab's antagonist (Bulkington would have been a more effectual human antagonist than Starbuck; but in Ishmael's intention only Moby Dick could be worthy of meeting Ahab conclusively); and, last, if Bulkington absurdly died before his natural leadership could play out its role, the direction and principle of the voyage would be too contrarily and specifically obliterated. For all such reasons, it does not matter that about Bulkington, Ishmael lies.

Ishmael's handling of Bulkington suggests, in fact, that we are not in danger of losing our bearings on his manipulated version of the Pequod's voyage because his major manipulations of reality—his hyperbole, irony, and lies—are in each case open to teleological analysis and, over all, are performed in the service of his vision of the meaning of the truth. In

short, Ishmael is simply a writer of fiction. As such, his truth is born of his lies; and given the nature of his truth, it could exist only by virtue of them.

Ishmaelean truth, as Ishmael's total vision of the world manifests it, is the truth of relativity: "There is no quality in this world that is not what it is merely by contrast," he says early in the book (xi); "nothing exists in itself." If things exist only in relation to other things, and assume their qualities by virtue of contrast with other qualities, then just as truth must exist by virtue of lies, Being by virtue of nonbeing, so the self must exist by virtue of the not-self: "O Nature, and O soul of man!" says Ahab, "how far beyond all utterance are your linked analogies! not the smallest atom stirs or lives on matter, but has its cunning duplicate in mind."

Such an ontology must assume an epistemology in which mind and matter are similarly interdependent. The reality of life, Ishmael tells us in the very first chapter of his book, is physically "ungraspable." It exists as an "image" of a "phantom" of itself seen by the water-dreaming Narcissus (who is "all of us") in the shifting water-world, which, before it is depths, is reflecting surfaces. Life as man knows it is a phantom image that is experienced superficially and elusively in a momentary present; it is dependent on an unsuspected source which both projects and ambiguously (in the end, mistakenly) perceives it, a relation which prevents it from being directly confronted. The future's attempt to grasp the phantom's solidity must destroy the reality as well as its image. Reality, in other words, is so evasive because at the same time that the seen does not exist apart from the seer, it is nevertheless different from him; and because both terms exist only in tenuous relationship, consciousness cannot be escaped in order to grasp any objective presence. To mistake this, like Narcissus and Ahab, is to risk death.

Meaning, in such a relationship, is as inescapable as it is elusive; and, whatever else it may be, it is first of all *human* meaning, conferred by man in the process of living. Meaning is inescapable because it is generated in the act of perception itself; the very clarity of outline of an object belongs to the meaning that is present in-the object's perception.[3] Meaning is human meaning because it existentially "is" only as the doubloon's value "is": conferred by man. Indeed, the doubloon chapter's chief function is to slow down the normal act of perception for the reader's edification: confronting the doubloon, each onlooker notices some details but not others, sees analytically or synthetically, perceives obverse or reverse, notes contexts or not, and in so doing creates partial and finite static value out of what must remain eternally itself and mute—a static value out of a coin which, nailed to the midpoint, is an integral part (the "navel," says Pip) of a ship that moves on a sea that moves on a world

itself whirling through the shifting skies. If Ishmaelean man must confer meaning on *things,* the things are processional and the meaning is dictated by the changeable limits of his self-structured experience and the evanescent dominance of his moods. Meaning is an integral part of reality, but reality does not exist apart from consciousness. Reality and meaning *are* the relation of man and world; they are the quality of his concern with the things of his world: a coffin may "be" a coffin, but "by a mere hap" of man's purposeful concern it may also be a sea-chest, then a life buoy—ultimately, in its potentiality it "is" all three at once, for Ishmaelean Being is becoming and is therefore always touched with possibility; with, that is, nothingness.

On such assumptions is founded the assertion that the highest truth is to be found in landlessness alone; that it is "shoreless, indefinite as God" (xxiii). It is why at sea each gam suggests a potential, *established* view of the whale, even unto the status of national attitudes; because, in the end as in the beginning, the overwhelming, unarguable facticity of the whale can be elucidated *only* in terms "of what has been promiscuously said, thought, fancied, and sung of Leviathan, by many nations and generations, including our own" (from the "Extracts" supplied by a sub-sub-librarian).

It is the reason, also, that Ishmael himself resembles the mutability and shiftiness he experiences as his world; because there is nothing on which he can solidly base his existence in a universe of infinite possibility that at the same time is infinite repetition, a world both fated and free and therefore dreadful, Ishmael can only be these contrarieties, a modern Narcissus. Thus we are never told Ishmael's real name: to name is implicitly to define, but because he can see nothing certain he can will nothing with his total being; therefore, for us as for himself, he can *be* nothing definite. Unlike Ahab, he has no aspirations to sainthood.

As character, Ishmael is a sailor; as narrator, a storyteller. The sort of book this uncommon sailor writes follows from the self-world relation which is his reality. It is a book not surprisingly grounded, often, in despair, an emotion whose forms are as protean and dialectical as those of boredom and dread.

Theologically, despair is the despair of God's power to save one's soul. In doubting that power, God as God is doubted, as is the nature of ultimate truth. Certainly, Ishmael has many moments when his despair is overt and resembles the theological, as in the passage in which he experiences death as absolute disappearance, or in his rejection of Christian hope in Chapter xcvi: "All is vanity. ALL. This wilful world hath not got hold of unchristian Solomon's wisdom yet." However, Ishmael's theological doubts do not express themselves always in such melancholy

tones. Quite evidently well-acquainted with the Bible, Ishmael admits to being a former believer ("I was a good Christian; born and bred in the bosom of the infallible Presbyterian Church," x) just before he humorously turns idolator with Queequeg. He cherishes "the greatest respect towards everybody's religious obligations, never mind how comical" (xvii). "Hell," he says cheerfully, "is an idea first born on an undigested apple-dumpling; and since then perpetuated through the hereditary dyspepsias nurtured by Ramadans" (xvii). No longer having doctrinal beliefs, he must needs be tolerant: "Heaven have mercy on us all—Presbyterians and Pagans alike—for we are all somehow dreadfully cracked about the head, and sadly need mending" (xvii). Without doctrine, he is, as he himself admits, a kind of pagan, "a savage, owning no allegiance but to the King of the Cannibals; and ready at any moment to rebel against him" (lvii). Beyond that, he is uncommitted, *even to paganism:* "Doubts of all things earthly, and intuitions of some things heavenly; this combination makes neither believer nor infidel, but makes a man who regards them both with an equal eye" (lxxxv); neither believer nor infidel, because no mere label will do.

Ishmael's minimal beliefs make him perhaps more prone to superficial mood swings than more solidly grounded citizens. Like "all sailors of all sorts" he is "more or less capricious," even "unreliable" (xlvi); he has lived in "the outer weather" and inhaled its "fickleness." Yet this very fickleness is a sign of the persistence of the despair that underlies it, a despair which is to be measured not only in specifically negative theological moments, but in the extent to which defeated hope pervades Ishmael's book.

The poet, says Emerson, meaning the term more broadly than versifier, is the sayer, the namer. Ishmael is a poet who names what he knows to be dreadfully nameless: he tells us of Timor Tom, New Zealand Jack, Don Miguel, and Moby Dick—all of them "famous whales" (xlv); but, if the final presence of Moby Dick may serve as index, the homeliness of these names falls absurdly short of defining the exotic wonder of their bearers' presences. What he does with individual whales, Ishmael does with the class of whales: a man who repeatedly protests his disbelief in the adequacy of systems, with humorous despair he offers us a "book" system of whale classification punningly based on the whale's most obvious feature—its sheer volume; a system in which his absurd and arbitrary ("Be it known that, waiving all argument, I take the good old fashioned ground that the whale is a fish," xxxii) terms must do "nothing less" than essay "the classification of the constituents of a chaos." Wishing to anatomize the idea of whaleness, he does so, literally, piece by piece, with actual whales; yet what his vision records is so contradictory he is repeatedly forced to confess that he can find no rational explanation

to make everything cohere. Emotions as well as reason falter before the whale, as Ishmael shows us the creature in every light so that our fear, awe, wonder, sympathetic concern (in, for example, the episode involving baby whales in "The Grand Armada"), even our pity (for the frightened old bull whose sore Flask pricks) are aroused, and though each emotion will do for a time, no feeling is in itself sufficient to comprehend both the temporal and spatial magnitude of the phenomenon, as well as its occasionally intimate appearances. To go whaling is to go mentally adventuring among the exotic wonders of the water-world, but there is emptiness in the experience; and even at the beginning of his book, the narrator's despair intrudes each time he records his hopeful exhilaration anticipatory of adventure, yet systematically subverts it with foreshadowings of separation and death ("From that hour I clove to Queequeg like a barnacle; yea, till poor Queequeg took his last long dive," XIII) so that underlying the exuberance and ferocity of the pursuit is a constantly deepening sense of futility. Such despair proceeds from the narrator's knowledge of the voyage's end, but it has become pervasive because of his deeper consciousness of endings.

Each increase in consciousness, says Kierkegaard, involves increased despair; yet the possibility of despair is man's advantage over animals.[4] Ishmael says he is a savage; being a savage implies, as with Queequeg, "unconsciousness" (XIII), a being able to be always equal to oneself. The civilized man because of his wider conceptual awarenesses can be of several minds, therefore not equal to himself; and to the extent that this describes Ishmael, Ishmael is not a savage. His savagery is "true" only in certain aspects and those only intermittently or qualifiedly. With him, as with Ahab or the whale, again no simple formula will do.

Ishmael shares, for example, the patience of savages:

> Now, one of the peculiar characteristics of the savage in his domestic hours, is his wonderful patience of industry. An ancient Hawaiian war-club or spear-paddle, in its full multiplicity and elaboration of carving, is as great a trophy of human perseverance as a Latin lexicon. . . .
>
> As with the Hawaiian savage, so with the white sailor-savage. With the same marvelous patience, and with the same single shark's tooth, of his one poor jack-knife, he will carve you a bit of bone sculpture, not quite as workmanlike, but as close packed in its maziness of design, as the Greek savage, Achilles's shield; and full of barbaric spirit and suggestiveness . . .
> (LVII)

Such artist-savages make material worthless in itself into things of value as, patiently, they literally fill their time with meaning. In telling his story, of course, so does Ishmael; with the difference that unlike the unreflective savages he describes he is conscious not only of what he is doing but of the contexts in which he is doing it. He is conscious, too, that the chief

meaning with which he fills up time is built of uncertainty, contradiction, and irony, barbarically spirited and suggestive without doubt, but hardly clear in detail. The precision of savage art is not attainable for Ishmael because his mind must comprehend more things, all of which he "tries," achieving what he can (LXXIX): a kind of "careful disorderliness" (LXXXII). Even the attempt to be a *primitive* artist is futile, because although he has the patience he does not have the unconsciousness.

Despair shows some of its dialectical capacity in its grounding of Ishmaelean humor, the major purpose of which is to articulate discrepancies between the actual and the ideal. Repeatedly, the point of Ishmael's humor is a demonstration of the incomprehensibly angular absurdities of himself or others projected against the implicit possibilities of human grace, thereby drawing attention to missed connections in the universe. Early in the book Ishmael had said:

> a good laugh is a mighty good thing, and rather too scarce a good thing;
> more's the pity. So, if any one man, in his own proper person, afford stuff
> for a good joke to anybody, let him not be backward, but let him
> cheerfully allow himself to spend and be spent in that way. And the man
> that has anything bountifully laughable about him, be sure there is more in
> that man than you perhaps think for. (v)

Later in the book Ishmael says: "that mortal man who hath more of joy than sorrow in him, that mortal man cannot be true—not true, or undeveloped. . . . The truest of all men was the Man of Sorrows" (XCVI). If despair is understood as the real ground of Ishmaelean humor, then the apparent contradiction between these two statements disappears:[5] like Stubb, the consistent humorist "has his history" (CXIV), and that history is not entirely a happy one. The humorist is what he is in relation to what he knows of sorrow. And that Ishmael is aware of despair as the potential basis for his own humor, his description of humorous despair shows:

> There are certain queer times and occasions in this strange mixed affair
> we call life when a man takes this whole universe for a vast practical joke,
> though the wit thereof he but dimly discerns, and more than suspects that
> the joke is at nobody's expense but his own. However, nothing dispirits,
> and nothing seems worthwhile disputing. He bolts down all events, all
> creeds, and beliefs, and persuasions, all hard things visible and invisible,
> never mind how knobby. . . . And as for small difficulties and worryings,
> prospects of sudden disaster, peril of life and limb; all these, and death
> itself, seem to him only sly, good-natured hits, and jolly punches in the
> side bestowed by the unseen and unaccountable old joker. . . . There is
> nothing like the perils of whaling to breed this free and easy sort of genial,
> *desperado* [italics added] philosophy. . . . (XLIX)

If the universe in this hyena mood seems like an obscure practical

joke, the literary world Ishmael creates for us is often mined with hidden banter. Often this is obscene. Sometimes it lurks as potential meaning where it has no business to be: "Of erections, how few are domed like St. Peters!" (LXVIII). Another instance seems to be when Pip, after equating the doubloon with the ship's "navel," which all the lookers-at are "on fire to unscrew" (XCIX), asks portentously: "But, unscrew your navel, and what's the consequence?"—a question which only too readily brings to mind the punch line of the old joke about the Hindu mystic.[6] Sometimes the nonpertinence of the potential ribaldry can be staggering. Lawrance Thompson, for example, holds that the chapter "A Squeeze of the Hand," so important to critics who see the book's social-ethical admonitions as final, is secretly obscene.[7] Insisting upon a nonwhaling meaning for the word "sperm," he naturally finds the whole passage full of the sort of "accumulated off color word play" that, if indeed there, is positively Shakespearean in its strained bawdiness (even "country" makes its appearance):

> Would that I could keep squeezing that sperm for ever! For now, since by many prolonged, repeated experiences, I have perceived that in all cases man must eventually lower, or at least shift, his conceit of attainable felicity; not placing it anywhere in the intellect or the fancy; but in the wife, the heart, the bed, the table, the saddle, the fire-side, the country; now that I have perceived all this, I am ready to squeeze case eternally. In thoughts of the visions of the night, I saw long rows of angels in paradise, each with his hands in a jar of spermaceti.

In this passage, and throughout the four paragraphs preceding it, Thompson finds Ishmael-Melville ridiculing by his obscenity the idea of Christian brotherhood. While there is no doubt that Ishmael-Melville is capable of this sort of word play—"archbishoprick" (XCV), about which there can be no question, proves it—nevertheless, the hypothesized bawdry of "A Squeeze of the Hand" is so *very* strained, in addition to being violently out of congruence with the lyrical rhetoric of at least the crucial paragraph just quoted (the self-conscious sentimentality of the preceding paragraphs makes them more plausible game), that the hidden presence of obscenity here seems less certain than Thompson says it is. The real difficulty is that all such obscenity must finally be in the eye of the beholder, for the passage itself contains merely the grammatical possibility of obscenity. Yet it does contain that (and so do passages throughout the book); and because it does, once the sincerity of the expressed sentiments is doubted, the words themselves can make us uncomfortable without ever *necessarily* resolving themselves into either democratic pietism or scurrilous anti-Christianity.

Perhaps, in short, precisely that irresolution is one literary function

of such passages. In the chapter in question, the democratic sentiments are undermined by the overt terms in which they are presented: it is explicitly "a strange sort of insanity" that comes over Ishmael to lead him to his "loving feeling," which is then dealt with in hyperbole appropriate to "insanity"; while the ideals of landed comfort are covertly undermined by Ishmael's continued bachelor-voyaging, for he has failed to choose the self and life he urges us to choose; and both *may* be further subverted by covert obscenity. What we have in such passages is a kind of willful destruction of specific meaning, meaning that is potential at several levels, but on no level is finally asserted.[8]

Here humor has shaded into the problematics of Ishmaelean irony, wherein no firm standpoint is offered the reader, and his wishes tend to be projected into the material to provide one, the reader thereby being forced to become part of what he reads. Such irony reflects—just as the implicit rationale of lying does—the attitude of a man who knows he does not know. It is the attitude of negative intellectual freedom that allows all standpoints to be playfully adopted for the moment. Committed to nothing, the Ishmaelean ironist can mockingly play with everything, as a result of which everything he touches is eerily tinged with the color of mere possibility: his ironies, like his lies, are "white."

Because they are, they become part of the methods by which Ishmael constructs a literary universe in which many meanings cannot be certified, a universe that reflects his own experienced universe and makes the Ishmaelean self a type of the alienated mind of fluid contrarieties. Here, conventional theological despair that doubts God shows its links with Kierkegaardian despair which with every increase of consciousness is increasingly uncertain that there is such a thing as a true self; for with no positive beliefs to characterize him, Ishmael can hardly be a continuously unified character. And, as has been suggested, others in Ishmael's book parallel his mode of despair: Pip's despair reflects inner and outer void, Ahab's becomes an intensity of selfhood that conceals a blank, Stubb's jolly despair hides his history (presumably one involving infidelities by his "juicy little pear" of a wife who gives parties to the "last arrived harpooneers" while he is away, xxxix),[9] Starbuck despairingly wills to be the self of his old land faith despite the kidnapping cannibal ways of the sea that would deny the fundamental bases of that self. In each instance, the Being of personal identity is related to inner and outer nonbeing, existing in intimate conjunction with it.

Indeed, when Ishmael survives at the end supported by an empty coffin, a thing significant of death has come to signify life by virtue of accident working together with man's forming intentions, and the survival can be read as in part a reflection of the book's ontology wherein Being is radically dependent on nonbeing. Taking this one step further,

283

one might say that Ishmael survives also by virtue of the book itself recording his survival; he survives therefore as an artist, and as a rather desperado artist whose desperation reaches into his book's style. It is, as Constance Rourke noted, an oral style. As such it is a highly personal style that creates its own implicit dramatic situation which suggests, at first, that Ishmael has cornered one auditor in, say, a bar, and spins him a yarn full of arguments and asides of what happened one memorable voyage. As the book progresses, the implied situation of narrator and auditor quickly shifts to that of a practiced storyteller now writing a sometimes awkward book for anyone at all to read, but an anyone addressed personally from time to time to recall something of the original storytelling situation. Ishmael therefore remains an habitual raconteur convivially telling tales, like the Town-Ho's, in bars, like Lima's Golden Inn; and because his tale of a whale is obsessively told—the product of almost total recall, invention, and what can best be termed extensive scholarly research—it may be suggested that the narrator is *driven* to tell it, as if he were a younger version of the ancient mariner, and his book the end result of many compulsive rehearsals. Ishmael is compelled to report and create meaning in what happened to him both despite, and because of, his sense of the uncertainty of meanings available to temporal man. Once more, Kierkegaard's categories can help to place the situation: if Ahab's response to despair is in its special way religious, and Starbuck's finally ethical, Ishmael's, beginning with his tormenting drive to seek out "the interesting," is aesthetic.

And that Ishmael's response is aesthetic to the point of his writing a book is sufficient explanation for his survival. He does not survive because of some merit on his part; to argue this—that what Ishmael has learned is what allows him to be saved, that Ishmael lives right or sees things in reasonable perspective while Ahab does not—to argue this is to assume an ethical universe of some sort: a tragically lopsided one in which innocents, like Pip, and good men, like Starbuck, die horribly precisely because of Ahab's moral-perceptional errors even though Ishmael does not. But whether the universe has any ethical character at all, lopsidedly tragic or otherwise, is a major part of what is in question in the first place; the argument assumes what it must demonstrate. Ishmael's book is in this respect prior to tragedy, though Ahab's story may well not be. His survival is therefore prior to all ethics, and the existentially sufficient reason for his survival is that what transcends death in time is art: art is what in fact does survive, often accidentally, and about its survival and Ishmael's as artist storyteller there is very little ethical that can, it seems to me, be convincingly posited.

Insofar as Ishmael's book exists in order to record his manner of survival, it exists in order to exist its writer as a dialectical being. Nega-

tively, the narrator becomes so involved with the not-self that he is often in danger of losing himself as a character in it—in events and in others, as if by virtue of his negative capability he experiences fully his own nonbeing as an analogue to the universal void. Positively, the narrator becomes most a "character" through his humor, which points out and reflects inner and outer limitations, but which also tends at times toward an optimism that can experience the naughting ambiguity of self and universe as the plenitude of intellectual freedom: as a nearly infinite number of things in the world and a multitude of potential meanings arising out of the interrelation of these things with men's minds which gives Ishmaelean man the real freedom to worship no unworthy gods, but instead to try all things, to explore, and by exploring to create his own world of meanings. One might summarize the self of the Ishmaelean narrator as that of an artist who has constructed, as Melville's contemporary Flaubert hoped to,[10] a highly personal, stylized work: a something founded on nothing in the face of a nothing, a something which creates Ishmael's own ambivalent self for him and for us, and gives its peculiarly problematic existence to his world.

Notes

[1] "I mean, sir," Ishmael goes on, "the same ancient Catholic Church to which you and I, and Captain Peleg there, and Queequeg here, and all of us, and every mother's son and soul of us belong; the great and everlasting First Congregation of this whole worshipping world; we all belong to that; only some of us cherish some queer crotchets noways touching the grand belief; in *that* we all join hands."

[2] There is another possibility, of course: the literal implication of the phrase, that Bulkington sleeps with Ishmael. This would posit an Ishmael out of Leslie Fiedler's worst moments who would rather not confess under his own name because, in part, of the implied homosexuality of several of his experiences. Despite the incredulity such a suggestion may raise, the grammatical and referential possibility *is* there, and for those who want it to be it can subvert the content of the Bulkington episode in ways similar to the ones soon to be discussed in the text.

[3] As in the case of Narcissus, who makes his image mean a being distinctly someone else in the water, and thereby clarifies it beyond what it is. The whale, however, with no face, cannot be given normal human perceptional meaning.

This assertion, in various formulations, is by now a commonplace of many modern psychologies, but it has been demonstrated most convincingly, perhaps, by Gestaltists. An elementary demonstration is the famous duck-rabbit drawing: the "duck" faces left, the "rabbit" right. Because it is hard to perceive the outline without making it "mean" discontinuously one or the other animal, it can be

concluded that for man, normally, objects hardly exist except insofar as they already have meaning, which is conferred in the very act of perception. Peception, in short, is really apperception.

[4]*Fear and Trembling and The Sickness unto Death* (New York, 1954), p. 148.

[5]I offer this analysis as an alternative solution to the one proposed by Otis Wheeler in "Humor in *Moby Dick:* Two Problems," *American Literature,* 29, No. 2 (1957). Wheeler notes the inconsistency and finds the reason for it in Melville's changing conception of the book as he rewrote it, Ishmael changing in the process from a comic character to a philosopher. Of course, a great many of the coarser jokes are in the revised sections, and the entire problem disappears if the inconsistency is more apparent than real.

[6]The joke, current on the Eastern seaboard about ten years ago, involves an extremely long, dead-pan build-up that stresses the sanctity and sincerity of a Hindu holy man on a high mountaintop who after years of contemplating his navel decides that it ought to be possible to unscrew it, and that if he were to do so he would at last have all the final answers. In some versions of the story a golden screwdriver descends from the sky to the mountaintop (the story is full of archetypes); the mystic grasps it and unscrews his navel, only to have his ass fall off. In an odd way the "fundamental" moral of the story fits as a possible answer to Pip's question, though the tone, here as elsewhere, does not. That the joke existed in the nineteenth century, a version of it in print in 1855, is noted by John Seelye in "The Golden Navel: The Cabalism of Ahab's Doubloon," in *Nineteenth Century Fiction,* 14, No. 4 (1960). Since jokes get into print considerably after their oral currency, it is hard not to believe that Melville knew it.

[7]Thompson, *Melville's Quarrel with God* (Princeton: Princeton Univ. Press, 1952), p. 218.

[8]Robert Shulman in "The Serious Function of Melville's Phallic Jokes," *American Literature,* 33, No. 2 (1961) finds that such jokes "help Ishmael satirize the norms of the respectable community and to assert the value of independent creativity and a socially defiant creator" (p. 194). Shulman's Lawrentian-Freudian bias leads him to assert but not demonstrate that phallicism meant creativity to Melville. I would agree that such meaning may very well have been part of Melville's timidly Rabelaisian intention, but forced as he was in nineteenth-century America to conceal most of his obscenities, these do not emerge from the book with sufficient force to be felt as in themselves of positive value; instead, the more hidden ones make the reader uneasy if he notices them at all, while the less hidden ones may be funny enough to help nullify serious meaning where they occur, but they do not seem to me bold enough to assert phallic countervalues. Shulman's argument differs from mine less in essence than emphasis, however: I feel that in their destruction of meaning is the major force of their creativity—if you destroy established values you have a chance, like Ishmael, to be born again from chaos and live your new life facing without mediation the leprous world: Melville is pre-Lawrence, not post.

[9]Ishmael suggests sexual play on the word "harpoon" in the chapter called "Fast-Fish and Loose-Fish," in which it is recounted that a "gentleman had originally harpooned" a lady, but "abandoned her on the seas of life" because

of her "plunging viciousness" and "a subsequent gentleman reharpooned her." The Shulman article cited in the preceding footnote documents many such usages.

[10]See especially Flaubert's letter of January 16, 1852, to Louise Colet. It appears on p. 125 of Francis Steegmuller's edition of the *Selected Letters* (Anchor Books, 1957). The letters on pages 139, 148, and 253 are also startlingly parallel to Melville's thought as Ishmael reflects it.

Infants, Boys, and Men, and Ifs Eternally— *Moby-Dick*

Edwin Haviland Miller

W... hen Ahab dies and Ishmael is spared, one generation succeeds another according to the ancient formula. In a real sense Ahab fathers Ishmael. If Ahab warps life by fixating his fifty-eight years of hurts upon a whale, he bequeaths his fixation to "another orphan" who in turn will narrate a tale of this "leviathanic" projection of megalomania, self-hatred, and life-hate, and which he will eventually christen *Moby-Dick*. Aboard the *Pequod,* in a patriarchal environment which sanctions his caprices, Ahab is lord, and Ishmael an insignificant seaman, the one active and the other passive. In recording Ahab's fate Ishmael reverses the order and replaces his rival.

Although Ahab and Ishmael never engage in dialog during the cruise, Ishmael enters the other's mind empathically. Like Ahab he himself not only bears the name of a biblical outcast but also worships non-Christian gods and finds companionship with one of an alien culture. Both are foundlings in search of a white phantom, impelled by imperious narcissistic needs, "isolati" from civilization, religion, and family. Ishmael, after falling under Ahab's magnetic sway, gradually in his active-passive reflective way, in monologs and digressions, frees himself and establishes his own identity. Yet the bond between the two is deep, the similarities great. As master of the narrative Ishmael is a match for the master of the *Pequod*. Both are tyrants.

Reprinted from *Melville* (New York: George Braziller, Inc., 1975), pp. 210–19. Copyright 1975 by George Braziller, Inc. Reprinted by permission of George Braziller, Inc.

In rage and deprivation but in heroic diction Ahab distorts the cosmos to conform to his own self-image. Not without awareness, although he is powerless to change, he acknowledges his warped perspective: "So far gone am I in the dark side of earth, that its other side, the theoretic bright one, seems but uncertain twilight to me." Ishmael as narrator provides only a partial corrective to Ahab's imbalance. In the midst of the "The Grand Armada" chapter, where the crew observes the mating and nursing habits of whales deep in the sea, Ishmael, looking deep into himself, admits the fissure within: "amid the tornadoed Atlantic of my being, do I myself still for ever centrally disport in mute calm; and while ponderous planets of unwaning woe revolve round me, deep down and deep inland there I still bathe me in eternal mildness of joy."

When Ahab speaks of the "theoretic bright" side of life, almost denying the existence of the sun for the sake of the darkness which harmonizes with his wounds, and Ishmael recognizes the "eternal mildness of joy," a difference in attitude (and art) emerges, although the distinction cannot be drawn too sharply without producing new distortions. Ahab commands not only by means of authoritarian decrees but also by means of his overpowering rhetoric with its magical evocations of timeless fears and tragedies. He strikes verbal postures in borrowed clothing, his language as irrelevant as Don Quixote's silver Latin in the Renaissance wasteland, and like Cervantes' immortal fool he pursues windmills with no time permitted for comedy which of course would undermine his megalomania.

Ishmael, however, is given, as he confesses in the first chapter, to "wild conceits," to salacious jests and scabrous puns, to burlesque and farce, to witty digressions and satire, and often to hilarity, sometimes as manic as Ahab's depressions. He does not serve as an old-fashioned comic norm, a common-sense corrective to Ahab's extremism. There is too much of Ahab's madness in Ishmael's nature for that, but, in true comic fashion, he invokes the unholy trinity, anal, oral, and genital. He ordinarily physicalizes what Ahab sublimates into abstractions and cloaks in the poetry of another time, another place. Yet the resolution of the novel points to the central axiom of the comic perspective, the triumph and survival of the son.

From his evocative opening sentence Ishmael is a virtuoso performer, in his antics witty and sometimes as mad as Ahab, as greedy for a well-turned phrase as the captain is for vengeance. Like Ahab, Ishmael follows a "predestinated" course: "doubtless, my going on this whaling voyage, formed part of the grand programme of Providence that was drawn up a long time ago." At the outset he playfully, but madly, reveals his suicidal course when he burlesques the drama he is about to unfold:

"Grand Contested Election for the Presidency
of the United States.
"WHALING VOYAGE BY ONE ISHMAEL.
"BLOODY BATTLE IN AFFGHANISTAN."

In a few lines he accomplishes three things: he minimizes his own "performance" as an artist, ridicules the narrative, and undercuts Ahab's and his own greatness. Such artistic courage is audacity or "madness," or possibly a little bit of both, certainly worthy of Ahab himself. Psychologically the burlesque is appropriate since it reflects Ishmael's personal instability and covers his aggressiveness with a comic overlay.

After the introductory chapter Ishmael presents a farcical account of his adventures before the ship sails. He falls in and out of bed with Queequeg, juxtaposes Presbyterianism and Yojo-ism, as well as a cannibal and a man of God, introduces a "cracked" prophet in Elijah and "cracked" shipowners in Bildad and Peleg, two Quakers whose religious views clash with their materialistic aspirations. Except for frequent intimations of doom sounding in the background, the first thirty-one chapters are maniacal in their rapid mood shifts and situational changes, picaresque in the seeming random and tentative organization, although the looseness is an artful contrivance in deliberate contrast with the eventual fixation of the book and the two central characters upon the white whale. The farce accords with the nonmanipulative role Ishmael assumes at this point in the narrative both in his passive relationship with Queequeg and in his seemingly offhand attitude toward his narrative.

After Ahab appears and makes his first speech there is a change in Ishmael's role. Beginning with Chapter 32, "Cetology," Ishmael the would-be sailor begins to recede from the center of the farcical stage and Ishmael the artist takes over as a witty commentator and a manipulator of the narrative. In his lengthy discussion of cetology and his casual but essentially systematic anatomy of the whale, he reveals a concentration and obsession equal to Ahab's. As the captain scans the waters in search of Moby Dick, Ishmael surveys all history in his cetological commentary. Where Ahab bears the scars of the ages, weighing the book down with his grandiloquent tragic viewpoint, Ishmael is light in his touch, seemingly balanced in his perspective. At first Ishmael succumbs as completely as the rest of the crew to Ahab's rhetoric, when he publicly announces his quest for the white whale—he, too, is "overmanned"—but gradually he frees himself from the "magnet" and establishes his own voice, or appears to do so, since his "free and easy sort of genial, desperado philosophy" is ultimately Ahab in another key.

Ishmael is truly genial-desperate. After Ahab's performance on the quarter-deck, Ishmael appears to be a corrective commentator when he

analyzes the captain's madness; he answers Ahab not in analysis but in a virtuoso chapter called "The Whiteness of the Whale." If Ahab seduces the crew, Ishmael seduces readers—by almost identical tactics—into accepting his irrational analysis of whiteness as logical discussion. By incantatory appeal to superstitions and by factitious analogies he posits that the hue of whiteness "strikes more of panic to the soul than that redness which affrights in blood," which culminates, after an orgy of emotionally charged language and allusions, in the undemonstrable assertion that whiteness is the "colorless, all-color of atheism from which we shrink."

In the course of an exposition which is quietly hysterical he asserts that the whiteness of the polar bear or of the albatross is demonic in the terror it arouses. But the terror is more verbal than real. Red bears against a white glacier or red birds, like the sea-hawk at the conclusion, can be equally terrifying. Atheism, regardless of the color given to it, terrifies only if one is imprisoned in religious fears and presuppositions about the nature of the cosmos and the afterlife—or if one is willing to suspend rational judgment. Although many commentators have singled out the profundity of this chapter, they appear to slight the fact that Ishmael undercuts it at one point in an imaginary conversation with readers: "But thou sayest, methinks this white-lead chapter about whiteness is but a white flag hung out from a craven soul; thou surrenderest to a hypo, Ishmael." And then he has the delightful effrontery to resume in the same vein, alleging that "here thou beholdest even in a dumb brute, the instinct of the knowledge of the demonism of the world"; and that "Though in many of its aspects this visible world seems formed in love, the invisible spheres were formed in fright."

"The Whiteness of the Whale" is a tour de force wittily and wickedly calculated by an artist who keeps all his ambiguities open and his readers off rational balance. Its appeal is as primitive as Ahab's rhetoric and as simplistic as the projection of evil and deity upon the innocent back of a white whale. Ishmael, like Ahab, reduces the cosmos to false dualisms which capture the emotions by denying rational distinctions and gradations. The chapter is no more profound than Mapple's sermon or Fleece's parody; it is but another, highly romanticized, way of surveying the multiform variety of life. "The Whiteness of the Whale" illustrates "madness maddened," the artifice of a wit who, while seeming to undercut the central character, constantly reenforces him and reveals the emotional affinity when he in turn projects his own frightened life experience upon the universe.

Ishmael begins mock-innocently in his comic course when he reduces to manageable and human proportions both whales and bibliography by speaking of Folio Whales, Duodecimo Whales, and so forth. But the wit

disguises the fact that he is attacking the making of books, again mocking both himself and his narrative. After he is exposed to death when the whaling boat he is in capsizes, he does not lose his wits as Pip is to do later; rather he laughs with a calculated leer in "The Hyena," when he arrives at a conclusion strikingly like Ahab's except for the language he employs:

> There are certain queer times and occasions in this strange mixed affair we call life when a man takes this whole universe for a vast practical joke, though the wit thereof he but dimly discerns, and more than suspects that the joke is at nobody's expense but his own. However, nothing dispirits, and nothing seems worth while disputing. He bolts down all events, all creeds, and beliefs, and persuasions, all hard things visible and invisible, never mind how knobby; as an ostrich of potent digestion gobbles down bullets and gun flints. And as for small difficulties and worryings, prospects of sudden disaster, peril of life and limb; all these, and death itself, seem to him only sly, good-natured hits, and jolly punches in the side bestowed by the unseen and unaccountable old joker. That odd sort of wayward mood I am speaking of, comes over a man only in some time of extreme tribulation; it comes in the very midst of his earnestness, so that what just before might have seemed to him a thing most momentous, now seems but part of the general joke.

The good-natured tone of the passage tends to minimize despair while actually reenforcing it, and at the same time camouflages Ishmael's continuing transformation from passivity to assertiveness. More and more he will play the role of "the unseen and unaccountable old joker." Ishmael's aspirations match Ahab's.

His latently aggressive nature emerges as he adds satire to his comic arsenal. Presbyterianism and Quakerism are diminished farcically in the first part of the book. The satirical harpoons are no less effective, perhaps more destructive, even though he hurls them unsystematically, even casually, or so it seems. Sometimes they are directed at topical matters like phrenology ("The Nut") or at cruelty to animals (he singles out ganders, not whales). Gradually he takes on more significant subject matter when he attacks man-made syntheses, the collective philosophical wisdom of the ages. The complexities of the age-old analysis of free will and chance are outrageously simplified when both become balls of yarn for a "matmaker" who, when startled, drops "the ball of free will." On one occasion the *Pequod* is balanced in the waves—once more the dualistic approach—by two dead whale heads christened Locke and Kant. "So, when on one side you hoist in Locke's head, you go over that way," Ishmael writes; "but now, on the other side, hoist in Kant's and you come back again; but in very poor plight. Thus, some minds for ever keep trimming boat. Oh, ye foolish! throw all these thunder-heads overboard, and then

you will float light and right." At another point he comments: "How many, think ye, have likewise fallen into Plato's honey head, and sweetly perished there?"

In "The Fountain" one paragraph converts some of the world's greatest minds into spray: "And I am convinced that from the heads of all ponderous profound beings, such as Plato, Pyrrho, the Devil, Jupiter, Dante, and so on, there always goes up a certain semi-visible steam, while in the act of thinking deep thoughts." If ancient "wisdom" becomes vapor, so too does Ishmael's satirical assertion of the fact, for immediately he holds himself up to ridicule, almost in punishment for his aggressions against the "fathers": "While composing a little treatise on Eternity, I had the curiosity to place a mirror before me; and ere long saw reflected there, a curious involved worming and undulation in the atmosphere over my head. The invariable moisture of my hair, while plunged in deep thought, after six cups of hot tea in my thin shingled attic, of an August noon; this seems an additional argument for the above supposition." His "genial, desperado philosophy" leaves a lot of wreckage in its wake, not unlike Ahab's monomania.

Just as Narcissus' watery image, which is "the key to it all," mirrors the fluctuations and rhythms of the two characters, the "gloomy-jolly" book itself reflects the author's deliberate assaults upon literary conventions. *Moby-Dick*, like the whale itself, bears its scars. Out of the wreckage Melville shapes his incredible artifice. Early, in the farcical phase, Ishmael justifies a digression with this comment: "But no more of this blubbering now, we are going awhaling, and there is plenty of that yet to come." Later the tone is mock-heroic when he states his "less celestial" purpose, "I celebrate a tail," or when he observes: "But is the Queen a mermaid, to be presented with a tail? An allegorical meaning may lurk here." At another point he notes that some people "will scout at Moby Dick as a monstrous fable, or still worse and more detestable, a hideous and intolerable allegory." (Later, in January 1852 he confessed to Sophia Hawthorne that "I had some vague idea while writing it, that the whole book was susceptible of an allegoric construction, & also that *parts* of it were"— surely one of the most disingenuous statements that he ever made.)

He shatters fictive illusion when he deliberately and comically makes us aware of the process of writing. In the midst of a serious commentary on Ahab's "madness" he refers to "a furious trope" in the preceding sentence. He introduces the last sentence of a paragraph filled with pretentious historical and mythic allusions, with the phrase, "In plain prose," which topples his stylistic inflation. "The foregoing chapter, in its earlier parts," he asserts in "The Affidavit," "is as important a one as will be found in this volume"—which at best is but a partial truth. In the interpolation called "The Town-Ho's Story," which in some respects is *Moby-*

Dick in miniature, he notes: "For my humor's sake, I shall preserve the style in which I once narrated it at Lima." In the midst of his ridicule of Locke and Kant he satirizes his satire: "Here, now, are two great whales, laying their heads together; let us join them, and lay together our own." At the conclusion of "Cetology" he suddenly writes: "God keep me from completing anything. This whole book is but a draught—nay, but a draught of a draught. Oh, Time, Strength, Cash, and Patience!" The irrelevancy of the two sentences—the ingenious comment upon the writing process and his own (meaning Melville's) financial need—is relevant since it lays bare all the author's manipulative control of his "crazy" structure. Later he asserts that he does not wish to proceed "methodically," and at another point he suggests that "There are some enterprises in which a careful disorderliness is the true method."

On still another occasion he presents his version of Emerson's organic theory of art: "Out of the trunk, the branches grow; out of them, the twigs. So, in productive subjects, grow the chapters." It is an impressive statement—until we recall that this is the first paragraph of a chapter entitled "The Crotch." Just as Queequeg associates the markings on the doubloon with his genitals, reducing the symbolism to its sexual origins, so Ishmael hints at the sexual underpinnings of art, somewhat in the fashion of Whitman's emphasis upon the phallus as seedman. He sexualizes a reality which Ahab seeks to desexualize, although his projection of the world's evil upon the whale that wounds him in the groin confirms the biblical association of evil and sexuality. Even the name Moby Dick may be a phallic pun.

Ishmael's dissection of the whale begins with the head, eventually concentrates upon the phallus in hilarious scenes like "Stubb's Supper," "A Squeeze of the Hand," and "The Cassock," where he transforms native bawdy humor into art, and finally arrives at the fundament, the skeleton of a divine whale in Arsacides. In this brilliant episode which devitalizes the majestic monster of the sea into the inevitable collection of bones after death, Ishmael employs reductionistic and regressive imagery. The locale is a bower reminiscent of similar settings in Spenser's *Faerie Queene* or of the first bower, the Garden of Eden. In the preface to the scene Ishmael the artist appropriately assumes the role of a parent, specifically a mother, and the artifact, the history of the life and death of a whale, becomes a child: ". . . it behooves me now to unbutton him still further, and untagging the points of his hose, unbuckling his garters, and casting loose the hooks and the eyes of the joints of his innermost bones, set him before you in his ultimatum; that is to say, in his unconditional skeleton." In the process of describing the scene, Ishmael, after the fashion of Jonah and Theseus, reenacts the birth process by reversing it to enter the womb. "To and fro I paced before the skeleton—brushed

the vines aside—broke through the ribs—and with a ball of Arsacidean twine, wandered, eddied long amid its many winding, shaded collonades and arbors." (At the same time he reexperiences Eve's birth from Adam's rib.) Inside the whale he takes "admeasurements" which, he informs us with playful pseudo-realism, "are copied verbatim from my right arm, where I had them tattooed; as in my wild wanderings at that period, there was no other secure way of preserving such valuable statistics."

The accuracy of his measurements is of little significance except perhaps to a literalist without a sense of humor or psychological imagination, the absence of which prevents empathy with Melville's "performance." To miss the joke evidences insensitivity to Melville's duplicitous art, his wild sense of comedy, and the profundity underlying it, and it is to succumb to Ahabitry, which is narcissistically arrested in an egocentric and humorless view of the universe. In order to arrive at the dimensions, Ishmael, the artist-parent that gives birth to and guides the manuscript omnisciently, must become for the time being the child that supplies the material and is the source of the manuscript. Here Ishmael assumes the perspective of a fetus surveying the "womb." The measuring duplicates the child's curiosity not only about the uterine state it has had to abandon forever except in moments such as this, but also about the proportions of the adult body, particularly of the mother, which from its diminutive perspective it regards as the ultimate mystery and ultimate fascination. It is a deliciously droll example of a child's searching out in its intuitive and irresistible desire for sexual knowledge.

At the conclusion of his examination, after all the wonderful indirections, Ishmael finds "forty and odd vertebrae in all" which lie "like the great knobbed blocks on a Gothic spire. . . . The smallest, where the spine tapers into the tail, is only two inches in width, and looks something like a white billiard-ball." Which brings us once more to the fundament (Arsacides again) and to the child's misunderstanding of the sexual passageways. "I was told," Ishmael adds with superfluous literalness, "that there were still smaller ones, but they had been lost by some little cannibal urchins, the priest's children, who had stolen them to play marbles with"—which is a wry way to assert the eternal cycle. The last sentence, masterly in its wit and in its psychic as well as artistic appropriateness, reveals Ishmael's complete awareness of his artistic manipulations: "Thus we see how that the spine of even the hugest of living things tapers off at last into simple child's play."

The reductionism here and elsewhere enables Ishmael to mask his "tornadoed" feelings and his alienation. The wit, often aggressive and hostile, is encased in a socially acceptable form. Ishmael does not knock off hats literally, but wittily. With impunity he punishes the world that has punished him. Like Ahab he takes his vengeance. Both are frightened

boy-men. If Ahab is "unbuttoned" and assumes a quixotic kind of her-
oism, Ishmael's comedy not only "unbuttons" the whale but the readers
and himself. A contemporary reviewer in *The Literary World* in November
1851 speaks, perceptively, of "Ishmael, whose wit may be allowed to be
against everything on land, as his hand is against everything at sea." His
verbal aggression undermines orthodoxy, philosophy, mythology, and
human aspiration. In reducing everything to "a great practical joke," he
secretly baptizes the book in a subversive comic norm—nothingness.

Ahab's magnificent rant transfigures his bankrupt life and impover-
ished sensibility, and grants him in his twilight years an unearned heroic
stature, not because of his humanity but because of his "crazy" courage.
He so poeticizes his self-hatred and his destructive tendencies that we
forget that the lonely, emotionally and physically crippled captain, with
whom in our own loneliness we empathize, hungers for the lullaby of
death.

When Ahab craftily universalizes his "madness" by evoking infantile
fears of the parent, his rhetoric hides from the crew, and readers too, a
basic lack of confidence or trust in himself and in life itself; his bombast
cloaks the impotency of his fears which he seeks to subdue through
verbal and physical aggressiveness. He observes that he "only feels, feels,
feels." In his own way he wallows in self-pity. When he goes on to
exclaim, "to think's audacity. God only has that right and privilege," he
exposes an intellect arrested in childish despair and primitive superstition.
At one and the same time he cannibalizes the deity and abdicates intel-
ligence to a creation that mirrors his hurts and tyrannizes over his imag-
ination as he in turn tyrannizes over his docile crew. Fatherless, he ac-
cepts the hierarchical structure of life at sea, and eventually becomes
captain or "father" in a patriarchal order built on fear rather than on
love, which is the seemingly inevitable outcome of the tragedy of his first
year. Beneath his authoritarian posture Ahab conceals his wounded ego.

Ishmael, on the other hand, although he too as an orphan is crippled
and goes to the sea to ward off suicidal tendencies, can "marry" Quee-
queg, which at least establishes his ability, limited though it may be, to
relate to others. More important, he can "divorce" himself from the
limitations of Ahab's monomania which is lifeless and affectless. Where
the captain broods compulsively on vengeance upon the white whale,
or death, Ishmael meditates not only upon Thanatos but also upon the
erotic continuity of the human condition. Unlike Ahab, he finds a non-
destructive outlet for his destructive tendencies. His aggressions he har-
nesses to a wit which will imperil no lives. Even the negations of the
satiric attacks fall into place in the context of *Moby-Dick*.

In his lonely study, where the shades of his artistic predecessors reas-
sert the continuum, Ishmael the artist-creator modulates and manipulates

his narrative, with the tender control of a fond parent over a wayward child. Tied as he is to the nihilism of Ahab and harried by his own hurts, Ishmael finds a form which encompasses and subdues chaos. Unlike Ahab, who reduces existence to conform to his own agony, Ishmael's art mutes and transforms his despair into a celebration of multi-faceted life.

In the Epilogue we see the cradle-coffin endlessly rocking, the maternal principle in the form of the ship *Rachel* timelessly reasserting itself. Ishmael the son survives Ahab the father, to tell a tale of death and rebirth. Such is the continuity of life and art. The sun and the son must ever rise.

From the womb of Melville's life experience and the blackness of his hurts, painfully, joyfully, maniacally, emerges a book which expands/contracts in the birth-death throes with which it begins. Before he finished writing, Melville, like Ahab, staggered beneath the pain and had trouble bringing it to a conclusion. The price of reactivating and reliving earlier pains and of rivaling Hawthorne was truly great intellectually and emotionally.

Moby-Dick is an exhilarating, frightening experience—perhaps the loveliest, most terrifying, "crazy-witty" meditation in the lonely American landscape.

Whitman
Leaves of Grass

Singing for Soul
and Body

Hyatt H. Waggoner

Emerson would have had to read no farther than the first page or so of the strange anonymous book he received in the mail, sent him, he could only suppose, by the unknown author himself, to realize that the writer was expressing some of his own central thoughts, sometimes in the same images. Here was a man neither timid nor apologetic, who dared to say "I am," even "I celebrate myself." Here was a man unashamed before a blade of grass. The first lines he read in the 1855 edition, the opening lines of a poem finally called "Song of Myself," were these:

> I celebrate myself,
> And what I assume you shall assume,
> For every atom belonging to me as good belongs to
> you.

> I loafe and invite my soul,
> I lean and loafe at my ease. . . . observing a spear of
> summer grass.

Whether Emerson remembered, when he read these lines, the passage he had written in "Self-Reliance" about learning to live above time, like the blade of grass or the blowing rose, we cannot know. But if he did not yet recognize variants of his own images in the "lean and loafe" (he had said "we lie in the lap") or in the "observing a spear of summer grass" (he had offered a "blade of grass," as model for man), he would

not have had to read much farther to sense how close the kinship between himself and this unknown poet was.

Not only in image and symbol but explicitly the poet was dissolving all miracles in the universal miracle, living wholly in the present where eternity is to be found, celebrating the "sanity and authority" of his soul. By the time Emerson had read to the forty-third line—"I and this mystery [the grass] here we stand"—he surely must have known that he was in the presence of a wholly like-minded poet.

In the passage from "Self-Reliance" which I have partially quoted as an epigraph, Emerson had fully stated the assumption that would make it not absurd for this unknown poet to "celebrate" himself. What Emerson puts abstractly, Whitman makes concrete, using himself as the example of one who has had contact with the "divine wisdom." Emerson's words are these:

> The relations of the soul to the divine spirit are so pure that it is
> profane to seek to interpose helps. It must be that when God speaketh he
> should communicate, not one thing, but all things; should fill the world
> with his voice; should scatter forth light, nature, time, souls, from the
> centre of the present thought; and new date and new create the whole.
> Whenever a mind is simple and receives a divine wisdom, old things pass
> away,—means, teachers, texts, temples fall; it lives now, and absorbs past
> and future into the present hour. All things are made sacred by relation to
> it,—one as much as another.

In what would later be numbered as section five of this opening poem in the first *Leaves of Grass* ("I mind how we lay in June," the "mystical experience" section), Whitman relates an instance of one "relation of the soul to the divine spirit." He then interprets the experience as bringing "the peace and joy and knowledge that pass all the art and argument of the earth."

In short, the unnamed poem Emerson read, that would later be called "Walt Whitman" and later still "Song of Myself," begins as a translation into concrete and personal terms of what Emerson has said about how to attain to "self-trust" in several paragraphs of "Self-Reliance." But Emerson, reading the poem, might have recognized not only his own generalizations in concrete rendering. He might have found superior analogues of some of his own images.

For Emerson was not always abstract. The paragraph that opens with "Man is timid and apologetic" continues this way:

> He is ashamed before the blade of grass or the blowing rose. These roses
> under my window make no reference to former roses or to better ones;
> they are for what they are; they exist with God to-day. There is no time to
> them. There is simply the rose; it is perfect in every moment of its

302

existence. Before a leaf-bud has burst, its whole life acts; in the full-blown flower there is no more; in the leafless root there is no less. Its nature is satisfied and it satisfies nature in all moments alike. But man postpones or remembers; he does not live in the present, but with reverted eye laments the past, or, heedless of the riches that surround him, stands on tiptoe to foresee the future. He cannot be happy and strong until he too lives with nature in the present, above time.

In his next paragraph Emerson draws the contrast between those who live in perfect trust in the eternal now like the grass and the rose and those whose knowledge of God is indirect, speculative, and based on the experience of someone else:

> This should be plain enough. Yet see what strong intellects dare not yet hear God himself unless he speak the phraseology of I know not what David, or Jeremiah, or Paul. We shall not always set so great a price on a few texts, on a few lives. We are like children who repeat by rote the sentences of grandames and tutors, and, as they grow older, of the men of talents and character they chance to see,—painfully recollecting the exact words they spoke; afterwards, when they come into the point of view which those had who uttered these sayings, they understand them and are willing to let the words go; for, at any time, they can use words as good when occasion comes. If we live truly, we shall see truly. It is as easy for the strong man to be strong, as it is for the weak to be weak. When we have new perception, we shall gladly disburden the memory of its hoarded treasures as old rubbish. When a man lives with God, his voice shall be as sweet as the murmur of the brook and the rustle of the corn.

Emerson must surely have seen, as he read Whitman's poem, a remarkable parallel between what he had written and what he was reading. For he found himself in the presence of a poet neither postponing nor remembering, claiming to have heard God without citing "the phraseology of . . . Paul," joyfully aware that everything about him was "sacred." He found the poet turning away from those who cite texts and going instead "to the bank by the wood" where he could "become undisguised and naked," like the grass itself or the rose. There, living "with nature in the present, above time," as he had recommended, the man whose verses he was reading claimed to know what the talkers in the rooms could not know:

> I have heard what the talkers were talking. . . . the talk of
> the beginning and the end,
> But I do not talk of the beginning or the end.
>
> There was never any more inception than there is now,
> Nor any more youth or age than there is now;
> And will never be any more perfection than there is now,
> Nor any more heaven or hell than there is now.

Emerson could not have found it surprising that a poet who claimed to know such things as these could turn from past humiliations and present worries as he turned from the "linguists and contenders." He must have found it "fortifying and encouraging" to read a poet who could celebrate himself despite "the sickness of one of my folks—or of myself. . . . or ill-doing. . . . or loss or lack of money. . . . or depressions or exaltations."

The man who had written that in mystical experience, all things are seen as "sacred . . . one as much as another," would not be expected to have difficulty understanding the "drift" of even such "shocking" lines as these:

> Divine am I inside and out, and I make holy whatever
> I touch or am touch'd from;
> The scent of these arm-pits is aroma finer than prayer,
> This head is more than churches or bibles or creeds.

With Emerson too much out of favor during the past half-century or so to be read thoroughly and perceptively by those who write our literary history, and with Whitman scholars thrown off the track, or rendered cautious, by Whitman's own deliberate efforts to obscure the extent of his knowledge of and debt to Emerson, it is perhaps not really surprising that the most important literary relationship in our poetic history has only just now begun to be studied and analyzed in detail. Whitman's emphatic denial, in writing, that he knew Emerson's work before he published the first edition of *Leaves of Grass* has too often been taken at face value.

Whitman was going to hear Emerson lecture and reading the essays for some ten years or so before his own book appeared. He reviewed Emerson and quoted from him in articles he wrote for the newspapers he was working for. He carried the essays in his dinner-pail to read at noon while he was working as a carpenter building houses in Brooklyn. At the end of his life he was still reading and talking about him compulsively with Traubel. After his final visit with Emerson in Concord a few months before Emerson's death, he mystified Traubel by saying that he now knew that Emerson still loved him, that Emerson had given him a sign, but not in words. Now that at last he had achieved independence of the father, he could afford to forgive him everything and love him as he deserved.

The story of the personal relationship of the two men, recently told by Alvin Rosenfeld,[1] confirms the greatness, the magnanimity and openness and intelligence, of them both. It also makes it perfectly clear that Whitman's addressing Emerson as "Master" in his open letter replying to Emerson's wonderful letter of praise was no gesture of merely defer-

ential politeness. It had been literally true, as he was once, much later, to admit, that he had been "simmering" and Emerson had brought him "to a boil."

He would not have needed to know Emerson's essays as well as he did by the time he started to write the poems of his first edition in order to have been brought to a boil. He could have known no more than the essay on "The Poet," for everything he needed was there. This is true not simply because the essay states nearly all the ideas Whitman was later to express in his poetry, or even because the essay recommends that the ideal poet should write in the *manner* of the author of *Leaves of Grass.* It is true because Emerson's idea of what a poet is and does was precisely the idea Whitman needed if he was to move beyond journalism and mediocre versifying.

He needed an idea that would allow him to begin as a poet where he *was*, with all his liabilities and his strength, and yet make it possible for him to move on toward the realization of his ideal self-image. A whole book has been written about "Walt Whitman's pose," showing that he was not the man he said he was. True; but he *became* the man he said he was. Roger Asselineau's title, *The Evolution of a Personality*, in which "evaluation" should receive the chief stress, contains the clue we need both to get beyond discussion of Whitman's pose, or poses, and to begin to see how the man, the ideas, and the work are related.

In "The Poet" Emerson had said that the poet tells us "how it was with him," writing "his autobiography in colossal cipher." One of the reasons we are all better for his confession is that we *all* "study to utter our painful secret." Imaginative utterance of the "secret" is not simply purgative, Emerson stressed, it is creative, for the power of imagination is such that it creates a reality that would not otherwise exist. "The man is only half himself, the other half is his expression"; or, as Whitman would say, "Speech is the twin of my vision." The poet is the representative man; he speaks for *us*. The world is always waiting for its poet to say what has not been said and cannot even be known until the poet says it.

If Emerson was right, the journalist with the "painful secret"—his strong homosexual tendency—could turn his liability into an asset. If isolation was the common lot of man, intensified in the poet as representative man, his own isolation could be seen in a new light. The poet, Emerson had said, "is isolated among his contemporaries, by truth and by his art"; but if he confesses truly what is in him, his confession will serve for us all.

Poetic confession would allow him to translate his uniqueness into universality and at the same time to move toward his ideal of himself, to become that "other half" which was his expression. As Asselineau has

shown, Whitman spent his life creating a self to fit the ideal self-image he announced in verse in 1855. Walter Whitman first imagined a "fictional" character, "Walt Whitman," then devoted himself to becoming that character.

The poetic confession gave the ideal a basis in truth. If the ideal had been announced without confession, if the poet had not been telling us how it *really* was with him, the ideal would have been the mere "pose" it has been called. But Emerson had stressed that the value to us of the poet's confession lies precisely in "the veracity of its report"; only thus, he said, could autobiography become universal symbol and the poet become at once our spokesman and our prophet. Emerson's formula for the poet called for absolute fidelity to fact as the means to a realization of the ideal.

Whitman was to discover that becoming Emerson's kind of poet enabled him finally to be the kind of man he wanted to be, strong, loving, courageous, secure, imperturbable, his feet "tenon'd and mortis'd in granite." Making art out of his life, he was able to make his life a work of art freely created. With so much at stake, he could afford to disregard literary niceties. "Who touches this book touches a man."

But he might also have said, of course, who touches this book touches an artist. For Emerson and Whitman, the man who suffers and the poet who creates are not distinct, as Eliot would later say, but united. The artist in words—the poet—is Man Naming. Naming is both a superior kind of Knowing and a superior kind of Doing. To give a name to a thing is to make it available to us, for the unnamed is the not yet known. The imagination, the gift that distinguishes the Namer from the Knower and the Doer, is thus constitutive of that part of reality that comes to consciousness. The artist is therefore creative in the deepest sense possible: He is man sharing with God or the Over-Soul in the act of creation. Responding to the "divine aura," he discloses a "reality" that for the rest of us did not exist before he named it. The artist is distinguished from other men not essentially by being a better technician in words, a "miglior fabbro" or greater artisan, but by being more of a *man* than most of us manage to be, which, as Emerson explained, means having a greater power both to receive and to impart. Allowing the suppressed to come to consciousness, drawing on "dream-power," and seeing all things freshly, not as the mind categorizes them or society catalogues them but as they are in themselves, he reattaches the parts to the whole, the many to the one, and thus sees, and makes *us* see, all things, even supposedly trivial or ugly things, as beautiful. Doing this, he enables us to grow toward larger circles of being. By the power of his imagination the poet can save us who "on the brink of the waters of life are miserably dying." Saving us, he also saves himself, though he may have to endure the jeers of the

world. He becomes in the end the earth's only true landlord, he for whom the rain falls as Beauty, who finds all conditions opportune, none ignoble.

That Whitman derived his idea of his role as a poet primarily from Emerson will some day I believe be known and accepted, but that was not all he got from Emerson, though of course it would be more than enough. One of the most puzzling lines in "Song of Myself" can give us the clue here. Section forty-six in the Deathbed Edition opens with lines that read like this in the 1855 edition:

> I know I have the best of time and space—and that I
> was never measured, and never will be measured.
> I tramp a perpetual journey,
> My signs are a rain-proof coat and good shoes and a
> staff cut from the woods;
> No friend of mine takes his ease in my chair,
> I have no chair, nor church nor philosophy;
> I lead no man to a dinner-table or library or
> exchange,
> But each man and each woman of you I lead upon a
> knoll,
> My left hand hooks you round the waist,
> My right hand points to landscapes of continents,
> and a plain public road.

Why should a "rain-proof coat" be the first of the "signs" of the true poet? There is no indication in the lines that precede or follow this passage that the poet tramping his perpetual journey is encountering bad weather—that rain is falling on him.

The idea of the poet as *homo viator,* man on the road, is, of course, all through Emerson; it is one of the chief ways, he thought, in which the poet *represents* us. But only in the ending of "The Poet" is the idea expressed in images that combine the metaphor of the *journey* with the metaphor of *rain.* Emerson's peroration to his essay concludes with these remarks on the true poet's reward for all his "renunciations and apprenticeships." I have added the italics.

> ... The world is full of renunciations and apprenticeships, and this is thine; *thou must pass for a fool and a churl* for a long season. This is the screen and sheath in which Pan has protected his well-beloved flower, and *thou shalt be known only to thine own, and they shall console thee with tenderest love.* And thou shalt not be able to rehearse the names of thy friends in thy verse, for *an old shame* before *the holy ideal.* And this is the reward; that the ideal shall be real to thee, and *the impressions of the actual world shall fall like summer rain,* copious, but not troublesome to thy invulnerable essence.

Thou shalt have the whole land for thy park and manor, the sea for thy bath and navigation, without tax and without envy; the woods and the rivers thou shalt own, and thou shalt possess that wherein others are only tenants and boarders. Thou true land-lord! sea-lord! air-lord! Wherever snow falls or water flows or birds fly, wherever day and night meet in twilight, wherever the blue heaven is hung by clouds or sown with stars, wherever are forms with transparent boundaries, wherever are outlets into celestial space, wherever is danger, and awe, and love,—there is *Beauty, plenteous as rain, shed for thee,* and though thou *shouldst walk the world over,* thou shalt not be able to find a condition inopportune or ignoble.

It is not hard to imagine how this passage would have struck Whitman, with his consciousness of his "peculiarity" and his lifelong interest in the "signs" by which friends might know each other. (Emerson had spoken earlier in the essay of the "signs" by which we might know the true poet.) Rain would be a hardship for an ordinary walker on the open road, but for Whitman with his rain-proof coat the hardship would be transformed into "Beauty" and power. An "old shame" could not keep him from knowing that his "essence" was "invulnerable."

The point is that Whitman is thinking of himself in the opening lines of section forty-six as *the* Emersonian poet, not just as a poet who accepts the general outlines of the ideal poet Emerson had described—an ideal widespread of course in the Romantic movement, an ideal that, in its most general outlines, Whitman might have found in a dozen places, or simply have picked up because it was "in the air," was common property. With his special situation, with his sense of his "shame," he could find himself justified, and not only justified, exalted, in the ending of Emerson's "The Poet."

That he undoubtedly read this passage with partially different meanings in mind from those Emerson had meant to express is what we should expect. Just so he seems to have read the "Friendship" essay, with its metaphors that could be read as intended to convey hints of manly love between friends. The point, once again, was that he thought he had found in Emerson not just a sage but a kindred spirit, true friend, a "Camerado" indeed. Late in life he repeatedly told Traubel that he knew Emerson loved him.[2]

So he would follow in detail the friend's directions for becoming a true poet. Hence the catalogues. Hence the "receiving" and "imparting." Hence the "metre-making argument"—the "free verse." Hence the constant "naming." No single prescription by Emerson in "The Poet" for the poet's *manner* of writing is ignored or overlooked in the first edition of *Leaves of Grass.*

But this is another story just now beginning to be studied and understood, another book indeed. For present purposes it will be sufficient to say that what I consider our greatest single critical essay was profoundly

influential on the man who may well be our greatest poet. Along with the other essays by Emerson, it made it possible for Whitman to *become* a poet.

Notes

[1]The fullest discussion of Whitman's debt to Emerson is Alvin Rosenfeld's in the doctoral dissertation ["Emerson and Whitman," Brown University, 1967—Editors]. My treatment of Whitman has been influenced by Rosenfeld's discoveries.

[2]In a long talk with Whitman in 1856, while the two walked on the Boston Common, Emerson urged Whitman to remove the "Calamus" and "Children of Adam" poems from his forthcoming second edition, not because they were "shocking" or "immoral," but because, as he said, in Whitman's account of the meeting, they would certainly interfere with the reception of the work, and he wanted the book to be *read* as widely as possible. He also felt that these poems were not *essential* to what Whitman had to say.

He was, as so often, right, it seems to me. Most readers since then seem to have found these poems simply boring—with one or two exceptions, such as "The Terrible Doubt of Appearances" and "There Was in Louisiana. . . ."

Nevertheless we should, I think, admire Whitman for refusing to accede to Emerson's prudential argument for excluding them.

Walt Whitman
and the American
Tradition

Floyd Stovall

T he American tradition has developed from the persistent belief in three basic concepts: the free individual, the moral law, and progress. The ideas themselves were, of course, of European origin, chiefly English, but their development in America has been powerfully influenced by conditions peculiar to this continent. They seem to be the ground of our faith in what we call American democracy, and they are like iron rails on which we move confidently towards our ideals of the good life. If we leave these guiding rails we lose our way and become lost in a wilderness of uncertainty.

The concept of the free individual had its inception in the Renaissance, which raised him up out of the grave of medievalism, though it professed little knowledge of him. The Enlightenment then put him under the microscope, defined him, and gave him intellectual freedom. In the course of time this free individual discovered himself at the center of the universe and endowed with certain natural rights, the first of which was happiness. He came to believe that all men are equally free and united in fraternal bonds, and that government is a contractual arrangement among sovereign individuals for their mutual protection and convenience. There are no rights in government except those delegated by the individuals to be governed. These ideas were transmitted through the generation of the American Revolution, found permanent expression in the Declaration of Independence, the Constitution, and the Bill of Rights,

Reprinted from *Virginia Quarterly Review*, 31 (Autumn 1955), 540–57. Copyright 1955 by *Virginia Quarterly Review*. Reprinted by permission of *Virginia Quarterly Review*.

and have since become firmly lodged in the popular mind. The stature of the free individual was not reduced, but rather glorified, by the infusion of romantic sentiment and idealism during the late eighteenth and early nineteenth centuries. This heritage of belief in the free individual and his perquisites is the most cherished intellectual possession of what we sometimes refer to as the Free World. Planted in New World soil and nourished by the frontier, this free individual has developed in ways that make him distinctively different from his European cousin.

The second of the basic American concepts, that of the moral law, has its origin in Christian teaching based on supernatural revelation. But the philosophers of the Enlightenment subjected revelation to the test of reason and concluded that morality is based on the intellect. We trace the effects of this school of thinkers on American Unitarianism. Later other philosophers developed a theory of morality based on feeling, and thus prepared the way for humanitarianism, Transcendentalism, and all kinds of reform movements. Two convictions arrived at by eighteenth-century thinkers have had great power over the minds of Americans and have affected their whole way of living. One was the conviction that church and state should be forever kept separate; the other was the conviction that the moral law is not only the law of God but also the law of nature. The separation of church and state has encouraged religious freedom and the multiplication of sects, and the identification of the law of nature with the will of God has seemed to justify the Transcendentalist, as well as other individualists in religion, to look within for evidence of the will of God rather than outside the self.

The third concept, that of progress, grows out of the other two. For if the individual is free to seek the will of God in himself and his happiness depends upon his finding there the moral law, it is of vital importance that his intuition shall not be defective or shallow. Even if he seeks the will of God in the Bible he must, as a true Protestant Christian, interpret the text for himself, or at least take personal responsibility for whatever interpretation he accepts and lives by. He will do well to become an earnest seeker and a diligent self-improver, whether in the manner of Franklin or of Edwards, and to use whatever means he commands to improve the world about him. In short, he must believe in progress or sink to the depths of despair. The direction of the progress he will need to make is towards the identification of his limited individual will with the universal will of God, or, if he prefers to name it so, the law of nature. He will need to find means to harmonize freedom with law, for he has committed himself to belief in both, and eventually to recognize the higher truth that genuine freedom can be found within the law.

The ideal of democracy is the individual who is both a law unto himself and an instrument of the universal law. A society made up of

such individuals might dispense with organized government. Many in the eighteenth century believed in the possibility of such an ideal society, and even in the nineteenth the concept of the perfectible individual must have been the philosophical basis of the American democrat's determination to limit the power of government, though there were also practical reasons growing out of experience with the misuse of governmental power. It is probable that most Americans did not approve or even understand the theory of man's perfectibility, yet they lived as if they believed in it. The great public men of America, though often mutually incompatible, were mostly believers. Franklin and Jefferson, Emerson and Jackson, Whitman and Lincoln, William James and Henry George, Robert Frost and Franklin Roosevelt—these are representative of the large number who had faith in man's power to advance his frontiers perpetually in the spiritual as well as in the material world. There have been plenty of skeptics too—in fact, every one of the men named had his moments of doubt—but until recently skepticism has not been strong enough to stem the tidal wave of confident optimism that has swept irresistibly across the American continent.

This movement has from time to time assumed different aspects. Deism in the eighteenth century helped to break down the defenses of Calvinism, but it gave way in its turn to Unitarianism and Transcendentalism in New England and Ohio, to Evangelicalism in the South and Southwest, and to "isms" of many other kinds here and there throughout the country. On the political front, democratic institutions steadily gained the ascendancy, and the stages of their advances are commemorated by such names as Jefferson, Jackson, Lincoln, Wilson, and Roosevelt. Geographically the advancing wave transformed the continent from wilderness to frontier and from frontier to settled community as if it were indeed the instrument of destiny. But whereas the West developed qualities of self-reliance, expansiveness, efficiency, and sometimes ruthlessness, the comfortably settled communities of the East occasionally drifted into complacency and conventionality. There were in fact timidity, imitativeness, and excessive sentimentality both East and West. Yet it would be a mistake to dwell exclusively on the differences between the regions because the frontier was continually transforming as it was being transformed by the culture of the East, which in turn was similarly related to Europe.

Needless to say, the conquest of a continent was not accomplished without strong manifestations of nationalism. To be sure, nationalism was also growing in Europe, but the struggle of the young nation to establish and maintain itself made the sense of nationality stronger in America. It is not surprising that some arrogance is to be observed in the dealings of the United States, finding itself suddenly powerful, with

neighboring nations less strong and of an alien culture. But the war against Mexico was justified in many minds by the conviction that the United States was destined to be a missionary to the world for the democratic way of life. One of the characteristics of the American nation was, almost from the beginning, a sense of mission, and this was felt by Europeans as well as by Americans. It was an inevitable conclusion of the grand logic of Hegel that Europe as thesis and Asia as antithesis were to be resolved in the synthesis of America. Most Americans were doubtless unaware of Hegel or his philosophy, but it was part of the strength of that philosophy that it seemed to its professors to be unfolding before their eyes in the events of history. It was one symptom of the times, of which the American belief in "manifest destiny" was another.

The spirit of optimism, whether transcendental or not, helped to fuse forces apparently contradictory. Thus for forty years after *The Origin of Species*, Darwinism was accepted by the Hegelians as the biological equivalent of their system. All things evolved: life, human society, even the human soul; and all things were moving towards some grand event, some union of man, nature, and God, which determined cosmic progress in accordance with the eternal laws, moral and natural, of the universe. To state it thus is of course to oversimplify and to forget that for most Americans life was an ordinary affair of toil, and hope, and defeat, and occasional success in the struggle to acquire property and achieve a comfortable security, but it is not to falsify the situation as it might be seen by the philosopher or the poet.

In comparison with its material aggrandizement, the United States was culturally undeveloped. The Revolutionary generation and the one following were too busy with other matters to concern themselves with literature and the arts further than to import as much from Europe as they had immediate need for. But after the struggle with England ended in 1815, pride in nationality and a revulsion against all things English combined to spur Americans to claim and eventually to produce a culture of their own. Their claims, which the *North American Review* was established to defend, were not, even before the Revolution, without some foundation. The colonists had been growing away from the mother nation not only politically and economically, but culturally as well. By 1815 it is certain that there was an American culture just as there was an Irish or a Scotch culture distinct from the English. There was not yet, however, an American literature. If there was an American tradition the literary nationalists were not yet in agreement as to what it was, for then and long afterwards the nation was not culturally united. New England, the Middle Atlantic States, the South, and the West were marked by strong regional differences, and their unification was not accomplished until

writers appeared whose vision was broad enough to encompass the entire nation. Irving, Cooper, Bryant, and Longfellow began the work of unification, but they were only half-hearted nationalists, on whom the hold of Europe was strong if not dominant. Emerson was the first to make something like a clean break in affirming the principle of a genuine and indigenous American culture. Thoreau, Whittier, Lowell, Poe, Hawthorne, and Melville contributed in different degrees to the confirmation or modification of this principle, but its first complete exemplar and advocate was Walt Whitman.

After the Civil War the Genteel Tradition of Longfellow, Holmes, and Lowell was carried on with diminished vigor by Aldrich, Stedman, and their friends; the radical Americanism of Emerson, Thoreau, and Whitman survived, with individual differences, in the work of Howells, Garland, William James, Royce, Robinson, Frost, and Sandburg, outlasting the Genteel Tradition; and the mood of Hawthorne and Melville, with its infusion of world-weariness and doubt, was continued in varying ways by Mark Twain, Henry Adams, and Henry James, and threatened after 1920 to become the dominant note of American literature and criticism. There were minor developments, like the bohemianism of Bierce, Saltus, Huneker, Mencken, and Cabell, the naturalism and Nietzschean complex of Norris, Dreiser, London, and their successors, and the utopian socialism of the 1880's and 1890's, the Communism of the 1930's, and the various esoteric and experimental groups of the twentieth century. Among all these movements and groups there were relationships, whether of affinity or of rebellious divergence, but the American tradition is sufficiently comprehensive to include them all.

At the heart of it is the democratic faith, born of the very struggle to harmonize order and freedom, the state and the individual, and surviving only by reason of the perpetual renewal of this struggle. It would therefore be a narrow and false conception of the American tradition to exclude all dissident elements from its main stream, which, as I have said, flows from the deep fountains of American belief in the free individual, the moral law, and the idea of progress. It would be equally false to assert that the American tradition is completely indigenous. Our culture was endowed from the beginning with a great heritage from the Old World, and it has continued to draw from that rich accumulation. The pull of the past has been a wholesome check on American tendencies to lawless individualism and utilitarian materialism. Our progress has therefore been one of advance and retreat and eventual compromise. One image of the American is that of a youthful dreamer who looks alternately forward with eagerness and backward with regret but only indifferently at the world immediately about him. But there is another very different image,

equally true, of a resolute worker who, like the squatter of the frontier, is perpetually clearing new ground in the fond hope that there he will settle for life.

II

In the development of the American tradition during the last two centuries, Whitman occupies a central position. He was the product of the first half of this period, in which liberal thought advanced from the rationalism of Franklin to the romantic idealism of Emerson, and he was in part the shaper of the second half, in which idealism survived the impact of realism, Darwinism, and materialistic determinism. To reveal the extraordinary importance of Whitman in absorbing and transmitting the American tradition it now becomes necessary to survey briefly his characteristic ideas in their relation to that tradition.

The first and perhaps the most notable of these was his idea of independence. He was an individualist who insisted upon the right to go his own way. This was in part a matter of temperament, but it was also the living up to a principle, for he conceded the same privilege to every other person. He was a child of the Revolution, which in turn was an outgrowth of the Enlightenment. Among Whitman's heroes were the radicals Thomas Paine, Frances Wright, and Elias Hicks, and in his own time he was a friend of Robert Ingersoll. He spoke in defense of Paine in 1877 before the Liberal League of Philadelphia, and he wrote in terms of eulogy of Elias Hicks, the radical Quaker, who had been the friend of his grandfather and whom Whitman himself at the age of ten had heard in an unforgettable sermon. When at seventy he recalled the enthusiasms of his youth, it seemed to him that he had fairly knelt at the feet of Fanny Wright, whose paper, the Free Inquirer, his father subscribed to, and whose picture he treasured to the end of his life. He longed to write at length about her, but he never did. Whitman thought that even Voltaire, though he could never be dear to the memory of man, was in some respects a fit precursor of the American era. He owned a copy of the *Philosophical Dictionary* and was familiar with other writings of Voltaire, as well as with the chief works of Rousseau and some of Volney's. There can be little doubt that his persistent anti-clerical feeling owed something to the French writers of the Enlightenment.

In politics he was, as everybody knows, a follower of the democratic republicanism born of the American Revolution and developed by Jefferson, Jackson, and Lincoln. In his youth he was a Democrat of the radical "Barnburner" faction, became a Free-Soiler about 1848, and voted with the Republican Party from 1864 to 1884, though he did not wholly

endorse its principles. With the advent of Cleveland he returned, it seems, to the Democratic Party. In effect, however, he had ceased after about 1850 to give allegiance to any political party, thus setting a precedent which many thoughtful people have since followed. In the late 1880's, under Traubel's prodding, he was induced to express sympathy for the aims of Henry George and the mild socialism of that time, but he would not advocate any definite means by which those aims might be achieved. One feels that he had then but little genuine interest in politics in general, and that towards Marxian socialism he was cold as he had been cold towards the socialism of Fourier in his youth. He remained from youth to age an individualist at heart, suspicious of governmental authority, yet recognizing the necessity of social organization and cautiously conceding such authority as might be required to conserve individual rights. The poem he chose to set first in his final arrangement of *Leaves of Grass* begins with the lines:

> One's-self I sing, a simple separate person
> Yet utter the word Democratic, the word En-Masse.

The individual and the community were for him the two poles of democracy, between which it maintains an effective but perpetually shifting center of balance. A similar balance is to be maintained between the states and the federal government, and between cities and the state, as we learn in another of his "Inscriptions":

> To the States or any one of them, or any city of the
> States, *Resist much, obey little,*
> Once unquestioning obedience, once fully enslaved,
> Once fully enslaved, no nation, state, city of this
> earth, ever afterward resumes its liberty.

Though Whitman was a child of the Enlightenment and the Revolution, he was nurtured by the Romantic Movement. As a youth he read the sentimental literature of his day, graduating in turn to the novels of Cooper, Scott, Dickens, and George Sand. In the theater he was delighted by the feudal pomp of Shakespeare's historical plays. He was equally pleased by the sweet singing of Mrs. Austin in a musical version of *The Tempest*, by the impressive acting of Junius Brutus Booth in *Richard III*, by the stentorian rhetoric of Edwin Forrest in the Old Bowery, and by the polished art of Fanny Kemble and her father at the Park. A little later, at the opera, he was entranced by the liquid music of Rossini, Donizetti, and Bellini on many an unforgettable evening. Reform movements caught him up, and he wrote a temperance novel in 1842, inveighed against capital punishment, and otherwise attacked man's inhumanity to man. He tried, with indifferent success, poems in the manner of Bryant and

stories in the manner of Poe and Hawthorne. At some time in his youth, possibly as early as 1845, he discovered Emerson and Carlyle, and during the following ten years, as his intellect matured, he developed a transcendentalism of his own that owed much to them and was a great advance over his juvenile romanticisms. Through Carlyle he was introduced to German thought, and through Emerson he was helped to his vision of a national literature as vital as the American people and as broad as the continent they inhabited.

Already, as editor of the *Brooklyn Eagle*, he had deplored American imitativeness and championed nationality in our literature. He did not underestimate the greatness of European literature nor its importance for American readers, but he did asseverate that America requires something different. He said that even the plays of Shakespeare and the novels of Scott, much as he loved them, were contrary to the spirit of American democracy and should not be accepted in lieu of American models. A democratic nation, he insisted, must have a democratic literature. He held to this view throughout his life and expressed it anew in "Democratic Vistas" (1871), in "Collect" (1882), and in "November Boughs" (1888). In music too, though he loved the Italian opera, he advocated as best for America what he called "heart-singing" as distinguished from "art-singing," and he cited by way of illustration the simple yet accomplished singing of the Cheney and Hutchinson families, both popular singing groups in the 1840's. Always he valued the natural and indigenous more than the artificial and the imported work of art. In 1863 he wrote half-seriously in one of his letters to the *New York Times* that he would be sorry to see removed from the Capitol dome in Washington the huge derrick, so symbolic of the constructive spirit of his age and nation, and raised in its place the odd figure in bronze that was called the Genius of America, which looked to him like a combination of a Greek goddess and a Choctaw girl.

In politics Whitman was equally nationalistic in conformity with the expansive spirit of the nineteenth century. It seemed to him that Mexico should recognize the advantage she would derive from becoming one of our own union of free states, and he expected as a matter of course that Cuba and Canada would eventually, on some terms, be incorporated. This expansiveness, perhaps the most characteristic feature of the American national mind in the two decades before the Civil War, became the controlling mood of Whitman's poetry and prose. The poet-hero of *Leaves of Grass* identifies himself at once with the character and with the geography of the United States and in the later poems moves in the direction of world identity. If he does not become an imperialistic hero waving the banner of "Manifest Destiny" it is because he was imbued, like Whitman himself, with the moral sense and the doctrine of natural rights that were the foundation of American democracy.

Whitman was too much a child of the Enlightenment, as I have shown, to succumb to the enthusiasm of the Evangelical movement that swept the country in the years of his youth—and indeed he condemned it for its spirit of intolerance that destroyed the reputation of Thomas Paine— but he shared the Evangelical faith in the power of the individual to establish an effective relationship with God without the intermediation of the institutional church, and he shared the missionary spirit of Evangelicalism. Even in his newspaper prose of the early 1840's, in which he often wrote with conventional piety, it is clear that his sentiments were grounded in genuine morality and a religion of the heart rather than of the head. His conception of Jesus was that of a good man and a loving comrade, a man of sufferings and charities, not a giver of commandments and prohibitions. Of course he rejected the theology and the ascetic morality of the Evangelical churches. In his talk with Traubel in 1889 he assented to Traubel's suggestion that in a world where Christians were rare, Tolstoy might be called one; yet he disliked Tolstoy's "ascetic side" as a reversion to medievalism. Though Christ was patient and tender, he was not a denier, and in "Song of Myself" the image of Christ as a sufferer and affirmer is unmistakable. Christ dies, but he also rises from the grave, and having done so he becomes the teacher of men. What he teaches, as reported by Whitman, is the immensity and immortality of the soul, forever fed yet never filled, and forever dying yet never dead.

In the identification of himself with Christ through a common experience, the hero-poet of *Leaves of Grass* does not lose his individuality. Some critics, citing Whitman's statement that he sometimes felt himself as two and noting the frequent occurrence of such duality in his poems, have concluded that he had an abnormally divided personality and was at war with himself. I think, on the contrary, that Whitman has merely accentuated in his hero a condition that exists in every individual. The sense of duality is merely a recognition of man's finite and infinite selves and of his consciousness of being both subject and object, the knower and the thing known. In short, it is simply the phenomenon of self-consciousness. When the knower looks into himself he may at rare moments have glimpses of a being more profound than he can compass, and this being, this "deep heart," as Emerson called it, is the infinite self that feeds his spirit from an inexhaustible fountain. Explain such an experience as you will—in terms of mysticism or in terms of imagination—it is equally close to the source of all poetry and all religion.

Of course this is Transcendentalism, but it is also akin to Evangelical religion as it was experienced in America. The mystery of conversion, the trance, the sense of purification and salvation, the consciousness of dying out of sin and being reborn to life and power—all these accompaniments of the revival meeting were implicit in the experience of Whitman's hero-poet. It is true that the repentance of the revival-meeting

convert did not always prove enduring; backsliding was all too common. But there is evidence of backsliding in Whitman's hero and his followers, and the devil is just as wily in *Leaves of Grass* as in any wavering human heart. "I know the sea of torment, doubt, despair and unbelief," the hero-poet confesses; "I take my place among you as much as among any." There is no unpardonable sin in these poems, but there is evil enough with its attendant torment. The development of the hero-poet from "Song of Myself" through "Passage to India" is that of a passionate and rebellious yet essentially religious person whose soul is purged by its own fires and stands at last tranquil and free.

This may be also, in general, the development of Whitman himself. Yet the critic must beware of the temptation to interpret *Leaves of Grass* as autobiography. The hero-poet is a mythical person and is no more identifiable with Whitman himself than with the American people, or even the human race. The end of the journey visualized in "Passage to India" is certainly not accomplished in his personal life, though doubtless he has come nearer the goal than most persons; otherwise he could not describe it so well. Even so we must give most of the credit to the poet's imagination. It is the passage of the soul from the dominant sense of physical life to the dominant sense of physical death. When the sense of life is strong, the spirit must content itself with mere moments of vision and freedom, but as the sense of death becomes dominant, the spirit sees more steadily and is less constrained. It is Christian's pilgrimage to the Celestial City seen not as Bunyan saw it but in the light of modern science and evolution. The journey image occurs in many of Whitman's poems, in some where it is not recognized at once. In "When Lilacs Last in the Dooryard Bloom'd" it is suggested in the fact that the poet-hero hears the hermit thrush singing its song of death from the beginning of the poem but he is only gradually drawn to it away from the powerful hold of the symbolic star of life.

In other terms, the journey theme is one from chaos to form, from diversity to unity, from freedom to law, and it is readily discernible in Whitman's increasing attention to poetic form in *Leaves of Grass* from 1855 to 1868. If there is a relapse in the later poems to the formlessness of some of the earlier ones, it proves merely that Whitman's power of execution, particularly after his paralysis, was inferior to his power of conception. It is also evident in the increasing certainty with which he foresees the triumph of man through the moral law. In "Thou Mother with Thy Equal Brood" (1872) he foresees in a successful American democratic nationality the confirmation of man's faith in himself:

> Scattering for good the cloud that hung so long, that
> weigh'd so long upon the mind of man,

> The doubt, suspicion, dread, of gradual, certain
> decadence of man.

A little later in the same poem he images Ensemble, Evolution, and Freedom as three stars set in the sky of Law. Here Law may be interpreted as the rule of God, embracing both the moral law and natural law as converging tendencies, whereas the three stars are the three terms of the Hegelian formula, Ensemble (or community) being the thesis, Freedom (or individual entity) the antithesis, and Evolution (or compromise) the synthesis. Something like the same scheme had been earlier indicated in the poem of cosmic order, "Chanting the Square Deific." This faith in the eventual triumph of law without denying freedom, expressed often in Whitman's prose as well as in his poetry, is a fundamental condition of the success of American democracy.

These are poetic illustrations of the American conception of progress. The will of God, whether it operates as natural law, as moral law, or by direct intervention, must prevail in the end. Man, as distinguished from nature, is a free moral agent, but his freedom is provided for by the will of God in the fundamental law that governs the universe. In human affairs progress is possible only through the interaction of man's free will and a previously established, though not an unchangeable, order. Many people who cannot accept the reasoning that attempts to justify this theory of progress nevertheless conduct their lives as if they accepted it.

Man is, more than other creatures, attended by the twin sisters, Memory and Hope, and he cannot exist as a human being without them. He is perpetually scanning the backward vista, and when he turns his eyes to the future he sees a similar pattern, only the images are less distinct, and if his mind is healthy they tend to be more agreeable. In proportion as a man's dreams advance beyond his interpretation of history does he believe in progress. What James Truslow Adams has called the "American Dream" is an eloquent testimonial to Western man's belief in progress. Among our literary men the dream is best told by Emerson and Whitman, and of the two, Whitman's version is the more positive and substantial. "Allons!" he cries, "after the great Companions, and to belong to them!" But progress is not an uninterrupted advance. It depends on memory as well as on hope. The end pre-exists in the means. As we are told in "Song of Myself,"

> Every condition promulges not only itself, it promulges
> what grows after and out of itself,
>
> And the dark hush promulges as much as any.

In other words, death grows out of life, and life is implicit in death, just as the future grows out of the past and will in turn become the past to

some other future. Earth's words, he writes in "A Song of the Rolling Earth," are motion and reflection. The ocean of life ebbs, but the flow will return. Asia that for centuries had been in eclipse was reviving in Whitman's day, and he foresaw that she would have much to teach America in the future. In "Going Somewhere," a memorial poem to his friend Mrs. Gilchrist, he wrote:

> The world, the race, the soul—in space and time
> the universes,
> All bound as is befitting each—all surely going
> somewhere.

And he made it clear that the going is towards something better, that evolution is progressive.

I have said that the American tradition, growing out of European culture and clinging to it even while opposing it, developed from the Enlightenment, through several phases of romanticism, through wars, through bohemianism, materialism, realism, naturalism, and various experimental movements, to the present age of spiritual crisis and hopeful skepticism. I have indicated that Whitman was a product of this development up to about the middle of the nineteenth century, the period of waning romanticism. I should now like to suggest that he was also in the main stream of the tradition in the second half of that century, and that he helped to prepare the way for its development in the twentieth century.

The bohemianism of *Leaves of Grass* in the editions of 1855, 1856, and 1860 is sometimes thought to be a truer expression of Whitman's real personality than the spiritual poems of later years. This is certainly not the case; it is but one of many phases of the character of Whitman's hero. It was, I believe, in some degree the reflection of the influence of Henry Clapp and his bohemian friends who made the *Saturday Press*, according to Howells, for a while the rival in importance to the *Atlantic Monthly* among the younger literary men. They were in rebellion against conventionality. Howells said that "if respectability was your *bête noire*, then you were a bohemian." Whitman's open letter to Emerson in the 1856 edition of *Leaves of Grass* probably offended Emerson because it seemed to confuse his radicalism with that of the bohemians.

It is not always easy to separate the bohemian from the revolutionary, the anti-clerical, the Jacksonian, the transcendental, and the realistic phases of Whitman's personality, for all were no doubt genuine. The error most to be avoided is that of identifying the poet with any one or two to the exclusion of the rest. Each has won friends for him, and these friends, less ample in their sympathies than he, have occasionally tried to impose their own boundaries on him. Emerson was the first and the greatest of

those who, for a while at least, saw Whitman in their own image. He took him to be a Transcendentalist, and when Whitman flaunted his bohemianism Emerson could not conceal his disappointment. Later John Addington Symonds thought he saw in *Leaves of Grass* an expression of homosexuality akin to that of ancient Greece, and others, for one reason or another, have emphasized this aspect of the poems, particularly as it appears in the "Calamus" group, and made it the key not only to the poems but to the personality of Whitman himself. Dr. Bucke, a psychologist, was confident that Whitman possessed what he called "cosmic consciousness." Being also a mystic, Dr. Bucke further believed that *Leaves of Grass* would prove to be the bible of a new religion. William O'Connor, an enthusiast, was most happy when leading a crusade in defense of the "Good Gray Poet." During the 1930's Marxian critics thought they found in his work support for Communistic ideals. Modern experimenters in new verse forms have been encouraged by *Leaves of Grass,* and writers of naturalistic fiction have seemed to find comfort in him, though he was not in sympathy with their pessimistic interpretations of life nor their predilection for characters with criminal or diseased minds. His own realism was akin to that of Howells. He told Garland in 1888 that writers should introduce evil only as a foil for good, as Shakespeare did. "Somewhere in your play or novel," he counseled, "let the sunlight in."

It must be admitted that opponents of democracy and those who deny the existence of an American culture independent of European culture have never claimed Whitman as an authority. Yet there are passages in Whitman's work which, removed from their context, might be cited by them with some effect, for he was in no sense either a political or a cultural isolationist. He believed passionately in the American political union, and he dreamed of the brotherhood of man throughout the world. Probably he would have approved a limited form of union among the nations if it had been proposed in his lifetime, but he would undoubtedly have shied away from the theory of a world state. He believed vigorously in the necessity of creating a distinctive American culture with its own characteristic literature, art, and social institutions, and he sharply reproved any and all who were content to follow European patterns. But he did not reject Europe nor minimize the value for Americans of its culture. He would not have agreed with the line in a poem by Carl Sandburg that calls the past a bucket of ashes, nor with Henry Ford's alleged declaration that history is the bunk. Did Whitman not say in the 1855 Preface that America "does not repel the past," and did he not in "Passage to India" ask, "For what is the present after all but a growth out of the past?" He was not blind to the imperfections of democracy. He knew the seamy side of life, such as a journalist may see in great cities, and he did not like it. He recognized the wolf, the snake, and the

hog in human nature; but he also recognized the divinity. It is the fashion in some quarters now to cite the earlier pages of "Democratic Vistas" in support of contemporary pessimism and anti-democratic sentiments, but it is not honest to do so without calling attention to the other and larger part of the essay which supports democracy. In spite of its imperfections, he concludes that "the democratic formula is the only safe and preservative one for coming times." And this is so because "it alone can bind, and ever seeks to bind, all nations, all men, of however various and distant lands, into a brotherhood, a family."

This then is Whitman's faith, as it is likewise the democratic faith, the seed and the fruit of the American tradition: that man is born to be free, that the only true freedom is freedom under the law, and that he will attain to it only when he becomes a law unto himself through moral perfection.

An Analysis of "Song of Myself"

Malcolm Cowley

F... irst statement: that the long opening poem, later mis-called "Song of Myself," is Whitman's greatest work, perhaps his one completely realized work, and one of the great poems of modern times. Second, that the other eleven poems of the first edition are not on the same level of realization, but nevertheless are examples of Whitman's freshest and boldest style. At least four of them—their titles in the Death-bed edition are "To Think of Time," "The Sleepers," "I Sing the Body Electric," and "There Was a Child Went Forth"—belong in any selection of his best poems. Third, that the text of the first edition is the purest text for "Song of Myself," since many of the later corrections were also corruptions of the style and concealments of the original meaning. Fourth, that it is likewise the best text for most of the other eleven poems, but especially for "The Sleepers"—that fantasia of the unconscious—and "I Sing the Body Electric." And a final statement: that the first edition is a unified work, unlike any later edition, that it gives us a different picture of Whitman's achievement, and that—considering its very small circulation through the years—it might be called the buried masterpiece of American writing.

All that remains is to document some of these statements, not point by point, but chiefly in relation to "Song of Myself."

II

One reason among others why "Song of Myself" has been widely mis-prized and misinterpreted, especially by scholars, is that they have paid a disproportionate share of attention to its sources in contemporary cul-

Reprinted from *Leaves of Grass* by Walt Whitman. Introduction by Malcolm Cowley, copyright 1959 by the Viking Press Inc. Reprinted by permission of Viking Penguin Inc.

ture. Besides noting many parallels with Emerson, they have found that it reflected a number of popular works and spectacles. Among these are Italian opera (notably as sung at the Astor Place Theatre in the great season of 1852–1853, when "Alboni's great self" paid her long and only visit to New York); George Sand's novel, *The Countess of Rudolstadt*, which presented the figure of a wandering bard and prophet (as well as another of her novels, *The Journeyman Joiner*, in which the hero was a carpenter and a proletarian saint); Frances Wright's then famous defense of Epicurean philosophy, *A Few Days in Athens*; the Count de Volney's *Ruins*, predicting the final union of all religions; Dr. Abbott's Egyptian Museum, on Broadway; O. M. Mitchel's book, *A Course of Six Lectures on Astronomy*, as well as other writings on the subject; and a number of essays clipped from the English quarterly reviews, of which the poet seems to have been a faithful reader. All these works and shows had a discernible influence on Whitman, but when they are listed with others and discussed at length they lead to one of the misconceptions that are the professional weakness of scholars. They tempt us to conclude that "Song of Myself" was merely a journalist's report, inspired but uneven, of popular culture in the 1850s. It was something more than that, and something vastly different from any of its literary sources.

I might suggest that the real nature of the poem becomes clearer when it is considered in relation to quite another list of works, even though Whitman had probably read none of them in 1855. Most of them he could not have read, because they were not yet written, or not published, or not translated into English. That other list might include the *Bhagavad-Gita*, the *Upanishads*, Christopher Smart's long crazy inspired poem *Jubilate Agno*, Blake's prophetic books (not forgetting *The Marriage of Heaven and Hell*), Rimbaud's *Illuminations*, *The Chants of Maldoror*, and Nietzsche's *Thus Spake Zarathustra*, as well as *The Gospel of Sri Ramakrishna* and a compendious handbook, *The Philosophies of India*, by Heinrich Zimmer (New York, 1951). I am offering what might seem to be a curious list of titles, but its double purpose is easy to explain. "Song of Myself" should be judged, I think, as one of the great inspired (and sometimes insane) prophetic works that have appeared at intervals in the Western world, like *Jubilate Agno* (which is written in a biblical style sometimes suggesting Whitman's), like the *Illuminations*, like *Thus Spake Zarathustra*. But the system of doctrine suggested by the poem is more Eastern than Western, it includes notions like metempsychosis and karma, and it might almost be one of those *Philosophies of India* that Zimmer expounds at length.

What is extraordinary about this Eastern element is that Whitman, when he was writing the poems of the first edition, seems to have known little or nothing about Indian philosophy. It is more than doubtful that

326

he had even read the *Bhagavad-Gita,* one of the few Indian works then available in translation. He does not refer to it in his notebooks of the early 1850s, where he mentions most of the books he was poring over. A year after the first edition was published, Thoreau went to see him in Brooklyn and told him that *Leaves of Grass* was "Wonderfully like the Orientals." Had Whitman read them? he asked. The poet answered, "No: tell me about them." He seems to have taken advantage of Thoreau's reading list, since words from the Sanskrit (notably "Maya" and "sudra") are used correctly in some of the poems written after 1858. They do not appear in "Song of Myself," in spite of the recognizably Indian ideas expressed in the poem, and I would hazard the guess that the ideas are not of literary derivation. It is true that they were vaguely in the air of the time and that Whitman may have breathed them in from the Transcendentalists or even from some of the English quarterly reviewers. It also seems possible, however, that he reinvented them for himself, after an experience similar to the one for which the Sanskrit word is samadhi, or absorption.

What it must have been was a mystical experience in the proper sense of the term. Dr. Richard Maurice Bucke, the most acute of Whitman's immediate disciples, believed that it took place on a June morning in 1853 or 1854. He also believed that it was repeated on other occasions, but neither these nor the original experience can be dated from Whitman's papers. On the other hand, his notebooks and manuscripts of the early 1850s are full of sidelong references to such an experience, and they suggest that it was essentially the same as the illuminations or ecstasies of earlier bards and prophets. Such ecstasies consist in a rapt feeling of union or identity with God (or the Soul, or Mankind, or the Cosmos), a sense of ineffable joy leading to the conviction that the seer has been released from the limitations of space and time and has been granted a direct vision of truths impossible to express. As Whitman says in the famous fifth chant of "Song of Myself":

Swiftly arose and spread around me the peace and joy and
 knowledge that pass all the art and argument of the earth;
And I know that the hand of God is the elderhand of my own,
And I know that the spirit of God is the eldest brother of my own,
And that all the men ever born are also my brothers . . . and the
 women my sisters and lovers.

It is to be noted that there is no argument about the real occurrence of such ecstasies. They have been reported, sometimes in sharp detail, by men and women of many different nations, at many historical periods, and each report seems to bear a family resemblance to the others. Part of the resemblance is a feeling universally expressed by mystics that they

327

have acquired a special sort of knowledge not learned from others, but directly revealed to the inner eye. This supposed knowledge has given independent rise to many systems of philosophy or cosmology, once again in many different cultures, and once again there is or should be no argument about one feature of almost all the systems or bodies of teaching: that they too have a family resemblance, like the experiences on which they are based. Indeed, they hold so many principles in common that it is possible for Aldous Huxley and others to group them all together as "the perennial philosophy."

The arguments, which will never end, are first about the nature of the mystical state—is it a form of self-hypnosis, is it a pathological condition to be induced by fasting, vigils, drugs, and other means of abusing the physical organism, or is it, as Whitman believed, the result of superabundant health and energy?—and then about the source and value of the philosophical notions to which it gives rise. Do these merely express the unconscious desires of the individual, and chiefly his sexual desires? Or, as Jungian psychologists like to suggest, are they derived from a racial or universally human unconscious? Are they revelations or hallucinations? Are they supreme doctrines, or are they heretical, false, and even satanic? They belong in the orthodox tradition of Indian philosophy. In Western Christianity, as also in Mohammedanism, the pure and self-consistent forms of mysticism are usually regarded as heresies, with the result that several of the medieval mystics were burned at the stake (though Theresa of Avila and John of the Cross found an orthodox interpretation for their visions and became saints).

Whitman cannot be called a Christian heretic, for the simple reason that he was not a Christian at any stage of his career, early or late. In some of the poems written after the Civil War, and in revisions of older poems made at the same time, he approached the Christian notion of a personal God, whom he invoked as the Elder Brother or the great Camerado. But then he insisted—in another poem of the same period, "Chanting the Square Deific"—that God was not a trinity but a quaternity, and that one of his faces was the "sudra face" of Satan. In "Song of Myself" as originally written, God is neither a person nor, in the strict sense, even a being; God is an abstract principle of energy that is manifested in every living creature, as well as in "the grass that grows wherever the land is and the water is." In some ways this God of the first edition resembles Emerson's Oversoul, but he seems much closer to the Brahman of the *Upanishads,* the absolute, unchanging, all-enfolding Consciousness, the Divine Ground from which all things emanate and to which all living things may hope to return. And this Divine Ground is by no means the only conception that Whitman shared with Indian philosophers, in the days when he was writing "Song of Myself."

III

The poem is hardly at all concerned with American nationalism, political democracy, contemporary progress, or other social themes that are commonly associated with Whitman's work. The "incomparable things" that Emerson found in it are philosophical and religious principles. Its subject is a state of illumination induced by two (or three) separate moments of ecstasy. In more or less narrative sequence it describes those moments, their sequels in life, and the doctrines to which they give rise. The doctrines are not expounded by logical steps or supported by arguments; instead they are presented dramatically, that is, as the new convictions of a hero, and they are revealed by successive unfoldings of his states of mind.

The hero as pictured in the frontispiece—this hero named "I" or "Walt Whitman" in the text—should not be confused with the Whitman of daily life. He is, as I said, a dramatized or idealized figure, and he is put forward as a representative American workingman, but one who prefers to loaf and invite his soul. Thus, he is rough, sunburned, bearded; he cocks his hat as he pleases, indoors or out; but in the text of the first edition he has no local or family background, and he is deprived of strictly individual characteristics, with the exception of curiosity, boastfulness, and an abnormally developed sense of touch. His really distinguishing feature is that he has been granted a vision, as a result of which he has realized the potentialities latent in every American and indeed, he says, in every living person, even "the brutish koboo, called the ordure of humanity." This dramatization of the hero makes it possible for the living Whitman to exalt him—as he would not have ventured, at the time, to exalt himself—but also to poke mild fun at the hero for his gab and loitering, for his tall talk or "omnivorous words," and for sounding his barbaric yawp over the roofs of the world. The religious feeling in "Song of Myself" is counterpoised by a humor that takes the form of slangy and mischievous impudence or drawling Yankee self-ridicule.

There has been a good deal of discussion about the structure of the poem. In spite of revealing analyses made by a few Whitman scholars, notably Carl F. Strauch and James E. Miller, Jr., a feeling still seems to prevail that it has no structure properly speaking; that it is inspired but uneven, repetitive, and especially weak in its transitions from one theme to another. I suspect that much of this feeling may be due to Whitman's later changes in the text, including his arbitrary scheme, first introduced in the 1867 edition, of dividing the poem into fifty-two numbered paragraphs or chants. One is tempted to read the chants as if they were separate poems, thus overlooking the unity and flow of the work as a whole. It may also be, however, that most of the scholars have been

329

looking for a geometrical pattern, such as can be found and diagramed in some of the later poems. If there is no such pattern in "Song of Myself," that is because the poem was written on a different principle, one much closer to the spirit of the Symbolists or even the Surrealists.

The true structure of the poem is not primarily logical but psychological, and is not a geometrical figure but a musical progression. As music "Song of Myself" is not a symphony with contrasting movements, nor is it an operatic work like "Out of the Cradle Endlessly Rocking," with an overture, arias, recitatives, and a finale. It comes closer to being a rhapsody or tone poem, one that modulates from theme to theme, often changing in key and tempo, falling into reveries and rising toward moments of climax, but always preserving its unity of feeling as it moves onward in a wavelike flow. It is a poem that bears the marks of having been conceived as a whole and written in one prolonged burst of inspiration, but its unity is also the result of conscious art, as can be seen from Whitman's corrections in the early manuscripts. He did not recognize all the bad lines, some of which survive in the printed text, but there is no line in the first edition that seems false to a single prevailing tone. There are passages weaker than others, but none without a place in the general scheme. The repetitions are always musical variations and amplifications. Some of the transitions seem abrupt when the poem is read as if it were an essay, but Whitman was not working in terms of "therefore" and "however." He preferred to let one image suggest another image, which in turn suggests a new statement of mood or doctrine. His themes modulate into one another by pure association, as in a waking dream, with the result that all his transitions seem instinctively right.

In spite of these oneiric elements, the form of the poem is something more than a forward movement in rising and subsiding waves of emotion. There is also a firm narrative structure, one that becomes easier to grasp when we start by dividing the poem into a number of parts or sequences. I think there are nine of these, but the exact number is not important; another critic might say there were seven (as Professor Miller does), or eight or ten. Some of the transitions are gradual, and in such cases it is hard to determine the exact line that ends one sequence and starts another. The essential point is that the parts, however defined, follow one another in irreversible order, like the beginning, middle, and end of any good narrative. My own outline, not necessarily final, would run as follows:

First sequence (chants 1–4): the poet or hero introduced to his audience. Leaning and loafing at his ease, "observing a spear of summer grass," he presents himself as a man who lives outdoors and worships his own naked body, not the least part of which is vile. He is also in love with his deeper self or soul, but explains that it is not to be confused

with his mere personality. His joyful contentment can be shared by you, the listener, "For every atom belonging to me as good belongs to you."

Second sequence (chant 5): the ecstasy. This consists in the rapt union of the poet and his soul, and it is described—figuratively, on the present occasion—in terms of sexual union. The poet now has a sense of loving brotherhood with God and with all mankind. His eyes being truly open for the first time, he sees that even the humblest objects contain the infinite universe—

And limitless are leaves stiff or drooping in the fields,
And brown ants in little wells beneath them,
And mossy scabs of the wormfence, and heaped stones, and elder
 and mullen and pokeweed.

Third sequence (chants 6–19): the grass. Chant 6 starts with one of Whitman's brilliant transitions. A child comes with both hands full of those same leaves from the fields. "What is the grass?" the child asks— and suddenly we are presented with the central image of the poem, that is, the grass as symbolizing the miracle of common things and the divinity (which implies both the equality and the immortality) of ordinary persons. During the remainder of the sequence, the poet observes men and women—and animals too—at their daily occupations. He is part of this life, he says, and even his thoughts are those of all men in all ages and lands. There are two things to be noted about the sequence, which contains some of Whitman's freshest lyrics. First, the people with a few exceptions (such as the trapper and his bride) are those whom Whitman has known all his life, while the scenes described at length are Manhattan streets and Long Island beaches or countryside. Second, the poet merely roams, watches, and listens, like a sort of Tiresias. The keynote of the sequence—as Professor Strauch was the first to explain—is the two words "I observe."

Fourth sequence (chants 20–25): the poet in person. "Hankering, gross, mystical, nude," he venerates himself as august and immortal, but so, he says, is everyone else. He is the poet of the body and of the soul, of night, earth, and sea, and of vice and feebleness as well as virtue, so that "many long dumb voices" speak through his lips, including those of slaves, prostitutes, even beetles rolling balls of dung. All life to him is such a miracle of beauty that the sunrise would kill him if he could not find expression for it—"If I could not now and always send sunrise out of me." The sequence ends with a dialogue between the poet and his power of speech, during which the poet insists that his deeper self—"the best I am"—is beyond expression.

Fifth sequence (chants 26–29): ecstasy through the senses. Beginning with chant 26, the poem sets out in a new direction. The poet decides

to be completely passive: "I think I will do nothing for a long time but listen." What he hears at first are quiet familiar sounds like the gossip of flames on the hearth and the bustle of growing wheat; but the sounds rise quickly to a higher pitch, becoming the matchless voice of a trained soprano, and he is plunged into an ecstasy of hearing, or rather of Being. Then he starts over again, still passively, with the sense of touch, and finds himself rising to the ecstasy of sexual union. This time the union is actual, not figurative, as can be seen from the much longer version of chant 29 preserved in an early notebook.

Sixth sequence (chants 30–38): the power of identification. After his first ecstasy, as presented in chant 5, the poet had acquired a sort of microscopic vision that enabled him to find infinite wonders in the smallest and most familiar things. The second ecstasy (or pair of ecstasies) has an entirely different effect, conferring as it does a sort of vision that is both telescopic and spiritual. The poet sees far into space and time; "afoot with my vision" he ranges over the continent and goes speeding through the heavens among tailed meteors. His secret is the power of identification. Since everything emanates from the universal soul, and since his own soul is of the same essence, he can identify himself with every object and with every person living or dead, heroic or criminal. Thus, he is massacred with the Texans at Goliad, he fights on the *Bonhomme Richard*, he dies on the cross, and he rises again as "one of an average unending procession." Whereas the keynote of the third sequence was "I observe," here it becomes "I am"—"I am a free companion"—"My voice is the wife's voice, the screech by the rail of the stairs"—"I am the man. . . . I suffered. . . . I was there."

Seventh sequence (chants 39–41): the superman. When Indian sages emerge from the state of samadhi or absorption, they often have the feeling of being omnipotent. It is so with the poet, who now feels gifted with superhuman powers. He is the universally beloved Answerer (chant 39), then the Healer, raising men from their deathbeds (40), and then the Prophet (41) of a new religion that outbids "the old cautious hucksters" by announcing that men are divine and will eventually be gods.

Eighth sequence (chants 42–50): the sermon. "A call in the midst of the crowd" is the poet's voice, "orotund sweeping and final." He is about to offer a statement of the doctrines implied by the narrative (but note that his statement comes at the right point psychologically and plays its part in the narrative sequence). As strangers listen, he proclaims that society is full of injustice, but that the reality beneath it is deathless persons (chant 42); that he accepts and practices all religions, but looks beyond them to "what is untried and afterward" (43); that he and his listeners are the fruit of ages, and the seed of untold ages to be (44); that our final goal is appointed: "God will be there and wait till we come"

(45); that he tramps a perpetual journey and longs for companions, to whom he will reveal a new world by washing the gum from their eyes—but each must then continue the journey alone (46); that he is the teacher of men who work in the open air (47); that he is not curious about God, but sees God everywhere, at every moment (48); that we shall all be reborn in different forms ("No doubt I have died myself ten thousand times before"); and that the evil in the world is like moonlight, a mere reflection of the sun (49). The end of the sermon (chant 50) is the hardest passage to interpret in the whole poem. I think, though I cannot be certain, that the poet is harking back to the period after one of his ten thousand deaths, when he slept and slept long before his next awakening. He seems to remember vague shapes, and he beseeches these Outlines, as he calls them, to let him reveal the "word unsaid." Then turning back to his audience, "It is not chaos or death," he says. "It is form and union and plan. . . . it is eternal life. . . . it is happiness."

Ninth sequence (chants 51–52): the poet's farewell. Having finished his sermon, the poet gets ready to depart, that is, to die and wait for another incarnation or "fold of the future," while still inviting others to follow. At the beginning of the poem he had been leaning and loafing at ease in the summer grass. Now, having rounded the circle, he bequeaths himself to the dirt "to grow from the grass I love." I do not see how any careful reader, unless blinded with preconceptions, could overlook the unity of the poem in tone and image and direction.

IV

It is in the eighth sequence, which is a sermon, that Whitman gives us most of the doctrines suggested by his mystical experience, but they are also implied in the rest of the poem and indeed in the whole text of the first edition. Almost always he expresses them in the figurative and paradoxical language that prophets have used from the beginning. Now I should like to state them explicitly, even at the cost of some repetition.

Whitman believed when he was writing "Song of Myself"—and at later periods too, but with many changes in emphasis—that there is a distinction between one's mere personality and the deeper Self (or between ego and soul). He believed that the Self (or atman, to use a Sanskrit word) is of the same essence as the universal spirit (though he did not quite say it *is* the universal spirit, as Indian philosophers do in the phrase "Atman is Brahman"). He believed that true knowledge is to be acquired not through the senses or the intellect, but through union with the Self. At such moments of union (or "merge," as Whitman called it) the gum is washed from one's eyes (that is his own phrase), and one can read an

infinite lesson in common things, discovering that a mouse, for example, "is miracle enough to stagger sextillions of infidels." This true knowledge is available to every man and woman, since each conceals a divine Self. Moreover, the divinity of all implies the perfect equality of all, the immortality of all, and the universal duty of loving one another.

Immortality for Whitman took the form of metempsychosis, and he believed that every individual will be reborn, usually but not always in a higher form. He had also worked out for himself something approaching the Indian notion of karma, which is the doctrine that actions performed during one incarnation determine the nature and fate of the individual during his next incarnation; the doctrine is emphatically if somewhat unclearly stated in a passage of his prose introduction that was later rewritten as a poem, "Song of Prudence." By means of metempsychosis and karma, we are all involved in a process of spiritual evolution that might be compared to natural evolution. Even the latter process, however, was not regarded by Whitman as strictly natural or material. He believed that animals have a rudimentary sort of soul ("They bring me tokens of myself"), and he hinted or surmised, without directly saying, that rocks, trees, and planets possess an identity, or "eidólon," that persists as they rise to higher states of being. The double process of evolution, natural and spiritual, can be traced for ages into the past, and he believed that it will continue for ages beyond ages. Still, it is not an eternal process, since it has an ultimate goal, which appears to be the reabsorption of all things into the Divine Ground.

Most of Whitman's doctrines, though by no means all of them, belong to the mainstream of Indian philosophy. In some respects he went against the stream. Unlike most of the Indian sages, for example, he was not a thoroughgoing idealist. He did not believe that the whole world of the senses, of desires, of birth and death, was only maya, illusion, nor did he hold that it was a sort of purgatory; instead he praised the world as real and joyful. He did not despise the body, but proclaimed that it was as miraculous as the soul. He was too good a citizen of the nineteenth century to surrender his faith in material progress as the necessary counterpart of spiritual progress. Although he yearned for ecstatic union with the soul or Oversoul, he did not try to achieve it by subjugating the senses, as advised by yogis and Buddhists alike; on the contrary, he thought the "merge" could also be achieved (as in chants 26–29) by a total surrender to the senses. These are important differences, but it must be remembered that Indian philosophy or theology is not such a unified structure as it appears to us from a distance. Whitman might have found Indian sages or gurus and even whole sects that agreed with one or another of his heterodoxies (perhaps excepting his belief in material progress). One is tempted to say that instead of being a Christian heretic, he was an Indian rebel and sectarian.

Sometimes he seems to be a Mahayana Buddhist, promising nirvana for all after countless reincarnations, and also sharing the belief of some Mahayana sects that the sexual act can serve as one of the sacraments. At other times he might be an older brother of Sri Ramakrishna (1836–1886), the nineteenth-century apostle of Tantric Brahmanism and of joyous affirmation. Although this priest of Kali, the Mother Goddess, refused to learn English, one finds him delivering some of Whitman's messages in—what is more surprising—the same tone of voice. Read, for example, this fairly typical passage from *The Gospel of Sri Ramakrishna*, while remembering that "Consciousness" is to be taken here as a synonym for Divinity:

> The Divine Mother revealed to me in the Kali temple that it was She who had become everything. She showed me that everything was full of Consciousness. The Image was Consciousness, the altar was Consciousness, the water-vessels were Consciousness, the doorsill was Consciousness, the marble floor was Consciousness—all was Consciousness. . . . I saw a wicked man in front of the Kali temple; but in him I saw the Power of the Divine Mother vibrating. That was why I fed a cat with the food that was to be offered to the Divine Mother.

Whitman expresses the same idea at the end of chant 48, and in the same half-playful fashion:

Why should I wish to see God better than this day?
I see something of God each hour of the twenty-four, and each
 moment then,
In the faces of men and women I see God, and in my own face in
 the glass;
I find letters from God dropped in the street, and every one is
 signed by God's name,
And I leave them where they are, for I know that others will
 punctually come forever and ever.

Such parallels—and there are dozens that might be quoted—are more than accidental. They reveal a kinship in thinking and experience that can be of practical value to students of Whitman. Since the Indian mystical philosophies are elaborate structures, based on conceptions that have been shaped and defined by centuries of discussion, they help to explain Whitman's ideas at points in the first edition where he seems at first glance to be vague or self-contradictory. There is, for example, his unusual combination of realism—sometimes brutal realism—and serene optimism. Today he is usually praised for the first, blamed for the second (optimism being out of fashion), and blamed still more for the inconsistency he showed in denying the existence of evil. The usual jibe is that Whitman thought the universe was perfect and was getting better every day.

It is obvious, however, that he never meant to deny the existence of evil in himself or his era or his nation. He knew that it existed in his own family, where one of his brothers was a congenital idiot, another was a drunkard married to a streetwalker, and still another, who had caught "the bad disorder," later died of general paresis in an insane asylum. Whitman's doctrine implied that each of them would have an opportunity to avoid these misfortunes or punishments in another incarnation, where each would be rewarded for his good actions. The universe was an eternal becoming for Whitman, a process not a structure, and it had to be judged from the standpoint of eternity. After his mystical experience, which seemed to offer a vision of eternity, he had become convinced that evil existed only as part of a universally perfect design. That explains his combination of realism and optimism, which seems unusual only in our Western world. In India, Heinrich Zimmer says, "Philosophic theory, religious belief, and intuitive experience support each other . . . in the basic insight that, fundamentally, all is well. A supreme optimism prevails everywhere, in spite of the unromantic recognition that the universe of man's affairs is in the most imperfect state imaginable, one amounting practically to chaos."

Another point explained by Indian conceptions is the sort of democracy Whitman was preaching in "Song of Myself." There is no doubt that he was always a democrat politically—which is to say a Jacksonian Democrat, a Barnburner writing editorials against the Hunkers, a Free Soiler in sympathy, and then a liberal but not a radical Republican. He remained faithful to what he called "the good old cause" of liberty, equality, and fraternity, and he wrote two moving elegies for the European rebels of 1848. In "Song of Myself," however, he is not advocating rebellion or even reform. "To a drudge of the cottonfields," he says, "or emptier of privies I lean . . . on his right cheek I put the family kiss"; but he offers nothing more than a kiss and an implied promise. What he preaches throughout the poem is not political but religious democracy, such as was practiced by the early Christians. Today it is practiced, at least in theory, by the Tantric sect, and we read in *Philosophies of India:*

> All beings and things are members of a single mystic family (*kula*). There is therefore no thought of caste within the Tantric holy "circles" (*cakra*). . . . Women as well as men are eligible not only to receive the highest initiation but also to confer it in the role of guru. . . . However, it must not be supposed that this indifference to the rules of caste implies any idea of revolution within the social sphere, as distinguished from the sphere of spiritual progress. The initiate returns to his post in society; for there too is the manifestation of Sakti. The world is affirmed, just as it is— neither renounced, as by an ascetic, nor corrected, as by a social reformer.

The promise that Whitman offers to the drudge of the cottonfields,

the emptier of privies, and the prostitute draggling her shawl is that they too can set out with him on his perpetual journey—perhaps not in their present incarnations, but at least in some future life. And that leads to another footnote offered by the Indian philosophies: they explain what the poet meant by the Open Road. It starts as an actual road that winds through fields and cities, but Whitman is doing more than inviting us to shoulder our duds and go hiking along it. The real journey is toward spiritual vision, toward reunion with the Divine Ground; and thus the Open Road becomes Whitman's equivalent for all the other roads and paths and ways that appear in mystical teachings. It reminds us of the Noble Eightfold Path of the Buddhists, and the Taoist Way; it suggests both the *bhakti-marga* or "path of devotion" and the *karma-marga* or "path of sacrifice"; while it comes closer to being the "big ferry" of the Mahayana sect, in which there is room for every soul to cross to the farther shore. Whitman's conception, however, was even broader. He said one should know "the universe itself as a road, as many roads, as roads for traveling souls."

I am not pleading for the acceptance of Whitman's ideas or for any other form of mysticism, Eastern or Western. I am only suggesting that his ideas as expressed in "Song of Myself" were bolder and more coherent than is generally supposed, and philosophically a great deal more respectable.

When Lilacs Last in the Dooryard Bloom'd

Richard Chase

T
here remained for Whitman, however, the writing of one more great poem. Apparently stemming from the mood of "Out of the Cradle," "When Lilacs Last in the Dooryard Bloom'd" is also related to "Crossing Brooklyn Ferry," capturing, as it does, the richness of the former and the vital abstractness and serene austerity of the latter. In the unique beauty of the Lincoln elegy one perceives both a farewell to poetry and the dim lineaments of a possible "late manner."

Lincoln had, of course, meant much to Whitman. He had voted for Lincoln in 1860 and had seen the President-elect when he stopped at the Astor House in New York on his way to Washington. Whitman noted how Lincoln "looked with curiosity" at the sullen, silent crowd that had gathered to see him, how he uttered no word but merely stretched his long limbs and stood there, an "uncouth" figure in his black suit and tall hat, gazing at the crowd with "perfect composure and coolness." Whitman thought he saw in Lincoln's posture "a dash of comedy, almost of farce, such as Shakespeare puts in his blackest tragedies," a description so accurate that one might imagine Lincoln unconsciously to describe himself in the same manner.

Matthiessen has pointed out the relevance of the Lincoln lecture Whitman was accustomed to give in later years to one's understanding of the genesis of the elegy. In this lecture Whitman recalled seeing the President on the occasion of the second inaugural address and noting

Reprinted from *Walt Whitman Reconsidered* by Richard Chase (New York: William Morrow, 1955), pp. 138–45. Copyright 1955 by Richard Chase. Reprinted by permission of William Morrow & Company, Inc.

how deeply cut were the marks of fatigue and worry on the "dark brown face" which still showed, however, "all the old goodness, tenderness, sadness, and canny shrewdness." Whitman recalled that just before the President stepped forth to the portico of the Capitol, the violent storm of the morning ceased and the day became so preternaturally clear that in the afternoon the stars shown "long, long before they were due." He recalled, too, the dramatic changes of weather in the weeks preceding the inauguration and how superbly beautiful some of the nights had been in the intervals of fair weather. Especially beautiful was the star he was to use with such effect in the elegy—"The western star, Venus, in the earlier hours of evening, has never been so large, so clear; it seems as if it told something, as if it held rapport indulgent with humanity, with us Americans."

It is of some psychological interest that when Whitman learned of the assassination, he was with his mother in Brooklyn. He described the scene in *Specimen Days:* "The day of the murder we heard the news very early in the morning. Mother prepared breakfast—and other meals afterward—as usual; but not a mouthful was eaten all day by either of us. We each drank half a cup of coffee; that was all. Little was said. We got every newspaper morning and evening, and the frequent extras of that period, and pass'd them silently to each other." The mood of hushed consecration in Whitman's poem, its treatment of death as a providential mother or bride, the large part played in the poem by reminiscences of childhood, such as the singing bird, the lilac that once bloomed in the dooryard of the Whitman farm—all these elements might have entered into the poem in any case but they are doubtless more of the poem's essence because of the circumstances under which Whitman first reflected upon the death of the President. (It is of some interest, too, that in *Specimen Days* Whitman described the star by which he symbolizes Lincoln as "maternal"; he had watched the setting of Venus on the night on March 18, 1879 and had jotted down the following: "Venus nearly down in the west, of a size and lustre as if trying to outshow herself, before departing. Teeming, maternal orb—I take you again to myself. I am reminded of that spring preceding Abraham Lincoln's murder, when I, restlessly haunting the Potomac banks, around Washington city, watch'd you, off there, aloof, moody as myself.")

The feelings expressed in this poem are exceedingly personal and exceedingly abstract. The death of the great person stirs the poet not to a tragic sense of life but to its exquisite pathos. The idea of redemption and eternal life is present, but the mood is aesthetic and moral rather than religious. In these qualities, as in its rather theatrical decor, Whitman's poem is closer in spirit to *The Wings of the Dove* than to the classic elegy.

If we compare "When Lilacs Last in the Dooryard Bloom'd" with "Lycidas," the greatest of English elegies, certainly notable differences emerge. "Lycidas" is, of course, written in the pastoral tradition, the convention of which is that a society of shepherds and more or less mythical personages mourns for the loss of a fellow shepherd. Nature, or its presiding geniuses, is chidden for its cruelty but joins in the universal mourning. And the consolatory thought is expressed that the dead person has actually escaped death and is assured of immortality. Whitman's democratic elegy departs from the practice of Milton exactly as we might expect. There is no society of shepherds in Whitman's poem; there is no image of any society at all, except of the sketchiest kind—on the one hand there are brief concrete images of "separate houses" with their "daily usages" and little groups of somber citizens at the depots watching the coffin, and, on the other hand, a generalized sense of the whole nation in mourning. Lincoln himself is absent from the poem, there being hardly a trace of either his person or his personality until the very end of the poem, where Whitman speaks vaguely of "the sweetest, wisest soul of all my days and lands." By comparison, we are told a good deal in "Lycidas" about Edward King, his youthful accomplishments and the promise of his career; and we are made very poignantly to feel the loneliness of the unfortunate youth as his body is tossed by the whelming tide. Whitman had formed sharp impressions of the powerful individuality of Lincoln, as we know from his graphic remarks about him elsewhere. He had even complained, in *Specimen Days,* that none of the portraits he had seen had at all caught the essential qualities of Lincoln's face, "the peculiar color, the lines of it, the eyes, mouth, expression." So that the impersonality of his elegy is all the more strongly brought home to us when Whitman writes:

> Here, coffin that slowly passes,
> I give you my sprig of lilac,

and we realize that not only has the poet not thought directly of the man in the coffin but that he has moved immediately into the abstract and universal, for he adds:

> Nor for you, for one alone,
> Blossoms and branches green to coffins all I bring,
> For fresh as the morning, thus would I chant a song
> for you O sane and sacred death.

Whitman's unacknowledged convention, here as everywhere, makes it impossible for him to conceive either the being or the value of the individual without conceiving him as an example of mankind in general. Were he to read Whitman's poem, Milton would doubtless observe that

instead of bestowing flowers upon Lincoln, as he should, the poet bestows them first on all the dead equally and then on death itself.

Elegiac feeling in American literature does not, in fact, characteristically take for its occasion the death of an individual—a Bion, an Edward King, a Keats, a Wellington. Or if it does, as in Whitman's poem, it moves quickly away from the particularity of the occasion, and without proposing the dead person as an example of tragic crisis in the human spirit or in human history. The American elegiac sensibility—in Cooper, Melville, Thoreau, Mark Twain, James, and others—is most strongly engaged by the sense of lost modes of innocence, lost possibilities of brotherhood, magnanimity, and freedom, lost sources of moral spontaneity and spiritual refreshment. The tone is of pathos, nostalgia, and despair. The emotions come to rest, if at all, in the personal virtues of forebearance and resignation—not in metaphysical, religious, or political orders of meaning. There is kinship in Cooper's lament for Lake Glimmerglass, Mark Twain's musings over Huck Finn and Jim on their raft, Isabel Archer's cry, "Oh my Brother," at the death of Ralph Touchett, and Walt Whitman's plea to his dim, evanescent "companions" in the Lincoln poem.

To set off the large abstractions of the Lincoln elegy there is really only one individual in the poem, the poet himself. To be sure, in "Lycidas" the poet makes his personal grief, his personal presence, and his own aspirations strongly felt; yet he finds solace for his grief and an enhanced understanding of his own probable fate by representing a society of actual and mythical persons who also grieve, and by showing the profound involvement of the dead man, and thus of himself and of all men, in the alternately destructive and healing motions of nature in a divinely directed order. In Whitman's poem the poet finds solace for his grief, not by placing himself in a grieving society but by withdrawing from the world and, in effect, curing his grief by feeling the more powerful emotion of loneliness. And the poem then recounts the poet's search for comrades, whom he finds in the symbolic star and singing bird and finally in death itself. There is no doubt that something morally incomplete has taken place when a poet is unable to speak of the death of a man—and he a beloved man—except in terms of his own loneliness. Yet there can be no doubt about the surpassing beauty of the verse:

> Then with the knowledge of death as walking one side
> of me,
> And the thought of death close-walking the other side
> of me,
> And I in the middle as with companions, and as
> holding the hands of companions,
> I fled forth to the hiding receiving night that talks not,

Down to the shores of the water, the path by the
swamp in the dimness,
To the solemn shadowy cedars and ghostly pines so
still.

If the poet of "When Lilacs Last in the Dooryard Bloom'd" does not
place himself in any ostensible society, neither does he very profoundly
place himself in nature. Had he read *Moby Dick,* Tocqueville might have
found an exception to his prediction that American writers, though they
might be profoundly moved by the majestic spectacle of mankind, would
not attempt to grasp the deeper implications of man's involvement in
nature. But like much of Whitman's poetry, the Lincoln elegy bears out
this prediction. Whitman is entirely incapable of conceiving anything like
Milton's image of Lycidas, who "visit'st the bottom of the monstrous
world." In contrast to Milton's tragic conception of nature, Whitman's
grasp upon nature issues, not in a vision of universal order (or disorder),
but either in the affective pathos of somewhat theatrical symbols like the
lilac and the cedars and pines or in the brooding, lyric but abstract med-
itations upon death.

It must be noted finally that in contrast to that in "Lycidas" the feeling
of immortality is extremely weak in Whitman's poem. There is no lib-
erating promise of personal immortality to the dead man, and at the end
we find a beautiful but very sad recessional instead of the buoyant prom-
ise of "fresh fields, and pastures new." The symbol of the lilac "blooming,
returning with spring" recurs, with its suggestion of resurrection. But this
does not at all succeed in releasing the poet from his conviction that he
has found the ultimate felicity of comradeship in the equalitarian de-
mocracy of death itself.

What we do supremely have in the Lincoln elegy is the expression of
Whitman's native elegance and refinement. These are not qualities which
we usually assign to this poet. When T. S. Eliot referred to that excessive
American refinement which did not belong to civilization but was already
beyond it, he was thinking of the refinement of Boston. He might have
added the conventional opinion that Whitman well represents the op-
posite strain of American life. But as we have noted before, Whitman is
in some ways an extremely sophisticated, even a decadent poet. There is
a premature old age in his poetry, as there was in the man himself. His
elegiac utterances sound an unmistakable note of Virgilian weariness.
And if the mind whose imprint we read on the Lincoln elegy is harmo-
nious and moving, it is also in danger of an excessive refinement. It is
in danger of wishing to substitute antiseptics for the healing processes of
nature in which it cannot quite believe any more. How else is one to
account for the sterile, the really Egyptian, atmosphere of odors, per-

fumes, herbage, pine, and cedar, to say nothing of the outright lyric worship of death itself?

Yet despite its artificiality "When Lilacs Last in the Dooryard Bloom'd" stands up well if we compare it with other expressions of the refined American spirit—the "Sunday Morning" of Wallace Stevens, let us say, and James's *The Wings of the Dove* and *The Golden Bowl,* and Eliot's *Four Quartets.* Different as these works are they share a tendency toward the abstract forms of myth and music, allegations of portents and miracles, appeals to the restorative cosmic forces. It is a "late" work, and (within the Whitman canon) it has the sound, as well as the emotional appeal, of a swan song.